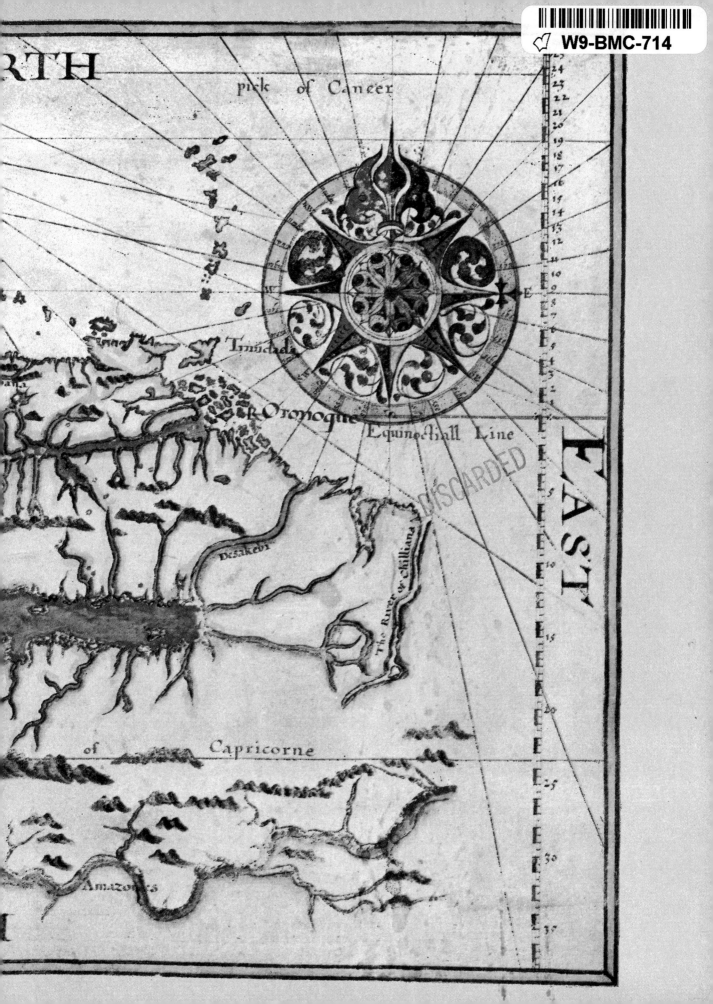

Art at Auction
1971-72

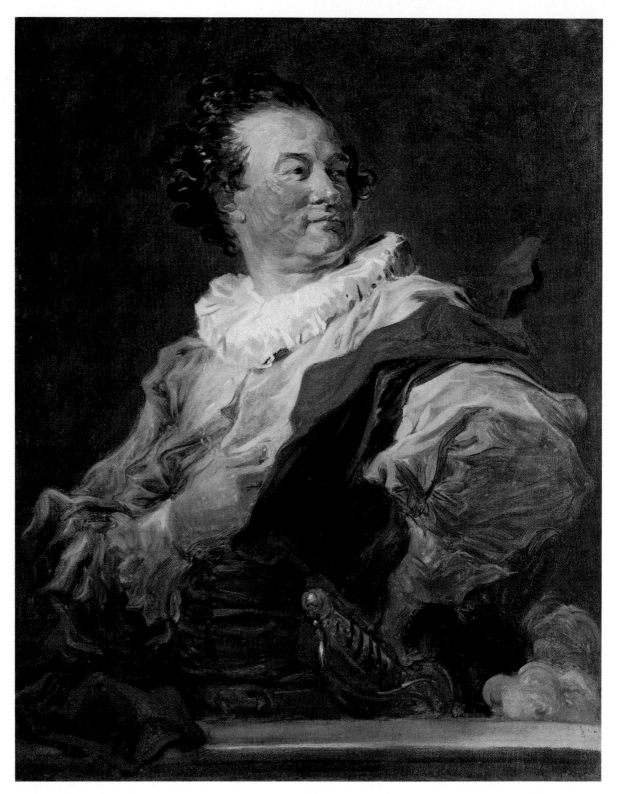

JEAN-HONORE FRAGONARD
Anne-François d'Harcourt, Duc de Beuvron.
Probably painted in 1767–68. 31¼ in. by 25 in.
London £340,000 ($850,000). 8.XII.71.
From the collection of the Duc d'Harcourt.

Illustrated on end papers:
Manuscript map of Guiana, on vellum [1596–9].
London £4,000 ($10,000). 9.XI.71.

From the collection of Boies Penrose, Esq., F.S.A., F.R.G.S.
The only known manuscript copy of Sir Walter Raleigh's
map of Guiana, made after his return from his voyage in
search of Manoa, the legendary capital of El Dorado.

Art at Auction

The Year at Sotheby's & Parke-Bernet

1971-72

Two Hundred and Thirty-Eighth Season

A Studio Book · The Viking Press · New York

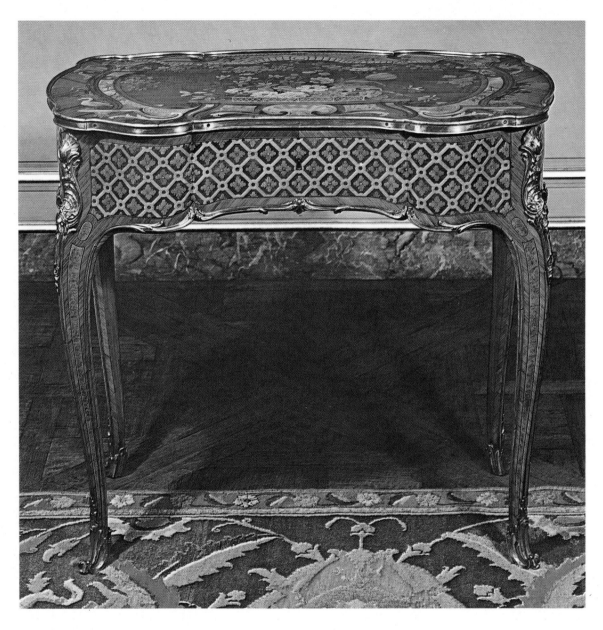

Art at Auction 1971–72, edited by Philip Wilson and Annamaria Macdonald
assisted by Joan Sarll
Jacket photograph by Jeanette Kinch

Copyright © 1972 by Sotheby & Co.

Published in 1973 by The Viking Press, Inc., 625 Madison Avenue, New York, N.Y. 10022

Published simultaneously in Canada by The Macmillan Company of Canada Limited

SBN 670-13403-1

Library of Congress catalog card number: 67-30652

Printed and bound in Great Britain by Lund Humphries, London and Bradford

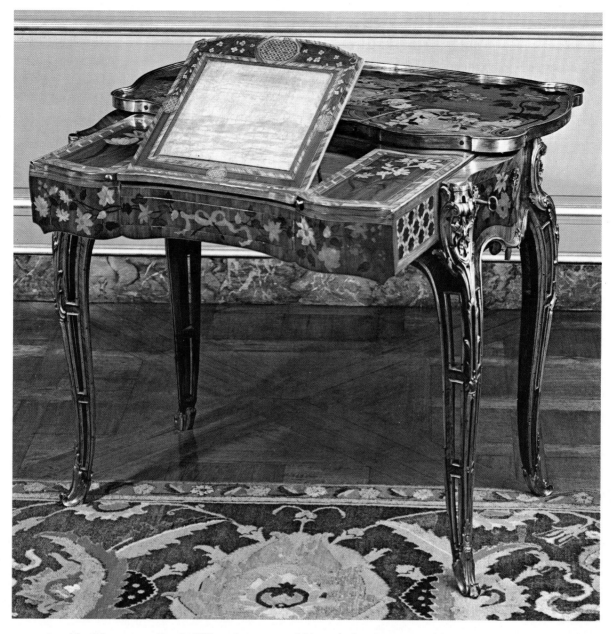

A mid-18th century Louis XV mahogany and kingwood marquetry table.
Signed: J. F. Oeben and R. V. L. (C.) JME.
Height 2 ft. 3½ in.; width 2 ft. 8¼ in.
New York $410,000 (£164,000). 23.x.71.
(See also pages 352–353.)

Opposite page:
A mid-18th century Louis XV kingwood and mahogany marquetry writing table signed J. F. Oeben.
Height 2 ft. 4 in.; width 2 ft. 7¼ in.
New York $270,000 (£108,000). 23.x.71.
(See also pages 338–339.)
These two tables were from the collection of the late Martha Baird Rockefeller.

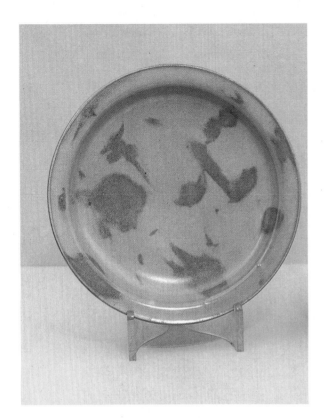

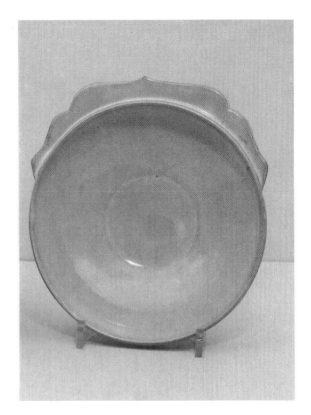

Left: A splashed Chün-yao dish (*p'an*). Sung dynasty. 7¼ in. London £8,000 ($20,000). 14.iii.72.
Right: A Chün-yao brushwasher (*hsi*). Sung dynasty. 7½ in. London £18,000 ($45,000). 14.iii.72.

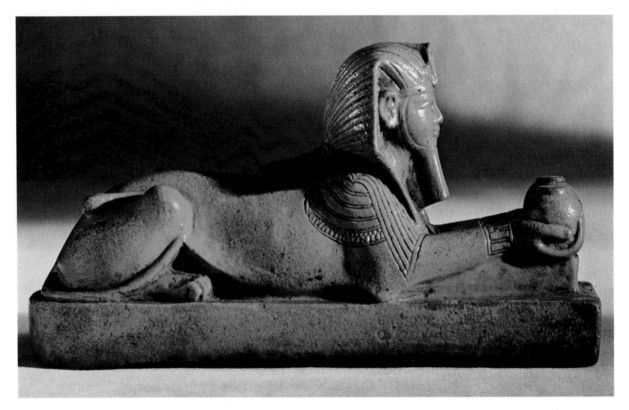

An Egyptian faience sphinx of Amenhotep III. Late 18th dynasty, *circa* 1410–1320 B.C. Length 9⅞in.
New York $260,000 (£104,000). 4.v.72.
From the collection of the Cranbrook Academy of Art, Bloomfield Hills, Michigan.

Contents

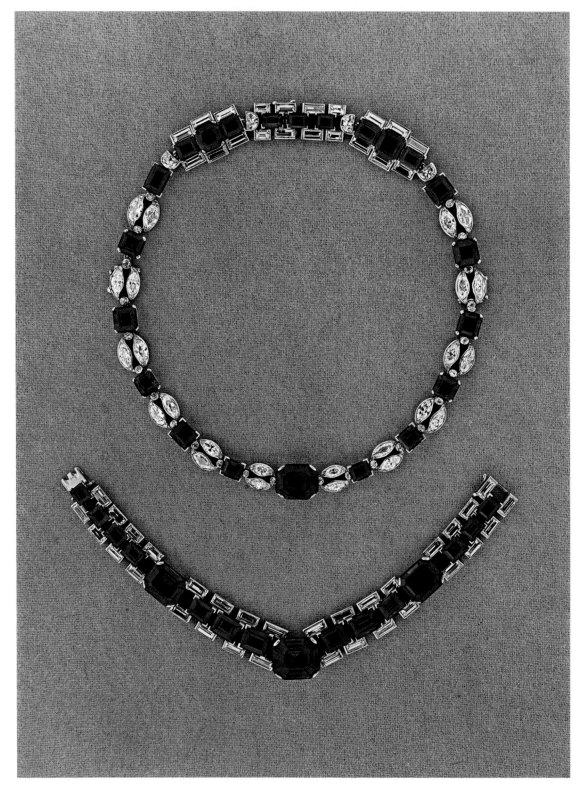

A sapphire and diamond necklace that divides to form three bracelets. The largest sapphires weigh 9·16, 14·42, 9·54 carats in the bracelet; 12·49 carats in the necklace.

Sizes are reduced in the illustration.

Zurich SF650,000 (£64,300; $168,100). 4.v.72.

For the sake of consistency all exchange rates have been calculated at $2.50 to the £1.00 despite fluctuations.

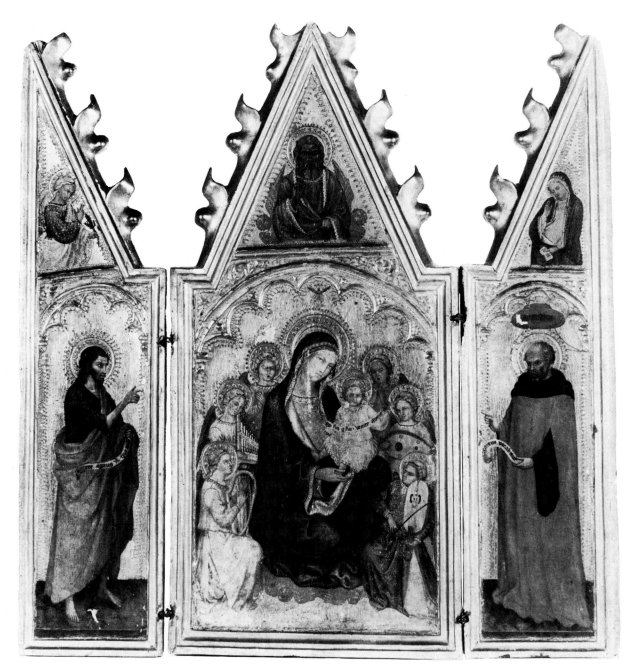

TADDEO DI BARTOLO
A triptych.
On panel. Signed *TAD . . . (DE?) SENIS PINXIT*. Centre panel: 18 in. by 8¼ in.
Each wing: 17½ in. by 3¾ in.
London £38,000 ($95,000). 8.XII.71.
From the collection of Lt-Col. G. T. M. Scrope, O.B.E.

Old Master Paintings

This season saw the first major sale of old master paintings held in New York for many years, a sale which proved an unqualified success. A rare panel by the 16th-century Flemish master Jan Gossaert, called Mabuse, was sold for $190,000 (£76,000); a splendid town view by Gerrit Adriaensz. Berckheyde, brought $85,000 (£34,000); $200,000 (£80,000) was paid for one of Philips Koninck's panoramic landscapes, and $140,000 (£56,000) for a beautiful landscape by Nicolaes Berchem, which had once been in the collection of Prince Eugène de Beauharnais. These pictures were part of a particularly distinguished group of Dutch and Flemish paintings, and all of them realised record auction prices.

Paintings of these schools have attained equally high prices in London. In July, *A scene on the outskirts of a village* by Pieter Brueghel the Younger realised £38,000 ($95,000) and a set of four panels depicting the Seasons by the same artist were sold for £85,000 ($212,500). In December, an oil sketch by Rubens, *The Continence of Scipio*, fetched £59,000 ($147,500). This sketch was of very high quality and was of considerable historical importance, being the final sketch for the large composition once in the collections of Queen Christina of Sweden and the Duc d'Orléans which was destroyed by fire in London in 1836. In the same sale, a fine coastal view by Salomon van Ruysdael fetched £30,000 ($75,000) and a beautiful still life by Jan Philip van Thielen realised £16,500 ($41,250), an indication of the popularity of early still lifes.

Two paintings of great interest to the British market were sold in December. The *Portrait of Mary Tudor, Queen of England* by Hans Eworth, fetched £28,000 ($70,000), and Canaletto's romantic view of *Old Walton Bridge*, £52,000 ($130,000). Eworth was court painter to Mary Tudor during her brief reign but this is his only known portrait of the Queen. It was purchased by Messrs Leggatt acting on behalf of the National Portrait Gallery, London.

Italian paintings sold this season included a newly discovered signed triptych by Taddeo di Bartolo, a work of high quality, which fetched £38,000 ($95,000), and an exceptionally fine Roman view by Antonio Joli, which realised a record £23,000 ($57,000) being sold by the Estate of the novelist Evelyn Waugh.

However, the most important paintings were unquestionably the works by the Bolognese 16th-17th century masters, Annibale and Lodovico Carracci and Il Guercino. £110,000 ($275,000) was paid for Guercino's monumental painting of a dog; the Paul Getty Museum purchased Lodovico Carracci's *St. Sebastian thrown by soldiers into the Cloaca Maxima* for £65,000 ($162,500), and Annibale Carracci's *A Boy in the act of drinking* from the Ellesmere collection, realised £40,000 ($100,000). These three pictures, taken with the Ellesmere drawings, represented one of the most important groups of Bolognese art offered at auction this century.

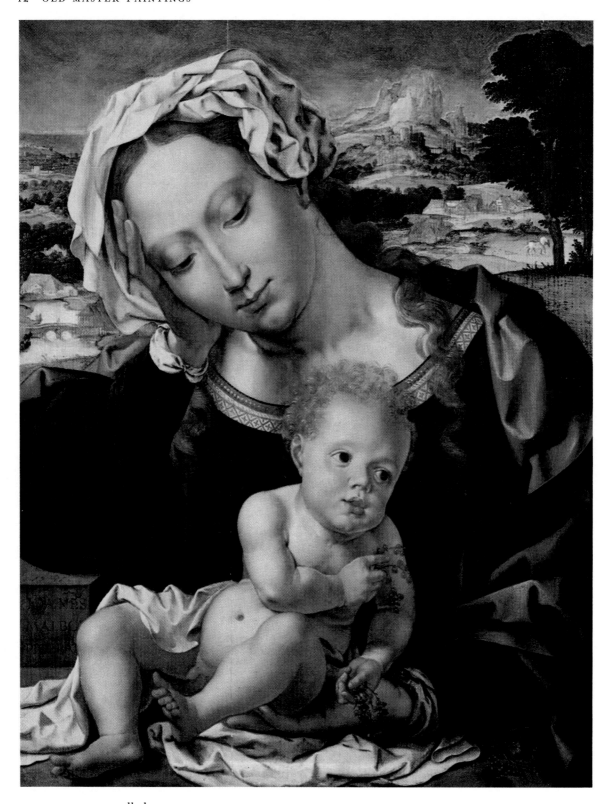

JAN GOSSAERT, called MABUSE
Madonna and Child.
On panel. Signed *Joanes Malbo/Pigebat*, dated 1531. 21¾ in. by 19⅞ in.
New York $190,000 (£76,000). 18.v.72.

From the collection of the Cranbrook Academy of Art, Bloomfield Hills, Michigan.

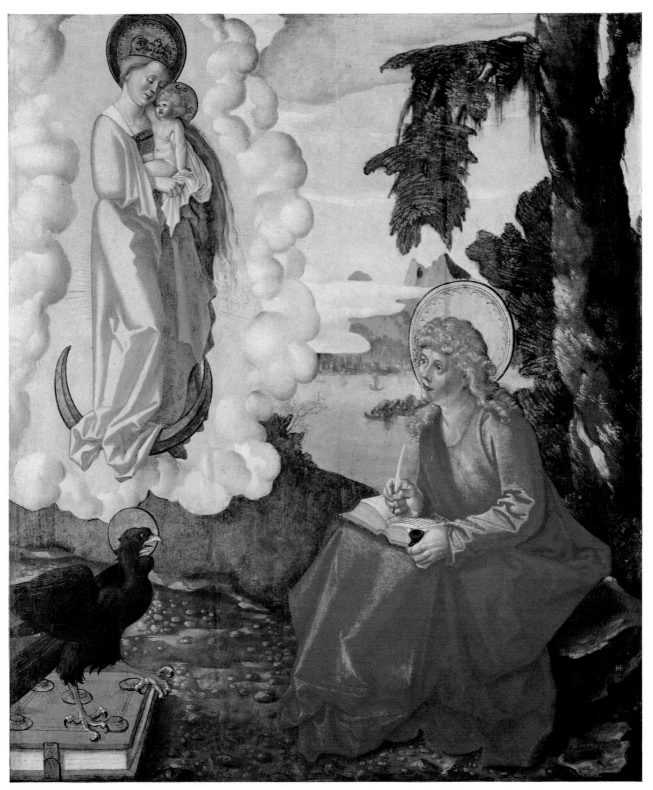

HANS BALDUNG, called GRIEN
St John the Evangelist on the Island of Patmos.
On panel. Signed in monogram. 35 in. by 30¼ in.
London £120,000 ($300,000). 8.XII.71.

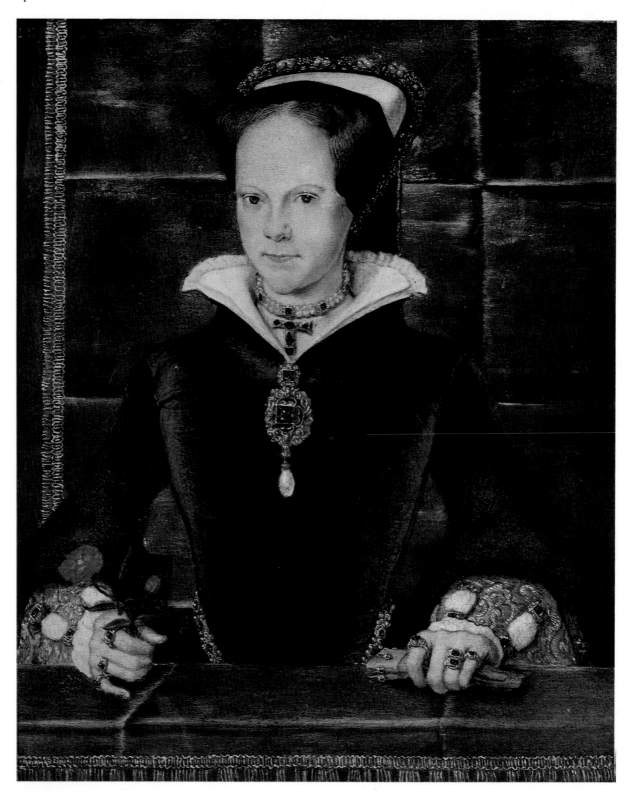

HANS EWORTH
Mary Tudor, Queen of England.
On panel. Signed in monogram. 8¼ in. by 6⅝ in.
London £28,000 ($70,000). 8.XII.71.

From the collection of Col. C. M. Paul, of New York.

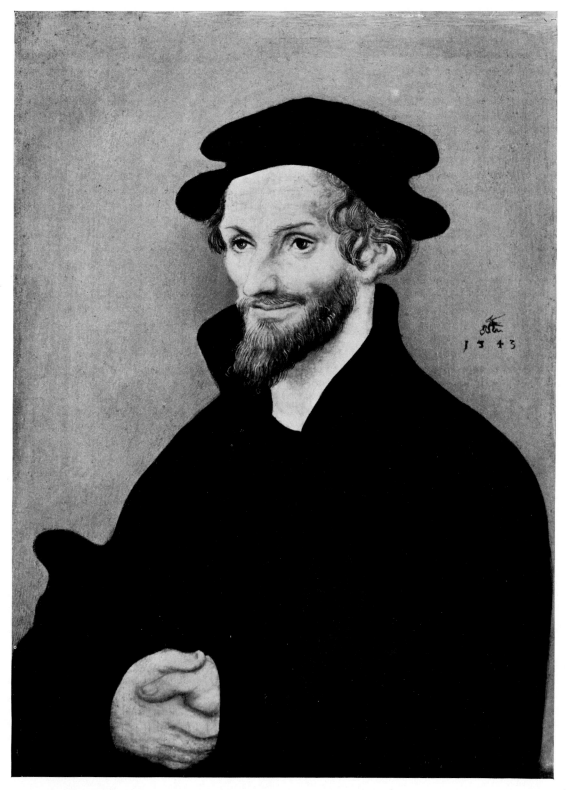

LUCAS CRANACH THE ELDER
Philipp Melanchthon.
On panel. Signed with the winged serpent, dated 1543. 7¾ in. by 6 in.
London £8,200 ($20,500). 8.XII.71.

From the collection of John Frederick Austin Huth, Esq.

FRANCESCO GUARDI
Interior of the Ridotto, Venice.
30 in. by 41¾ in.
London £32,000 ($80,000). 19.IV.72.
From the collection of Baroness de Rothschild.

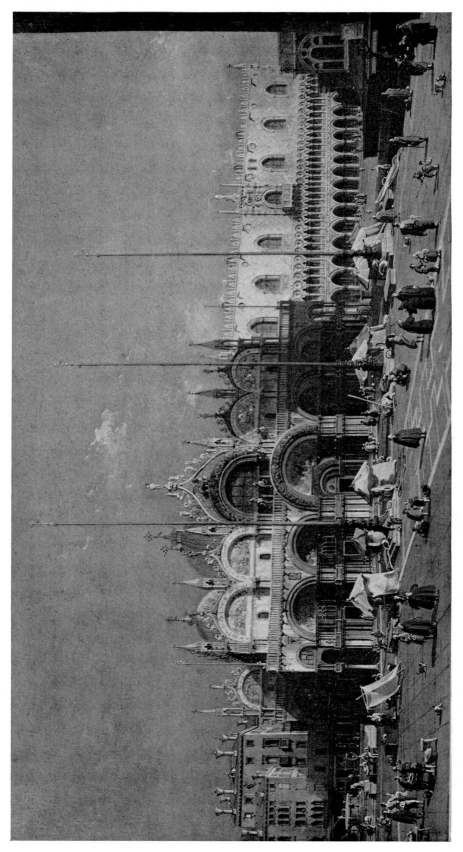

ANTONIO CANALE, called CANALETTO
The Piazza San Marco, looking East from North of the central line.
$22\frac{1}{2}$ in. by 31 in.
New York $135,000 (£54,000). 18.v.72.
From the collection of the Cranbrook Academy of Art, Bloomfield Hills, Michigan.

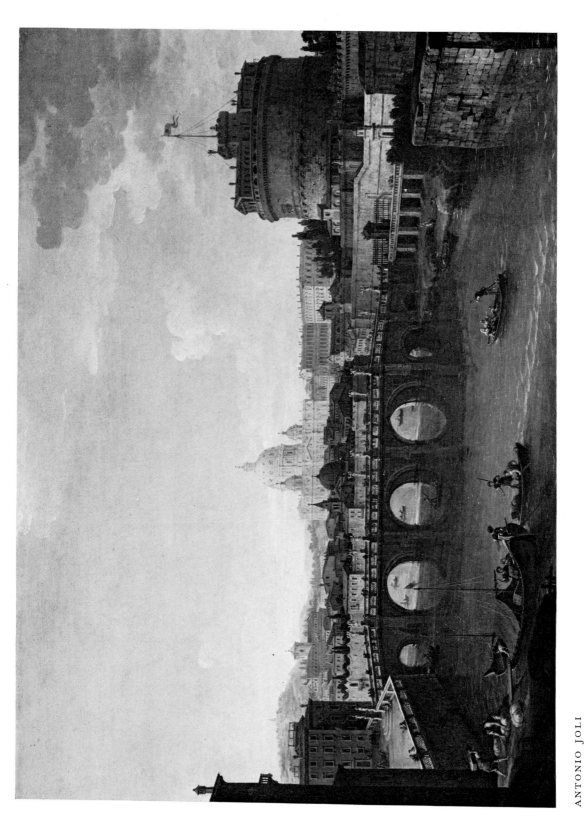

ANTONIO JOLI
A view in Rome.
Signed: *Jolli/Madrid.* 46½ in. by 64 in.
London £23,000 ($57,500). 8.xii.71.
From the collection of the late Evelyn Waugh.

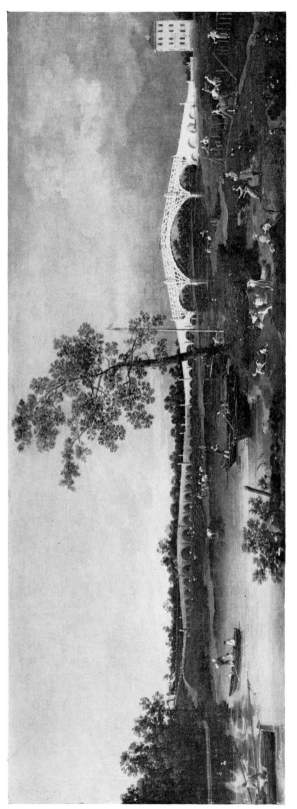

ANTONIO CANALE, called CANALETTO
Old Walton Bridge.
Inscribed on back of lining canvas: *Fatto nell'anno 1755 in Londra . . . Antonio Canal detto il Canaleto.*
17¾ in. by 47¾ in.
London £52,000 ($130,000). 8.xii.71.
From the collection of Mrs L. Skrine.

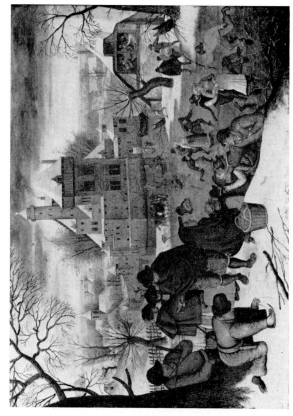

PIETER BRUEGHEL THE YOUNGER. *The four seasons.*
Signed. 16 in. by 22¼ in. each. London £85,000 ($212,500). 12.VII.72.

PIETER BRUEGHEL THE YOUNGER. *A scene on the outskirts of a village.*
On panel. 16¾ in. by 23¼ in.
London £38,000 ($95,000). 12.VII.72.
From the collection of Sir Henry Carden, Bt.

SALOMON VAN RUYSDAEL
An estuary.
On panel, signed and indistinctly dated. 13 in. by 17¼ in.
London £27,000 ($67,500). 8.XII.71. From the collection of Mrs B. P. Hall.

SALOMON VAN RUYSDAEL
The coast at Egmond-aan-Zee.
On panel. Indistinctly signed and dated. 19½ in. by 29¼ in.
London £30,000 ($75,000). 8.XII.71.

JAN VAN GOYEN
A view of Overschie.
On panel, signed with
initials, dated 1643.
11¼ in. by 12⅝ in.
London £10,000
($25,000). 8.XII.71.

GERRIT ADRIAENSZ.
BERCKHEYDE
*A view of the Grote Markt
and the Stadhuis, Haarlem.*
Signed, dated 1691.
20¾ in. by 24¾ in.
New York $85,000
(£34,000). 17.V.72.

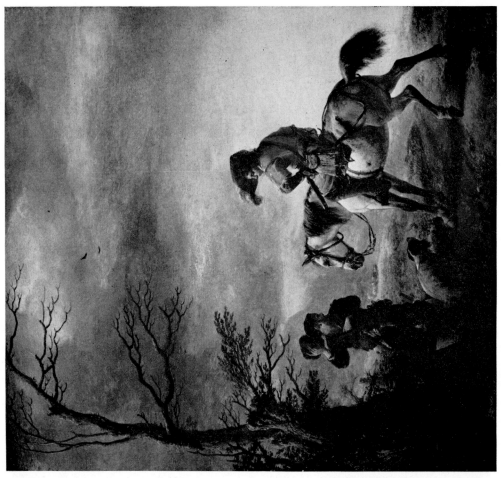

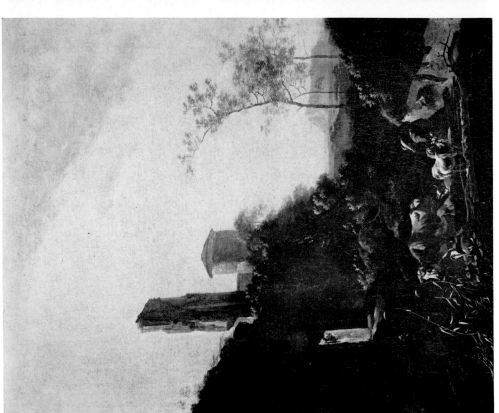

PHILIPS WOUWERMANS
A peasant greeting a horseman.
On panel, signed with monogram, dated 1649.
12¼ in. by 11¼ in.
London £11,000 ($27,500). 12.VII.72.
From the collection of Bruce Hungerford of New York.

ADAM PYNACKER
Italian landscape.
Signed. 26¾ in. by 21 in.
London £8,500 ($21,250). 19.IV.72.
From the collection of the late Walter Morrison.

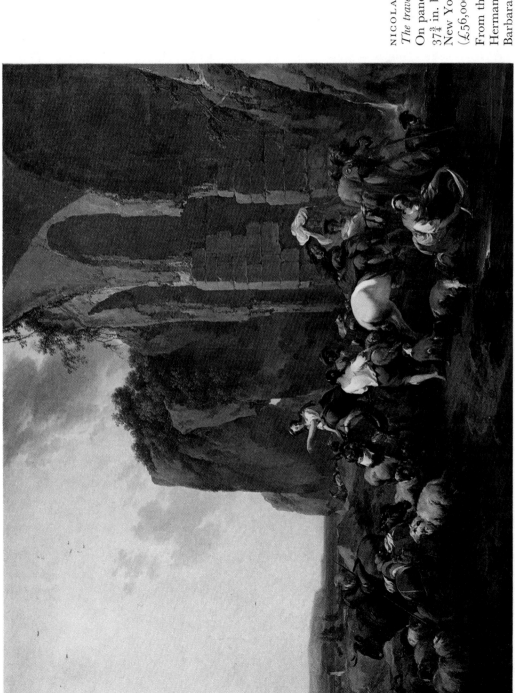

NICOLAES BERCHEM
The traveller's halt.
On panel. Signed.
37¾ in. by 45½ in.
New York $140,000
(£56,000). 18.v.72.
From the collection of
Herman Peterson of Santa
Barbara, California.

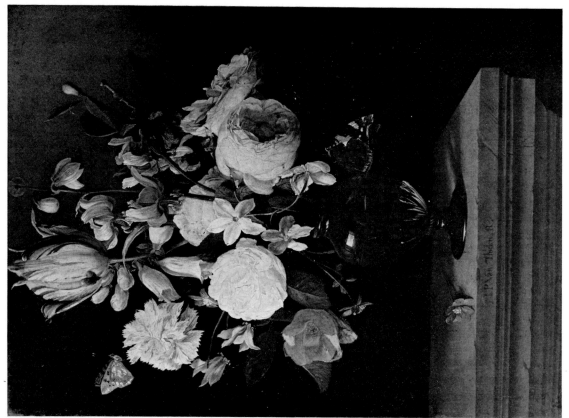

JAN PHILIP VAN THIELEN
Flowers in a glass vase.
On panel. Signed. 20¼ in. by 14½ in.
London £16,500 ($41,250). 8.xii.71.

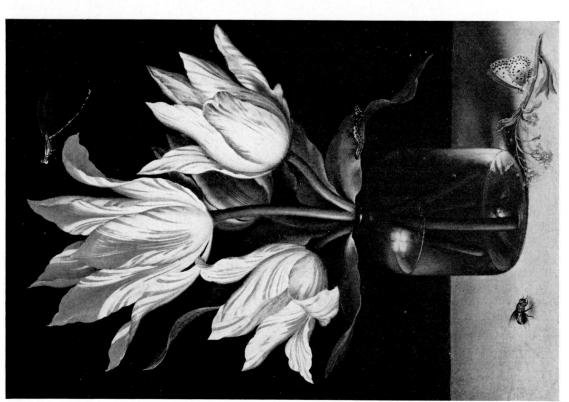

AMBROSIUS BOSSCHAERT
Flowers in a glass bottle.
On panel. 9⅝ in. by 6¾ in.
London £12,500 ($31,250). 8.xii.71.

From the collection of Mrs Alexander Keiller.

JAN MYTENS
A wedding portrait.
Signed, dated 1653. $37\frac{1}{2}$ in. by $66\frac{1}{2}$ in.
London £11,500 ($28,750). 12.VII.72.

GIOVANNI FRANCESCO BARBIERI, called IL GUERCINO
Portrait of a dog.
43¾in. by 68 in.
London £110,000 ($275,000). 12.VII.72.

From the collection formed by members of the Smith-Barry family, Marbury Hall, Northwich, Cheshire.

SIR PETER PAUL RUBENS
The Continence of Scipio.
On panel. 12¼ in. by 19½ in.
London £59,000 ($147,500). 8.xii.71.

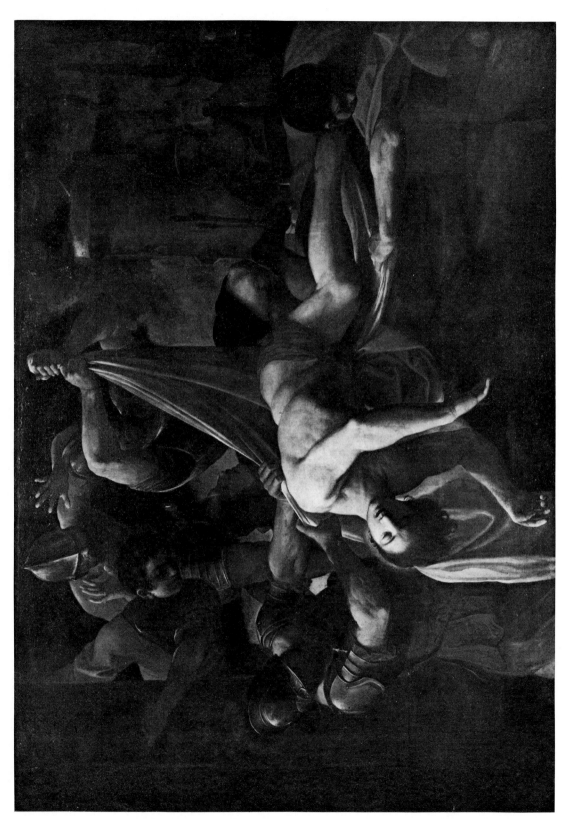

LODOVICO CARRACCI
St Sebastian thrown by soldiers into the Cloaca Maxima.
63½ in. by 89¾ in.
London £65,000 ($162,500). 12.VII.72.

This painting was commissioned from the painter in 1612 by Cardinal Maffeo Barberini (later Pope Urban VIII) and was intended for the Barberini chapel in Sant Andrea della Valle in Rome.

The Carracci Drawings from the Ellesmere Collection

BY JULIEN STOCK

On the 11th July 1972 the first part of the celebrated Ellesmere Collection came up for sale at Sotheby's. It consisted mainly of drawings by Lodovico (1555–1619), Agostino (1557–1602) and Annibale (1560–1609) Carracci with a few fine examples of Guercino (1591–1666) who had studied the Carracci, especially Lodovico, at Bologna. The Carracci founded the 17th century school of Bolognese painting and their work became one of the main sources for both the baroque and classical styles of the next centuries. Luigi Lanzi, the learned late 18th century historian of Italian painting, was probably right in declaring that 'to write the history of the Carracci is equivalent to writing the history of painting of the last two centuries'. The collection provided a good general view of their œuvre and also enabled one to observe their differences in personality. It had previously been on loan, since 1954, to the Leicester Museum and Art Gallery and in June 1972 was exhibited in Germany at the Kunsthalle, Hamburg.

The drawings once formed a small part of Sir Thomas Lawrence's collection. Lawrence, whose appetite for drawings was insatiable, built up his collection mainly through his close friend Samuel Woodburn, who purchased, either *en bloc* or in part, such notable collections as those of Jean-Baptiste Wicar, the Marquis de Lagoy, Count von Fries of Vienna and Thomas Dimsdale, the latter, until his death, Lawrence's great rival. Woodburn was the most respected and knowledgeable art dealer of his day, as is borne out from the obituary in 1853 in the *Art Journal*: 'The judgement of Mr. Woodburn was rarely at fault, and his integrity was always to be relied on; hence, few transactions of any moment connected with his profession occurred without his opinion being consulted. The death of Mr. Woodburn is a loss to the art-intelligence of this country, for with all respect to the few trusty connoisseurs he has left behind, we know of no one who can so efficiently and worthily fill his place as an able judge and an upright dealer.' At his death in 1830, Lawrence left explicit instructions in his will for preserving his collection as a whole. It was to be offered for £18,000 to George IV, who was, in fairness, already far too ill to exert himself over such matters – then to the Trustees of the British Museum, who showed little interest, and afterwards successively to Sir Robert Peel and the Earl of Dudley. If it was not sold within two years the whole collection was to be either put up for auction or sold by private treaty. Since all the above-mentioned parties declined, Keightley, the sole executor, was faced with a difficult problem. He appointed Woodburn as agent for the collection, who no doubt was responsible for Keightley's attempts to sell it to the nation by means of a public subscription and, that having failed, to the Government for the National Gallery, an attempt which was also unsuccessful. Keightley was then compelled to sell it to Woodburn for £16,000 because Lawrence, at the time of his death, owed Woodburn a substantial sum of money. The latter then placed the famous collector's mark *TL.* on the vast majority of the drawings and he too offered it to the

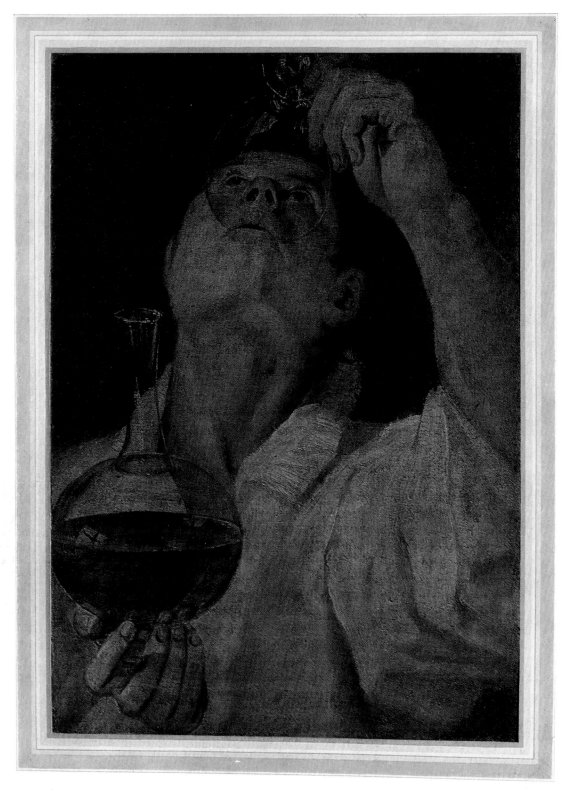

ANNIBALE CARRACCI
A boy in the act of drinking.
Oil on canvas. 24¼ in. by 17½ in. £40,000 ($100,000).
From the collections of Jean-Baptiste-Joseph Wicar and Sir Thomas Lawrence.

Government; after almost a year of waiting the reply was in the negative. After these failures, which he looked on as final, he set about arranging a series of ten exhibitions, each of one hundred drawings, which have since proved to be the most splendid commercial exhibitions of Old Master Drawings ever to have been held. The drawings by the Carracci formed the sixth exhibition which took place in 1836, and were sold for £1,500. This sum included sixty further drawings which had not been shown in the exhibition. All the 160 drawings were purchased by Lord Francis Egerton, later 1st Earl of Ellesmere, who presented those not exhibited in Woodburn's exhibition to the Ashmolean Museum, Oxford.

The recent auction, which realised a world record total of £472,160, more than doubled any previous Old Master Drawing sale and, as one would imagine, easily broke the previous record for a drawing by Annibale hitherto held by the *Head of a young man* which was sold in our rooms for £3,300 in 1969. The highest price in the sale was £40,000 for an oil study by Annibale of *A boy in the act of drinking* (page 32) while the highest price for a drawing, again by Annibale, was £34,000 paid by the National Gallery of Victoria, Melbourne (page 39) for the celebrated *Ignudo*, a preliminary study for one of the nude figures on the vault of the Galleria Farnese (1597–1600), the masterpiece of Annibale and Agostino which in the 17th and 18th centuries was held in the same esteem as Raphael's *Stanze* and Michelangelo's Sistine Chapel. Another fine study for the Galleria Farnese of *Jupiter and Juno* (page 40) realised £9,500 while the final study for the *Tazza Farnese* (page 41), Annibale's famous engraved silver salver of *The Drunken Silenus* (page 41) was purchased by the Metropolitan Museum, New York for £15,500. The two drawings that probably captured most collectors' hearts were *Three studies of men* (page 37) and *Two studies of a boy and two of a girl* (page 38). The former dating from the 1580's was bought by an anonymous private collector for £30,000; it shows Annibale in an informal mood almost verging on caricature, a genre which he is believed to have invented. The latter drawing, which shows Annibale's extraordinary anticipation of the 18th century, especially of such artists as Watteau and Piazzetta, was purchased by the Metropolitan Museum for £32,000. Probably the two most enchanting drawings were the *Domestic Scenes* (pages 36 and 40). The interior with an old man and child warming a cat's belly was bought by an English private collector for £7,000 and will be lent to the Fitzwilliam Museum, Cambridge. The other study of a young mother airing a shirt or nightgown was bought for £25,000 by the Metropolitan Museum. The collection also comprised an important group of landscapes. The Pierpont Morgan Library purchased what is perhaps the finest, a *River landscape with a wooded cliff and tree trunks* (page 34) for £10,200. An important German museum bought *A seashore with the sun setting* (page 42) for £7,000 and the British Museum the *Landscape with the sun setting* (page 42) for £4,800, both executed in the artist's last years and both anticipating Domenichino and Claude Lorrain. Other notable prices were £8,500 for Annibale's large *Wooded landscape with buildings* (page 40) which shows strong Venetian influence deriving from Titian and Campagnola and £4,500 for his *Landscape with a boat* (page 42), a typical 'Bolognese landscape' to which a painting in the London National Gallery is related. It was bought by the Cleveland Museum of Art, Ohio.

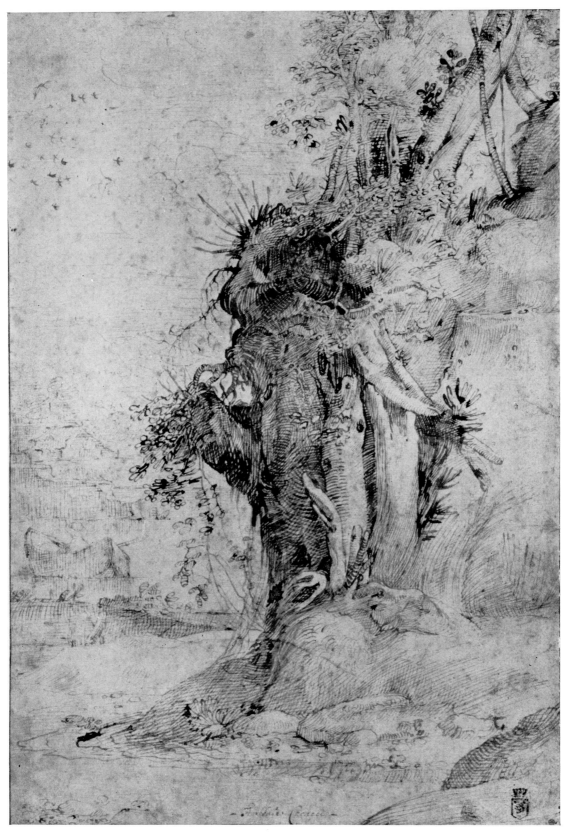

ANNIBALE CARRACCI
River landscape with a wooded cliff and tree trunks.
Pen and brown ink. 402 mm. by 280 mm. £10,200 ($25,500).
From the collections of Pierre-Jean Mariette and Count Moriz von Fries.

From the group of drawings by Agostino (pages 44 and 45), the superb *Sheet of studies including shepherds for an Adoration* realised £15,500 and was bought by an American private collector, while the *Studies for the frescoes in the Palazzo del Giardino, Parma* (page 44), Agostino's last commission, was purchased by the Metropolitan Museum for £10,500. The beautiful study of the *Virgin and Child in a feigned circular frame* (page 44) realised £9,500 and has now found a permanent home at the British Museum. The top price among the drawings by Lodovico (page 43) was £7,500 paid by an American private collector for the study of the *Virgin and Child* in red and white chalks on blue paper, while an English private collector purchased for £6,500 the beautiful study of the same subject, in black chalk on buff paper, for a painting or fresco in a high position. The powerful study of a standing *St Jerome* (page 43) was secured by the British Museum for £3,200.

The few drawings by Guercino were all overshadowed by the very sensitive *Crucified Christ* (page 44) with its delicate handling of brown wash. It fetched £11,000, a new world record for this master.

The taste for the seicento, one might think, after such a sale, is at its peak, with most major museums and institutions outbidding the seasoned private collector of a few years back. However, the process of revaluation is a continuous one and young collectors would be well advised to take a stroll in some of the fascinating by-ways which the historian–connoisseur is exploring at the moment.

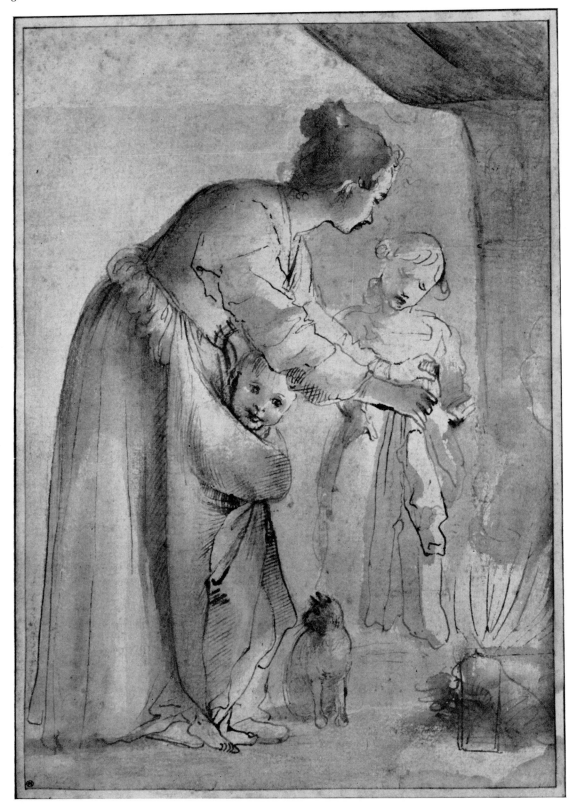

ANNIBALE CARRACCI
A domestic scene.
Pen and black ink and grey wash. 327 mm. by 235 mm. £25,000 ($62,500).

From the collections of Carlo degli Occhiali, Pierre Crozat, Pierre-Jean Mariette and Count Moriz von Fries.

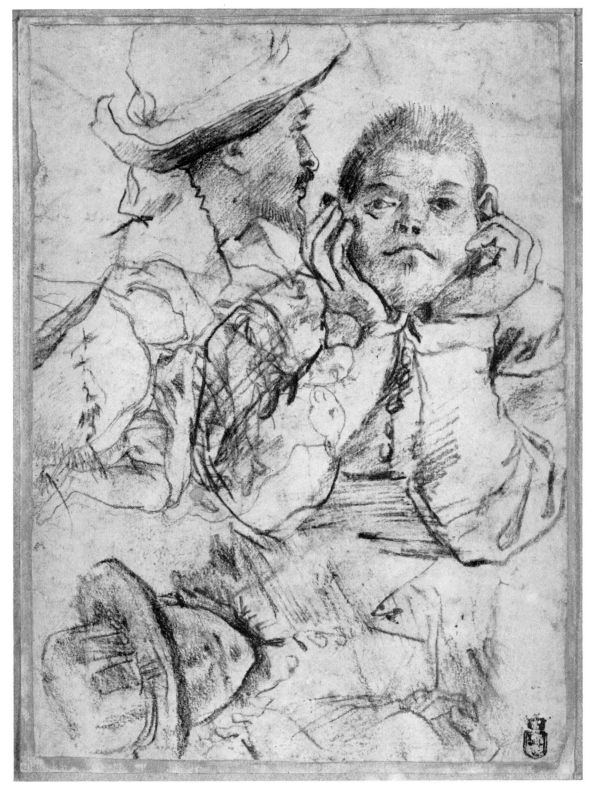

ANNIBALE CARRACCI
Three studies of men.
Black chalk. 278 mm. by 204 mm. £30,000 ($75,000).

From the collections of Uvedale Price and Thomas Dimsdale.

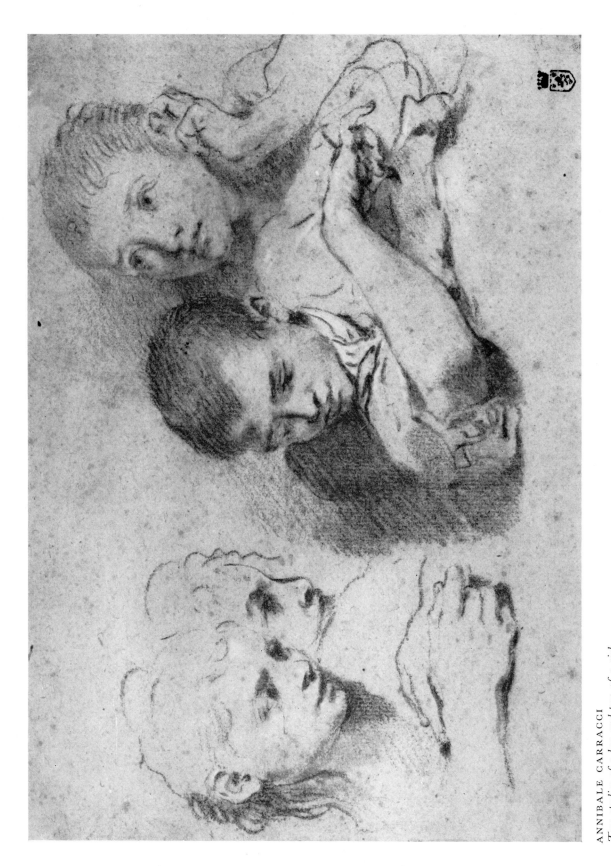

ANNIBALE CARRACCI
Two studies of a boy and two of a girl.
Red chalk heightened with white chalk. 226 mm. by 319 mm. £32,000 ($80,000).
From the collections of the Marquis de Lagoy and Thomas Dimsdale.

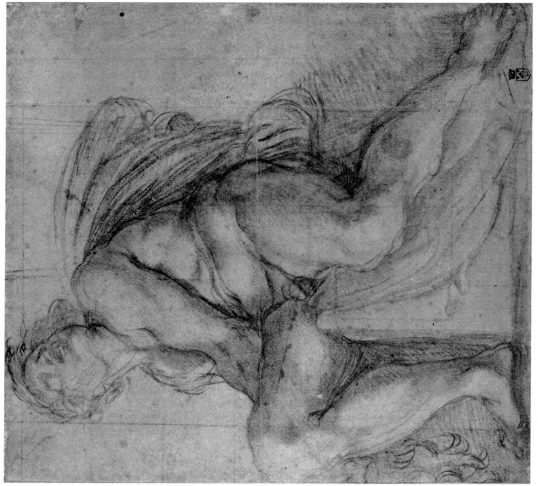

ANNIBALE CARRACCI
Study for an Ignudo in the Galleria Farnese, Rome.
Black chalk heightened with white chalk. Squared for enlargement.
377 mm. by 326 mm. £34,000 ($85,000).

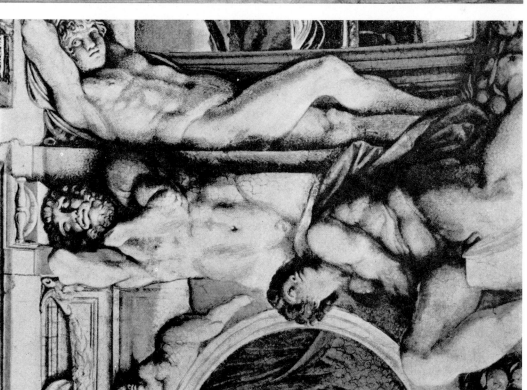

ANNIBALE CARRACCI
Detail of one of the Ignudi in the Galleria Farnese, Rome.

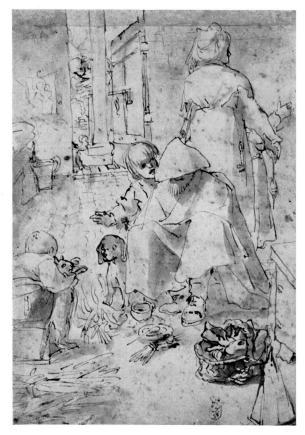

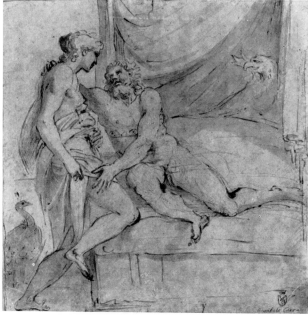

ANNIBALE CARRACCI. *Final study for the tazza Farnese.*
Pen and brown ink and wash. Diameter 255 mm. £15,500 ($38,750).
From the collections of the Marquis de Lagoy and Thomas Dimsdale.

Opposite page above:
ANNIBALE CARRACCI. *Extensive wooded landscape with buildings.*
Pen and brown ink over red chalk. 284 mm. by 426 mm. £8,500 ($21,250).

Opposite page left:
ANNIBALE CARRACCI. *A domestic scene.*
Pen and black ink and grey wash. 271 mm. by 191 mm. £7,000 ($17,500).
From the collections of Pierre Crozat, Pierre-Jean Mariette and Count Moriz von Fries.

Opposite page right:
ANNIBALE CARRACCI
Jupiter and Juno: Study for the Galleria Farnese.
Pen and black ink and blue-grey wash. 314 mm. by 313 mm. £9,500 ($23,750).
From the collections of Narcisse Révil and Count Bianconi.

ANNIBALE CARRACCI
A seashore with the sun setting.
Pen and brown ink.
149 mm. by 220 mm.
£7,000 ($17,500).

From the collections of
Paignon-Dijonval and
Thomas Dimsdale.

ANNIBALE CARRACCI
Landscape with boat.
Pen and brown ink.
223 mm. by 405 mm.
£4,500 ($11,250).

From the collections of
Everard Jahbach, Pierre
Crozat and Pierre-Jean
Mariette.

ANNIBALE CARRACCI
Landscape with the sun setting.
Pen and brown ink.
270 mm. by 425 mm.
£4,800 ($12,000).

From the collections of
Paignon-Dijonval and
Thomas Dimsdale.

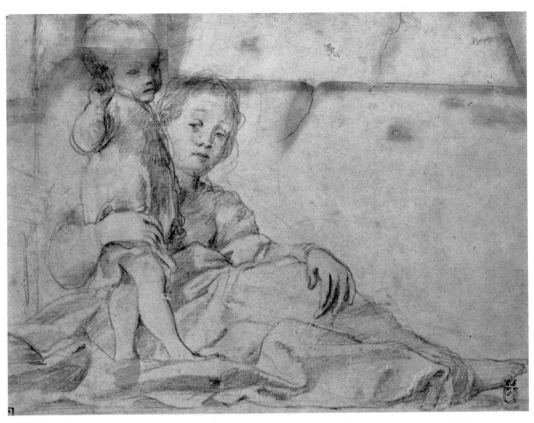

LODOVICO CARRACCI. *The Virgin and Child.*
Black chalk. 254 mm. by 345 mm. £6,500 ($16,250).
From the collections of Sir Joshua Reynolds and William Young-Ottley.

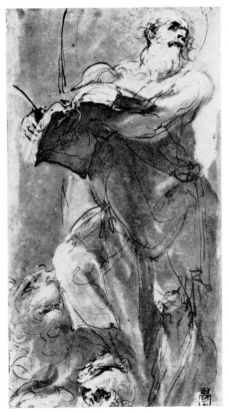

LODOVICO CARRACCI. *St. Jerome.*
Pen and brown ink and wash.
289 mm. by 157 mm. £3,200 ($8,000).
From the collection of Jean-Baptiste Wicar.

LODOVICO CARRACCI. *The Virgin and Child.*
Red and white chalk. 282 mm. by
245 mm. £7,500 ($18,750).
From the collection of Count Bianconi.

AGOSTINO CARRACCI *Studies for the frescoes in the Palazzo del Giardino, Parma.*
Pen and brown ink. 283 mm. by 400 mm. £10,500 ($26,250)
From the collection of Pierre-Jean Mariette.

AGOSTINO CARRACCI
The Virgin and Child in a feigned circular frame.
Pen and brown ink and wash.
190 mm. by 164 mm. £9,500 ($23,750).
From the collection of Count Gelosi.

GUERCINO
The crucified Christ.
Pen and brown ink and wash.
192 mm. by 128 mm. £11,000 ($27,500).

AGOSTINO CARRACCI
Sheet of studies including shepherds for an adoration.
Pen and brown ink. 404 mm. by 307 mm. £15,500 ($38,750).
From the collections of the Marquis de Lagoy and Thomas Dimsdale.

REMBRANDT HARMENSZ. VAN RIJN
Sheet of studies: *An old beggar in a wide-brimmed hat.*
Pen and brown ink. 167 mm. by 114 mm.
London £17,000 ($42,500). 25.XI.71.

Opposite page:
REMBRANDT HARMENSZ. VAN RIJN
An actor in a wide-brimmed hat.
Pen and brown ink. Perhaps *circa* 1635.
71 mm. by 72 mm.
London £5,000 ($12,500). 23.III.72.

Old Master Drawings

Apart from the Ellesmere sale, which is discussed in detail on pages 31–45, the Old Master Drawing department held a number of important sales.

From the Dutch School the following group of drawings sold during the season are worthy of special mention. The *Study of a beggar in a wide-brimmed hat* by Rembrandt, a brilliant study drawn from the life in Amsterdam in about 1633–34, realised £17,000 ($42,500) in November; while a small sketch of an *Actor* sold the following March realised £5,000 ($12,500). In July, two street scenes by Jan van Goyen, both of extremely high quality, realised world record prices of £5,800 ($14,500) and £5,200 ($13,000).

It is perhaps worth noting that drawings of high quality can still be purchased for surprisingly small sums of money. A beautiful Flemish 17th century landscape in pen and ink and watercolour was sold for £450 ($1,125) in March, and in the same sale a charming landscape by Hans Bol fetched only £280 ($700). Both would have been admirable additions to any drawing collection, however distinguished.

Italian drawings of the 17th century were not cheaply bought. The beautiful pen and ink composition by Pier Francesco Mola of *The Angel appearing to Hagar in the desert* fetched £1,600 ($4,000); and a pastoral scene by Castiglione, executed in oil colours with the brush, fetched £3,200 ($8,000). Drawings by Guercino have always been in great demand, which was evident by the very high sum paid for the magnificent Ellesmere *Crucifixion* (see p. 44) and also the sum of £5,000 ($12,500) for the fine landscape in the following sale.

Important Italian 18th century drawings included Giambattista Tiepolo's *The Flight into Egypt*, from the famous Orloff album, at £7,800 ($19,500) and two beautiful landscape gouaches by Marco Ricci at £1,700 ($4,250) and £1,300 ($3,250); while French drawings of that period, of which there were few this season, included an elegant *Landscape composition with figures* by Fragonard which realised £4,400 ($11,000) in November and, the following July, Greuze's *Study of the head of an old man* which sold for £5,800 ($14,500).

Although there is now great interest in Italian Mannerist prints, drawings of the same period remain surprisingly inexpensive. Cavaliere d'Arpino's red chalk *Nymph and satyr* fetched £450 ($1,125) in November, in a sale which also contained one of the finest drawings by Cambiaso ever to have appeared at auction, *The Annunciation*, which realised £1,100 ($2,750). A drawing by Giulio Romano of *A classical female figure with a goat* fetched the not excessive sum of £360 ($900), in the same sale. Drawings by Giulio Romano form the nucleus of the second part of the Ellesmere Collection, to be sold in December of this year, and it will be interesting to compare prices realised in this sale with those of the past. Giulio, Raphael's principal assistant and an exciting and original painter and architect in his own right, was a fascinating draughtsman who has been highly appreciated by collectors and connoisseurs since the earliest times.

JAN VAN GOYEN
A street scene with peasants by a wooden gateway. Black chalk and grey wash. Signed with monogram, dated 1653. Inscribed in pencil: *Van Goyin.* 206 mm. by 306 mm.
London £5,800 ($14,500). 13.VII.72.

FLEMISH SCHOOL, early 17th century
A landscape with mountains by a lake.
Pen and brown ink and coloured washes, over black chalk. 170 mm. by 266 mm.
London £450 ($1,125). 23.III.72.

HANS BOL
Huntsmen in a landscape.
Pen and brown ink and wash, over black chalk. 67 mm. by 220 mm.
London £280 ($700). 23.III.72.

Opposite page below:
JAN VAN GOYEN
A street scene in a village with an itinerant vendor and a group of peasants.
Black chalk and grey wash. Signed with monogram in black chalk; dated 1656.
174 mm. by 274 mm.
London £5,200 ($13,000). 13.VII.72.

JAN VAN HUYSUM
Flowers in an urn.
Watercolour over black chalk, heightened with white. Inscribed: *van Huysum*. 550 mm. by 370 mm.
London £1,000 ($2,500). 23.III.72.

PIERRE-JOSEPH REDOUTE
A study of geraniums.
Watercolour. Indistinctly dated: *Juillet* . . . 300 mm. by 230 mm.
London £2,300 ($5,750). 23.III.72.

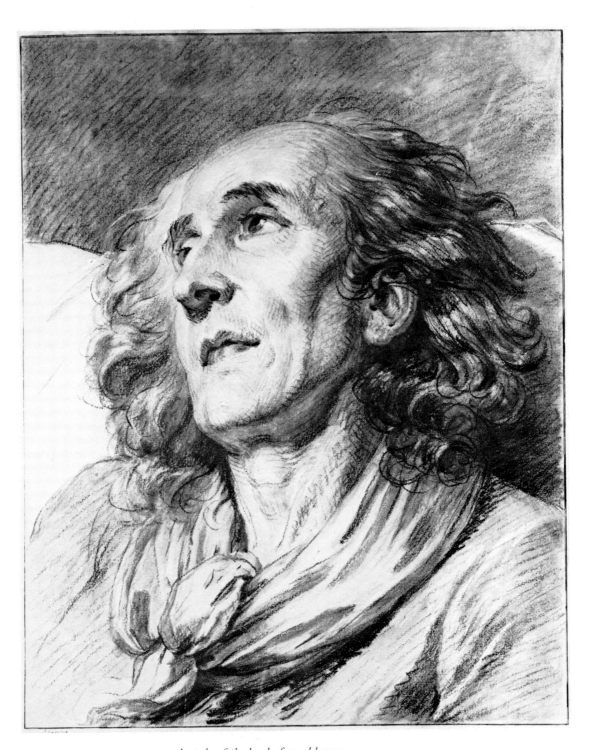

JEAN-BAPTISTE GREUZE *A study of the head of an old man.*
Coloured chalks, heightened with white. Inscribed in ink on mount: *Greuze.* 466 mm. by 376 mm.
London £5,800 ($14,500). 13.VII.71. From the collection of the Cranbrook Academy of Art.

Opposite page above:
JEAN-HONORE FRAGONARD *A view of an Italian villa.*
Pen and black ink and grey and brown wash, with touches of pink and yellow wash,
heightened with white, over black chalk. 193 mm. by 238 mm.
London £4,000 ($10,000). 13.VII.72.

Opposite page below:
JEAN-HONORE FRAGONARD *Elegant figures resting and walking in a park.*
Drawn with the brush in brown wash over traces of black chalk. Dated *Roma 1774.* 289 mm. by 369 mm.
London £4,400 ($11,000). 25.XI.71. From the collection of Dr Peter Dalbert.
The painter was in Rome between 5th December, 1773 and 14th April 1774.

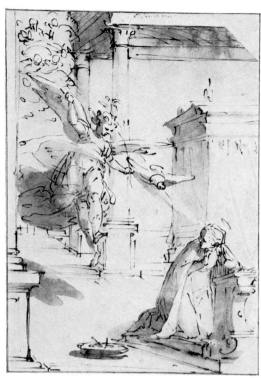

LUCA CAMBIASO *The Annunciation*.
Pen and brown ink and wash. 290 mm.
by 204 mm.
London £1,100 ($2,750). 25.XI.71.
This is a preliminary study for a painting
in the Chiesa della SS. Annunziata di Portoria
in Genoa, which was commissioned in 1568.

GIOVANNI BATTISTA TIEPOLO
Recto: *Caricature*. Pen and grey ink and
wash. Verso: *Study of part of a figure*. Pen
and brown ink. 216 mm. by 132 mm.
London £920 ($2,300). 23.III.72.
From the collection of the Cranbrook
Academy of Art, Bloomfield Hills, Michigan.

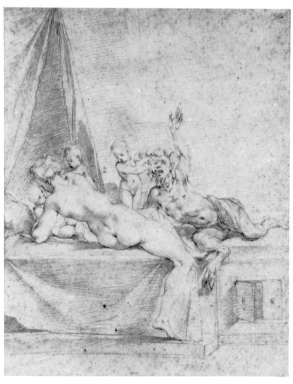

GIULIO PIPPI, called GIULIO ROMANO
A classical female figure with a goat.
Pen and brown ink. 125 mm. by 86 mm.
London £360 ($900). 25.XI.71.

GIUSEPPE CESARI, called CAVALIERE
D'ARPINO *Nymph and satyr*.
Red chalk. 286 mm. by 235 mm.
London £450 ($1,125). 25.XI.71.

1. *The Angel appearing to Hagar in the desert* by Pier Francesco Mola. 190 mm. by 265 mm. £1,600 ($4,000). 23.III.72. **2.** *Study of an ass* by Federico Barocci. 110 mm. by 219 mm. £420 ($1,050). 25.XI.71. **3.** *Moses and the burning bush* by Taddeo Zuccaro. 170 mm. by 231 mm. £950 ($2,375). 25.XI.71. **4.** *A pastoral scene with travellers and huntsmen resting* by Giovanni Benedetto Castiglione, called Il Grechetto. 405 mm. by 565 mm. £3,200 ($8,000). 23.III.72. **5.** *The Flight into Egypt* by Giovanni Battista Tiepolo. 305 mm. by 446 mm. £7,800 ($19,500). 13.VII.72. **6.** *Gentleman's hairdressing salon* by Bartolomeo Pinelli. Signed and dated: *Pinelli fece 1824 Roma.* 330 mm. by 460 mm. £460 ($1,150). 25.XI.71. **7.** *The Molo looking West with the Ducal Palace* by Giacomo Guardi. 140 mm. by 240 mm. £820 ($2,050). 25.XI.71. **8.** *A capriccio with a ruined arch* by Francesco Guardi. 252 mm. by 376 mm. £2,800 ($7,000). 23.III.72. **9.** *Entrance to the Grand Canal from the West end of the Molo* by Giacomo Guardi. 130 mm. by 241 mm. £850 ($2,125). 25.XI.71. **10.** *A mountainous landscape* by Marco Ricci. 289 mm. by 443 mm. £1,700 ($4,250). 23.III.72. **11.** An extensive *Landscape with figures by a lake* by Giovanni Francesco Barbieri, called Il Guercino. 260 mm. by 424 mm. £5,000 ($12,500). 13.VII.72. **12.** *A mountainous landscape*, by Marco Ricci. 304 mm. by 446 mm. £1,300 ($3,250). 23.III.72.

Prints

This has been a good season, with a small number of important prints. In October £4,300 ($10,750) was paid for an impression of Dürer's *The Landscape with a Cannon*; this has a significant place in the history of printmaking since it is one of a small number of experiments Dürer made with the technique of etching. These were printed from iron plates, rather than copper, and are closer in texture to engravings. Dürer never properly mastered the medium, and the iron plates rusted over very quickly, causing blemishes on late impressions. The present example was a rare early pull, showing no signs of rust. A magnificent impression of the artist's engraving *St Eustace*, realised £7,500 ($18,750) in July, a world auction record for a Dürer print.

Very high prices have been paid for woodcuts this year. Plates from Dürer's *Passion* have been fetching around £1,000 ($2,500); a chiaroscuro woodcut, *The Rest on the Flight into Egypt*, by Christoffel Jegher after Rubens, fetched £2,500 ($6,250).

Some extremely good modern prints have been sold in America during the season. Sales of contemporary graphics in Los Angeles have been very well received and a set of the ten lithographs which comprise Jasper Johns' *Colour Numerals* series fetched $21,000 (£8,400) in December. These may be considered amongst the most important post-war American prints.

At Parke-Bernet in May, a rare impression of Dubuffet's lithograph of 1962, *Nez Carotte*, was sold by the Cranbrook Academy of Art for $7,250 (£2,900). Dubuffet's coloured lithographs are the result of an extremely complicated printing technique whereby anything up to six stones are super-imposed to give an effect of great richness and depth.

In the same sale, the set of ten colour-printed lithographs by Lazar (El) Lissitzky comprising the portfolio called *Die Plastische Gestaltung Der Elektro-Mechanischen Schau – Sieg Über Die Sonne* (*The plastic form of the electromechanical peepshow 'Victory over the Sun'*), fetched $28,500 (£11,400). Executed in 1920–21, this portfolio depicts El Lissitzky's concept of an electromechanical production of A. Kruchenykh's opera *Sieg Über die Sonne*; this opera, first produced in the Luna Park Theatre, St. Petersburg, in December 1913, with nonsense-libretto by Kruchenykh, music by Matiushin and costumes and decor by Malevich, was described by Malevich as representing the birth of Suprematism. The opera's anarchic ideals – revealed by Kruchenykh as being an attempt 'to transform the world into chaos, to break into pieces the established values and from these pieces create anew' – naturally appealed to the later Constructivists and Lissitzky's designs demonstrate his highly individual approach to typography and layout, an approach then considered wholly iconoclastic.

After SIR PETER PAUL RUBENS
The Rest on the Flight, by Christoffel Jegher.
Chiaroscuro woodcut from two blocks printed in black and pale brown. 467 mm. by 607 mm.
London £2,500 ($6,250). 13.VII.72.

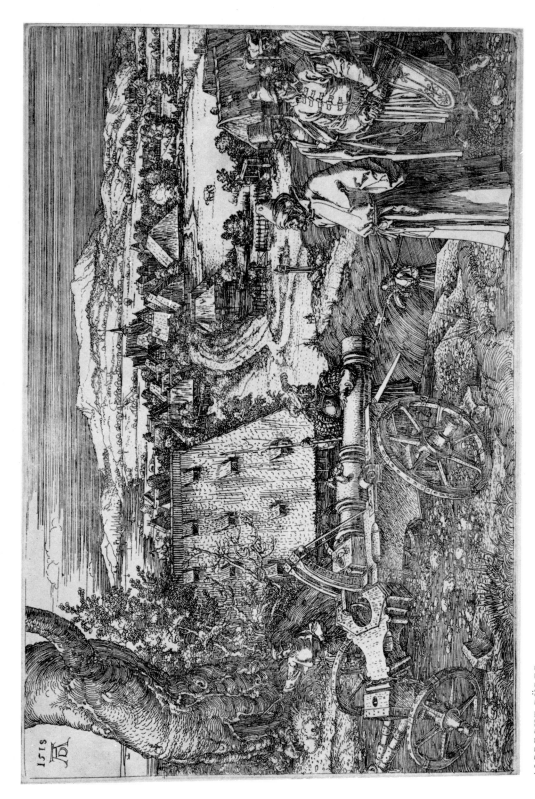

ALBRECHT DÜRER
The Landscape with the Cannon.
Etching on iron. 220 mm. by 322 mm.
London £4,300 ($10,750). 23.xi.71.
From the Allan Kirkwood Trust collection.

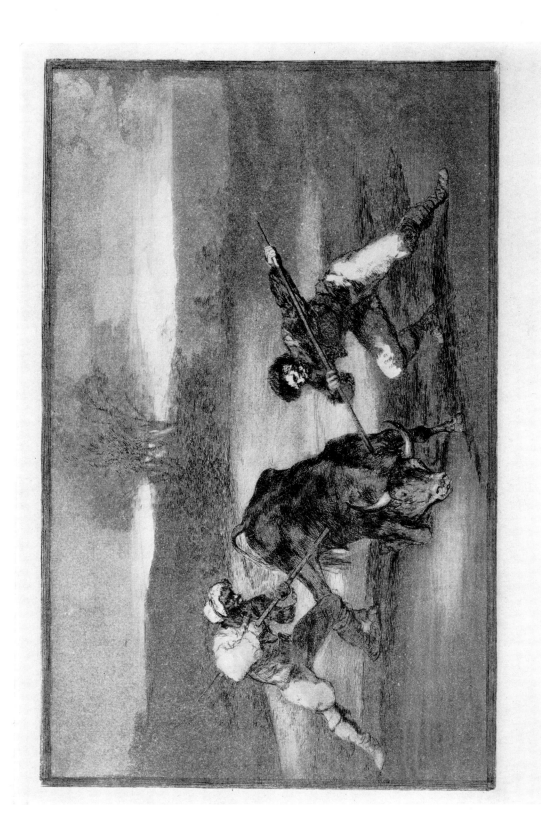

FRANCISCO JOSE DE GOYA Y LUCIENTES
La Tauromaquia.
Etchings with aquatint, the set of thirty-three plates in the first edition of 1816.
Each 252 mm. by 356 mm.
London £18,000 ($45,000). 13.VII.72.

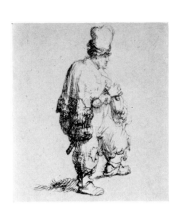

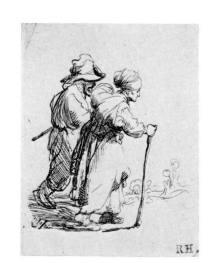

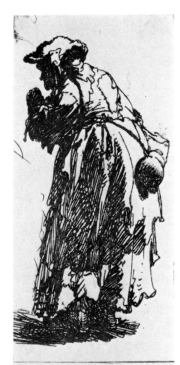

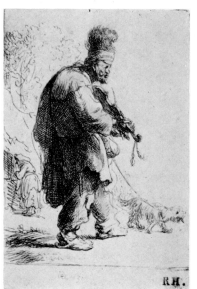

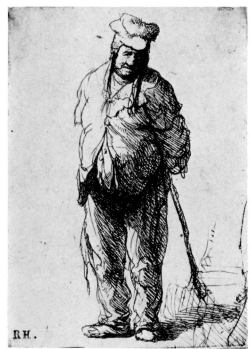

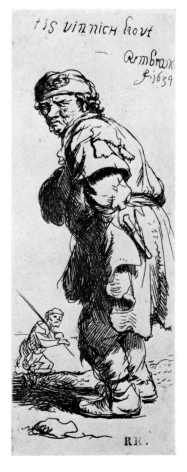

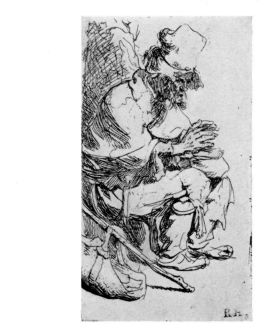

Opposite page:

REMBRANDT HARMENSZ. VAN RIJN
A standing Polander. £270 ($675). *Two tramps.* £500 ($1,250). *A beggar-woman.* £400 ($1,000). *The blind fiddler.* £300 ($750). *A peasant holding a stick.* £480. ($1,200). *A beggar leaning on a stick.* £380 ($950). *A beggar warming his hands.* £280 ($700). 'Tis Vinnich Kout'. £300 ($750). The etchings illustrated on the opposite page were sold at Sotheby's on 23rd November 1971.

Right:

ALBRECHT DÜRER
The Satyr's Family.
Engraving. 115 mm. by 72 mm.
London £1,500 ($3,750). 13.VII.72.

Below:

After PIETER BRUEGHEL THE ELDER
The Alchemist.
Engraving, second state of four.
337 mm. by 457 mm.
London £1,600 ($4,000). 21.III.72.

From the collection of D. E. Evans, Esq.

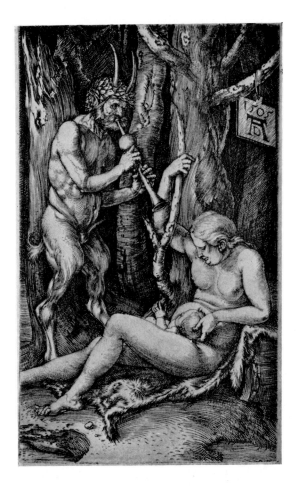

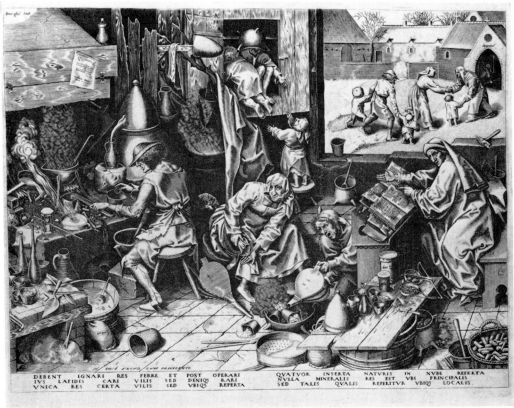

Left:
HENRI MATISSE
Nu.
Lithograph, on chine volant, from
edition of fifty. Inscribed in ink by the
artist. 1906. 310 mm. by 245 mm.
London £1,100 ($2,750). 4.XI.71.

Below:
HENRI DE TOULOUSE-LAUTREC
L'Entraineur.
Lithograph printed in blue, numbered 22
from the edition of about 40. 1899.
236 mm. by 446 mm.
New York $5,700 (£2,280). 12.V.72.

Right:
HENRI MATISSE
Nu assis, chemise de tulle.
Lithograph printed on chine volant.
Signed in pencil. 1925.
365 mm. by 270 mm.
London £2,700 ($6,750). 7.III.72.

From the collection of
Herbert Melbye of Copenhagen.

Below:
EDVARD MUNCH
Sterbezimmer.
Lithograph. Signed in pencil. 1896.
432 mm. by 598 mm.
New York $9,250 (£3,700). 11.V.72.

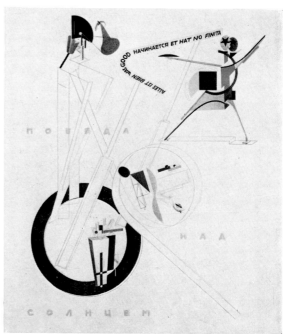

LAZAR (EL) LISSITZKY
Die plastische Gestaltung der elektro-mechanischen Schau – Sieg über die Sonne, 1920–21.
Complete set of ten lithographs printed in colours and title page, published by Robert Leunis &
Chapman, Hanover, 1923.
Each signed in pencil, the title page numbered 61, from the edition of 75, sheet size 533 mm. by 453 mm.
New York $28,500 (£11,400). 11.v.72.
This portfolio depicts El Lissitzky's concept of an electro-mechanical production of Kruchenykh's
opera *Sieg über die Sonne* (1913). The Russian Constructivists produced relatively few prints of this
nature. This portfolio, which is rare as a complete set, is regarded as one of the more important graphic
works of the 20th century.

JEAN DUBUFFET
Nez carotte.
Lithograph printed in colours. Signed in pencil, dated '62. 604 mm. by 377 mm.
New York $7,250 (£2,900). 10.v.72.

From the collection of the Cranbrook Academy of Art, Bloomfield Hills, Michigan.

JASPER JOHNS
Color Numerals.
Set of ten lithographs printed in colour, published by Gemini G.E.L.
in 1969, each signed, dated and numbered *13/40*.
Each *circa* 27¼ in by 22 in.
Los Angeles $21,000 (£8,400). 6.XII.71.

Jacopo da Strada, XVI century antique dealer

BY J. F. HAYWARD

One of the most remarkable success stories of the sixteenth century is that of Jacopo da Strada, the goldsmith's apprentice from Mantua who became one of the leading antiquaries and most highly regarded art consultants and dealers of his time.

He was born in Mantua about 1515, but his family was probably of Flemish origin. Having completed his apprenticeship he seems to have been employed in the late 1530's and early 1540's on carrying out some of the designs for silver vessels prepared by the court architect and painter, Giulio Romano, for the Gonzaga Dukes of Mantua. Two circumstances suggest some connection with Giulio Romano, firstly the fact that in 1562 he acquired from the latter's son, Rafaello, all of Giulio's surviving drawings, and secondly, that a collection of silver designs published by Jacopo's son, Ottavio, in 1597 was drawn almost entirely from originals by Giulio. It is also significant that Jacopo da Strada left Mantua finally in 1546, the year in which Giulio Romano died. Some years before, probably in the early 1540's, da Strada had succeeded in entering on a new career, that of art expert. He began under the aegis of the powerful Augsburg banking family of Fugger and spent some two years purchasing classical coins and marbles in Italy for them. Some of these were probably intended for the Fuggers' own collections at Schloss Kirchheim, but the bankers acted as agents for various princely families and would doubtless have passed on some of their purchases at a profit.

In 1546 da Strada applied for permission to reside in the South German city of Nuremberg, then one of the chief artistic centres of Europe. In his application he described himself as a painter (*Maler*), a fact which can perhaps be explained by his having worked on some of the decorations of the Palazzo del Te. Permission was granted within twenty-four hours; this may have been due to his having already acquired a considerable reputation outside Italy, or, more probably, to his application having the support of Wenzel Jamnitzer, the leading Nuremberg goldsmith. Shortly after receiving his residence permit he was, although not yet admitted as master-goldsmith to the guild, granted permission for one year to work in his own house, instead of in that of a Nuremberg goldsmith, on a commission for certain goldsmith's work for Giovanni, Marchese di Marignano, an Italian nobleman who had fought in the service of the Emperor Charles V. Even more exceptional was the permission he obtained at the same time, namely to engage a Nuremberg master goldsmith or journeyman to assist him in the task. Such concessions can most probably be attributed to the influence of Wenzel Jamnitzer.

In January 1549 da Strada was granted citizenship of Nuremberg and so obtained the right to settle there permanently. He must, however, have quickly realized that the knowledge of classical antiquities he had gained in Italy, together with his many contacts there and his familiarity with the language, offered a more exciting future than that of a successful Nuremberg goldsmith. It was about this time that he began

Portrait of Jacopo da Strada by Titian, showing the sitter in fashionable dress with rapier and dagger, a fur over his shoulders and a gold chain of four strands with pendant portrait medallion, presumably presented to him by the Emperor Maximilian II. The objects shown in the portrait relate to his various activities. The marble Venus and the fragmentary torso refer to his collection of antiquities, (though the Venus is in fact a contemporary sculpture) the coins to his study of numismatics, the two books on the shelf above to his collection of inscriptions and the two vases in the top left hand corner to his purchase of antique hardstones, while the hour glass is a standard feature of Renaissance portraiture referring to the brevity of life. The escutcheon with inscription on the right hand side describes him as a Citizen of Rome, Court Antiquary and Member of the Council of War. It has been restored and the present date, 1566, probably originally read either 1567 or 1568.

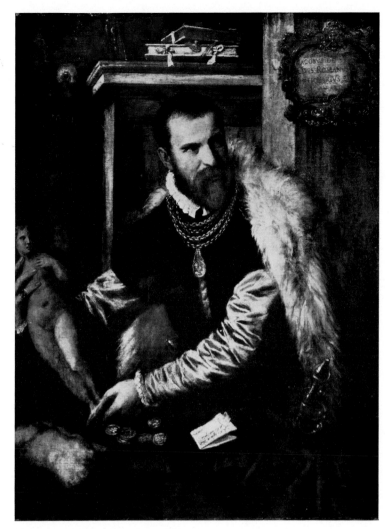

Kunsthistorisches Museum, Vienna

a commission from Johann Jakob Fugger for a corpus of drawings of classical coins, with details of inscriptions and owners' names. This particular member of the Fugger family went bankrupt in 1566 and was taken on by the Duke of Bavaria as his art adviser. He eventually became one of da Strada's chief customers. In July 1552 da Strada obtained permission to leave Nuremberg for three years in order to prepare the publication in the French city of Lyons of a treatise on his own collection of classical coins. This appeared in 1553. Thereafter he went to Rome and in 1554 he is recorded as being in the service of Pope Julius III. He stayed on in Rome during the short period of the pontificate of Marcellus II. It must have been at this time that he acquired the title of *Civis Romanus* which he subsequently used with evident pride. It was probably on this same visit to Italy that he made the acquaintance of the architect Serlio, from whom he purchased directly a copy of the text and plates of the latter's Seventh Book of Architecture.

When he finally returned to Nuremberg he resumed work as a goldsmith, possibly in

the employ of Wenzel Jamnitzer. At all events, when in 1556 Jamnitzer was commissioned by the Archduke Ferdinand of Tirol to produce a huge silver table fountain, he wrote to the latter explaining that, having accepted important commissions from the Emperor Maximilian, he was unable to proceed with his order. Jamnitzer suggested, however, that as a preliminary step he should instruct an artist to produce some designs for the fountain. For this work he recommended his assistant, Jacopo da Strada, whom he described as a diligent workman, Italian by birth, and a fellow citizen of Nuremberg who was skilled both in painting and in other crafts. In view of the difficulties anticipated in the production of the fountain, which was to represent the theme of Adam and Eve in Paradise, Jamnitzer suggested that da Strada should visit the Archduke in person, show him a scale model and discuss the project in detail. Da Strada also then wrote to the Archduke explaining that it was impossible to represent so complex an object by drawings alone and suggesting that he should make a model as did architects who were designing a palace. Finally he offered to go to Prague, where the Archduke·was in residence, to discuss the fountain, but only on condition that he should be entrusted with the whole commission – presumably to the exclusion of Jamnitzer. In January 1557 he set off for Prague and thus gained a direct entrée to the court of the Habsburg Holy Roman Emperor, the most important source of patronage in Europe. Eventually da Strada abandoned his interest in the fountain, perhaps because his insistence on exclusive control was not granted. Jamnitzer did some further work on it, but it was never completed. Da Strada's part was sufficiently important for the Archduke to have rewarded him in February 1557 with a fee of 100 Taler and 54 Gulden to buy a costume (*Ehrenkleid*) in recognition of his services. He then set off again for Italy to buy antiquities for the Fuggers and from this time he was rarely resident in Nuremberg. In 1558 the Nuremberg City Council granted him permission to live in Vienna for three years and thereafter he seems to have set aside the tools of the goldsmith for good. Little is known of his early duties in Vienna, but in 1559 or 1560 he was appointed to the commission that advised on the redesigning of the monument of Maximilian I in the Innsbruck *Hofkirche*. This appointment would only have been entrusted to a person whose talents were very highly regarded. There can be no doubt that it was his knowledge of antiquities and the means of acquiring them, rather than his skill as a goldsmith, that made him welcome at the Habsburg court. His capacity to recognize the genuine article must have been particularly valuable at a time when the manufacture of spurious antiquities was a major industry in Rome. He had by now developed another skill, that of architect. In 1565 he was sent to Prague to advise on the design of the tomb of the Emperor Ferdinand I and received a fee of 50 Gulden for his services. Subsequently he was to be entrusted with major architectural commissions for the Bavarian court.

In 1564 da Strada was appointed to the Imperial Court at an annual salary of 100 Gulden. His function was to act as Court Antiquary; he filled this post unofficially from January 1564 until October 1567 when the title was confirmed to him. His decision to abandon the craft of goldsmith in Nuremberg was now fully justified. His new title carried an incomparably higher status. The most convincing proof of this can be seen in the portrait he commissioned about 1568 in Venice from no less a master than Titian (page 69). This shows him wearing a fur-trimmed robe with,

around his neck, a golden chain of four loops and a gold pendant medal, while he holds an antique marble statue in his hand. A cartouche, which is believed to have been added on the instructions of his son and successor as Court Antiquary, Ottavio, describes him as *Civis Romanus Caes. Antiquarius et Com. Belic.* The second title – member of the Council of War – was presumably granted to him in recognition of his understanding, as an architect, of military fortification. The Titian portrait shows da Strada as a person of rank in comparison with whom the extant contemporary portraits of other goldsmiths, even the Jamnitzers, look modest. In the year following his appointment to the Habsburg court in Vienna, da Strada was lent by the Emperor Maximilian II to Duke Albrecht V of Bavaria as architectural adviser and spent several years in the latter's service. His task was twofold: to design the *Antiquarium* of the Munich Residence, to purchase objects to fill it and also to make acquisitions for the ducal *Kunstkammer*, which was a separate institution. He claimed on a subsequent occasion to have been the sole designer of the interior of the Antiquarium (*totius structurae ordine interiori a me delineato*), but in fact his plans were revised by the Bavarian Court Architect, Wilhelm Egkl. In 1567 he set off for Italy once again where he made vast purchases on the Duke's behalf. As might be expected, da Strada went back to Mantua on this occasion and it was from there that he wrote on 14 June 1567 to Duke Albrecht V of Bavaria to announce that he had succeeded in acquiring the whole collection of the Loredano family in Venice, comprising a large collection of hardstones, drawings and statues, valued at a total of 3,134 florins. A fortnight later he wrote from Rome to announce the dispatch of another shipment of antiquities. His next visit was to Venice where he negotiated the purchase of a collection of antiquities from the Vendramin family, another ancient Venetian patrician family. Altogether he spent the large sum of 21,940 Gulden on behalf of the Archduke in the course of this journey. He also found time on this same Italian journey to prepare a set of drawings of the decorations by Giulio Romano and his workshop in the Palazzo del Te, in which he had probably had a hand himself when he was still working in Mantua.

It is no longer possible to distinguish the antiquities purchased by da Strada from others in the Munich collections, but inspection of the large numbers of classical busts still displayed in the *Antiquarium* of the Residence does not suggest that da Strada was particularly careful in his choice. Though the majority retain authentic classical elements they are all much restored, and were apparently acquired in that condition. There are also a good many Renaissance fakes of classical busts amongst them. Da Strada may not have been responsible for their purchase as Duke Albrecht had another art agent in Italy, Niccolo Stoppio. A number were also acquired by Johann Jakob Fugger, but these had in turn largely been bought by da Strada himself. In spite of his status and title, da Strada's reputation as an art buyer did not escape unfavourable comment. Our source for this is a letter written by Cardinal Otto von Augsburg in Rome to the Archduke Albrecht V, on 3 September 1569. Referring to da Strada's purchase of the Loredano collection, the Cardinal writes, 'It is related here that your Excellency has spent a sum approaching 7000 *Kroner* in Venice on the purchase of antiquities which are neither old nor good and that your Excellency could have done much better and cheaper here. I do not understand these things myself but I have good friends who understand them much better than most.' We do

not, of course, know whether the Cardinal had been offered some inducement if a sale could be arranged, but the terms of a second letter written a few days later make this likely. This time he writes that a certain Alessandro Grandi in Rome has some exceptional, finely and boldly wrought antiquities of which he will send a list. It is said that the Duke has sent Jacob Strada to Venice and that he has bought at a cost of about 7,000 *Kroner* antiquities which are in no way special and far too dear. Strada has sold similar things to the Fuggers and does not have a good reputation (*gut beschrayt*). It is said furthermore that the Duke intends to send da Strada to Rome again and that many dealers are expecting this and have forced up prices accordingly. If the Duke wants some complete objects (presumably in contrast to the much repaired pieces bought by da Strada) then he (the Cardinal) will consult honourable people such as Monsignore Garimberti, Thomaso Cavallieris and the Fra del Piombo and would hope to get something rare quite cheaply.

The Munich records do not enable us to follow the story further – except for one incident. Following upon the recommendation of Cardinal Otto von Augsburg, Bishop Garimberti promised to present a few antiquities to the Duke provided he was given a watch in exchange. He received the watch but there is no record of the antiquities in Munich. This criticism by competitors did not seriously prejudice da Strada. In the years between 1564 and 1568 he seems to have been in equal demand in Vienna and Munich and still received his annual retainer of 100 Gulden in Vienna as an Imperial Court servant, although he was also paid by the Duke Albrecht.

In spite of his long residence north of the Alps da Strada had kept in touch with the ducal court at Mantua, and a series of letters preserved in the Gonzaga archives throw further light on his activities in the late 1560's. In December 1568 he wrote to Duke Guglielmo Gonzaga acknowledging the protection given by the latter to his son, Ottavio da Strada, and offering his services in either Vienna or Munich in return. He also informed the Duke about his own collections. They included a library of over 3,000 volumes including many in Hebrew and Arabic and a medal collection together with a book of drawings of them (actually these were classical coins covering all the Roman Emperors from Nerva to Alexander Severus). Furthermore he had collected in the course of his journeys throughout Europe over 12,000 descriptions of medals he had seen; these filled thirteen large volumes. There were seven large volumes with inscriptions he had copied on the same journeys including some from Turkey, Egypt and the parts of Hungary in Turkish occupation. Finally there was a polyglot lexicon of eleven languages upon which he had worked for eighteen years. A postscript refers to his possession of marble statues and all kinds of figure sculpture. The extent of his collections, which he described as a museum, is such as to suggest that he had not failed to take a profit on the numerous deals which he had arranged for his princely and his banker patrons.

His activities in Munich had eventually led to his name being removed from the Vienna payroll, but in 1571 he resumed his appointment and retaining fee there. He now set to work to complete his lexicon and record of inscriptions. Such was his personal standing at court that the Emperor Maximilian wrote to the Nuremberg City Council and to the Archduke Albrecht in August 1573 asking for support in their publication which was impossible without financial subvention. This does not seem

to have been forthcoming, apart from a small offer of 40 florins from Nuremberg, but in the following year da Strada received a payment of 540 Kroner in respect of antiquities which he had obtained for the imperial collection. In the same year he received signal proof of imperial favour by being ennobled. Da Strada had in fact already married into the aristocracy: his wife was born a Baroness Schenk von Rossberg. Through Katharina, one of his daughters from this marriage, he should have gained considerable influence in the very highest quarter. She was, in fact, for many years mistress of the Emperor Rudolph, by whom she had six children. In spite of this family relationship, da Strada was never on such good terms with Rudolph as with his elder brother, Maximilian.

Da Strada's chief patron, the Emperor Maximilian II, died in 1576 and, although in the following year da Strada obtained the useful concession of his rent being paid from imperial funds, he was not happy in the service of Maximilian's successor, Rudolph II. In 1579 he requested to be released from imperial service, complaining that he had spent twenty-five years working with diligence and uprightness for the ruling house of Austria, but that, unlike others who had done far less than he, he had never received favours or concessions (*Provisionen*). He was in fact discharged with effect from 1 January 1579. In spite of his complaints he was doubtless able to live out his days in Vienna in comfort until his death there in 1588. The Emperor Rudolph II appointed his son Ottavio to succeed him in the position of Court Antiquary.

One aspect of da Strada's manifold activities remains to be mentioned: he was also a specialist in hydraulics and produced a series of 300 drawings showing possible uses of water-power. These were intended for publication but did not appear until twenty-nine years after their author's death. Da Strada's son, Ottavio, had offered them for sale to the Nuremberg City Council in 1593 and again in 1596 to the Duke of Mantua, but it was only in 1617 that two selections, each of fifty plates, were published in Frankfurt am Main by his grandson, also named Ottavio. Apart from his printed works little survives now to represent da Strada's unremitting diligence. The twenty-nine volumes containing 9,000 drawings of rare and interesting coins which da Strada had begun for Johann Jakob Fugger in 1550 and completed for the Archduke Albrecht at a cost, it is said, of one gold Gulden per drawing, were looted from the *Kunstkammer* of the Dukes of Bavaria by the Saxons during the Thirty Years War and have since disappeared. During his many years as Court Antiquary he failed to produce an inventory of the collection of Rudolph II. Even the series of sixty drawings of classical vases in the Munich Staatsbibliothek, which was attributed to da Strada in the 1582 catalogue of the Bavarian Ducal library, has been shown to be the work of another master.

The breadth of da Strada's knowledge is typical of the Renaissance scholar. Only an outstanding goldsmith would have been received with open arms in Nuremberg and employed in a responsible role by Wenzel Jamnitzer. To this craft he added the arts of painting, designing and architecture, the science of hydraulics and even military affairs. That he was a consummate courtier is proved by the excellence of his relations with the Emperor Maximilian and with the Dukes of Bavaria and Mantua and even more convincingly by his appearance and bearing in Titian's portrait. Like most good dealers he took some of his best pieces home and his Museum, long since dispersed, was well known to his contemporaries.

18th, 19th and 20th Century English and Foreign Paintings and Drawings

On 19th July, Sotheby's sold the most important English painting to have appeared at auction for over a decade. Thomas Gainsborough's *Portrait of Mr and Mrs John Gravenor and their daughters Elizabeth and Dorothea*, was a completely new discovery, hitherto unknown to scholars, and it fetched £280,000 ($700,000), a world auction record for an English work of art.

By a happy coincidence, two paintings which had at one time been in the collection of the great English actor-manager David Garrick, arrived at Sotheby's during the course of the season from different sources. In November, *David Garrick and William Windham of Felbrigg* by Francis Hayman realised £15,500 ($38,750) and the following July, *David Garrick as Sir John Brute in Vanbrugh's 'Provok'd Wife'* by Johann Zoffany, realised £11,000 ($27,500). This latter picture portrayed Garrick in one of his most famous roles, which he first performed at the Drury Lane Theatre in the 1744–45 season.

English pictures and works of the 19th century Continental schools have been enjoying a particularly healthy market: William Hannan's pair of views in Redgrave Park at £8,500, William Marlowe's *Blackfriars Bridge and St Paul's Cathedral* at $55,000, Patrick Nasmyth's *Wooded landscape with a pond* at £7,500 and John Sell Cotman's *An old house at Saint Albans* at £11,000 all fetched unprecedented prices.

Among Continental paintings, the Italian *Macchiaioli*, for so long under-rated outside their native country, are now causing widespread international interest; a charming small panel by Telemaco Signorini, *Young fishermen leaning over a harbour wall*, realised £8,500 at Sotheby's in November. A painter rarely represented at auction is Gaetano Chierici, *The Happy Family* of 1870, made £8,000 also in November. German and Austrian academic painting has also proved exceedingly popular. Eugene de Blaas's *The Gossips* of 1905 fetched £8,400 in London, whilst Franz von Defregger's *The Prize Horse* was sold for $28,000 in February in Los Angeles.

Another feature of the past season has been the continued rise in the prices fetched by lesser known watercolourists, such as A. V. Copley-Fielding and William Callow. However, these prices have not deterred the private collector. Although work by minor 18th and 19th century artists can still be had at reasonable prices, the demand for all drawings has never been greater.

Modern British pictures continued their upward trend. A beautiful Ben Nicholson painting entitled *Piccolo, November 1956*, made a world record price of £18,500 in July. Another fine painting by him which fetched £15,000 had broken the previous record the December before. Other record prices were £7,200 for an important early painting, *The Battle of the Lapiths and the Centaurs*, 1912, by David Bomberg and £4,600 for a lovely Spencer Gore of a woman seated on a bed. A small but fine Lowry entitled *Steps*, 1944, fetched £10,500 and other interesting prices were £1,950 for an attractive Sargent watercolour of a girl reading, £4,500 for an Augustus John painting of *Dorelia*, £2,000 for a small Jack Yeats picture, £4,200 for a Moore drawing of *Miners making a tunnel roof*, 1942, and £4,600 for a Graham Sutherland gouache of 1948, *Blue vine*. Works by modern Australian painters also fetched high prices including £1,500 each for two works by Sidney Nolan of *Ayers Rock* and *Aaron Sherrett*, £800 for a Sali Herman, £2,400 for an Arthur Boyd and £850 for a watercolour by Donald Friend of a young guitarist.

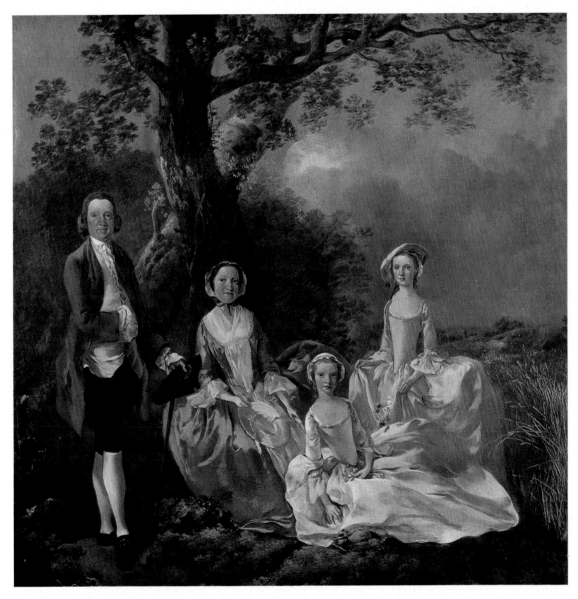

THOMAS GAINSBOROUGH, R.A.
Portrait of Mr and Mrs John Gravenor and their daughters Elizabeth and Dorothea.
Painted *circa* 1748. 35½ in. by 35½ in.
London £280,000 ($700,000). 19.VII.72.

From the collection of the late Major J. Townshend.

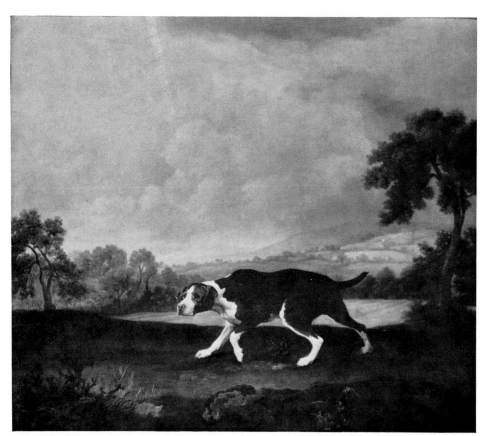

GEORGE STUBBS, A.R.A.
The Spanish pointer.
Signed. 23¾ in. by 27¼ in.
London £30,000 ($75,000).
19.VII.72.

From the collection of the
late Eben Beers Knowlton.
Formerly in the collection of
Mr Bradford (1768) and
Colonel C. H. Eyre Cook.

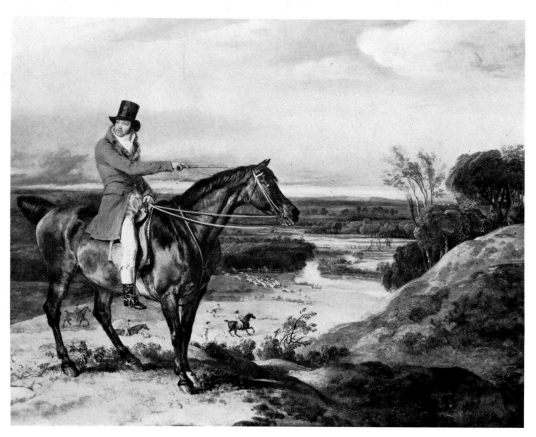

JAMES WARD, R.A.
John Levett, Esq. at Lychnor.
Signed and dated 1817.
39 in. by 50 in.
New York $100,000
(£40,000). 29.IV.72.

From the collection of the
late Jessie Woolworth
Donahue.

JOHN FREDERICK
HERRING, SENIOR
Industry and Caroline Elyma.
Signed and dated 1838.
$27\frac{1}{4}$ in. by $35\frac{1}{4}$ in.
New York $25,000
(£10,000). 18.V.72.

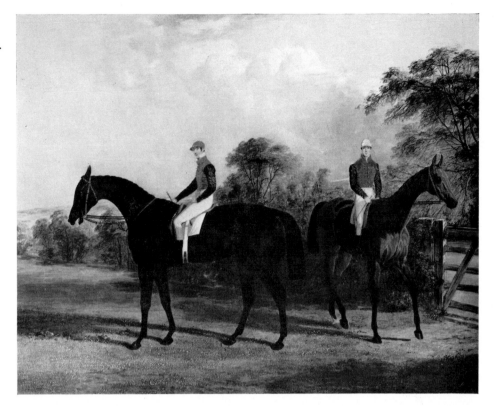

JOHN FERNELEY SENIOR
Sir David Baird.
Signed and dated *Melton
Mowbray* 1820. 33 in. by $41\frac{1}{2}$
in.
New York $23,000 (£9,200).
29.IV.72.

From the collection of the
late Jessie Woolworth
Donahue.

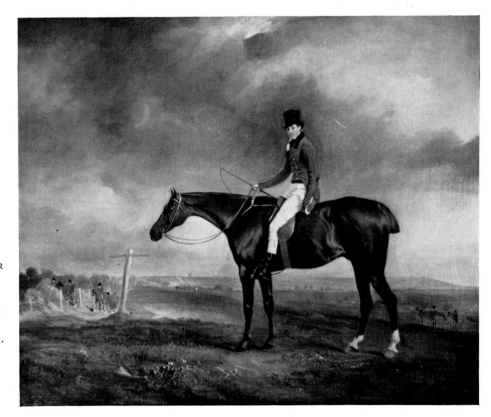

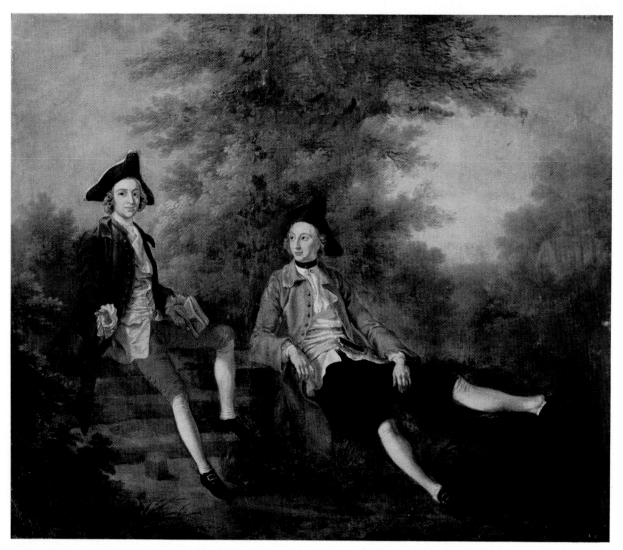

FRANCIS HAYMAN, R.A.
David Garrick and William Windham of Felbrigg.
33½ in. by 40 in.
London £15,500 ($38,750). 17.XI.71.

From the collection of Captain G. Lowther.

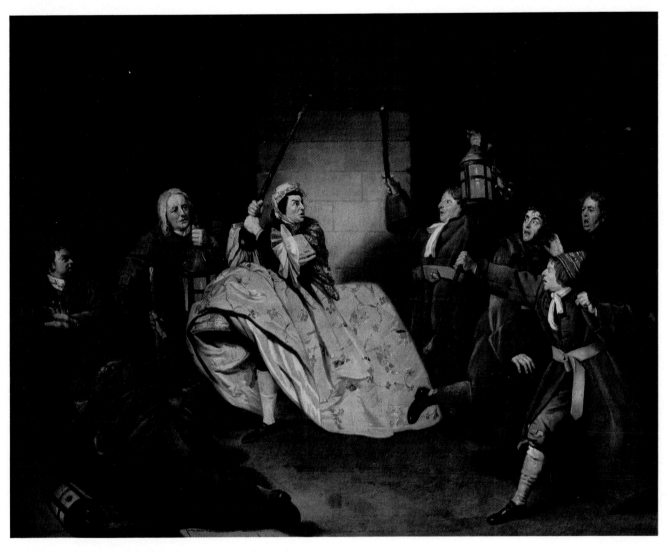

JOHANN ZOFFANY, R.A.
David Garrick as Sir John Brute in Vanbrugh's Provok'd Wife.
39 in. by 49½ in.
London £11,000 ($27,500). 19.VII.72.

From the collection of Mrs Trevor (a descendant of David Garrick).

Arthur William Devis: Portrait Painter in India (1785–95)

BY MILDRED ARCHER

In the last quarter of the eighteenth century, a number of British artists were tempted to visit India. The wealth of the returning nabobs and the tales that reached England of affluent societies in Madras and Calcutta all suggested that a flourishing market awaited British portrait painters. It was probably these tales, combined with a love of adventure and gay life, which led Arthur William Devis (1762–1822), son of the artist Arthur Devis, to visit India. After a hazardous voyage to the Pelew Islands and Macao, followed by a year's stay in Canton, he reached Calcutta in January 1785. He remained in Bengal, apart from a short visit to Madras in 1793, for ten years, returning to England in January 1795 at the age of thirty-three.

Devis was a versatile artist. He was first taught by his father, Arthur Devis, the well-known painter of small conversation pieces, and this training was to have a deep influence upon him. He also studied at the Royal Academy Schools and was awarded a silver medal by Sir Joshua Reynolds. He was a precocious student and had exhibited at the Free Society of Artists as a boy of thirteen and at the Royal Academy at the age of nineteen. While on the voyage to the Pelew Islands he had to work as a topographical artist, but on reaching Calcutta he concentrated on portait-painting, the most lucrative type of work for a British artist in India.

He soon acquired a reputation, especially for intimate portraits depicting subjects in their houses, gardens or places of work. William Baillie, Superintendent of the Free School and himself an amateur artist, remarked in a letter of November 1793: 'Devis paints most delightfully, I think, especially small figures in which I like his handling and colouring even better than Zoffani's.' Devis possessed a gay temperament and amiable character. As a result he built up a flourishing practice and secured many commissions for portraits. It is still difficult to list and enumerate his Bengal portraits since he rarely signed or dated his pictures. As a result, much of his work has in the past been attributed to other artists. It is only in recent years that a careful stylistic comparison of unsigned portraits with certain signed and well-documented works by Devis has made it possible to attribute further pictures to him.[1]

Amongst the latter are two portraits from the collection of Sir Robert A. W. Dent, C.B., made for an ancestor of his, William Dent. These were sold at Sotheby's on 22 March 1972. In the 1920's they had belonged to the Reverend Dr Blakiston of Trinity College, Oxford, whose grandmother was the eldest daughter of William.[2] At that time both paintings were attributed to Zoffany and listed as such by Manners and Williamson.[3] On grounds of style, however, they are clearly the work of Devis.

[1] S. H. Pavière, *The Devis family of painters* (Leigh-on-Sea, 1950).
[2] On Dr Blakiston's death, the paintings passed to Sir Robert Dent as head of the senior branch of the Dent family.
[3] Lady Victoria Manners and G. C. Williamson, *John Zoffany, R.A.: his life and works, 1735–1810* (London, 1920), pp. 112, 179–80. It is significant that a label on the back of the painting (page 83) dating from Dr Blakiston's time is inscribed: *William and John Dent of Tumlook, Bengal by Zoffany.*

William Dent served in the Bengal Civil Service of the East India Company from 27 June 1776 until early in 1796 when he returned to England. His first postings were to Patna in Bihar as Assistant to the Council of Revenue, and to Buxar as Assistant to the Collector of Customs, Patna. In 1783 he went as Salt Agent to Tamluk, where he was to spend the rest of his service. Tamluk, in the Midnapur district of Bengal, is situated twelve miles up the river Rupnarain, a tributary of the river Hooghly, and about thirty miles below Calcutta. Today it is a quiet country town but in the late eighteenth century it was busy with shipping. It was also situated in an area where salt was made. Salt had for long been a government monopoly and in many parts of its territory the East India Company had Salt Agents who supervised the manufacture of salt and levied a tax on it. While at Tamluk, William Dent married Louisa Blunt, third daughter of Sir Charles William Blunt, 3rd Bart, on 30 September 1786. A daughter, Sophia Louisa, was born in 1787 and baptised in Calcutta on 18 August 1787. A son, Charles William, was born the following year and baptised on 31 August 1788.

It is these children who provide a clue to the date of the first of the Dent paintings, a portrait of Louisa Dent with her two eldest children. The scene is set in the extensive compound of William Dent's house at Tamluk. The mother is shown seated under a pipal tree, her children at her knee. She wears a white dress with a greenish-blue wrap trimmed with ruched orange silk and swansdown. In the distance can be seen the Dents' large Palladian mansion and a number of thatched outhouses; in the middle distance is a pond beside which cattle and a small herd of five deer are grazing. Charles appears to be between eighteen months and two years of age and Sophia nearly three. It seems probable, then, that Devis painted the portrait at Tamluk some time during the first half of 1790. It is known that Devis on occasions left Calcutta and moved around Bengal painting portraits. In November 1788 Thomas Daniell in a letter to Ozias Humphry had noted that 'Devis has been running about the country'.

The second picture shows William Dent in a maroon coat and buff breeches standing with his younger brother John who wears military uniform with a scarlet coat. The brothers are shown under a neem tree with a white-robed Indian, holding papers, standing behind William, and an orderly with sword and shield behind John. William is pointing towards a labourer with a mattock who is digging up sods of earth and putting them in a small basket. In the background is William Dent's mansion seen from the front and approached by a road, with a thatched building to the left and a view of a river to the right.

This painting almost certainly commemorates three different events which have all been combined in one picture. The first was probably a visit by John Dent to his brother which may well have prompted William's invitation to Devis to come and paint the family portraits. John, born in 1763/4, served in the Bengal Infantry from 1782 until 1792 when he resigned the service. In 1789 he was adjutant and quarter-master to the Sepoy Corps, 2nd Brigade, and until 1790 was stationed in the Bengal Presidency. In mid-1790 he went south with Lt Colonel John Cockerell's Bengal detachment to serve in the Third Mysore War of 1790 to 1792. After a march of 1,200 miles from Calcutta, the detachment reached Conjeeveram on 1 August 1790. Before leaving for the war, it is therefore most probable that John visited his brother and sister-in-law in the early months of 1790.

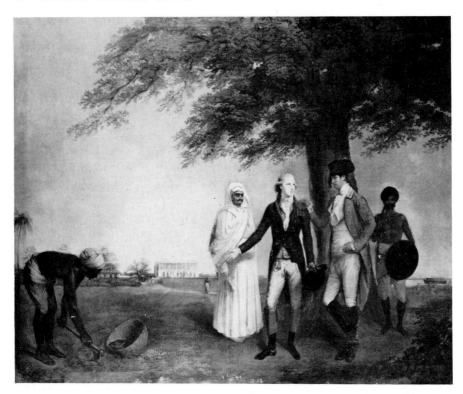

ARTHUR WILLIAM DEVIS
*Portrait of William Dent of
Tamluk, Bengal, and his
brother Captain John Dent
with their servants.*
59½ in. by 73 in.
London £26,000
($65,000). 22.III.72.

From the collection of
Sir Robert A. W. Dent, C.B.

This visit may have recalled an earlier occasion when William obtained a large piece of land at Tamluk for building a house, and his brother John may have come to witness the transaction. A series of documents in the India Office Records brings this transaction to life.[4] They reveal that on 28 May 1786, four months before he got married, William Dent had forwarded a deed to Calcutta for approval by the Revenue Department. It was duly registered and returned to him. This deed granted Dent the right to hold a piece of land in Tamluk subject to the payment of a specified annual rent to the landlord. In September 1795, when William Dent was tidying up his affairs before leaving for England in January 1796, he discovered that he had mislaid the deed. He therefore obtained a new one from the landlord and forwarded it to the Revenue Department at Calcutta for sanction. A copy of this *patta* or deed, duly approved, is preserved in the India Office Records and it enables us to visualise the estate on which William Dent built his house and to identify the various landmarks in the two paintings.

The deed was granted by an Indian landlord named Anand Narain and covered an estate of approximately seventeen acres. Lying beside the river, it was made up of five different plots sited around a large pond named Baul Pokhra. On a part south of the pond Dent built his house, and on land south-west of the pond was his office or *kutchery* with a road leading up to it. The five pieces of land formed a fine rectangular estate and it is the actual transfer of this estate to Dent which is depicted in the painting. The old ceremony of *feoffment* by sod-cutting is taking place with John as a witness and the landlord, Anand Narain, standing by with the title deed in his hand. *Feoffment*, which was not finally abolished until 1925, was still practised in the eighteenth

[4] I.O.R. Bengal Public Consultations, nos. 10–11 of 9 November 1795, Range 4, vol. 36. I am indebted to Mr Martin Moir for assisting me to trace this reference.

ARTHUR WILLIAM DEVIS
Portrait of Mrs William Dent
with her daughter Sophia
Louisa and son Charles
William. 39½ in. by 41 in.
London £7,500
($18,750). 22.III.72.

From the collection of
Sir Robert A. W. Dent, C.B.

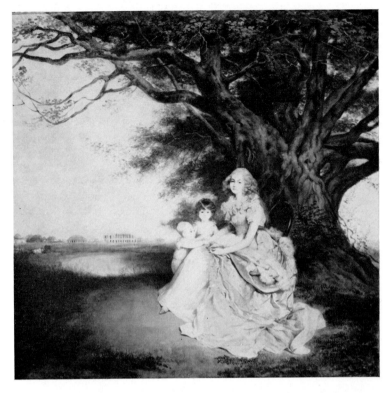

century. A law dictionary of 1810 describes the ceremony. 'The *feoffor* or his attorney comes to the land; and there, in the presence of witnesses, declares the contents of the *feoffment* of which livery is to be made and then the *feoffor*, if it be of land, doth deliver to the *feofee*, a clod or turf or a twig or bough, there graving with words to this effect "I deliver these to you in the name of *seisin* of all the lands and tenements contained in this deed".' Although this ceremony was normally used for the transfer of freehold land, it could also be used when a leasehold interest was to endure in perpetuity since at common law this was regarded as tantamount to freehold.[5] Whether this ceremony was used in India and had in fact taken place is beside the point. William Dent clearly wanted Devis to paint a picture recording his acquisition of the estate, a picture which he would take home to England with him when he retired. The only way in which Devis could do this in terms which Englishmen would understand was by depicting the ceremony of sod-cutting.

The third event shown in the pictures is the completion of the house. In the painting of the brothers it is seen from the front with great sweeping staircases. In the portrait of Louisa with her children it is seen from the garden side with the family enjoying the extensive grounds reminiscent of English parkland. The deed makes it possible to identify the various landmarks in the pictures – the river, the pond and the road leading up to the thatched office-building. The two pictures reveal how in the eighteenth century a portrait group was no mere fortuitous assemblage but a carefully planned and rational composition which threw light on landowners and their pride in families, houses and estates.

[5] I am deeply grateful to Mr F. O. Bell, O.B.E., I.C.S. retd., for translating technical terms in the deed and to Mr Peter Thomson, Bar-at-Law, for elucidating for me the ceremony of *feoffment*.

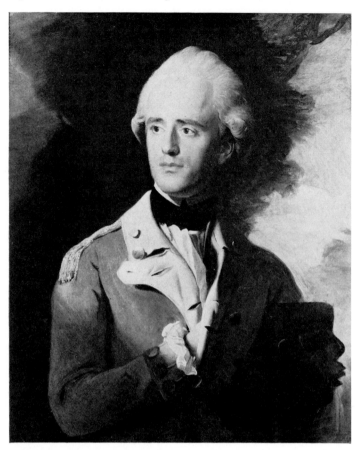

JOHN SINGLETON COPLEY,
R.A.
Portrait of Henry Barry.
$29\frac{1}{2}$ in. by $24\frac{1}{2}$ in.
London £16,000 ($40,000).
22.III.72.

From the collection of Henry
Barry Esq., M.C.

WILLIAM MARLOW
*Blackfriars Bridge and St. Paul's
Cathedral.*
$41\frac{1}{2}$ in. by $65\frac{1}{4}$ in.
New York $55,000 (£22,000).
18.V.72.

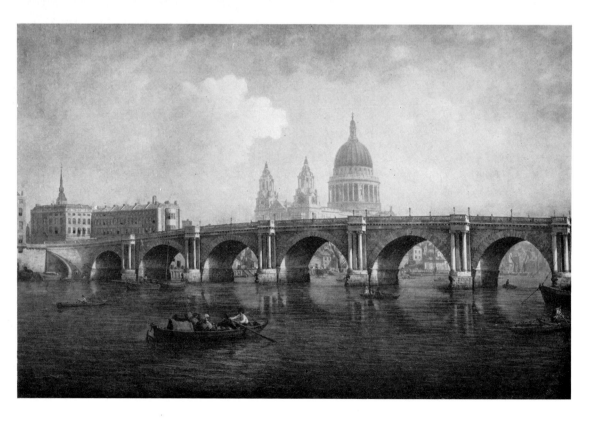

WILLIAM SHAYER,
SENIOR
Outskirts of a Fair.
Signed 29½ in. by 39 in.
London £11,500 ($28,750).
17.XI.71.

From the collection of the
late S. R. Christie-Miller.

PATRICK NASMYTH
A wooded landscape with a pond.
On panel. Signed and dated
1828. 13 in. by 17¼ in.
London £7,500 ($18,750).
19.VII.72.

From the collection of
L. Rodney, Esq.
Formerly in the collection
of the Earl of Moray.

PAUL SANDBY, R.A. *St. George's Gate, Canterbury.*
Watercolour. Inscribed, numbered 2556 on the reverse. 12¾ in. by 20 in.
London £5,400 ($13,500). 20.VII.72.
From the collection of Colonel J. Nichol.

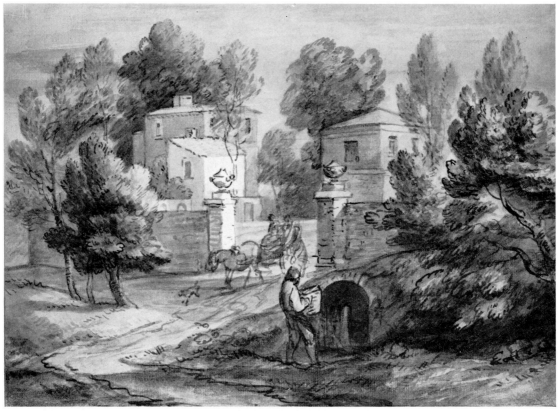

THOMAS GAINSBOROUGH, R.A. *A carriage entering park gates.*
Pen and ink and grey wash, heightened with white. 10¼ in by 14⅜ in.
London £1,100 ($2,750). 20.VII.72.
From the collection of the Cranbrook Academy of Art.
Formerly in the collections of Dr Monro and William Esdaile (1834).

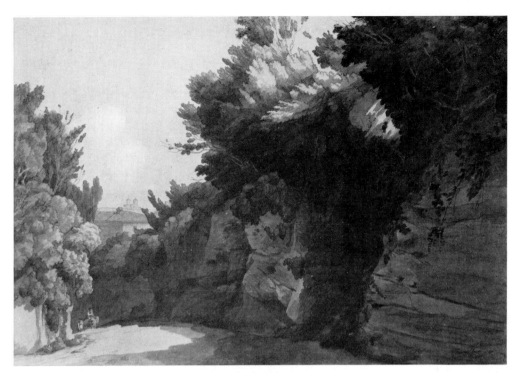

FRANCIS TOWNE. *A view near the Arco Oscuro, Rome.*
Watercolour. Signed and dated 1785. 12¾ in. by 18½ in.
London £1,700 ($4,250). 20.IV.72. From the collection of Mrs J. Leahy.

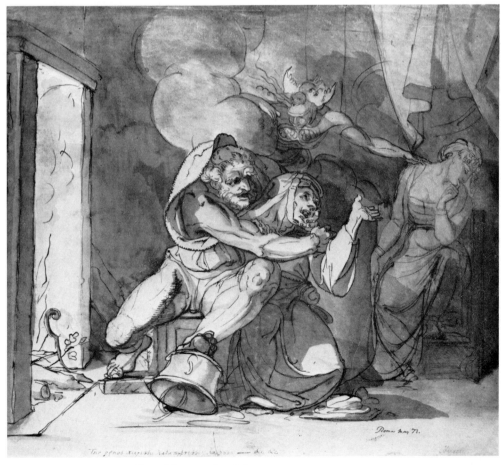

HENRY FUSELI, R.A. *Eurycleia recognises Odysseus.*
Pen and sepia ink and grey wash. Dated *Roma, May '71.* 17½ in. by 20½ in.
London £2,800 ($7,000). 20.VII.72.
From the collections of R. A. Harari, O.B.E. and Mrs Manya Harari.

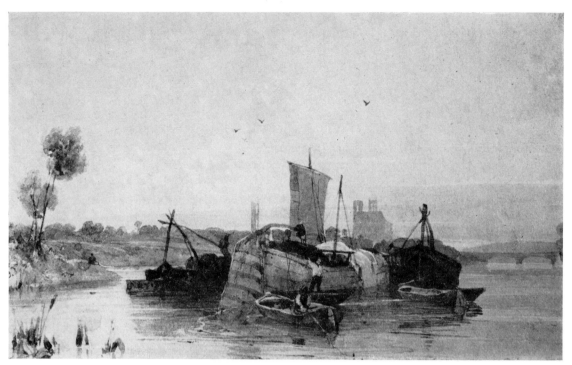

RICHARD PARKES BONINGTON *The Seine near Mantes.*
Sepia wash. Signed with initials. 5½ in. by 8½ in. London £2,200 ($5,500). 20.IV.72.

From the collection of Princess Helena Moutafian.
Formerly in the collection of H. A. C. Gregory.

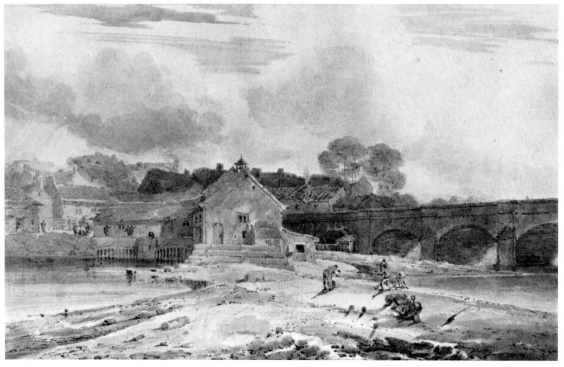

THOMAS GIRTIN *A riverside town with a stone bridge.*
Watercolour. Executed *circa* 1801. 12½ in. by 20½ in. London £4,700 ($11,750). 20.IV.72.

From the collection of C. A. Keen, Esq.
Formerly in the collection of A. T. Keen, Esq.

JOHN SELL COTMAN
An old house at St Albans.
Millboard laid on panel. Painted
circa 1824. 16¾ in. by 13 in.
London £11,000 ($27,500).
19.VII.72.

From the collection of
Mrs Humphrey Neame.
Formerly in the collection of
John Staats Forbes and Colonel
Fairfax Rhodes.

WILLIAM HANNAN
Extensive views in Redgrave Park (a pair).
Each 31½ in. by 47½ in.
London £8,500 ($21,250). 22.III.72.

From the collection of
P. J. Holt-Wilson, Esq.

HERMANUS KOEKKOEK *A calm at sunset.*
Signed and dated 1860. 20¾ in by 29½ in. London £7,200 ($18,000). 10.XI.71.
From the collection of the Edward James Foundation.

JOHANN BERNARD KLOMBEEK and EUGENE VERBOECKHOVEN
An extensive wooded winter landscape.
Signed by both artists, dated 1868. 36 in. by 48½ in.
London £9,500 ($23,750). 1.III.72. From the collection of Mrs E. G. L. Temple.

CHARLES LEICKERT *An extensive river landscape.*
Signed and dated '69. 25 in. by 39 in.
London £7,200 ($18,000). 1.III.72. From the collection of Charles Mason, Esq.

CORNELIUS SPRINGER
A street market in a Dutch town.
On panel. Signed with monogram and dated '50. 14 in. by 17¼ in.
London £4,300 ($10,750). 1.III.72. From the collection of Mrs E. M. Blanford.

TELEMACO SIGNORINI *Young fishermen leaning over a harbour wall.*
Signed, painted *circa* 1872. 11 in. by 16½ in.
London £8,500 ($21,250). 10.XI.71

GIUSEPPE DE NITTIS *A garden fête at the time of Louis XVI.*
On panel. Painted in 1869. 22½ in. by 36 in.
London £8,000 ($20,000). 10.XI.71

GAETANO CHIERICI *The Happy Family*.
Signed and dated 1870. 31¾ in. by 42 in.
London £8,000 ($20,000) 10.XI.71.
From the collection of C. R. W. Sale, Esq.

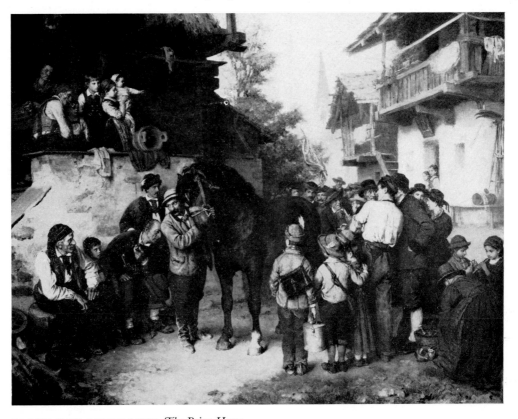

FRANZ VON DEFREGGER *The Prize Horse*.
Signed and dated 1873. 39¼ in. by 51½ in.
Los Angeles $28,000 (£11,200) 28.II.72.
From the collection of the late Victor Emmanuel Wenzel von Metternich.

SPENCER GORE
Woman seated on a bed.
19½ in by 15¾ in.
London £4,600 ($11,500).
26.IV.72.

From the collection of Mrs
J. B. Priestley.

SIR ALFRED MUNNINGS, P.R.A.
The Clark Sisters riding.
Signed. 24½ in by 29½ in.
London £11,000 ($27,500).
15.XII.71.

From the collection of the late
Celia Tobin Clark.

WALTER RICHARD SICKERT, A.R.A. *La Giuseppina and the Model*.
Signed on the reverse. Painted 1903-4. 17½ in. by 20½ in.
London £2,200 ($5,500). 15.XII.71.

From the collection of Mrs M. M. Gill.

PHILIP WILSON STEER, O.M.
A summer's evening : three bathers on the sands.
Painted in 1888. 58 in. by 89½ in. London £3,400 ($8,500). 15.XII.71.

From the collection of Talbot Clifton, Esq.

JAMES GLEESON
*Sea-wrack involving the heads of
Tristan and Isolde.*
Signed. 1947. 47¼ in. by 35½ in.
London £650 ($1,625). 26.IV.72.

From the collection of Stephen
Warwick, Esq.
Formerly in the collection of
Mr Kingsley.

SIDNEY NOLAN
Ayers Rock.
On board. Signed and indistinctly
dated '51. 19¾ in. by 24 in.
London £1,500 ($3,750). 5.VII.72.

DONALD FRIEND
Guitarist.
Pen and ink and watercolour, on
board. Signed. 29¾ in. by 21¼ in.
London £850 ($2,125). 5.VII.72.

From the collection of Stanley
Hall, Esq.

ARTHUR BOYD
Bride running away, 1960.
Oil and gouache, on board.
Signed. 23½ in. by 31½ in.
London £2,400 ($6,000). 26.IV.72

From the collection of Neil
Davenport, Esq.

LAURENCE STEPHEN LOWRY, R.A.
The Steps.
Signed and dated 1944. 15½ in. by 19¾ in.
London £10,500 ($26,250). 5.VII.72.

From the collection of the Rt. Hon. G. R. Strauss, M.P.

BEN NICHOLSON, O.M.
Piccolo, November, 1956.
On panel. Signed and dated on the reverse. 39 in. by 39¾ in.
London £18,500 ($46,250). 5.VII.72.

AUGUSTUS JOHN, O.M., R.A.
Dorelia in a landscape (*The Red Feather*).
On panel, signed. 12¾ in. by 16 in.
London £4,500 ($11,250). 26.IV.72.

JOHN SINGER SARGENT, R.A. *Reading.*
Watercolour, heightened with body colour. Signed, painted *circa* 1909. 13½ in. by 19½ in.
London £1,950 ($4,875). 26.IV.72. From the collection of P. G. Browne, Esq.

GRAHAM SUTHERLAND, O.M. *Blue vine*.
On board. Signed and dated '48. 22¼ in. by 32 in.
London £4,600 ($11,500). 15.XII.71.
From the collection of the late Godfrey Winn.

DAVID BOMBERG *The Battle of the Lapiths and Centaurs*.
Signed on the reverse. Painted 1912. London £7,200 ($18,000). 5.VII.72.

Topographical Pictures

BY DENNIS GOLDBERG

The 24th November will go down in the annals of Sotheby's history as marking the occasion of the first sale to be held in Johannesburg. *The Kafirs Illustrated* by George French Angas (R3,000, £1,500), a rare book, was one of the outstanding items in the sale. The *Portrait of Frau Kammacher*, dated 1915, is the earliest known oil painting by Irma Stern done at Einbeck in Germany. It fetched R2,000 (£1,000) and was bought by the National Gallery of South Africa, Cape Town. A highly amusing watercolour drawing, *circa* 1795, by an unknown hand, of *Table Mountain in the distance with the Heerengracht (now Adderley Street)*, realised R600 (£300). A view of *Westford Farm* (owned by George Rex) by Thomas Bowler, signed and dated 1857, made R3,100 (£1,550). Bowler is probably the best known of all artists who worked in South Africa. He produced a large number of watercolours and drawings during his thirty-four years at the Cape.

John Thomas Baines was born in King's Lynn. He left for Cape Town on 5th February 1848 on the *Amazon*. Numerous expeditions were undertaken during which highly accomplished drawings were executed. *74 Going Free*, an oil on canvas signed and inscribed on the verso (as was usually the case with the artist's canvases), fetched R2,100 (£1,050). Another excellent work by Baines was sold at Sotheby's Belgravia on 31st May. It came from the collection of Mrs Alston, the great-great-granddaughter of Lt. Gen. Sir Henry Somerset, K.C.B. (son of Lord Charles

South African School
Table Mountain in the distance, a view of Cape Town.
Watercolour, *circa* 1795. 6⅞ in. by 15 in.
Johannesburg R600 (£300; $750). 24.XI.71.

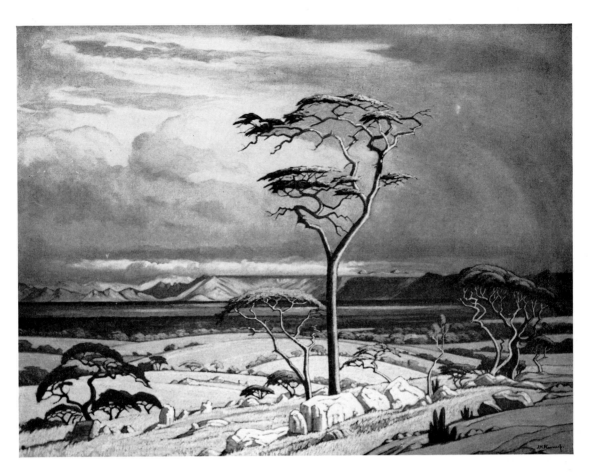

JACOB HENDRIK PIERNEEF
Laeveld.
Oil on canvas, signed and dated 1945. 29½ in. by 39⅜ in.
Johannesburg R8,800 (£4,400; $11,000). 24.XI.71.

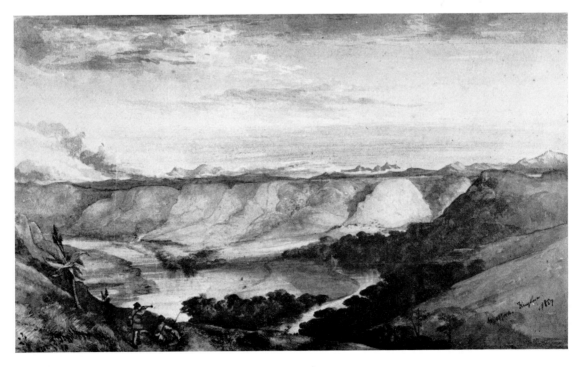

THOMAS W. BOWLER
Westford, Knysna.
Watercolour, signed and dated 1857. 12⅜ in. by 21 in.
Johannesburg R3,100 (£1,550; $3,875). 24.XI.71.

Somerset), for whom the artist painted the picture. *Loss of 42 Waggons in Trompetters Drift* was its title and it fetched £1,000. At this time Baines had not been to the Eastern Province; he probably painted this picture from a description by one of the officers who returned from the frontier. The scene depicts waggons being attacked by natives in a mountainous landscape. Perhaps the highlight of the Johannesburg sale was *Laeveld* by Jacob Pierneef, an oil on canvas signed and dated 1945 which fetched R8,800 (£4,400). Bronzes by Van Wouw included *The Miners*, which made R8,000 (£4,000). The sale was a great success and promises to be an annual event.

At Sotheby's Belgravia on 7th December 1971 an extraordinarily large water-colour by W. F. Friend, measuring 18½ in. by 59 in., realised £1,600. It was a *View of Niagara as seen from the Canadian Side. A Family of Mic-Mac Indians at their camp beside a river in Nova Scotia* by J. Brown fetched £1,200. This watercolour, dated 1807, is almost identical to lots 233/4 in the Reford Collection, sold in Toronto 27–29th May 1968 and is also similar in style to a painting of Mic-Mac Indians in the National Gallery of Canada (No.6663) painted about 1820–30. *The Return home of the Trappers at Sunset*, an early work by Cornelius Krieghoff, reached £2,700 at Sotheby's Belgravia on 31st May 1972. Many of this artist's pictures were bought by officers of the garrison and others in Quebec and taken to England.

Conrad Martens left England on his travels when Capt. Blackwood of the *Hyacinth* offered him a three year cruise to India; he transferred from the *Hyacinth* to the *Beagle* at Montevideo, after hearing that the Captain of the *Beagle* wanted to engage an artist in succession to Augustus Earle. It was on the *Beagle* that Martens met Charles Darwin, who became a close friend during the next two year voyage. Darwin and Capt. Fitzroy (the latter being a keen student of meterological phenomena) did much to influence Martens' work which, hitherto, had reflected the qualities of his teacher, Copley Fielding. Martens settled in Sydney in Cumberland Street and set up a studio. Two fine views of Sydney, *A view of the harbour* and *A view of the town looking towards the cove with the Macquarie Obelisk in the foreground*, made £1,700 and £1,450 respectively at Sotheby's Belgravia on 7th December 1971.

A volume of twenty watercolour drawings, *circa* 1820, probably by Joseph Lycett (a convict artist transported to New South Wales for forgery in 1811) relating to the incidents in the Aboriginal Way of Life in New South Wales, fetched £9,500 at Sotheby's Belgravia on 31st May 1972. The book was acquired by Charles Albert La Trobe in New York in 1872. These drawings are extraordinary in that Lycett is known as a landscape artist and hitherto is not known to have attempted the kind of figure work shown in these drawings. There is every possibility that these watercolours may have been working studies for a set of prints which was never published.

In the same sale a fine landscape of the *Hot Springs of Gardiners River, Yellowstone National Park, Wyoming Territory* by Thomas Moran fetched £7,000.

In the sale of important Canadian pictures held in Toronto on 13–14th June 1972, *The Royal Mail Crossing the Ice from Quebec to Levi* by Cornelius Krieghoff, signed and dated 1859, fetched $27,000 (£10,800). The sale also included good works by Verner. The Group of Seven's works were well represented: *Late Winter, St. Urbain* by A. Y. Jackson was sold for $15,000 (£6,000) and *Winter Logging Scene* by Frederick Simpson Coburn, dated '37, for $4,500 (£1,800).

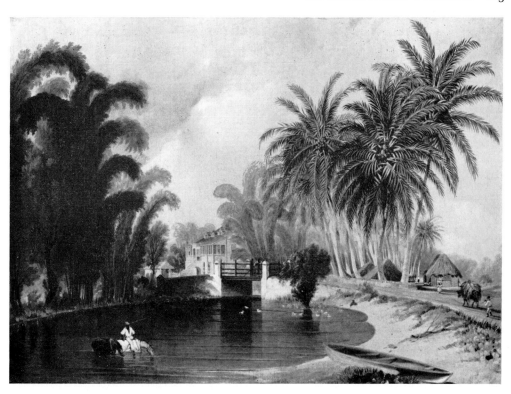

JOSEPH-BARTHOLOMEW KIDD, R.S.A.
Jamaica, Ferry Inn, between Kingston and Spanish Town.
Oil on canvas, *circa* 1840. 22½ in. by 31⅛ in.
London £3,300 ($8,250). 7.XII.71
From the collection of Miss B. M. Haddon.

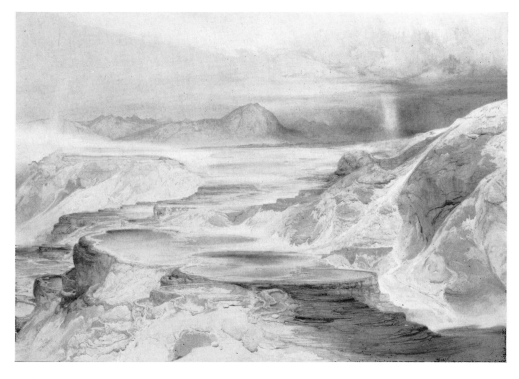

THOMAS MORAN
The Hot Springs of Gardiners River, Yellowstone National Park, Wyoming Territory.
Watercolour and bodycolour, signed, dated 1872. 20¼ in. by 28⅝ in.
London £7,000 ($17,500). 31.V.72.
From the collection of the Geological Society of London.

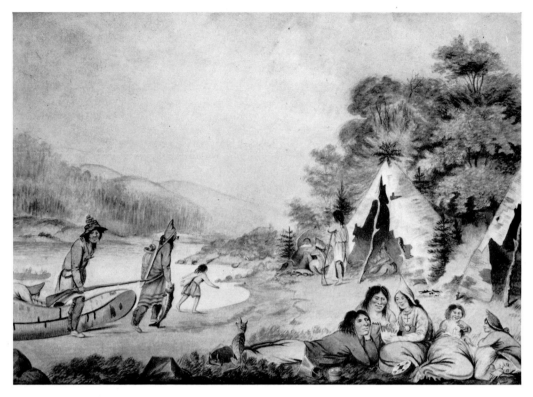

J. BROWN
Mic-Mac Indians seated beside tepees on the bank of a river in Nova Scotia.
Watercolour, signed and dated 1807. 10 in. by 14 in.
London £1,200 ($3,000). 7.XII.71.

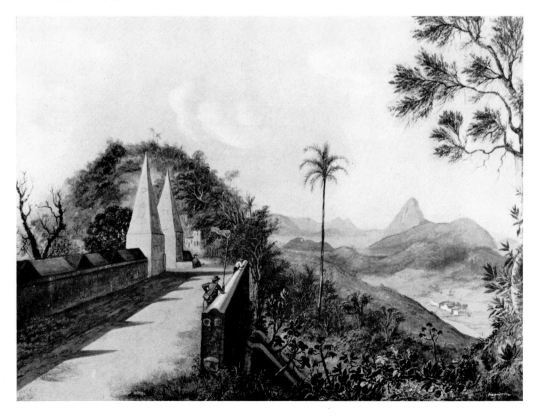

FRIEDRICH HAGEDORN
Rio de Janeiro.
Gouache, signed. 20 in. by 27¼ in.
London £1,100 ($2,750). 7.XII.71.

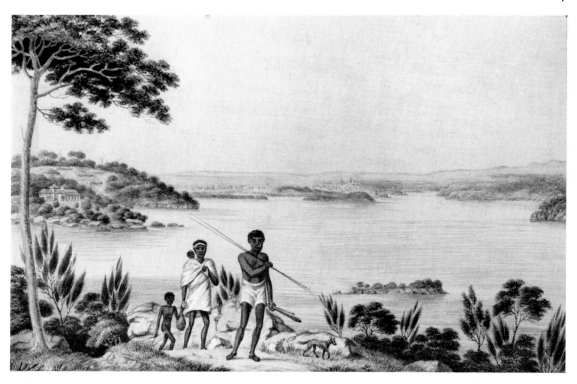

A distant view of Sydney and the Harbour, Captain Piper's Naval Villa at Eliza Point on the left, in the foreground a family of Aborigines.

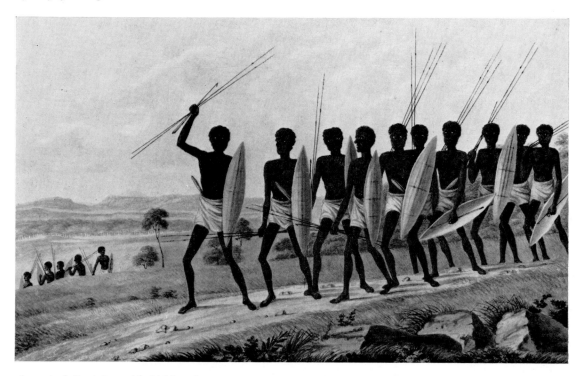

A group of Aborigines with shields and spears.

From a volume of twenty watercolour drawings, probably by Lycett, relating to incidents in the Aboriginal way of life in New South Wales. *Circa* 1820. 7 in. by 11 in.

London £9,500 ($23,750). 31.v.72.

From the collection of Mrs C. E. Blake.

CORNELIUS KRIEGHOFF
Sunset in the Woods.
Oil on canvas, signed and dated 1865. 13 in. by 18 in.
Toronto $19,500 (£7,800). 2.XI.71.
From the collection of Mrs Geoffrey Elliot-Square.

CORNELIUS KRIEGHOFF
The Royal Mail Crossing the Ice from Quebec to Levi.
Oil on canvas, signed and dated 1859. 17 in. by 24¼ in.
Toronto $27,000 (£10,800). 13.VI.72.

LAWREN STEWART HARRIS, O.S.A.
Lake Superior, Sketch XCIX.
Oil on panel. Signed and titled on the reverse. $10\frac{1}{2}$ in. by $13\frac{7}{8}$ in.
Toronto $5,100 (£2,040). I.XI.71.

ALEXANDER YOUNG JACKSON, O.S.A., R.C.A.
Late Winter, St. Urbain, 1930.
Oil on canvas, signed. 32 in. by 40 in.
Toronto $15,000 (£6,000). 13.VI.72.
From the collection of Mr & Mrs Alex Graydon of Meaford.

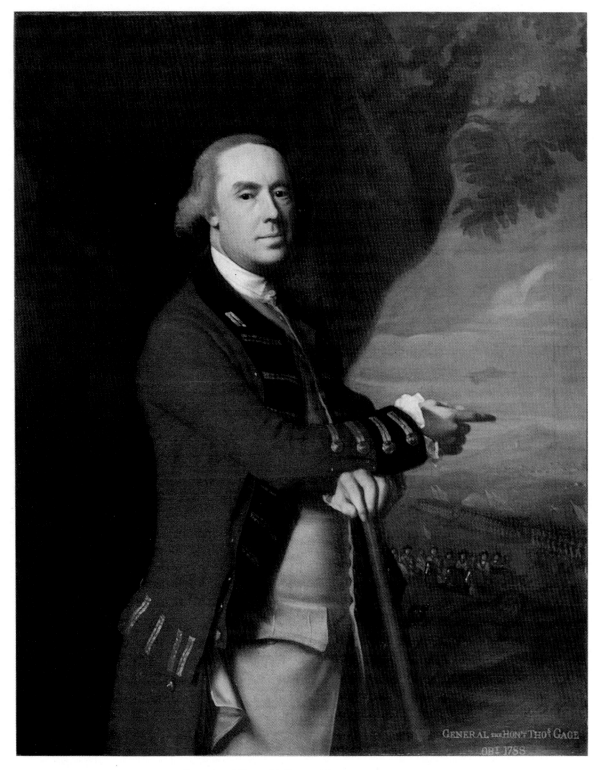

JOHN SINGLETON COPLEY. *Portrait of General Thomas Gage.*
On canvas mounted on masonite. 50 in. by 39¾ in.
New York $210,000 (£84,000). 28.x.71.

From the collection of Mrs Montgomery Scott Harkins (*née* Harriet Moseley).

This portrait was painted by Copley in New York *circa* 1768–69, some years prior to the companion
portrait of Mrs Gage which is in Copley's later English style.

CHARLES WILLSON PEALE
Self-portrait: Study for "The Artist in his Museum".
Painted 1822. 26 in. by 22 in.
New York $60,000 (£24,000). 28.x.71.

From the collection of Miss Elise Peale Patterson (a descendant of the artist).

American Painting and Sculpture

For students of American painting, the works offered throughout the season have illustrated a wide spectrum of the history of American art; some magnificent 18th and early 19th century portraits, outstanding 19th century landscapes, including one of the finest works by Inness to have appeared on the market for some time, the Lester E. Bauer collection of Western paintings, which contained Charles M. Russell's masterpiece *Death of a Gambler*, at a record $100,000 (£40,000), and a splendid group of pictures covering the development of painting in the United States in the 20th century.

Amongst the early works, the most important was John Singleton Copley's *Portrait of Thomas Gage*, painted in New York in about 1768–69, some five years before the artist left for England. Thomas Gage, an intransigent high Tory, held important office in Colonial America and was, when this picture was painted, Commander-in-Chief of Forces in North America. He later became Governor-in-Chief of the province of Massachusetts Bay and his decision to send an expedition to Concord to seize arms ultimately brought on open fighting at Lexington and Bunker Hill, fighting which marked the beginning of the War of Independence. Painted at a time when Copley was the most highly patronised artist in America, this portrait sold for $210,000 (£84,000).

Of all the major American artists active towards the end of the 18th century Charles Willson Peale, the founder of the Philadelphia School of Painting, was the only one not to leave his native country for Europe, either permanently or for an extended period, although as a pupil of Benjamin West's between 1767 and 1769, he was one of the first American artists to go to Europe and return with first hand cultural knowledge. This was typical of a man whose varied interests in the arts and sciences are characteristic of the 18th-century approach to Rationalism; he was probably more interested in his museum, which he founded in Philadelphia in 1786, than he was in painting although he fathered a prodigious family of artists, four of whom he named Raphaelle, Rembrandt, Rubens and Titian. Charles Willson's fine self-portrait of 1822 made $60,000 (£24,000) in October, whilst the following April, Raphaelle's portrait of his brother Rubens made $40,000 (£16,000); both these prices were auction records for the artists.

The beginnings of modern art in America are the paintings of The Eight, also known as the Ash Can School, who first exhibited in 1908 under the leadership of Robert Henri. The stylistic link between the artists – Henri, Sloan, Glackens, Shinn, Luks, Lawson, Arthur B. Davies and Prendergast – was tenuous but they were held together by their determination to break the hold of Academic retrogression. One of the finest painters, although ironically the least successful financially, was John Sloane (1871–1951), who did not sell a picture until he was over forty; this season, *Gray and Brass*, a superb early work of 1907, fetched a record $52,000 (£20,000).

RAPHAELLE PEALE
Rubens Peale – Mascot of 'The Macpherson's Blues'.
Inscribed with artist's name. Painted in 1795. 26 in. by 22 in.
New York $40,000 (£16,000). 19.IV.72.

From the collection of Miss Elise Peale Patterson (a descendant of the artist).
In 1794, when citizens in Western Pennsylvania resisted the federal government's attempts to tax liquour,
President Washington summoned 15,000 militiamen to enforce authority. Ten-year-old Rubens,
as commander of a company of boy soldiers, had staged a demonstration in sympathy with French
Libertarians, and was invited to join in a dinner to honour the visiting French minister, M. Fauchet.
Rubens noted, "my brother Raphaelle had me dressed in the uniform of McPherson Blues [*sic*] in which
company he was an officer, I marched with them to the camp-ground. After their return he painted my
portrait in the uniform which I wore at the time . . . " (in Rubens Peale's book of reminiscences).

Left:
ALBERT BIERSTADT, N.A.
The artist, sketching in Yosemite Valley.
On board. 13½ in. by 19 in.
New York $16,000 (£6,400).
27.X.71.

From the collection of
Dr Lester E. Bauer.

Below:
GEORGE INNESS, N.A.
A June day.
Signed and dated 1881. 22¾ in.
by 28¾ in.
New York $39,000 (£15,600).
19.IV.72.

From the collection of the
John-Esther Gallery,
Abbot Academy, Andover,
Massachusetts.

Opposite page: ALFRED JACOB MILLER
Sioux camp scene.
17 in. by 23½ in.
New York $35,000 (£14,000). 27.X.71.
From the collection of Dr Lester E. Bauer.
In 1837 Miller was engaged as artist to the expedition to the Rockies sent by the American Fur Company, and throughout the expedition he made sketches for paintings commissioned by the commander, Captain William Drummond Stewart.
There is a smaller version of the same subject in the Walters Art Gallery, Baltimore.

Right:
ALBERT BIERSTADT, N.A.
Sunrise in Yosemite Valley,
California.
Signed and dated '64. 14 in. by
20 in.
New York $19,000 (£7,600).
19.IV.71.

HENRY F. FARNY
Wyoming Indian group.
Gouache and watercolour. Signed. 8½ in. by 14 in.
New York $23,000 (£9,200). 27.X.71. From the collection of Dr Lester E. Bauer.

HENRY W. HANSEN
Attack on the stagecoach.
Signed. 36½ in. by 50 in.
New York $25,000 (£10,000). 27.X.71. From the collection of Dr Lester E. Bauer.

CHARLES M. RUSSELL
Death of a gambler.
Signed and dated 1904. 24 in. by 36 in.
New York $100,000 (£40,000). 27.X.71. From the collection of Dr Lester E. Bauer.

WILLIAM HENRY DETHLEF KOERNER
Rustlers.
Signed and dated 1928. 25 in. by 44 in.
New York $21,000 (£8,400). 27.X.71. From the collection of Dr Lester E. Bauer.

This painting was clearly painted for "On the Road to Jericho's," a story of cattle rustling by
Edmund Warre, published in *American Magazine*, 1929.

EASTMAN JOHNSON, N.A.
Rustic violinist with little girl.
On board. Signed and dated '68. 15½ in. by 13 in.
New York $27,000 (£10,800). 19.IV.72.

From the collection of Miss Elise Peale Patterson.

EASTMAN JOHNSON, N.A.
Confidence and Admiration.
Signed and dated 1859. 14 in. by 12 in.
New York $28,000 (£11,200). 28.x.71.

MAURICE PRENDERGAST
Revere Beach.
Watercolour. Signed and dated 1896. 14 in. by 10 in.
New York $28,500 (£11,400). 19.IV.72.

Opposite above:
JOHN SLOAN
Gray and brass.
Painted in 1907. Signed. 22 in. by 27 in.
New York $52,000 (£20,800). 24.V.72.

From the collection of the late Lincoln Isham.

Opposite below:
ANDREW WYETH, N.A.
The Bucket Post.
Watercolour. Signed, executed in 1953. 22½ in. by 28½ in.
New York $23,000 (£9,200). 24.V.72.

From the collection of the City College Fund, New York.

WILLIAM GLACKENS, N.A.
Café Lafayette (Portrait of Kay Laurell).
Signed. Painted in 1914. 31¾ in. by 26 in.
New York $29,000 (£11,600). 24.v.72.

From the collection of the late Lincoln Isham.

BEN SHAHN
The Lucky Dragon.
Tempera. Signed. 84 in. by 48 in.
New York $27,500 (£11,000). 24.v.72.
On March 1, 1954, the *Lucky Dragon*, a Japanese fishing trawler, sailed close to Bikini Atoll. There the United States was testing its new H-bombs, unknown to the crew of the *Lucky Dragon*. The fishing boat was covered with radioactive ashes, and on the voyage home the crew became ill. One of them, Aikichi Kuboyama, died the following September, after a long illness. The cause of his death was not listed as radioactive poisoning, but as hepatitis caused from an injection given in the hospital to counteract the effect of the H-bomb fallout. The painting depicts this tragedy. The artist made a number of drawings for this series, to illustrate three articles by the physicist Ralph Lapp done for *Harper's Magazine* in 1957–8.

JASPER JOHNS
Shade.
Encaustic and objects on canvas. Executed in 1959. 52 in. by 38½ in.
New York $60,000 (£24,000). 17.XI.71.

From the collection of Dr Leo Steinberg.

ANDY WARHOL
Self portrait.
Acrylic and silkscreen enamel on canvas. Executed in 1967. 72 in. by 72 in.
New York $39,000 (£15,600). 17.XI.71.

From the collection of Governor Nelson A. Rockefeller, New York.

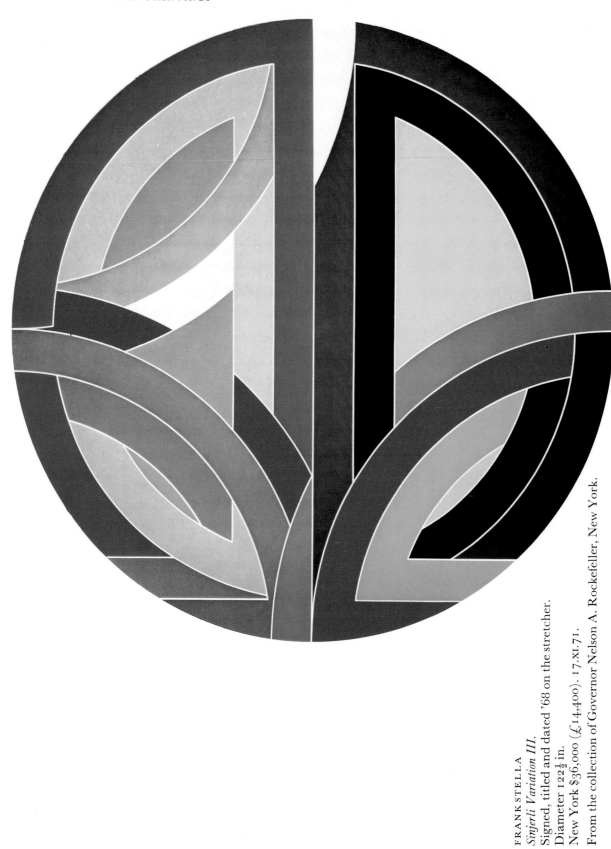

FRANK STELLA
Sinjerli Variation III.
Signed, titled and dated '68 on the stretcher.
Diameter 122½ in.
New York $36,000 (£14,400). 17.XI.71.
From the collection of Governor Nelson A. Rockefeller, New York.

DAVID SMITH
Composition.
Signed and dated 9.15.1953. Iron. Length 40½ in.
New York $20,000 (£8,000). 17.XI.71.

From the collection of Mr and Mrs George Wittenborn, New York.

HENRI ROUSSEAU
Paysage exotique.
Signed and dated 1910. 51¼ in. by 64 in.
New York $775,000 (£310,000). 21.x.71.
From the collection of Mrs Robert R. McCormick.

Impressionist and Modern Sales

The standard of Impressionist and Modern sales has been particularly high this season. Important paintings by Delacroix, Pissarro, van Gogh, Modigliani and others have fetched exceptional sums. Apart from these, there have been a small number of other truly outstanding paintings and sculptures.

Foremost amongst these was the *Paysage Exotique* by Henri Rousseau, purchased by the Norton Simon Foundation for $775,000 (£310,000) at Parke-Bernet in November, the highest auction price for any 20th-century work of art. The subject of the jungle fascinated Rousseau, and of the large number of such compositions he executed, the present example may justly be described as one of the eight finest, and certainly the only one of its quality likely to come on the market. Like some of his other master-pieces in this genre, it was painted in 1910, the year in which Rousseau died.

German Expressionist painting has been well represented in the sale room and in much demand. The sale by the Solomon R. Guggenheim Foundation of 48 oils and watercolours by Kandinsky, for a total of $1,955,500 (£782,200), was obviously the most important event. This group included *Bild mit drei Flecken nr. 196* of 1914, which realised a world record $300,000 (£120,000). When the Guggenheim Foundation sold another superb group of fifty paintings by Kandinsky at Sotheby's in 1964, the total was £536,500 ($1,502,200); this first group, however, contained 49 oils and 1 gouache, whilst the second group contained only 15 oils. The considerable difference in prices between these two sales may be gauged from the fact that in 1964, *Improvisation* of 1914, one of the artist's greatest masterpieces, fetched £50,000 ($140,000).

Also of great rarity was the composition by Franz Marc, *Die blaue fohlen* of 1913. Marc was a seminal figure, with Kandinsky, in founding the Blue Rider group and because of his early death in the First World War, his mature work is seldom seen on the market. This painting was typical of Marc's work, exhibiting all the qualities of residual romanticism combined with the new techniques in construction learnt from the Cubists in Paris. It was also of a particularly admired subject. All these factors accounted for its high price of £66,000 ($165,000).

Four exceptional sculptures were sold this season, all of them for record prices. Anton Pevsner's *Pour une façade de musée* is the first bronze by this artist seen at auction and, not surprisingly, fetched £32,000 ($80,000). Born in Russia in 1884, he visited Paris in 1912. As well as being interested in the Cubist works he saw, he was most deeply impressed by the Eiffel Tower, the structural elements of which greatly influenced his work. In 1917, he was teaching at the Academy of Fine Arts in Moscow, together with Kandinsky and Malevich; and, with Gabo, was one of the pioneers of abstract sculpture.

In March at Parke-Bernet, the Cranbrook Academy sold a group of very important sculptures which included Barlach's wood carving of 1911, *Der Schwertzieher,* and Henry Moore's monumental elmwood *Reclining Figure* of 1945–46. The Barlach fetched $110,000 (£44,000), being bought by the Barlach Museum in Germany, and the Moore realised $260,000 (£104,000). In London in June, Modigliani's stone head of *circa* 1910–11, fetched the surprisingly high price of £72,000 ($180,000). This sculpture was known only from a photograph taken in 1911, the re-appearance of this work after 60 years causes a valuable addition to the 25 sculptures which were all that was thought to have survived.

EUGENE DELACROIX
Cavalier arabe.
Signed. Painted in 1856. 22 in. by 18 in.
London £49,000 ($122,500). 1.XII.71.

JEAN-FRANÇOIS MILLET
Les Jeunes Couturières.
Signed. Painted *circa* 1848–50. 12½ in. by 9½ in.
London £13,000 ($32,500). 28.VI.72.

From the collection of the late Frank D. Stout, Chicago.

CAMILLE PISSARRO
La Route de Saint-Germain à Louveciennes.
Signed and dated 1870. 15 in. by 18 in.
London £52,000 ($130,000). 1.XII.71.

CLAUDE MONET
Le Bateau echoué.
Signed and dated '81. 32 in. by 23½ in.
London £60,000 ($150,000). I.XII.71.

From the collection of Adalbert Mangold, Esq.
Previously in the collection of Henry Zimet. Sold at Sotheby's on 23rd October 1963
for £30,000 ($84,000).

PIERRE-AUGUSTE RENOIR
Fille en rose.
Signed. Painted *circa* 1890. 13 in. by $16\frac{1}{4}$ in.
London £65,000 ($162,500). 28.VI.72.

From the collection of Stavros S. Niarchos, Esq.

JEAN-BAPTISTE-CAMILLE COROT
Jeune Femme sur un Sentier en vue d'un Etang.
Signed. Painted *circa* 1865–8. 25¼ in. by 15¾ in.
London £64,000 ($160,000). 28.VI.72.
From the collection of Sir Edward Hulton, K.T.

CAMILLE PISSARRO
Les Quatre Saisons.
above : L'Hiver, opposite page : Le Printemps (not illustrated *L'Eté* and *L'Automne*).
Signed and dated 1872. 21¾ in. by 51¼ in.
London £220,000 ($550,000). 1.XII.71.
From the collection of the late Hugo Cassirer.

CAMILLE PISSARRO
Les Quatre Saisons : Le Printemps.

The *Four Seasons* were painted by Pissarro for Achille Arosa, one of the first collectors of the Impressionists, who became Pissarro's patron. They later appeared in Arosa's sale in 1891 when Pissarro, writing to Octave Mirbeau on 17th December 1891, referred to them: 'Ce *Printemps* a été vendu par moi à M. Arosa 100 fr. en 1872, il y avait les quatre saisons au même prix chaque. Les quatre toiles ont passé inaperçues à une vente à l'Hôtel Drouot, elles ont été achetées 1.100 fr. les quatre. Cela vaut actuellement 2.500 fr." In a letter to his son Lucien on 26th December 1891 Pissarro wrote about the Seasons: "Did I let you know that M. Chéramy has bought a fan from Durand and paid 850 francs? He told me he would have liked to acquire for 2,500 francs one of the panel friezes at Bernheim's, but it was too large. The said Bernheim told me that the panels were a great success, little Meyer also told me that".

HENRI FANTIN-LATOUR
Roses blanches et roses.
Signed and dated '90. 14½ in. by 12½ in.
London £34,000 ($85,000). 28.VI.72.

Opposite page:
ALBERT MARQUET
Le Jardin de Porquerolles.
Signed. Painted in 1939. 25½ in. by 32 in.
London £11,250 ($28,125). 12.IV.72.

MAXIMILIEN LUCE
Les Lavandières.
Signed and dated 1906. 23¾ in. by 32 in.
London £12,500 ($31,250) I.XII.71.

PIERRE-AUGUSTE RENOIR
Jeune Fille appuyée sur sa Main.
Signed. Painted in 1894. 18½ in. by 16½ in.
London £57,000 ($142,500). 28.VI.72.
From the collection of Stavros S. Niarchos, Esq.

PIERRE BONNARD
Jeune Fille au Col bleu.
Stamped with the signature. Painted *circa* 1920. 21¼ in. by 13 in.
London £26,000 ($65,000). 1.XII.71.

ODILON REDON
La Liseuse.
Pastel. Signed. 14¾ in. by 11½ in.
London £17,000 ($42,500). 28.VI.72.

PABLO PICASSO
La Jupe rouge.
Pastel on board. Signed. Executed in Spain in 1901. 22 in. by 18¾ in.
London £51,000 ($127,500). 28.VI.72.

ERNST BARLACH
Der Schwertzieher.
Signed and dated 1911. Wood. Height 29½ in.
New York $110,000 (£44,000). 1.III.72.

From the collection of the Cranbrook Academy of Art.

AMEDEO MODIGLIANI
Tête.
Stone. Executed *circa* 1910–11. 19¾ in. high.
London £72,000 ($180,000). 28.vi.72.

AMEDEO MODIGLIANI
La Rousse au Pendentif.
Signed. Painted in 1917. 36¼ in. by 23½ in.
London £115,000 ($287,500). 28.VI.72.

From the collection of Monsieur Henri Belien, Brussels.

KEES VAN DONGEN
Femme au Chapeau de Roses.
Signed. Painted *circa* 1910–11. 39¼ in. by 32 in.
London £30,000 ($75,000). 28.VI.72.

From the collection of Clifford and John Rykens.

JUAN GRIS
Le Cahier de Musique.
Signed and dated 4–22. 37¾ in. by 24¼ in.
New York $125,000 (£50,000). 27.IV.72.

From the W. Averell and Marie Harriman Collection, New York.

FERNAND LEGER
Paysage animé (Ier état).
Signed and dated 1921. 25¾ in. by 20 in.
New York $66,000 (£26,400). 27.IV.72.

HENRI MATISSE
Nu couché III (*torse rond*).
Bronze. Signed. Executed in 1929. Length 18 in.
New York $42,500 (£17,000). 1.III.72.
From the collection of Mr and Mrs Eugene Twining.

PAUL KLEE
Sirenen Eier.
Signed; inscribed and dated *1939 E. E. 20* on the stretcher. $19\frac{1}{2}$ in. by 43 in.
London £39,000 ($97,500). 12.IV.72.

FRANZ MARC
Die blaue Fohlen.
Signed with the initial. Painted in 1913. 21 in. by 14¾ in.
London £66,000 ($165,000). 12.IV.72.

VASILY KANDINSKY
Bild mit drei Flecken, nr. 196.
Signed and dated 1914. 47½ in. by 43½ in.
New York $300,000 (£120,000). 20.x.71.

From the collection of the Solomon R. Guggenheim Foundation, New York.
A total of 48 paintings and watercolours and drawings from this collection were sold
by Sotheby–Parke-Bernet for $1,955,000 (£782,200).

VASILY KANDINSKY
Offenes Grün, nr. 263.
Signed with the initials and dated '23.
38¼ in. by 38¼ in.
New York $155,000 (£62,000). 20.x.71.

From the collection of the Solomon R. Guggenheim Foundation, New York.

VASILY KANDINSKY
Locker-Fest, nr. 369.
Signed with the initials and dated '26. 43¾ in. by 39½ in.
New York $105,000 (£42,000). 20.x.71.

From the collection of the Solomon R. Guggenheim Foundation, New York.

VASILY KANDINSKY
Voltige, nr 612.
Oil with sand. Signed with the initials and dated '35. 32 in. by 39¼ in.
New York $100,000 (£40,000). 20.x.71.
From the collection of the Solomon R. Guggenheim Foundation, New York

OSKAR KOKOSCHKA
London, Waterloo Bridge.
Signed with the initials. Painted in 1926 from a room in the Savoy Hotel. 35 in. by 51 in.
New York $150,000 (£60,000). 21.X.71.

ANTON PEVSNER
Pour une Façade de Musée.
High relief, oxidised bronze. Signed with the initials and dated '43–44. This sculpture is unique.
16 in. by 28½ in.
London £32,000 ($80,000). 12.IV.72.
From the collection of Arnold Maremont, Esq.

HENRY MOORE
Two forms.
White marble. Length 23½ in. Executed *circa* 1964.
New York $55,000 (£22,000). 1.III.72.
From the collection of the Very Reverend Walter Hussey, Dean of Chichester.

IVAN PUNI
Suprematist Construction.
Painted wood, metal and cardboard. Executed *circa* 1916.
$14\frac{1}{4}$ in. by $9\frac{1}{2}$ in.
London £3,200 ($8,000). 12.IV.72.

ALEXANDRA EXTER
Suprematist Composition.
Gouache. Stamped with the mark of the artist's estate. Executed *circa* 1916.
16½ in. by 15¼ in.
London £2,800 ($7,000). 12.IV.72.

IVAN KLIUN
Suprematist Composition.
Gouache and watercolour. Signed and dated 1920.
13½ in. by 10¼ in.
London £3,000 ($7,500). 12.IV.72.

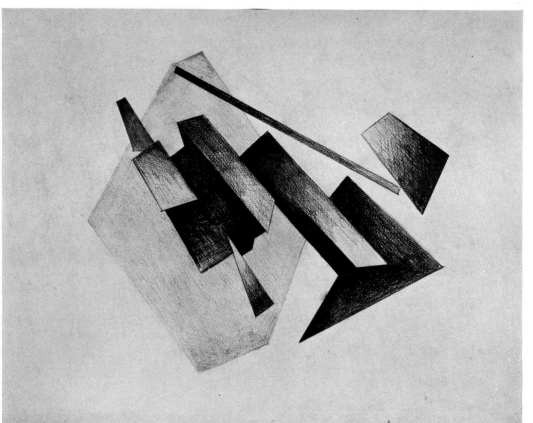

OLGA ROSANOVA
Abstract Composition.
Black and blue crayon. Signed on the reverse and dated '9,16.
18 in. by 14 in.
London £1,300 ($3,250). 12.IV.72.

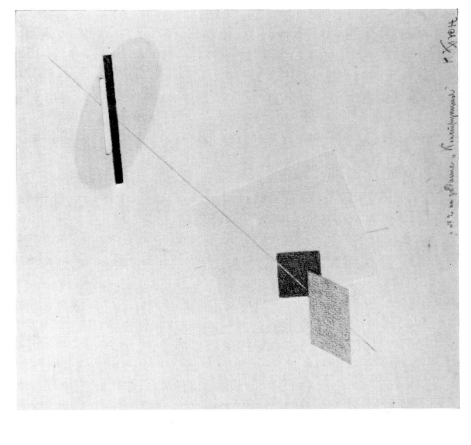

IVAN KLIUN
Study for a Suprematist Construction.
Pencil. Signed and inscribed. Drawn *circa* 1920.
7¾ in. by 7 in.
London £2,000 ($5,000). 12.IV.72.

KASIMIR MALEVICH
Suprematism (34 drawings).
Book lithographed by the Vitebsk Art Studios, 1920.
London £1,400 ($2,600). 12.IV.72.
The lithography was presumably executed under the
direction of Lissitsky, who was at this time in charge of
the Vitebsk workshops.

HENRY MOORE
Reclining Figure.
Elmwood. Executed 1945–46. Length 75 in.
New York $260,000 (£104,000). 1.III.72.

Since its creation, this sculpture has inspired criticism and analysis by noted art historians. Executed concurrently with the Dartington Hall *Reclining Figure*, the two have frequently been compared. Moore describes his feelings at the time:

"For Dartington Hall I chose an idea which was calm and peaceful and seemed to me to be most suitable. But at the same time, in my studio, I was doing a large wood sculpture which was very different in spirit. This was at a time when I was catching up on the two years of sculpture time I had lost through the war and I had many accumulated ideas to get rid of. And so I was doing two sculptures at the same time although the two were completely different from each other in mood. Thus I was able to satisfy both sides of my nature by working on the rather gentle Dartington figure at the same time as the Cranbrook *Reclining Figure* in elmwood, which for me had great drama, with its big beating heart like a great pumping station." (Hedgecoe and Moore, (*v.i.*)).

From the collection of the Cranbrook Academy of Arts, Bloomfield Hills, Michigan.

FAUST (schlafend) – Unselige Gespenster! so behandelt ihr
Das menschliche Geschlecht . . .
FAUST (sleeping) – Unhallowed spectres, plague of mortal flesh,
Thus have you led mankind . . .

$9\frac{3}{4}$ in. by $7\frac{1}{2}$ in.

The Drawings by Max Beckmann for Goethe's 'Faust II'

CHOR–Was geschehen werde,
 sinnst du nicht aus!...
 Gutes und Böses kommt
 Unerwartet dem Menschen;

CHORUS – Shapes of things to come you
 cannot divine...
 Blessings or evils come
 Unforeseen by us mortals;

9¾ in. by 4 in.

SEE: J. W. Goethe, *Faust II*, p. 213

It was thanks to the initiative of Georg Hartmann that what can be considered the most important illustrated book by a major German artist in the 20th century was realised. Georg Hartmann was not only a notable collector of books, medieval wood sculptures and impressionist and modern paintings but was also the founder of the Bauersche Giesserei, Frankfurt, the well known firm of typefounders. Having commissioned Beckmann in 1943 to produce a set of lithographs to illustrate the *Apocalypse*, Hartmann suggested that he should now go on to illustrate either Cervantes' *Don Quixote* or Goethe's *Faust Part Two* (Goethe wrote *Part One* between 1790 and 1797; *Part Two* was completed only shortly before his death in 1832). Beckmann knew both works well since reading was his favourite occupation when not painting. He eventually chose *Faust* and as we know from his diaries, started to work on the drawings on the 15th April 1943 and completed them on the 15th February 1944, while still living in exile in Amsterdam. He was given a completely free hand with this commission, being able to choose whatever passages from *Faust Part Two* he wished and to illustrate them in whatever manner he chose, hence these drawings show a very personal and at the same time contemporary interpretation of the theme. Beckmann inscribed on the reverse of many of the drawings direct quotations from the text to be used as titles.

Because of the situation in Germany just after the war, it was impossible to publish the drawings at that time. However in 1957 the Bauersche Giesserei published a private and limited edition of *Faust Part Two* with only thirty-five of the Beckmann drawings and it was not until 1970 that the entire series was published by Prestel-Verlag in Munich. It is sad to think that Georg Hartmann, who died in 1954, never saw the final realisation of his commission which was to take such an important position in 20th century art.

Series of 127 drawings. Pen and indian ink.
London £75,000 ($187,500). 1.XII.71.
From the Bauersche Giesserei Collection, Frankfurt-am-Main.

EDGAR DEGAS
Danseuses sur la Scène.
Peinture à l'essence, gouache and pastel. Signed. Executed *circa* 1879.
13½ in. by 22½ in.
London £13,500 ($33,750). 28.VI.72.

Opposite page:
PIERRE-AUGUSTE RENOIR
Recto: *La Plage de Guernsey.*
Verso: *Etude de femmes et d'hommes.*
Charcoal. Drawn in 1883. 18¾ in. by 21¾ in.
London £10,000 ($25,000). 28.VI.72.

Recto

Verso

VINCENT VAN GOGH *Jardin Public à Arles.*
Pen and sepia ink. Signed. Drawn in September 1888. 12 in. by $9\frac{1}{4}$ in.
London £22,000 ($55,000). 28.VI.72.

From the collection of M. F. Feheley, Esq. of Toronto.

GUSTAVE MOREAU *Saint Sebastien secouru.*
Watercolour. Signed. $10\frac{1}{2}$ in. by 13 in.
London £11,000 ($27,500). 2.XII.71.

LYONEL FEININGER *Dorf*.
Watercolour. Signed and dated *Saturday, August 17th 1912*. 8 in. by 9½ in.
New York $16,000 (£6,400). 26.IV.72.

GINO SEVERINI *Nature morte au buste et à la guitare*.
Collage, gouache and charcoal. Signed. Executed *circa* 1912. 19¾ in. by 23½ in.
London £6,500 ($16,250). 28.VI.72.

VASILY KANDINSKY

No. 225.

Watercolour and Indian ink. Signed with initials and dated '27. 19 in. by 12½ in.

New York $32,000 (£12,800). 20.x.71.

From the collection of the Solomon R. Guggenheim Foundation.

VASILY KANDINSKY
No. 40.
Watercolour and Indian ink. Signed with initials and dated '22. 18 in. by 16½ in.
New York $30,000 (£12,000). 20.X.71.

From the collection of the Solomon R. Guggenheim Foundation.

1. Léon Pourtau *Port au pied des falaises*. Signed,
1890. 21½ in. by 30¼ in. £2,000 ($5,000). 2.XII.71.
2. Berthe Morisot *La Chèvre Colette*. Signed. 23¾ in.
by 19¾ in. £16,500 ($41,250). 1.XII.71. 3. F.-H.
Morisset *Le Lac au crépuscule*. Signed. 29½ in. by
39¾ in. £1,100 ($2,750). 29.VI.72. 4. James Ensor
Les Poupées. Signed, 1916. 31 in. by 38½ in.
£20,000 ($50,000). 1.XII.71. 5. Charles Maurin
Les Illuminations d'Arthur Rimbaud. Signed. 31½ in.
by 39¼ in. £800 ($2,000). 13.IV.72. 6. Félicien
Rops *Le vieux pêcheur surpris de trouver sa place habituelle
occupée*. Signed, 1876. 17 in. by 25¾ in. £3,100
($7,750). 29.VI.72. 7. André Dunoyer de Segonzac
La Baie de St Tropez. Signed, 1927, 32 in. by 25¾ in.
£8,500 ($21,250). 12.IV.72. 8. Pavel Tchelitchev

Homme nu s'exerçant. Signed, *circa* 1926. 36 in. by
28¼ in. £2,000 ($5,000). 13.IV.72. 9. Alexej
Jawlensky *Oberstdorfer Landschaft*. Signed, 1912.
19¼ in. by 21 in. £9,400 ($23,500). 1.XII.71.
10. Lovis Corinth *Chrysanthemen II Fassung*. Signed,
1923, 37½ in. by 31½ in. $30,000 (£12,000).
21.X.71. 11. François Bonvin *Une Servante indiscrète*.
Signed, 1871. 20¼ in. by 13¼ in. £1,600 ($4,000).
2.XII.71. 12. Henri de Toulouse-Lautrec *Yvette
Guilbert*. Ceramic plaque. Signed. 20½ in. by 11 in.
£4,200 ($10,500). 2.XII.71. 13. Emil Filla *Homme
assis tenant un journal*. Signed, '20. 30¾ in. by 14½ in.
£2,600 ($6,500). 2.XII.71. 14. Wienerwerkstatt
School *Bildnis einer Frau in goldenem Gewand*.
46 in. by 26¼ in. £4,900 ($12,250). 2.XII.71.

1. Pablo Picasso *Danse sur la Plage*. Signed, 1946. 19¼ in. by 25¼ in. £6,500 ($16,250). 28.VI.72.
2. Pablo Picasso *Nu*. Signed, *circa* 1903–4. 10¼ in. by 14¼ in. £11,500 ($28,750). 28.VI.72. **3.** Marc Chagall *Peintre au Chevalet*. 1919. 7 in. by 8¾ in. £6,000 ($15,000). 2.XII.71. **4.** René Magritte *Sans titre*. Signed, *circa* 1925–6. 15¾ in. by 21½ in. £7,800 ($19,500). 2.XII.71. **5.** Paul Delvaux *La Sirène*. Signed, 1950. 29¼ in. by 43 in. £9,200 ($23,000). 2.XII.71. **6.** René Magritte *Le Char de la Vierge*. Signed, 1965, 9½ in. by 13 in. £4,400 ($11,000). 12.IV.72. **7.** Amedeo Modigliani *Caryatide*. Signed. 16¾ in. by 10 in. £6,200 ($15,500). 28.VI.72. **8.** Edgar Degas *Danseuse à la Barre*. Circa 1877–9. 18 in. by 11¾ in. £15,000

($37,500). 28.VI.72. **9.** Egon Schiele *Freundinnen*. Signed, 1914. 19 in. by 12¾ in. $27,000 (£8,280). 21.X.71. **10.** Paul Cézanne *L'Enfant au chapeau de paille* (recto illustrated,) *Lac d'Annecy* (verso). 17 in. by 10½ in. £11,000 ($27,500). 28.VI.72. **11.** Le Corbusier *Nature morte au Violon, aux Bouteilles et à la Carafe*. Signed *Jeanneret*, dated '22. 28½ in. by 23½ in. £3,500 ($8,750). 28.VI.72. **12.** Max Ernst *Les Moeurs des Feuilles*. Signed, 1925. 16¾ in. by 10¼ in. £5,200 ($13,000). 20.VI.72. **13.** Fernand Léger *Les Amoureux*, 1954. 17½ in. by 12½ in. £3,250 ($8,125). 28.VI.72. **14.** Gino Severini *Train dans un Paysage*. Signed, 1913. 25¾ in. by 20¼ in. £9,000 ($22,500). 2.XII.71.

MARC CHAGALL
Paysan sur le Toit.
Gouache. Signed. Executed *circa* 1909–11.
10¾ in. by 7¾ in.
London £8,000 ($20,000). 2.XII.71.

EGON SCHIELE
Stehender akt (mit tuch).
Tempera and pencil. Signed and dated 1917.
18 in. by 11¾ in.
New York $26,000 (£10,400). 27.IV.72.
From the collection of Miss Eichberg.

PABLO PICASSO
Tête d'homme.
Gouache. Executed in 1909. 25⅛ in. by 18¾ in.
New York $75,000 (£30,000). 21.X.71.

PAUL KLEE
Geisterzimmer mit der höhen Türe (Neue Fassung).
Ink and watercolour. Signed, titled and dated 1925. 19 in. by 11½ in.
New York $46,000 (£18,400). 27.IV.72.

The London Gallery and the lean years of Surrealism

BY GEORGE MELLY

And now, inevitably, it's the time for the Surrealists to soar up into the financial stratosphere. Painters who, less than a decade ago, could be bought for three figures go for five. Even the less talented adherents of the movement are snapped up, even poorer pictures by the established names make their price. It wasn't always like that.

In 1947, recently demobbed from the Navy and with a cheque for £900 from my father I left Liverpool, a rather immature 22, to work at the newly re-opened London Gallery, Brook Street, w.1.

The £900 was to buy me into the business. I was to invest it in pictures of my choice which were to remain available for resale, and any profit I was to reinvest in gallery stock. In exchange I was to be trained as a picture dealer at a starting salary of £3.10s. a week, even in those days a startlingly modest amount.

My employer, the managing director, was the Belgian poet and collagist E. L. T. Mesens, whom I had met during my naval career after contacting the Surrealist Group in London, and who had become a great friend. I was soon to discover that riotous Surrealist evenings as a bell-bottomed sailor-poet were rather different from long days as a rather grubby and inefficient gallery employee, and that Edouard as guardian of the Surrealist flame was a different proposition from M. Mesens, art-dealer and exaggeratedly business-like employer. Of course off duty I remained his friend, in itself an unnerving if rewarding role, but at work (and his ideas of reasonable hours and the lengths to which loyalty and devotion might be stretched were almost infinitely elastic) he was as rigid as a regimental sergeant-major. His wife too was on the strict side. She worked as a buyer at Dickens and Jones in nearby Regent Street and came back and forth quite often, if rather unexpectedly. As Sybil Mesens she was as much a friend as Edouard, but as Miss Fenton, her business name, she could be extremely critical as to my nails, manner of dress, and seating posture, and this despite the fact that she had no official role in the running of the gallery. Altogether the two-and-a-half years I spent at the Gallery were not entirely happy, particularly when my growing involvement with the emerging jazz revival began to reduce my efficiency yet further due largely to lack of sleep. Even so I learnt a lot and there were very marvellous times too.

To understand the London Gallery it's necessary to give a partial account of E.L.T.'s involvement in the London Art World, his intentions in reopening, and the way in which his hopes and aspirations foundered on the rocks of the age of austerity.

He had come here first to help hang and organise the International Surrealist exhibition at the New Burlington Galleries in 1936. The exhibition created an enormous furore and Mesens was attacked and defended, fêted and shouted at in a manner highly agreeable to a man of his temperament. In 1938 he returned to manage the London Gallery, then in Cork Street and, the Surrealists still being news and money not too scarce, succeeded in remaining solvent without compromising too basically

RENE MAGRITTE
Au Seuil de la Liberté.
Signed. 99 in. by 73½ in.
London £55,000 ($137,500). 12.IV.72.
This is one of three paintings commissioned by Edward James in the mid-1930's for his house in Wimpole Street. From the collection of the Edward James Foundation.

his loyalty to the strict tenets of the movement to which, idealistically, he owed allegiance. He also edited a magazine *The London Bulletin* which began as a catalogue for the Gallery with accompanying texts and notes but gradually grew to become a lively art journal of general interest although naturally enough with a Surrealist emphasis. In those prewar days the London Gallery was in friendly competition with two others of similar if more eclectic tendency, the Mayor Gallery and Guggenheim Jeune owned and run by Peggy Guggenheim, both of whom were advertised in the *Bulletin*. The war closed the gallery and put an end to the magazine; 'Fight Hitler and his ideology wherever it appears' implored a full page in the last issue. Mesens went first into the army and then to the B.B.C.

The London Gallery reopened in Brook Street a few months before I joined it. The plans were ambitious. It occupied a whole building on the Claridges pavement. A picture restorer used one room, the rest were galleries. There was a bookshop-entrance gallery, the shelves low enough to allow the hanging of smaller pictures. On the wall behind the desk was a cemented three-dimensional mural by F. E. McWilliam; a huge detached plaster eye, mouth, nose, and lips arranged with systematised disorder in relation to their usual placing on the head. Three steps led down to the rush-matted large gallery behind. Below was an additional windowless gallery and a storage cellar. Above, an office and another gallery. Above that a further two rooms. Above that a very pretty maisonette occupied by the Mesens. The house was built about 1780 and painted white throughout.

In the cellar, with the exception of a few very special items which were kept in the offices, the stock was neatly stacked. The special items were an oval cubist Picasso portrait of 1909, a Chirico, a Gris, a Rousseau. The normal stock included at least a dozen Miró, twenty Ernst, a great many Klees, a few Magrittes (most of Mesens' own collection were in Belgium), Tanguy, Delvaux, and all the lesser lights such as Brauner, Masson, and Dominguez. There was also a certain number of British artists, Banting, Penrose and so on.

It was from this cache that I spent my first Sunday with E.L.T. choosing pictures to the value of my £900.

These were not the very first pictures I'd bought. While still in the Navy and already a friend of Mesens I'd seen, at Roland Browse and Delbanco, a small Ernst pencil frottage of a bird in a cage. Its price was £12. I had offered a pound down and five shillings a week and had been accepted. Mesens said, typically, that I'd paid too much, but he sold me an Ernst oil, a *personnage* with insects, for £80 which I raised by selling a few shares I'd been left by an aunt.

Even so £900 seemed to me a vast sum. With E.L.T. pointing at what to pull out, I ranged most of the stock around the gallery walls and thought about what to choose.

Disregarding a very typical Mesens joke; he insisted I took, for £10, a poor picture by an obscure Belgian called Guiette; and ignoring some of the smaller items, I bought: a Picasso cubist drawing of 1914; a Klee watercolour of the same date, plus an early etching and a tiny watercolour; a beautiful Magritte; a small oil and a large frottage by Ernst; a huge Miró of 1936, very brutalist in manner and a small Masson.

RICHARD OELZE
L'Attente.
Pencil. Signed and dated '35. 14½ in. by 17½ in.
London £3,000 ($7,500). 26.IV.72.
A study for the large painting of 1935–36, in the Museum of Modern Art, New York.
From the collection of the late E. L. T. Mesens.

I took them back to Chelsea and hung them round my room together with some pictures by Peter Rose-Pulham, Scottie Wilson, John Banting, and two drawings by Wilfredo Lam. A month or two later I traded in one of the Klees for Magritte's *Le Viol* which Sybil Mesens didn't like and refused to have up.

Naturally I paid a dealer's price, but as E.L.T. said (Guiette aside), I was 'well served'.

Two questions may spring to mind. One, what persuaded my father to give me £900 to invest in what to him, as a Liverpool businessman, must surely have seemed to be at best meaningless? The answer is that when he was my age an Uncle had spent considerably more buying him into a business that was to bore him for the rest of his life whereas I was obviously mad about Surrealism and he envied and respected enthusiasm. Furthermore, as it transpired, he had some potential feeling for it himself and became particularly fond of Magritte. Indeed during the last ten years of his life he made collages which were not at all bad.

SALVADOR DALI
Las Llamas llaman.
Signed, titled, inscribed and dated 1942. $57\frac{1}{2}$ in. by $48\frac{1}{2}$ in.
New York $82,500 (£33,000). 27.IV.72.

From the collection of the late Col. LeRay Berdeau of Palm Beach, Florida.

PAUL DELVAUX
Femme au Miroir.
Signed and dated 12–36, 28 in. by 36 in.
London £28,000 ($70,000). 12.IV.72.

From the collection of Monsieur André Delvaux, of Rhode St. Genèse, Belgium.

JANN HAWORTH
Dolly.
Foam rubber construction with nylon and plastic.
Height 37¼ in.
London £680 ($1,700). 26.IV.72.
From the collection of the late E. L. T. Mesens.

The second question is why I myself was drawn towards an art form at the time almost universally despised, not only by those who had always disliked Surrealism, but also among those who had admired it when it was 'smart', but now felt it to be *vieux jeu*. Naturally I'd like my answer to be that I alone, among my generation, recognised its merits, but this isn't at all the case. The only difference between me and a great many young people all over Britain was that I had the good luck to meet Mesens, to know in consequence where to go to buy the pictures, and to have some money available to do so.

For many young people at that time the discovery of Surrealism was similar to their parallel discovery of early jazz. There was however no democratic surrealist equivalent of the jazz-club. Take Anthony Earnshaw for instance, the co-author of 'Musrum' and 'Wintersol' and the splendid 'Wokker' comic strip in *The Times Educational Supplement*. He, like me, stumbled upon Herbert Read's *Surrealism* anthology during the war and, in his own words 'felt I'd been wandering all my life and of a sudden arrived at some place where I was no longer alone . . . ' And yet, although he knew there was a Surrealist group in London he never contacted them. He wrote ' . . . I saw myself as a scruffy working lad, no money, uneducated, no talent . . . Nothing to offer but my restlessness. The idea of a *real* surrealist like Mesens overawed me'.

And even if it hadn't there was no question of Earnshaw finding £900 or even £50. Surrealist painting was already thought of as merchandise even if virtually unsaleable. To penetrate the Inner Surrealist circle needed middle-class confidence. How many others denied themselves a voice in British Surrealism through shyness and a feeling of educational and social inadequacy?

To return to the London Gallery there I was helping to hang the exhibitions, the only job I did well, to order for the bookshop, write the invitation cards, and try to sell the pictures. Naturally we couldn't depend simply on the stock. Mesens had to find new artists, some close to the Surrealist spirit like Lucian Freud, others far from it like Freud's friend John Craxton.

Craxton actually was where British painting was at during the late forties. Romantic, touched by Cubism, charming. His exhibitions were widely reviewed, had brilliant private views and sold out. 'Butter' said E.L.T. defensively, 'but honest butter'. Lucian too sold well but produced very slowly. They certainly helped the gallery to keep going but it wasn't enough, nowhere near enough, and they were under contract too.

The three directors and principal shareholders of the Gallery were Roland Penrose, Peter Watson and Anthony Zwemmer, the art-bookshop owner. Zwemmer's interest was frankly commercial, but Watson and Penrose had more complicated roles. Penrose never lost his belief in and enthusiasm for Surrealist painting and indeed much of the stock was drawn, on sale or return, from his famous collection. He had, however, quarrelled with Mesens on ethical grounds, remaining, for example, a friend of the poet Paul Eluard after his post-war split with André Breton. As a result Mesens and Penrose hardly spoke, and E.L.T.'s potential ally among the directors became in consequence more or less alienated. Watson was a different case. A sensitive and tortured man, he had become as bored by Surrealism as by life and would depress us all by wandering around any exhibition we had put on murmuring 'no tension'. Lacking his fellow directors' enthusiasm or belief in what he was doing, Mesens was forced to use any stratagem to keep solvent. The purity of the early months of the gallery's renaissance was soon muddied. We began to let rooms in order to pay for at least an occasional show not altogether repugnant to E.L.T.'s convictions. This led to some really painful exhibitions: trees on Hampstead Heath; the sculptures of a religious paranoid ('At least' said Mesens 'the Christian Iconography is difficult to read'); the polite and whimsical gouaches of an F.O. civil servant, and so on.

Yet at least the paying artists' friends came and sometimes bought. Our own exhibitions were almost ignored. An Ernst show – 'unremarkable' wrote Wyndham Lewis in *The Listener* just before he acknowledged his growing blindness – sold one, to a courageous primary school teacher who paid the £40 in instalments. (I hope he still has the picture.) Klee, at an average of £60, none. Schwitters – two sold, one to me, one to Robert Melville, then an employee of the gallery, both at £12 each. For the same sum I managed to buy an Arp relief in the 'Christmas bazaar'. It was all very disheartening.

Mesens himself took much of his modest salary in pictures at admittedly favourable yet not ridiculous prices. Some of his wife's larger yet far from astronomical salary was similarly bespoke.

Occasionally there was a break. A rich young man was persuaded to buy some important pictures and looked like becoming a steady client. Alas a 'knowing' friend told him that Magritte was a joke. He sold the masterpiece he'd bought from us for less than the modest sum he'd paid and bought no more.

MAX ERNST
La Règle du Jeu.
Signed and dated '57. 28¾ in. by 23½ in.
London £19,000 ($47,500). 1.XII.71.

Still Mesens, admittedly drinking increasingly and using me as something of a whipping boy, continued to soldier on. Almost alone he supported the ailing Schwitters, buying those beautiful little collages on the artist's rare visits from Cumberland, and organising a recital of the 'Sonate in Urlauten' in the hope that the B.B.C. might be persuaded to record it (their representative left at the interval). He also discovered Scottie Wilson, promoted the extraordinary automatic work of Austin Cooper, a famous ex-poster artist with a Blake complex ('The man's sick' murmured Peter Watson), and Peter Rose Pulham, an ex-photographer who, if he hadn't died so young, might have challenged his friend Francis Bacon as an imaginative force. Old friends like John Banting were exhibited and occasionally a young artist was given a room for nothing because Mesens had found something alive in his work.

Even so we began to sink. The staff, originally four, became three, then two (myself and Roy Edwards, 16 years old and a fine poet), then me. Eventually, coinciding happily with my resolution to become a full-time jazz singer, it was decided to go into liquidation. The stock was auctioned between the directors. The adventure was over by the beginning of the fifties.

Mesens' failure was that whereas he found it acceptable to let off rooms to anybody ('Frank commercialism' as he called it), he refused, with the exception of Craxton, to run with the tide. If he showed anyone under his own imprimatur he had to believe in the artist at every level and what he believed in was unacceptable in the chauvinist piss-elegant atmosphere of post-war Britain. Yet our relationship with the few other galleries of *avant-garde* tendencies was friendly. With the Mayor Gallery exceptionally so, and with the St. George's Gallery also.

The Hanover Gallery, which opened while we were still in business, should have been close but offered Robert Melville a post, at a larger salary which, not unnaturally he accepted thereby feeding E.L.T.'s always hungry sense of persecution and ruling out any kind of liaison. The Hanover was the first of the new galleries, recognising that the trappings of luxury implied the possession of desirable objects. Our rush matting and cheap framing didn't help. Sometimes out of sheer boredom we'd sell another gallery a picture at trade price or buy one. Now and then we'd send a picture for the Tate to consider – they refused a beautiful early Tanguy for £120.

We had a small yet faithful public, mostly young and poor. Colin McInnes was a regular, so was Francis Bacon, the only visitor who agreed with me that Magritte was marvellous, a view held generally to be either perverse or a proof of naïve idiocy. Of course E.L.T. tended to turn on anyone he felt patronising or unsympathetic. There was no chic about the London Gallery, even his 'business sense' was wrong. It lacked the casual and amateur touch which the British dilettanti prefer when in contact with art. Still he was right, and most of those who fumed at what we showed or, if more sophisticated, sneered at it were wrong. I am only amused by the way in which those who ignored it then praise Surrealism now. The pictures are the same. 'How lucky you were . . . ' some people who were around then, and not without means, occasionally say to me on discovering I still own some of my sadly diminished £900 worth. They're right of course, but how blind they were.

Qui deuero Dieu nous asseure
Qui ce ne croit si ne voit honte
Honte certes ne voit il point
A me est auenues en ce point
Quant aus peulos de lentendemt
Car Dieu de ces vij. point no[us] point
Ceste armenue ce pour point
Et est une grandissement
Et ontve tout enuaissement
Dontve buerl smonlierement
Parler de cim point apoint
Car si affectueusement
Ne si tresamoureusement
Riens que je sache ne me point
Histovve de la natuute me seugnenz

Tresglorieuse naissance
Qui humiliac sa puissance
A qui nulle ne se compare
Qui fais du sens dieu enfance
Qui desordenas ordonnance
Quant tu fais de fille mere

Sir Thomas Phillipps: a Centenary Tribute

A. N. L. MUNBY

Sir Thomas Phillipps died on 6 February, 1872. Independent to the last, he was sustained on his deathbed by champagne and brusquely refused an invitation to join in prayer with his son-in-law, the Reverend John Fenwick. Five days previously he had signed his will, a document of which he had made different drafts for a period of fifty years. Its chief aim was to preserve intact the vast library to the formation of which he had devoted his life and to safeguard it from fire, from booksellers, from Roman Catholics and especially from James Orchard Halliwell, his eldest daughter's detested husband, who under an entail would inherit his estates and assume his name. To prevent Halliwell from setting foot in the library had been the main motive for abandoning his mansion at Middle Hill, near Broadway, and moving to Thirlestaine House in Cheltenham; and it was of the latter house that Lady Phillipps made the memorable complaint about being "booked out of one wing and ratted out of the other".

The future of his library had exercised Phillipps throughout his collecting career. In the eighteen-twenties and thirties financial crises had driven him to make approaches to the Bodleian and the British Museum. Later he turned his mind to setting the library up in Wales; for he was proud to trace his descent from the Philipps family of Picton, on whose estate was the ancient castle of Manorbier, the birthplace of Giraldus Cambrensis. The British Museum made a valiant attempt to flatter Phillipps into bequeathing the collection to the nation by making him a Trustee, a gesture which took too little account of Phillipps's constitutional incapacity for the give-and-take of service on any form of committee. In the event he used his position to prosecute private vendettas and rarely attended meetings; but he sent sharp and wounding directives to Panizzi, the Principal Librarian, a man himself more used to handing out than to receiving peremptory demands. Between 1851 and 1862 he kept the University of Oxford in play, demanding among other things either the Ashmolean building or the Radcliffe Camera for his books, and adding for good measure a proposal that he himself should become Bodley's Librarian. In truth, I doubt whether Phillipps ever entertained really serious intentions of giving or bequeathing his collection to any public institution. He certainly relished the temporary power and influence to be derived from dangling golden expectations before credulous librarians and trustees, but I concur with Halliwell's judgement when he remarked that his father-in-law

Opposite page:
JEAN DE MEUNG
Le Testament, with four other works in French verse and one in prose. Manuscript on vellum, decorated with five miniatures and illuminated initials, [France, *c.*1400–10].
London £5,200 ($12,480). 30.XI.71. From the collection of the late Sir Thomas Phillipps Bt. (1792–1872). The author is the famous continuator of the *Roman de la Rose*.

should be "classed in the eel tribe which is not only slippery but partakes of the wisdom of the serpent".

Thus it was that Phillipps's second daughter Katharine and her husband John Fenwick received a bequest of an acutely embarrassing kind, the life-tenancy of a vast entailed house and library with an endowment totally inadequate for its upkeep. Reforming legislation enabled the Court of Chancery in 1885 to rescue the Fenwicks from their predicament; and a year later began the series of sales of manuscripts and printed books with which the name of Phillipps and of Sotheby will always be associated.

When Phillipps began to buy manuscripts the shops were full of items from such legendary dispersals as the Roxburghe sale of 1812 and he died in the lifetime of Sir Sydney Cockerell, well-known personally to many collectors of today. For fifty years there was hardly an auction at which he was not active, hardly a year in which some large private transactions did not substantially augment his accessions from the sale-room. I have computed that the total may have comprised sixty thousand manuscripts and fifty thousand printed books, acquired at a cost of not less than two hundred thousand pounds. Up to, and including the sale of the residue of the library to Messrs. Lionel and Philip Robinson in 1945 I calculate that Phillipps's heirs had sold books and manuscripts to the value of at least £360,000, of which rather less than a third was contributed by sales at auction. The five volumes of my *Phillipps Studies* took the Phillipps saga up to 1957, to the retirement from business of the brothers Robinson. This is a convenient place to refer briefly to later facets of the story.

The reputation of Sir Thomas Phillipps has grown over the last decade. His centenary is being celebrated in New York this year by an exhibition drawn from the incomparable collection of Mr Harrison D. Horblit; and in the collector's native Broadway an exhibition this year to mark the thousandth year of the town's history contained, also on loan from Mr Horblit, a series of the photographs of the neighbourhood which Phillipps, a pioneer in his appreciation of the new art, commissioned in the eighteen-fifties and sixties. Middle Hill is now used as a school and the pilgrim to Broadway Tower, once the home of the Middle Hill Press, can make his way down a private estate road with a view of the house before inspecting the Phillipps monuments in the church of St. Eadburgh at the foot of the hill. Growing use has been made of Phillipps's personal papers, generously given to the Bodleian by the brothers Robinson, and the volume of correspondence which reaches me from scholars seeking to trace Phillipps manuscripts shows no sign whatever of abating. A curious aspect of these enquiries is the steady trickle of letters addressed to Phillipps himself or to his librarian at Thirlestaine House, Cheltenham – evidence, I suppose, of those ivory towers inhabited by scholars, insulated from any knowledge of the events of the last century. The finding-list of Phillipps manuscripts, a project to which I was rash enough to refer in print in 1960, is still many years away from completion: locations of about thirteen thousand manuscripts have so far been noted. I have salved my conscience over the delay by reflecting that nothing can be finalised until the dispersal is complete, and that the new series of Phillipps sales provide me with an alibi.

For this is the major development since I last wrote about Phillipps — the splendid series of consignments of manuscripts which the Trustees of the Robinson Trust have

entrusted to Sotheby and Co. since 1965. Normally there have been two sales a year, one of mediaeval manuscripts and one of later material, and, including one sale of *Americana* held in New York, around a million and a half pounds had been realised in this operation up to the end of 1971: and a century after the death of the collector, during which there has been continuous dispersal, the process is still some way from completion. In scale and in value no comparable library has ever reached the market, nor can it ever do so. The uniqueness of the dispersal is matched by the unique obsessive quality of the library's original acquisition, and the origins of this lay in the uniqueness of the collector himself. Writers on Phillipps have tended to dwell on the disagreeable aspects of his character, which were manifold and which I have never sought to conceal. But these flaws in his humanity, these failures in family relationships, all sprang from one cause – the singleminded dedication with which he subordinated everything to his life work. Life-long firmness of purpose in the face of innumerable difficulties and obstacles is a quality which compels admiration, and it is for this that I wish to salute Phillipps in his centenary year – for this and for his veneration of learning. Writing in these pages at Sotheby's invitation I am embarrassed to confess that I have sometimes regretted that the entire Phillipps collection could not have been kept together as a single entity in the nation's custody: but that was not to be. And, if it had been, we should have been denied an incomparably interesting series of sale catalogues; and the manuscript stocks of libraries and record offices all over the world would have been the poorer.

Two unpublished photographs of Sir Thomas Phillipps taken *circa* 1860 (left) and *circa* 1870 (right).

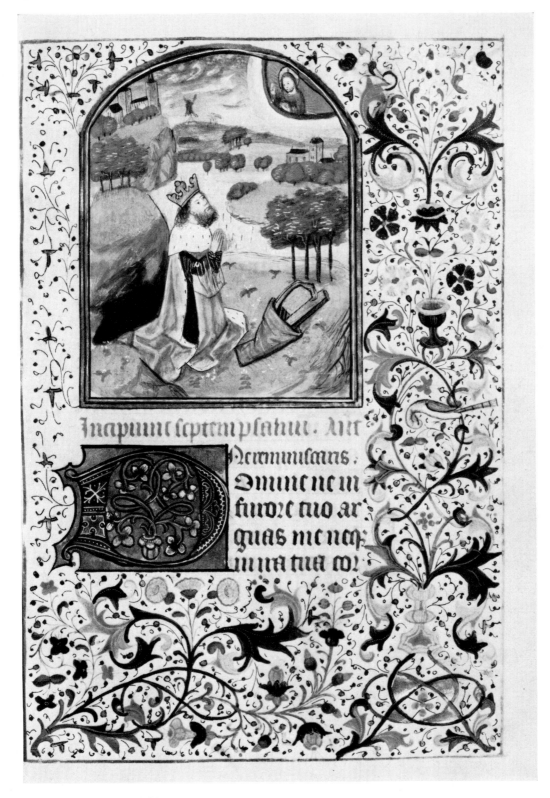

Hours of the Virgin, use of Rome.
Manuscript on vellum, decorated with 54 miniatures, illuminated borders, and initials,
[Northern France, *c.*1460]
New York $8,000 (£3,200). 16.v.72.

Books

The distinguished libraries sold this season included three selections from the Willis King III collection of early printed books and works of bibliographical interest, the second part of the Boies Penrose collection of travel and exploration, two further parts of the Phillipps library, a selection from Roger Senhouse's library, consisting of books which had passed to him from the collection of Lytton Strachey, a selection from Lady Gregory's library at Coole, books from the library of Lord Brownlow and the Bignold collection of colour-plate books. Amongst more specialised collections were the travel books sold by the Honorable Society of King's Inns, Dublin, two sales devoted to Australiana, the Hutton calligraphic collection sold in March, the Scraemli library of works connected with gastronomy and the superb collection of Dickens material formed by the late Comte Alain de Suzannet. A new departure in May was a sale of 19th and 20th century British illustrated books which proved extremely popular and will be repeated.

The eighth part of the Phillipps Library, New Series, sold in July, contained a fascinating collection of forgeries by one of the great masters of that art, Constantine Simonides. Arriving in England in 1853, Simonides proceeded to offer for sale groups of classical manuscripts, several of which purported to be centuries older than any known surviving text. Sir Thomas Phillipps, whose insatiable thirst for books and manuscripts brought him into contact with many rogues, of whom Simonides and Gugliemo Libri were the most famous, was an obvious target, but Phillipps seems to have had a strangely ambivalent attitude towards the forger, on the one hand trying to persuade himself that some of the most important pieces were genuine and on the other, well aware that he was being sold fakes, but prepared to accept them nonetheless because of their great curiosity and the obvious skill with which they had been executed. Also Simonides was a contact with sources of manuscripts otherwise inaccessible to Phillipps.

In the sale, a forged roll of the first three books of the *Iliad* fetched £280 ($700) and the same price was paid for a manuscript of the *Hortatory Poem* by Phocylides, a piece claimed by Simonides to be a 4th century copy from a monastery on Thessolonica, but of which Phillipps remarked 'In Greek Capitals in the fine large hand of Simonides, and in his brown ink, which still smells strongly of the perfume in its composition.' The top price of £360 ($900) was paid for a history of Byzantine painting purporting to have been written by one Meletius of Chios but in fact an original composition by Simonides himself, which Phillipps noticed had been 'dipped in tobacco water and strangely used to make it look old'.

The Dickens collection of Comte Alain de Suzannet was sold for a total of £73,220 ($183,050) in November. Two lots of exceptional importance were the 12 autograph pages of Dickens' first major novel *The Pickwick Papers*, which fetched £9,000 ($22,500) and 22 pages of *Nicholas Nickleby*, the third novel, which realised £12,000 ($30,000). These were the only known autograph pages of Dickens' great novels remaining in private hands.

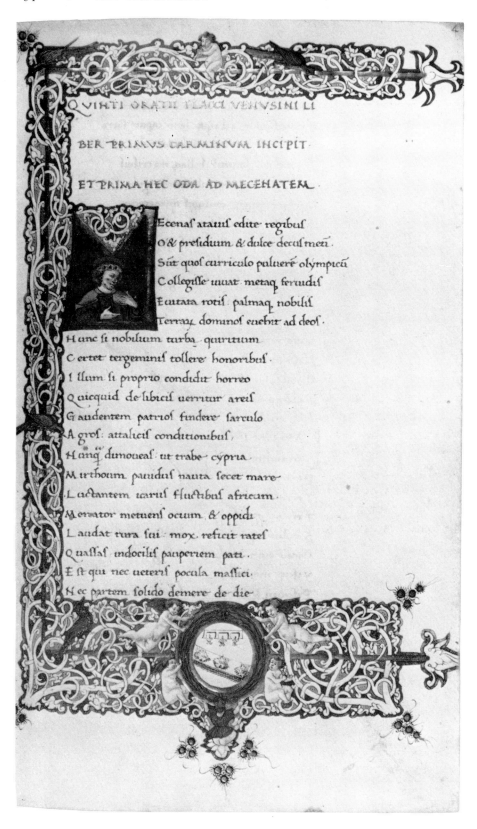

QUINTUS HORATIUS FLACCUS
Opera.
Manuscript on vellum, with illuminated title-page and 10 illuminated initials, signed by the scribe at the end with his initials *L.J.*, [Florence, *c.*1460].
London £10,000 ($25,000). 6.XII.71.

ANACREON *Odes*.
and PYTHAGORAS *Golden Verses*.
Manuscripts on rolls of very fine vellum,
in a Congreve matchbox.
London £550 ($1,375) 4.VII.72

From the collection of the late Sir Thomas
Phillipps Bt. (1792–1872)
The manuscripts were written and sold with others
to Sir Thomas Phillipps by Constantine Simonides,
the forger of Greek manuscripts.

Hours of the Virgin, use of Rome.
Manuscript on vellum, decorated with
14 large miniatures, 10 historiated initials,
and illuminated borders,
[? Tours, *c*. 1490–1500].
London £10,500 ($26,250) 10.VII.72

Hours of the Virgin, use of Utrecht. Manuscript
on vellum, decorated with 7 large miniatures,
one historiated initial, and 6 large
illuminated initials, [? county of Holland,
second quarter of the fifteenth century].
London £3,000 ($7,500) 10.VII.72

PETER OF POITIERS
Compendium Historiae in Genealogia Christi.
Illuminated vellum roll, decorated with
10 miniatures, [England, *c*. 1250].
London £1,900 ($4,750) 10.VII.72
The manuscript describes the descent of Christ
from Adam. The miniature illustrated here
depicts Cain raising an axe to slay Abel.

INXPINOE INCIPIT VITA.
ET CONVERSATIO SERVI
DI MACHARII ROMA
NI HEREMITE QVIINVEN
TVS EST PROPE PARA
DISO AD VIGINTI MILIARIA
LORIAET MAGNIFI

centia dō soli benignissimo. quip innu
merabilia miraculoy exempla. nos tepidos
& indignos. cotidie muttat adbeata gaudia uitae
eglestis. Nos denq; miseri. & humiles mona
chi. teophilus. sergius. & chi inus. depcam
uos oms scissimos patres. & frs. ut acco mo
detis aures. his quae uob narraturi sumus de
uita & conuersatione scissimi macharii ro
mani. qui apparuit nob ppepara dysum.
ad uiginti miliaria. & hoc rogamus ut fide

Vitae Patrum. Manuscript on vellum in a large rounded Carolingian hand, [North Italy (Lombardy or Emilia), *c.*1000]. London £14,000 ($33,600). 30.XI.71. From the collection of the late Sir Thomas Phillipps Bt. (1792–1872)

This manuscript was one of 40 bought by the monk Pietro Ardengo for the Benedictine Abbey of Nonantola in the time of Abbot Rodolfo I (1002–35). It remained there until the 17th century and was eventually acquired for Sir Thomas Phillipps in 1848.

In
di
cū
qd
&
ru
brū

CASPIŪ

ΠΓΠ
ΠΙΑΠΕ

Scipio

Quā̈ ̈ſi cupiat proleſ futuroꝛ hominū· deinceps laudeſ unuſ cuiuſq̃ nr̄m a patrib; acceptaſ poſteriſ prodere. tamen propter eluuioneſ exuſtioneſq̃ terraꝝ· quaſ accidere certo tempore neceſſe eſt· non modo non exerna· ſed ne diuturnā quidē glorīā aſſequi poſſumuſ; Virtutiſ fructū ſapienſ in conſci entia ponit· minuſ perfectuſ in gloria; Unde ſcipio perfectione cupienſ infundere nepoti· auctor eſt· ut conſcientiae contentuſ premio· gloriam non requirat; In qua appetenda quoniā duo ſunt maxime quę poptari poſſint· ut & quālatiſſime uageꝛ̄· & quā diutiſſime perſeueret· poſtquam ſuperiuſ de habitationiſ nr̄ę anguſtiiſ diſſerendo· xocuſ terre quę ad celū pūnch locū optinet· minimā quandā docuit anri generi hominib; parta

MACROBIUS: *De Somnio Scipionis*, with the *Epistola ad Gerbertum Papam* by Adelbold, Bishop of Utrecht. Manuscript on vellum, the commentary illustrated with six coloured and two uncoloured diagrams, the letter with four uncoloured diagrams, [France, early 12th century].
London £13,000 ($31,200). 30.XI.71. From the collection of the late Sir Thomas Phillipps Bt. (1792–1872).

The author is considered to be one of the leading authorities of his time on astronomy and geography. He helped to maintain the belief that the world was round, and was an influence on future map makers. The diagram reproduced here includes the Mediterranean (*nostrum mare*), The Caspian (*caspium*) and the Indian or Red Sea (*indicum quod et rubrum*).

TOBIAS ALSTON
Autograph Poetical
Commonplace Book,
[*c*.1639].
London £3,800 ($9,500).
27.VI.72.

From the collection of
Dr. Mary Pickford.
The commonplace book is
important for the large
number of poems by Robert
Herrick that it contains,
together with verse by other
celebrated poets of the
period, and a hitherto
unknown masque written
for a visit by James I to the
house of Sir John Crofts at
Little Saxham, Suffolk.

MARTIN LUTHER
Autograph letter to Johann
Lang, prior of the Erfurt
Augustinians,
[25 July] 1520.
New York $10,500 (£4,200).
28.III.72.

The recipient was Luther's
great friend and supporter.

THOMAS WEELKES
Autograph manuscript of
the quintus part for
*Sir: frances Steward, his
Canzonett.*
New York $4,750 (£1,900).
28.III.72.

Below:
CLAUDE DEBUSSY
Detail of the autograph
manuscript of the
composer's orchestral
arrangements of the first
and third *Gymnopédies* by
Eric Satie, with fair copies
in the latter's hand
containing a few directions
by Debussy, inscribed at
the end of each arrangement
by Debussy to Satie.
London £2,400 ($6,000).
8.V.72.

E was an Eagle
So grand and so regal,
Who sate on some rocks
And siezed on the flocks.
E!
Fly away Eagle!

EDWARD LEAR
Autograph manuscript for a pictorial nonsense alphabet [c.1860].
London £750 ($1,875). 14.iii.72.

DR JOHN COVEL
Autograph natural history field note-book, illustrated with many pen
and ink drawings of plants, insects, birds, fish, etc., 1660–1713.
London £3,000 ($7,500). 29.xi.71.

Although well-known to other naturalists of his day, Covel's note-book
remained unrecognised from the time of his death, and was only
identified when submitted to Sotheby's for sale. It contains the earliest
scientific descriptions of some of the flora and fauna of the Near East,
as well as recording observations and dissections made by Covel in this
country.

SARAH JOSEPHA HALE
Autograph manuscript of *Mary's Lamb*, together with a piece of wool from the lamb, and letters authenticating both the poem and the wool.
New York $5,000 (£2,000). 11.IV.72.

JOHN KEATS
Autograph letter to his brothers, postmarked 16 April 1817.
London £11,000 ($27,500). 27.VI.72.

From the collection of Mrs Madeleine Buxton Holmes.
This important letter was written by Keats on his first expedition undertaken entirely alone. He was travelling to the Isle of Wight, taking with him the recently started *Endymion*.

CHARLES DICKENS
Autograph manuscript for the first 22 pages of chapter xv of *Nicholas Nickleby*.
London £12,000 ($30,000). 23.xi.71.
From the collection of the late Comte Alain de Suzannet.

CHARLOTTE BRONTË
The autograph manuscript for *The Evening Walk. A Poem by the Marquis of Douro*.
London £4,000 ($10,000). 27.vi.72.

The manuscript, one of several made in miniature format, is the first in which the author used the pseudonym Marquis of Douro. It is illustrated here full-size, together with the Dutch filigree binding in which it is fitted.

JOHN WOTTON
Speculum Christiani.
First edition, printed in London by William de
Machlinia for Henry Frankenberg, [c.1486]
London £6,500 ($16,250). 27.III.72.

The book contains a considerable section of English
verse, and is one of the few with English text printed by
Machlinia.

GEOFFREY CHAUCER
A treatise on the Astrolabe.
Manuscript on vellum,
[England, middle of the 15th century].
London £8,500 ($20,400). 9.XI.71.

From the collection of Boies Penrose, Esq, F.S.A., F.R.G.S.

Hours of the Virgin (use of Besançon).
Printed on vellum with 14 full-page and four slightly
smaller woodcuts, Paris, [Antoine Chappiel] for Simon
Vostre, [*c*.1512].
London £1,600 ($4,000). 5.x.71.

GUILELMUS CAORSIN
Obsidionis Rhodiae Urbis Descriptio, and other tracts.
First collected edition, illustrated with 36 full-page
woodcuts, Ulm, Johann Reger, 24 October 1496.
London £1,700 ($4,250). 4.x.71.

Nebiïm Rishonim [Former Prophets] : Joshua, Judges,
Samuel, Kings.
Leiria, [Samuel Dortas], January 1494.
New York $11,000 (£4,400). 30.V.72.

The ninth German Bible.
2 vol. in I, 109 large woodcuts coloured by a contemporary
hand, in a 16th century binding of blind-stamped vellum over
oak boards, Nuremberg, A. Koberger, 17 February 1483.
London £3,400 ($8,500). 22.II.72.

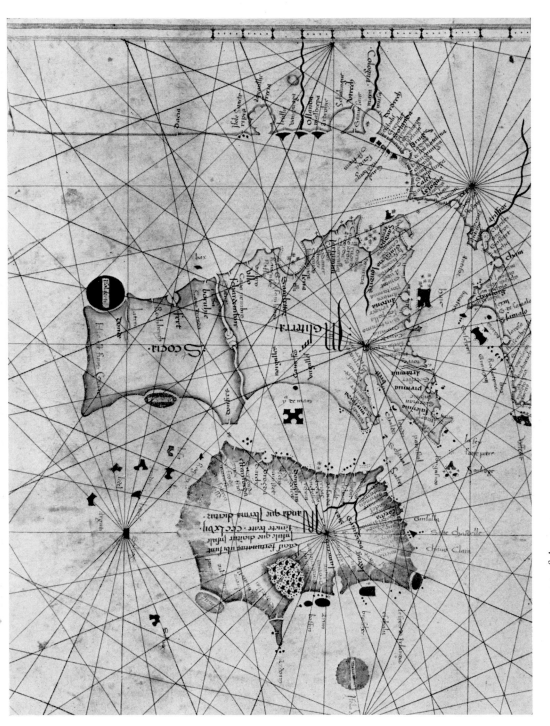

GRAZIOSO BENINCASA of Ancona
Portolan Chart of Western Europe and North-West Africa.
A richly coloured manuscript map on vellum, Venice 1468.
London £5,000 ($12,000). 8.XI.71.

From the collection of Boies Penrose, Esq., F.S.A., F.R.G.S. This is the only known example of a single map of a particular area, apparently made for practical use. The illustration shows only the portion covering the British Isles and the coast of Europe. Benincasa is the most celebrated of all portolan cartographers.

enough to hold his trap. Like the damned fool that he was he goes to the police station and registers a complaint. A week later, while he's sitting on a bench snoozing, a gang of roughnecks break into the place and they beat him to a pulp. His head was so ~~was~~ smashed in that his brains looked like an omelette. ~~As a~~ good measure they emptied the safe and turned it upside down. Dave died on the way to the hospital. They found five hundred dollars hidden away in the toe of his sock. Then there was ~~Candies, Herman~~ and ^Lena. They came in together when he applied for the job. Lena had a baby in her arms and he had two little ones by the hand. They were sent to me by some relief agency. I put him on as a night messenger so that he'd have a fixed salary. In a few days I had a letter from him, a batty letter in which he asked me to excuse him for being absent as he had to report to his parole officer. Then another letter saying that his wife had refused to sleep with him because she didn't want any more babies and would I please come to see them and try to persuade her to sleep with him.

I went to his home--~~it was~~ a cellar in the Italian quarter. ~~and~~ seven months under way, and on the verge of idiocy. She had taken to sleeping on the roof because it was too hot in the cellar, and because she didn't want him to touch her any more. when I said it didn't make any difference now she looked at me and grinned. ~~Candies~~ had been in the war and ~~made~~ the gas had made him a bit goofy--at any rate he was foaming at the mouth. He said he would brain her if she didn't stay off that roof. ~~Besides~~ he insinuated that she was sleeping up there so that she could carry on with the coal man who lived in the attic. Lena smiled again with that mirthless batrachian

Tropic of Capricorn, carbon copy of the author's typescript with autograph corrections and revisions.

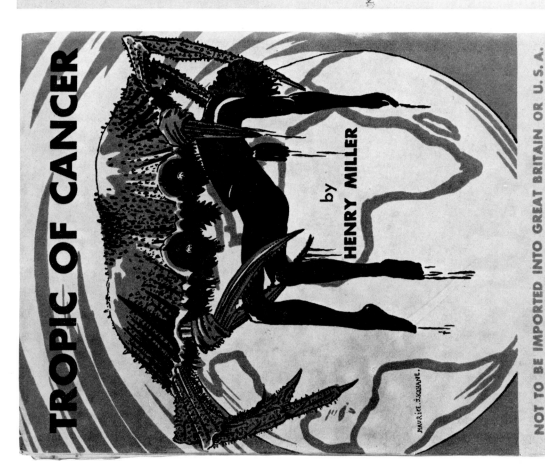

Tropic of Cancer, first edition, Paris, 1934.

Henry Miller's Tropic of Cancer and Tropic of Capricorn

BY MICHAEL HESELTINE

Henry Miller is among the best-known of all contemporary writers, yet his work seldom appears in the London salerooms. However, this season Sotheby's have sold a first edition of *Tropic of Cancer*, as well as several other books by him, and a carbon copy of his typescript for *Tropic of Capricorn*.

Tropic of Cancer was the first book by Miller to be printed although he had written others earlier. It was published by Jack Kahane at the Obelisk Press, and was financed by Anaïs Nin, who wrote the preface. Other authors published by Kahane included Lawrence Durrell and Cyril Connolly who, with Miller, raised the literary level of books from the press. They were all issued as paperbacks and have rarely survived in the excellent condition of the copy of the *Tropic of Cancer* sold in May for £450. The typescript sold for £1,100 and these prices indicate the secure position Miller holds in 20th century literature. The two *Tropics* are among the most outstanding autobiographical works ever written. Miller's concern for humanity, particularly in the cities, has only been equalled by the present interest in environment and ecology. The more salacious passages helped to prepare the way for greater freedom in literature, the theatre, and the cinema.

Tropic of Cancer records Miller's life in Paris during his struggle for success as a writer. In *Tropic of Capricorn* he reverts to his years as a child and young man in New York. The typescript contains a considerable amount of autograph revision, together with passages of varying length which have been deleted, some of which further indicate his bitterness for the inhumanity of New York, and the effect of modern society on the individual: 'If I had never known another life I might well imagine myself to be insane. But though there is misery and suffering everywhere in the world, even in the glad, lazy, warm places, there are no streets, that I can say, which are as ugly and empty, as sordid and sinister as the American street.'

One of the most important features of the typescript are the names of the people portrayed. When writing the book Miller used the real names of these people, and then went through this copy substituting pseudonyms for forty-four characters. Some were little more than casual acquaintances, but a number were his close friends. Two of the women are almost certainly his second wife, to whom the book is dedicated. Her christian names June Edith were given one to each of two characters before the pseudonyms 'Mara' and 'Yeta' were adopted.

'Ulric', who appears briefly towards the beginning of the book, was probably the most important of the characters in real life. He was, in fact, Emil Schnellock, whom Miller considered to be his best friend. They maintained a steady correspondence, some of which was subsequently published. Schnellock had returned from Europe to America as a young man, and his enthusiasm for the old world was a major influence on Miller. In *Tropic of Capricorn* Miller writes: 'Those nights discussing Europe in Prospect Park with my old friend Ulric are responsible, more than anything else, for my being here in Paris today.' They were also responsible for the genesis of *Tropic of Cancer* and *Tropic of Capricorn*, which in turn established Miller's reputation.

Tropic of Capricorn was first published in Great Britain by Calder and Boyars in 1963.

VESPASIANO AMPHIAREO
Un Novo Modo d'Insegnar a Scrivere et Formar Lettere de Piu Sorti.
First edition, with 85 woodcuts, Venice, 1548.
London £650 ($1,625). 27.III.72.

CASPAR BRYNNER
Kurze Ordnung artlicher kunstlicher und wolproportionierter Teutscher und Latinischer Zierschriften.
Manuscript on vellum, comprising title page, preface, five pages showing the formation of letters, and thirty-nine pages of examples, with later additions, Augsburg, 1573.
London £1,600 ($4,000). 27.III.72.

Oexercicio, e Louvor
e as Letras, que o mundo acclama
tem na Nobreza o melhor
berço, a que illustra a jama,
por mais sagrado esplendor.

Andrade

MANOEL DE ANDRADE DE FIGUEIREDO. *Nova Escola para Aprender a Ler Escrever, e Contar.*
First edition, with engraved frontispiece, portrait and 45 plates, Lisbon [1722].
London £320 ($800). 27.iii.72.
The three books are from the fine collection of calligraphic books and manuscripts
formed by Mrs E. F. Hutton of New York City.

PAUL SANDBY MUNN

Theatrical maquettes for the pantomime *Omai, or a Trip Round the World* by J. O'Keefe, and other plays, one dated April 1787.
London £1,400 ($3,500). 9.v.72.
Omai, based on Captain Cook's voyages, was first performed at Covent Garden in 1785. The maquettes were possibly made for a toy theatre, and include various special effects such as erupting volcanoes with molten lava flowing down the slopes. The artist was about 14 years old when the maquettes were made, and was instructed in painting by his godfather Paul Sandby.

A pictorial catalogue of wooden toys issued by Rau & Co. of Nuremberg, [c.1859]
London £600 ($1,500). 14.III.72.
The catalogue illustrates hundreds of toys including model trains, Noah's Arks, toy soldiers, model villages, markets, zoos, and farms, whistles, popguns, and mechanical toys.

FREDERIC, COMTE DE WALDECK
Voyage Pittoresque et Archeologique dans la Province d'Yucatan (Amerique Centrale) pendant les années 1834 et 1836.
Engraved map and 20 lithographed plates, Paris and London, 1838.
London £850 ($2,125) 26.IV.72

PERCY BYSSHE SHELLEY
Posthumous Poems, 1824.
In a jewelled binding by Sangorski and Sutcliffe incorporating various coloured leathers, emeralds, amethysts, turquoises and opals.
New York $2,700 (£1,080) 16.V.72

G. D. EHRET
Plantae et Papiliones Rariores Depictae.
15 hand-coloured plates, 1748–59.
London £1,300 ($3,250). 27.iii.72.

GEORGE BROOKSHAW
*Pomona Britannica, or a collection of the most esteemed fruits
at present cultivated in this country.*
87 plates (of 90) printed in colour and finished by hand,
[1804]–12.
New York $4,250 (£1,700). 16.v.72.

F. LEVAILLANT
Histoire Naturelle des Perroquets.
2 vol., 145 plates printed in colour and finished by hand,
Paris, 1801–5.
London £3,000 ($7,500). 26.vi.72.
From the collection of Chetham's Library, Manchester.

JOHN JAMES AUDUBON
The Birds of America from Original Drawings.
4 vol., 435 engraved plates coloured by hand, Edinburgh
1827 and London 1827–38.
London £62,000 ($155,000). 26.vi.72.
From the collection of Chetham's Library, Manchester.

Charles Dickens
His Reading Book
To H. M. Ticknor, 25th April, 1868.

MRS. GAMP.

BY

CHARLES DICKENS.

AS CONDENSED BY HIMSELF, FOR HIS

READINGS.

WITH AN ILLUSTRATION BY S. EYTINGE, JR.

BOSTON:

TICKNOR AND FIELDS.
1868.

Left: GEORGE GORDON NOEL, LORD BYRON *A Sketch from Private Life*, 1816.
London £2,400 ($6,000). 26.VI.72.
The very rare first edition. Of the 50 copies printed only a few are known to have survived.

Right: CHARLES DICKENS *Mrs. Gamp as condensed by himself for his Readings*, Boston, 1868.
London £3,600 ($10,250). 22.XI.72.
From the collection of the late Comte Alain de Suzannet.
This copy was used by Dickens at his last readings in Boston, and contains numerous autograph corrections, additions, and underlinings. It was afterwards presented by Dickens to his publisher in Boston, H. M. Ticknor.

SKETCH FROM PRIVATE LIFE.

March 30, 1816.

"Honest—Honest Iago!
"If that thou be'st a devil, I cannot kill thee."
Shakspeare.

BORN in the garret, in the kitchen bred,
Promoted thence to deck her mistress' head;
Next—for some gracious service unexprest,
And from its wages only to be guess'd—
Rais'd from the toilet to the table,—where
Her wondering betters wait behind her chair.
With eye unmoved, and forehead unabash'd,
She dines from off the plate she lately wash'd.
Quick with the tale, and ready with the lie— 10
The genial confidante, and general spy—
Who could, ye gods! her next employment guess—
An only infant's earliest governess!
She taught the child to read, and taught so well,
That she herself, by teaching, learn'd to spell.
An adept next in penmanship she grows,
As many a nameless slander deftly shows;
What she had made the pupil of her art,
None know—but that high Soul secur'd the heart,
And panted for the truth it could not hear, 20
With longing breast and undeluded ear.

Foil'd was perversion by that youthful mind,
Which Flattery fool'd not—Baseness could not blind,

PAUL GAUGUIN *Le Sourire*.
Duplicated periodical written and illustrated by Gauguin with drawings and woodcuts. Tahiti, 1900–01.
London £9,000 ($22,500) 3.VII.72.
This set of the satirical magazine by Gauguin was specially prepared for his friend Georges-Daniel de Monfried. The first six issues were written out by hand, and the set specially bound in Tahitian fabric with two extra woodcuts.

WILLIAM BLAKE
The Book of Thel.
8 plates printed in golden brown, painted with light watercolour washes, 1789.
New York $21,000 (£8,400) 19.x.71.

Oriental Manuscripts and Miniatures

BY TOBY FALK

A most unusual sale on 11th April was that of the Dent collection which consisted of miniatures brought from India in the second half of the eighteenth century by an ancestor of Sir Robert A. W. Dent, probably by one of the Dent brothers in the painting by Arthur W. Devis described in Mildred Archer's article (p.80). The collection gave particular insight into the range of miniatures available to the British who were in India at the time, and the group had remained intact in the possession of the family ever since. While many of the pictures were examples of eighteenth-century painting that would have been readily obtainable, others were outstanding samples from earlier periods. Of these, the portrait of Shāh Abūl Ma'ālī signed by the artist Ustād Dūst Musawwir was of special importance. This Persian artist is recorded in a sixteenth-century Persian treatise as having left the country for India, but hitherto there has been no direct evidence of his presence in India. The signature gives the title of the patron, the second Mughal emperor Humayun, and this confirms conclusively that Ustād Dūst Musawwir was one of the key Persian artists involved in the foundation of the Mughal style. Examples of this style at its best are four illustrations from an *Akbarnāma* of *circa* 1600–10 (the major part of this manuscript is now in the Chester Beatty Library, Dublin) which have been sold in London and New York for $7,500, $9,750, £4,000 and £1,500. The celebrations taking place in the page illustrated in colour are probably the result of a royal birth: the girls of the palace dance while in the foreground coins are handed out to the local poor.

Another skilled Persian artist who travelled to Mughal India was Farrokh Beg. His style was particularly influenced by his visit to the Deccan early in the seventeenth century, which explains the unrealistic but extremely decorative quality of his portrait of a youth holding a sprig of narcissus (£3,800).

It is unusual for a miniature from one of the Rajasthani states to attract as much attention as its Mughal counterpart, but the eighteenth-century Kotah picture of an elephant hunt achieved this fame. While the works of certain modern European artists have been compared quite favourably with this style, the extraordinarily life-like and active pictures produced by a few inspired artists at Kotah in the eighteenth century have never really been equalled in Europe or India.

A series of eleven Persian illustrations to a manuscript of Firdausī's *Shāhnāma* copied in A.D. 1493–4 for Sultān Mīrzā 'Alī of Gīlān (1478–1504) were sold for a total of £8,340. The one illustrated shows the hero Gurāza leading away the body of his victim Siyāmak, and it displays very well the powerful portrayals of horrific incidents that are to be found in this manuscript.

Opposite page: *A celebration in the women's quarters of a palace.*
An illustration from a manuscript of the *Akbarnāma* by Abu'l Fazl. Mughal, *circa* 1600–10. 213 mm. by 133 mm.
London £4,000 ($10,000). 7.XII.71.

An elephant hunt taking place in a wooded landscape by a river.
Kotah, *circa* 1770–80. 460 mm. by 510 mm.
London £5,500 ($13,750). 7.XII. 71.

A portrait of Shāh Abūl Ma'ālī. Painted by Ustād Dūst Musawwir. Mughal, *circa* 1550–60.
144 mm. by 172 mm.
London £6,000 ($15,000). 11.IV.72.
From the collection of Sir Robert A. W. Dent, C.B.

Gurāza leading away the body of Siyāmak whom he has slain in the battle of the Twelve Rukhs.
An illustration from a manuscript of the *Shāhnāma* by Firdausī. Persia, Gīlān, *circa* 1493–94.
233 mm. by 152 mm.
London £1,700 ($4,250). 11.VII.72.

A portrait of a youth holding a sprig of narcissus.
Painted by Farrokh Beg. Mughal, *circa* 1605–15. 159 mm. by 82 mm.
London £3,800 ($9,500). 11.IV.72.

Antiquities and Primitive Art

Some magnificent Classical, Egyptian, Pre-Columbian and African antiquities were sold by the Cranbrook Academy of Art at Parke-Bernet in May, many of which were purchased by leading American museums. A splendid 27th dynasty Egyptian stone figure of a man, of hieratic pose, was bought by the Carnegie Institute for $16,000 (£6,400), the magnificent blue faience sphinx of Amenhotep III for a world record $260,000 (£104,000) by the Metropolitan Museum of Art. This object was unquestionably the finest example of Egyptian art to have appeared at auction since the war, it dates from the 18th dynasty, *circa* 1410–1320 B.C., and at one time had been in the collection of Howard Carter, the great British archeologist and discoverer of the tomb of Tutankhamun. The Metropolitan also purchased a bronze group of Isis and Horus, dating from around the 25th to the 26th dynasty, for $2,400 (£960).

Another superb sculpture was the late 18th or early 19th dynasty figure of Amun, which was sold for $55,000 (£22,000). In fact, this piece depicts the god through the likeness of a reigning Pharaoh; one possibility is that it represents Tutankhamun, alternatively it may be Rameses II.

Among the classical antiquities in the Cranbrook collection, the most outstanding was an Attic grave stele erected to the memory of Philokydis, daughter of Aristokles and Timagora, of *circa* 360–350 B.C., which realised $155,000 (£62,000), the highest price paid at auction for a work of art from this civilisation. Grave stelae of this period are rare enough in any condition, and particularly in the almost pristine state of this example.

Not surprisingly, the Cranbrook collection was rich in Pre-Columbian works of art. A Honduras stone figure of *circa* 500–100 B.C.

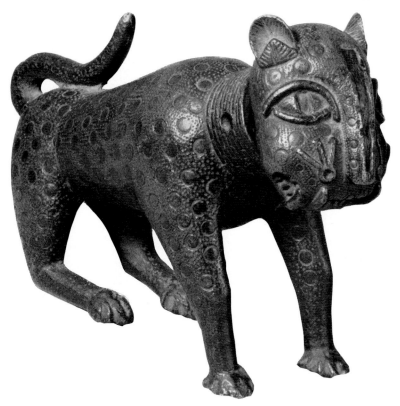

A Benin bronze bottle in the
form of a crouching figure of a
leopard. 5½ in.
London £4,200 ($10,500).
11.VII.72.

realised $7,300 (£2,920); a carved stone vessel, from the same country but dated about
A.D.900–1000, fetched $23,000 (£9,200); this had at one time been in the collection of
the sculptor Prince Pierre Troubetzkoy. An extremely handsome Columbian gold
pendant depicting an anthropomorphic deity, circa A.D.1000–1500, fetched $26,000
(£10,400), while a smaller pendant of the same period from Peru was sold for $6,000
(£2,400).

African bronze and ivory sculptures of great importance have been sold in both
London and New York. The Cranbrook collection included a very rare Afro-Portu-
guese ivory saltcellar, bought by the Metropolitan Museum for $32,500 (£13,000); in
London, a 16th century Benin bronze head of an Oba of a most unusual form fetched
£29,000 ($72,500), the auction record for any African work of art. The London sale
in July included some fine Benin bronzes, the most impressive of which was a group
of a warrior on horseback, which was sold on behalf of Harrow School for £18,000
($45,000); about fifteen of these groups are known to exist, they are thought by some
scholars to represent Moslem horsemen from the north.

Opposite page:
An early Benin bronze head of an Oba.
16th century A.D. Height 20 in.
London £29,000 ($72,500). 7.XII.71.
From the collection of Frau Maria
Fischer and Herr Bernd Fischer.

1. Tibetan medical diagram. 19th C. 18 in. by 20 in. £500 ($1,250). 15.v.72. **2.** Benin bronze gaming piece. 2⅝ in. £2,000 ($5,000). 11.vii.72. **3.** Benin ivory bracelet £1,000 ($2,500). 11.vii.72. **4.** Detail of an 18th C. Tibetan tanka, 34¼ in. by 65½ in. £1,400 ($3,500). 11.vii.72. **5.** Babylonian pottery barrel cylinder, reign of Nebuchadnezzar II, 604–562 B.C. Height 8¼ in. $8,000 (£3,200). 4.v.72. **6.** Rayy pottery pitcher, late 12th-early 13th C. 7½ in. £440 ($1,100). 15.v.72. **7.** Byzantine bronze steelyard weight, Anatolia 5th–6th. C. A.D. Height 9 in. £1,050 ($2,625). 10.vii.72. **8.** Byzantine bronze grain measure *circa* 6th C. A.D. Height 5¼ in. £1,250 ($3,125). 6.xii.71. **9.** A Gandhara grey schist figure of a Bodhisattva. 3rd–4th C. A.D. Height 26⅛ in. £2,300 ($5,750). 11.vii.72. **10.** Pala bronze figure of Buddha. 9th–10th C. Height 7⅛ in. £3,200 ($8,000). 11.vii.72. **11.** Tibetan gilt-bronze figure of the Dhyanibodhisattva Aryavalokitesvara, 18th C. Height 39⅜ in. £2,200 ($5,500). 11.vii.72. **12.** South Indian bronze figure of Vishnu. 10th C. 8½ in. £1,100 ($2,750). 11.vii.72.

A Benin bronze group of a warrior on horseback. Height 23½ in.
London £18,000 ($45,000). 11.VII.72.

From the collection of the Governors of Harrow School.
The group was presented to Harrow School in 1927, by the widow of Mr. J. F. Moseley, in memory of her husband, who was at the school from 1879–81 and died in 1926.
A plaque on the wood socle reads 'Taken from the sacrificial house in the City of Benin, by the Officers of the Benin Punitive Expedition, February, 1897.'

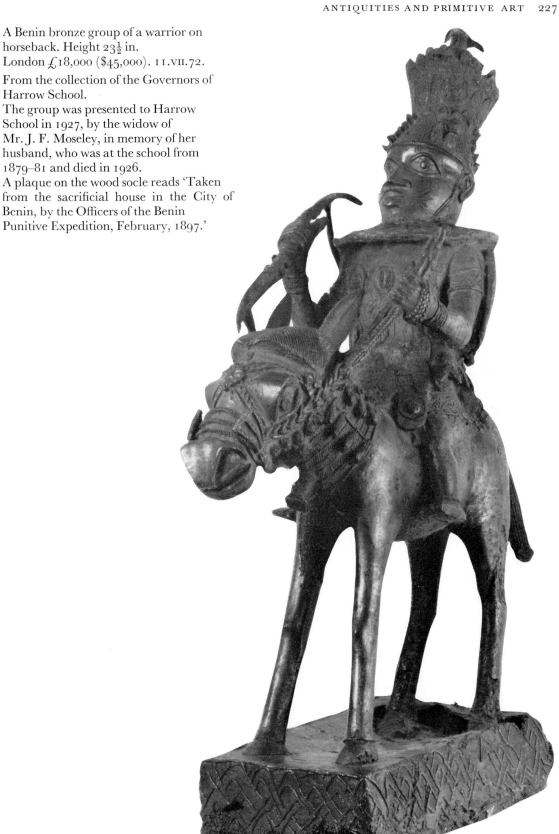

1. Roman marble torso of a hermaphrodite. *Circa* 2nd C. A.D. £2,400 ($6,000). 10.VII.72. **2.** Mid-18th Dynasty Egyptian buff quartzite statue of a Pharaoh. 14½ in. £1,300 ($3,250). 10.VII.72. **3.** Hellenistic bronze leg, *circa* 3rd–2nd C. B.C. 8¼ in. £480 ($1,200). 10.VII.72. **4.** Roman marble male torso, *circa* 2nd C. A.D. £3,000 ($7,500). 10.VII.72. **5.** Attic white ground lekythos *in the manner of the Woman Painter*, Revelstoke Group, *circa* 420 B.C. 20 in. £1,400 ($3,500). 10.VII.72. **6.** Roman stone head of Hercules, *circa* 2nd C. A.D. Height 9¾ in. $9,000 (£3,600). 4.V.72. **7.** Cypriot stone head of a Votary, *circa* 425–450 B.C. Height 15 in. $1,800 (£720). 5.XI.71. **8.** Egyptian stone figure of a man. 27th Dynasty. Height 22½ in. $16,000 (£6,400). 4.V.72. **9.** Hellenistic terracotta group of a warrior on horseback, *circa* 2nd C. B.C. 9½ in. £820 ($2,050). 10.VII.72. **10.** Egyptian bronze group of Isis and Horus, 25th–26th Dynasty. Height 8¼ in. $2,400 (£960). 4.V.72. **11.** Greek bronze figure of a priestess, Late 5th C. B.C. £1,600 ($4,000). 6.XII.71. **12.** Fragment of a Roman marble head of a woman, 3rd–4th C. A.D. £620 ($1,550). 10.VII.72.

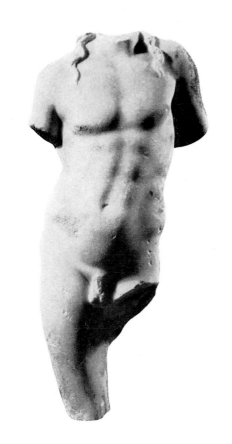

Left:
A Roman marble torso of Apollo, *circa* 100 B.C.–100 A.D. after a Greek model of the 4th century B.C. Height 33 in.
New York $11,000 (£4,400) 5.XI.71.

From the collection of the late R. A. McKinnon. Now in the Santa Barbara Museum of Art, California.

Right:
A Roman stone torso of a satyr, late 1st–early 2nd century A.D., after an Hellenistic model of the 3rd century B.C. Height 38½ in.
New York $13,000 (£5,200). 5.XII.71.

From the collection of the late R. A. McKinnon.

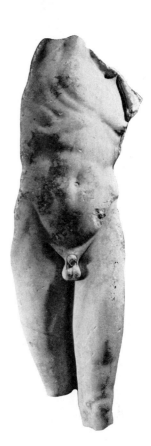

Left:
The Greek stone grave stele of Philokydis, daughter of Aristokles and Timagora. Attic, *circa* 360–350 B.C. Height 38¾ in.
New York $155,000 (£62,000). 4.V.72.

From the collection of the Cranbrook Academy of Art.

Right:
An Egyptian stone figure of Amun, thought to represent Tutankhamun or Rameses II. Late 18th–early 19th Dynasty. Height 33½ in.
New York $55,000 (£22,000) 4.V.72.

From the collection of the Cranbrook Academy of Art.

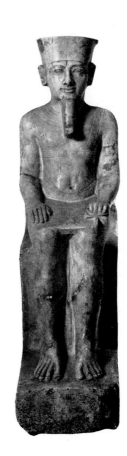

Above:
Honduran marble vessel
with openwork pedestal
base. Ulúa Valley, *circa*
900–1000 A.D. Diameter
6⅞ in.
New York $23,000 (£9,200).
4.V.72.

From the collection of the
Cranbrook Academy of Art.

Right:
An African Portuguese-
Bini ivory saltcellar.
Height 7 in.
New York $32,500 (£13,000).
4.V.72.

From the collection of the
Cranbrook Academy of Art.
Now in the Metropolitan
Museum of Art, New York.

A Navajo Indian woollen blanket. 70 in. by 59 in.
New York $3,600 (£1,440). 25.v.72.
From the Green Collection of American Indian Art.

A Panamanian gold pendant in the form of the figure of a frog. Veraguas Region, *circa* 800–1500 A.D. Length $4\frac{1}{4}$ in. New York $6,000 (£2,400). 4.V.72.

A dark green stone figure, possibly from Honduras, late Formative Period, *circa* 500–100 B.C. Height $12\frac{1}{8}$ in. New York $7,300 (£2,920). 4.V.72.

A Colombian gold pendant in the form of an anthropomorphic deity. Darien, *circa* 1000–1500 A.D. Height $7\frac{1}{4}$ in. New York $26,000 (£10,400). 4.V.72.

The objects illustrated on this page were part of the collections of the Cranbrook Academy of Art.

1. Pair Colombian gold nose ornaments. Tairona, *circa* 1000–1500 A.D. Width 2⅝ in. $2,400 (£960). 4.XII.71. 2. Woodlands Indian buckskin coat, of European style of George III period. £2,900 ($7,250). 11.VII.71. 3. Peruvian gold funerary mask. Chimu, *circa* 1000–1470 A.D. Length 16¼ in. $3,700 (£1,480). 4.XII.71. 4. Indian basketry vessel. Tulare. Diameter 20¼ in. $2,100 (£840). 19.XI.71. 5. Pomo Indian basketry and feathers vessel. Diameter 6½ in. $3,200 (£1,280). 19.XI.71. 6. Indian basketry vessel, by Dat-So-La-Lee, Washo. Diameter 13½ in. $6,100 (£2,440). 19.XI.71. 7. Sioux Indian hide dress. 64½ in. by 62 in. $3,300 (£1,320). 19.XI.71. 8. Plains

Indian scalp lock. Length 17½ in. $1,600 (£640). 19.XI.71. 9. Apache Indian basketry vessel. Diameter 23½ in. $1,600 (£640). 19.XI.71. 10. Southern Plains Indian hide dress. 53 in. by 41½ in. $3,600 (£1,440). 19.XI.71. 11. Peruvian pottery stirrup-spout vessel. Chavin, *circa* 800–400 B.C. Height 10 in. $2,300 (£920). 4.XII.71. 12. Hawaiian wood stick god. 14⅜ in. £5,000 ($12,500). 7.XII.71. 13. Baluba carved wood ceremonial axe. Height 12¼ in. £1,600 ($4,000). 11.VII.72. 14. Peruvian pottery vessel. Nazca, Middle–Late Period, *circa* 200–600 A.D. Height 9⅞ in. $2,500 (£1,000). 4.V.52.

An Arapaho Indian hide robe. 67 in. by 50½ in.
New York $4,600 (£1,840). 19.XI.71.
From the Green Collection of American Indian Art.

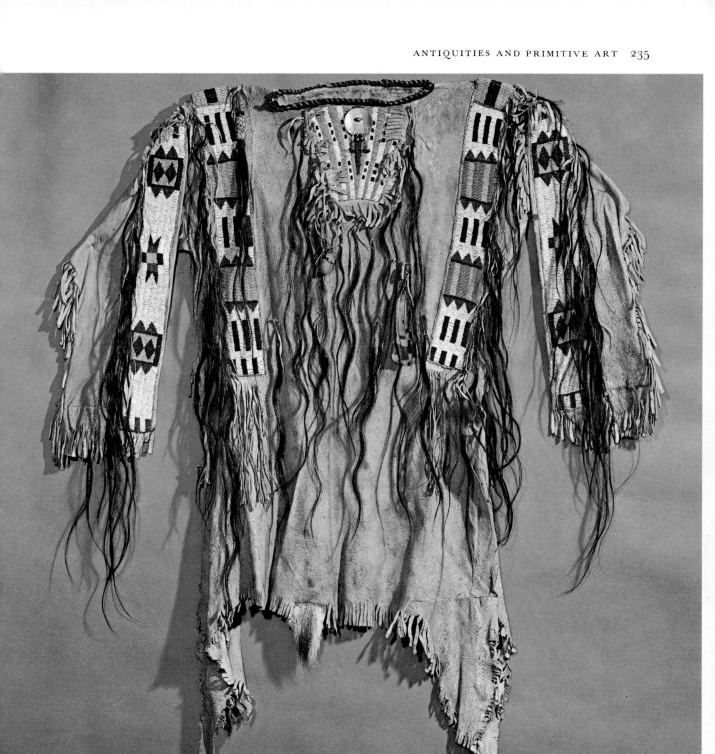

A Plains Indian hide scalp shirt. 44 in. by 64½ in.
New York $4,500 (£1,800). 19.XI.71.

From the Green Collection of American Indian Art.

Five years of the market in early Chinese porcelain (T'ang to Ming)

BY GERALD REITLINGER

This attempt to bring up to date a survey, published in *Art at Auction* in 1967, has not been simplified by the sale of a 14th-century wine jar or *kuan*, 13½ inches high, at Christie's on 5th June, 1972, for £220,500. The purchaser was a Japanese dealer and the jar, blue and white with mesh-work reliefs in underglaze red, very rare, very beautiful and very damaged. I recall its more perfect but paler-complexioned companion which now reposes in the David Foundation, when it was in Sotheby's rooms in 1933. Under an attribution to the early 16th century it then made a price unprecedented for blue and white, supposedly of the Ming period, namely £350. Thus the five years of my survey end with a mighty big question mark. The price of the *kuan* was considerably more than double that of any ceramic object on the postwar market, and more than ten times that of any European ceramic object. Does it indicate a new market for Oriental vases at prices which a dozen years ago were paid only for Cezanne, Rembrandt and Rubens? To those who think they are watching the kettle boil over I offer my usual tranquillizer, the time scale. In 1915 P. A. B. Widener paid a price which was probably not unique, namely $150,000 or £30,860 for a huge *famille noire* vase, now in the Metropolitan Museum. To calculate the 1972 equivalent one must multiply the Sterling figure by at least 10·5 – and this is an ultra-conservative estimate after three years' annual depreciation of the pound at the rate of twelve per cent and more. The resulting figure, £324,000, for the *famille noire* vase, suggests that the Japanese multi-millionaires, whose rivalries are said to determine the highest prices of the Oriental porcelain market, have still some way to go.

To obtain the measure of the Japanese impact on the market over the past five years, it is better to treat the sale of the £220,500 *kuan* as the beginning of the future rather than the end of the past. A truer scale of measurement can be reached by watching the progress of standard types. Glazed standing horses of the T'ang dynasty on a monumental scale are an instance. The largest size of all, 33¾ inches high, first passed the £2,000 barrier at a Cologne sale in 1966. In 1972 a horse of this size was sold by Parke-Bernet for $42,500 or £16,320, but a slightly better horse, 22½ inches high, had already made £33,000 at Sotheby's in 1971. Polo players riding at a flying gallop are not standard T'ang types but they show a similar progression, from £3,500 in 1964 to £28,000 in 1972. I do not believe that, since the war, these all but mass-produced grave-furnishings have regained the round-eyed admiration of the early years of the century when there were rhapsodists who did not hesitate to compare them with the horses of the Parthenon. That the price of a country house can be spent on a pottery horse, lacking still more in the qualities which appealed to the late Sir Alfred Munnings, is due to the fact that it is always the easily recognized which becomes *chic*, no matter where. Furthermore, it is precisely in the past five years that a sense of security has strengthened a once wobbly market through the availability of thermoluminescent tests. Between 1927 and 1948 it was almost impossible for a T'ang

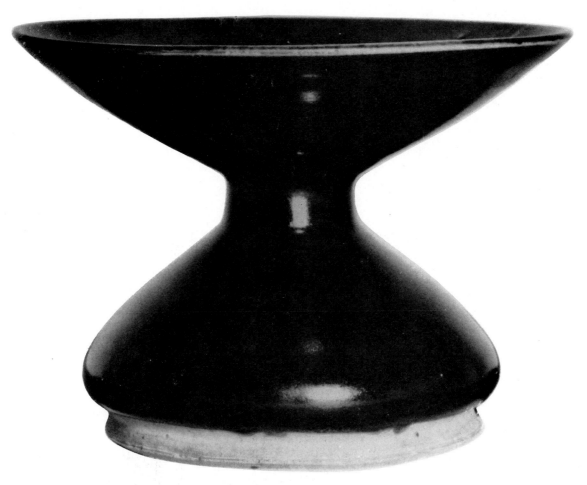

A brown-glazed Leys Jar (*cha tou*), with low conical body and wide flared mouth.
10th century A.D. Height 4⅜ in., diameter 6¼ in.
London £8,500 ($21,250). 14.III.72.
From the collections of the late Sir Herbert Ingram, Bt. and of Michael Ingram, Esq.

horse to make £100. By the end of 1970 T'ang horses were rivalled by oviform vases with patterns in coloured glazes, a 10-inch specimen reaching £28,000. Very much higher prices have been paid for T'ang wares. For instance, after a 12-inch ewer of metal shape with Sassanian affinities had been sold by Christie's in 1970 for £25,200, in 1972 another elaborate ewer was sold by a London dealer for £45,000.

Some may prefer the sensitivity of the smaller wine and food vessels of the T'ang dynasty which make smaller prices, but only relatively smaller, for in 1971–72 Sotheby's sold a 7½-inch plain blue potiche jar and a 4½-inch plain brown leys jar for £8,500 each. Extreme asceticism at a very high cost, which is still the basis of Japanese collecting taste in spite of its excesses, is to be found under the Sung dynasty rather than the T'ang. An example of the rare lavender *Ju* ware, a sort of bath on four feet known as a narcissus bowl, 8¾ inches wide, was sold by Sotheby's for £2,100 in 1959 and £46,000 in 1970. The smoke had scarcely cleared before Christie's opened the October season with a well-known octagonal ribbed bottle of the light grey-green *kuan* ware at £94,500. In 1903 it had been insured for £10, but in 1943 it was sold for

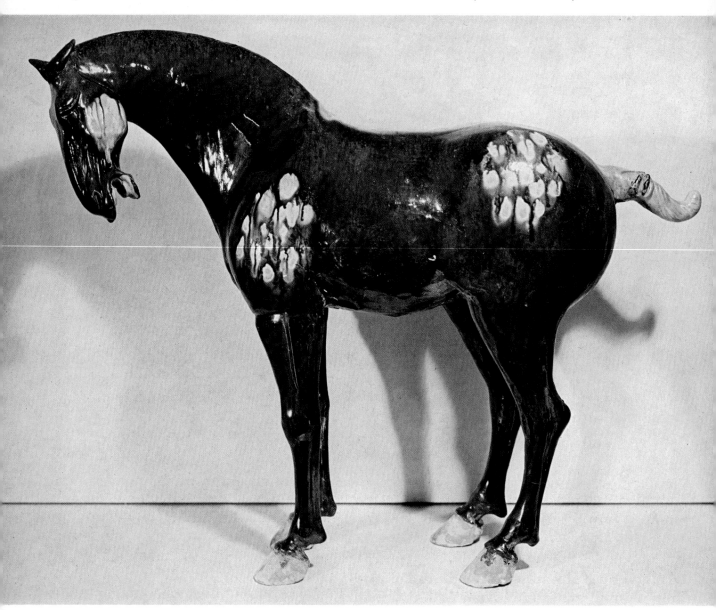

A glazed pottery figure of a Fereghan horse, the body covered with a rich chestnut glaze, the shoulders and hind quarters dappled in green, white and chestnut.
T'ang Dynasty. Height 22½ in., width 28 in.
London £33,000 ($82,500). 14.XII.72.

£550 and in 1953 for £2,400. Thus the unadorned and unspectacular Sung wares became the dearest ceramics in the world, a singular reversal of the early part of the century when the garish *famille noire* vases dominated the market. The veneration of the new Japanese collectors for the classic wares of the Sung period was in fact under-rated in 1970, for in the same sale an arrow vase of the *kuan* type, catalogued without an illustration as "18th century or earlier" overcame that handicap by making £22,050.

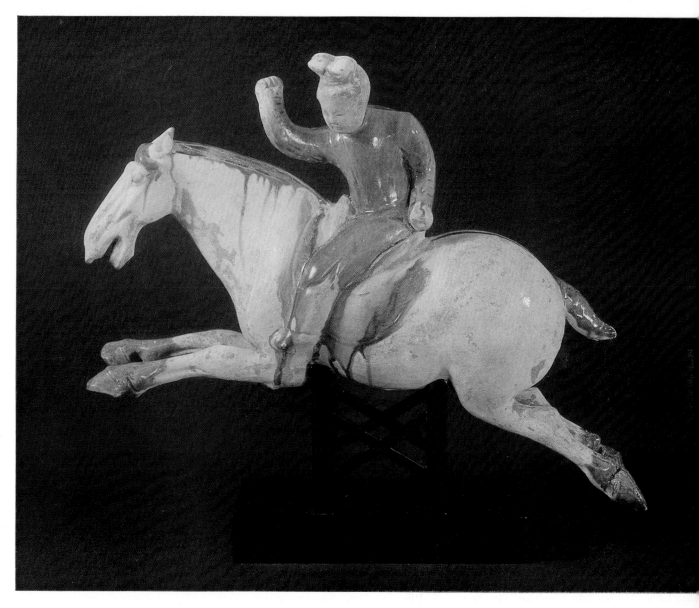

A glazed pottery figure of a polo player.
T'ang Dynasty. Length 15 in.
London £28,000 ($52,000). 14.III.72.

High prices for Sung wares began in the early 1920's with the purple-splashed Chün pieces with incised numerals. One of them, a small *jardinière* reached £1,890 at the Benson sale at Christie's in 1924, the equivalent of about £12,300 in 1972 money, but by the end of the 1940's this group fell out of favour and in 1953 a comparable *jardinière* cost the Bristol City Art Gallery £580. There was no recovery till 1967 when Parke-Bernet sold a 7¾-inch bowl for $5,000 (£2,085). Such a price for Chün ware

was not surpassed till March 1972, when Sotheby's sold a unique baler bowl with a loop handle from the Brodie Lodge Collection for £18,000. Against this there must be recorded the failure of an apparently new fashion to make headway. At the Fuller sale at Christie's in 1965 a small olive-green carved bowl of northern celadon ware made £8,190. Only five years had passed since these bowls had reached the thousand pound mark, but the feat was not repeated. Excellent examples have made £4,830 in 1970 and £4,200 in 1971, while in 1970 a much rarer 12-inch dish made £5,250.

A fairly standardised Sung ware, standardised enough at least to provide a general yardstick of appreciation, are the delicately incised white Ting bowls, a favourite class in the immediate post-war years. Though naturally varying in quality, the following are at least all on the $8\frac{1}{2}$ inch scale:

1931	£290	resold 1948	£860
1955	£340	resold 1966	£1,600
1957	£450	resold 1968	£6,500 (Sedgwick sale)
1955	£400	resold 1971	£9,500.

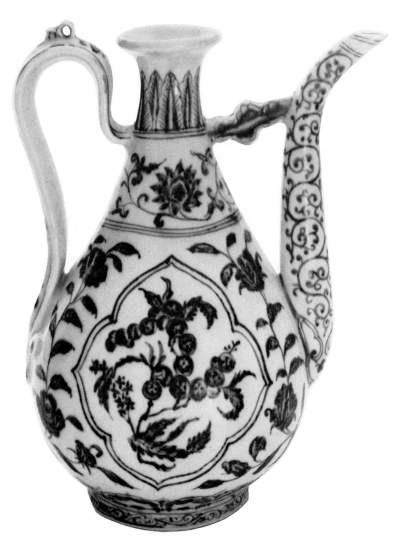

An early Ming blue and white ewer (*chih-hu*), of Near Eastern inspiration, the body painted in deep underglaze blue, each side with a quatrefoil panel flanked by sprays of peony, chrysanthemum and camellia.
Early 15th century. $10\frac{3}{4}$ in.
London £15,000 ($37,500).
14.III.72.

From the collection of
L. A. Basmadjieff, Esq.

The last was a cracked specimen. In the same year Mrs Alfred Clark's perfect and grander basin of the same diameter reached £49,000.

Early Ming porcelain, made between the mid-14th and early 16th centuries, has proved a continuously advancing market since the early 1950's. In my survey of 1967 I tabulated four groups of standard wares, but, being standard wares, they have not shared in the giddier flights of the past five years. It is even possible that they have not exceeded the general advance of all Chinese porcelain, which has been considerable. The most familiar class of early Ming blue and white, appearing in the sale rooms four or five times in some years, are the 15th century 'palace dishes', distinguished by their closely repeated designs, massive potting, unglazed bases and absence of reign-marks. Till June, 1967 the highest prices were £3,200 for a grape vine dish, £2,600 for a water plants dish and £2,600 for a dish with stylised flowers. In 1970 a dish of this last class, of the average size of 15 inch diameter, was sold at Sotheby's for £6,800, while in 1972 a 15¾-inch dish, painted with waterplants reached £9,500 and a miniature specimen, only 11 inch diameter, £6,200. There has not been a perfect example of the grape-vine pattern since 1969 when the David Foundation dish made £4,500. Presumably this too should now be worth more than £9,000. If so, the palace dishes as a class will have trebled their value in five years. Other standard types will not have done as well, for instance the late 15th and early 16th century blue and white dishes with enamelled yellow backgrounds. They average 8½ and 11½ inches diameter and bear the reign-marks of Hung Chih (1488–1505) and Chêng Tê (1506–22). A specimen of an exceptionally fine blue made £5,500 as early as 1962. Average specimens have made £5,700 in 1968 and £6,500 in 1971 as against £3,800 in 1966.

A standard class, though a very rare one, consists of blue and white bowls, only 5¾ inches in diameter, with the mark of Ch'êng Hua (1465–87) and beautiful meanders of narcissus, lily or iris. In 1967 I recorded the recent price of £16,500, paid at Sotheby's for the Herschel Johnson bowl. Another bowl of this kind made no more than £8,000 at the Sedgwick sale of 1968 but was resold by Sotheby's in 1972 for £18,000. After five years' depreciation of the pound this was a lower price than that paid in 1967 but there was a difference in quality. At the Eumorfopoulos sale of 1940 the two bowls made £36 and £24.

At the Sedgwick sale of 1968 there were other brisk advances in the value of early Ming blue and white. A rather prosaic early 16th century dish with an Arabic inscription and the mark of Chêng Tê had made £24 in 1940, £2,200 in 1962 and now reached £20,000. A famous and much admired 11½-inch dish with white fruit and flowers on a rich blue ground (mark of Hsüan Tê, 1426–35) rose from £775 in 1954 to £18,000, while a potiche jar, only 3½ inches high, with the mark of Ch'êng Hua made a price which still seems handsome, namely £9,000.

The two most impressive prices for early Ming blue and white in 1969 were paid outside England. Parke-Bernet sold a 10-inch saucer with a single peony spray and the mark of Hsüan Tê for $40,000 (£16,665). In Tokyo Christie's sold a richly decorated 14th-century kuan, 14½ inches high, for 22 million Yen or £25,699. The comparable kuan in the British Museum had cost almost exactly a tenth in 1960, but the present value of such a piece must be affected by the £220,500 'umbrella stand' of 1972 in spite of the strikingly different style of decoration. Another fine 14th century piece,

a potiche jar painted with swimming fish, made £16,225 at Christie's in 1970, although smaller (10½ inches high) and very badly damaged.

The year 1971 saw what remains for the moment the dearest piece of blue and white on the post-war market, an extremely pretty stem-cup, 8½ inches high, with the mark of Hsüan Tê, which Sotheby's sold for £44,000. If on the one hand a single cup made the price of a magnificent collection of much earlier Islamic pottery, on the other hand it was not the dearest piece of blue and white. The Huth 'blue hawthorn' vase, an early 18th-century ginger jar and cover in a conventional design of no historic or special aesthetic interest, made £5,900 in 1905, the equivalent of £62,000 in the money of 1971.

On the 14th March 1972, early Ming blue and white had to face the severest of saleroom tests, the return of a number of highly-priced pieces, acquired in recent sales. In addition to the Sedgwick Ch'êng Hua bowl which Sotheby's sold for £18,000 there was a well-known Hsüan Tê marked potiche jar, painted with lion-dogs, which rose from £5,000 in 1968 (£2,100 in 1964) to £14,500. An unmarked 15th-century ewer of standard Islamic shape rose from £11,000 in 1969 to £15,000. Almost exactly the same price had been paid in Tokyo in 1970 for a ewer of this kind with only an incised decoration on the bluish white ground. In general, however, monochrome early Ming pieces do not make as much as blue and white with sound reign-marks. A quite exceptional price, paid in 1972, was £5,200 for a white 6¼-inch bowl with the mark of Hung Chih (1488–1505).

Among polychrome enamelled Ming wares the miniature pieces of the reign of Ch'êng Hua (1465–87) in *tou ts'ai* or soft enamels are the most sought after. My 1967 survey included a cup, 2 inches high, in the Aykroyd sale at £6,000. In 1968 a 'chicken cup', 3¼ inches in diameter, made £3,500 at the Sedgwick sale to rise to £14,000 in 1971, a remarkable advance even for three inflationary years and an indication that few others are expected to reach the market. Of a very different category was a 15½-inch double-gourd vase in the early 16th century *kinrandé* style. The coarse and rather ugly design includes gilding on iron-red panels. The price at Sotheby's Tokyo sale of 1969 was 23 million yen or £27,380, though a very similar vase had been sold by Sotheby's in London in 1963 for £1,700. This class of enamelled ware has a special appeal in Japan. It may be on account of the sentimental interest of similar pieces, long preserved in the country – or is it just another facet of the unpredictable Japanese taste?

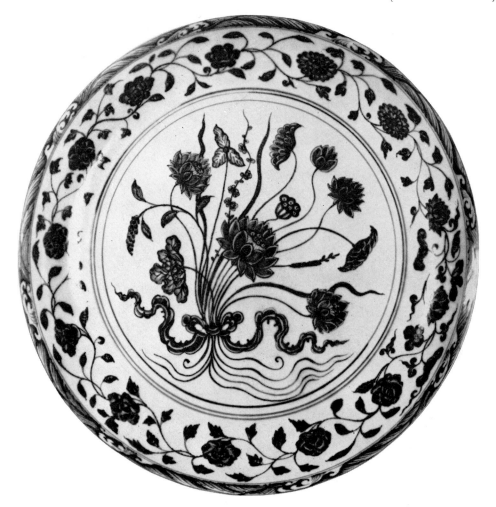

Above: A blue and white saucer dish painted in underglaze blue with lotus flowers and pods and other aquatic plants. Early 15th century. 15¾ in.
London £9,500 ($23,750). 14.III.72.

From the collection of L. A. Basmadjieff, Esq.

Left: A blue and white Potiche (*kuan*) painted with two Buddhist lions. Six-character mark of Hsüan Tê within a double circle. 15th century. Height 7½ in., width 8½ in.
London £14,500 ($36,250). 14.III.72.

From the collection of L. A. Basmadjieff, Esq.

The D. David-Weill Collection

The Chinese works of art sold in February from the collection of the late M. David-Weill included perhaps the most interesting group of bronzes, jades and silver to appear in the sale-room since the Burnet sale in 1940. Among the archaic bronzes the classical Shang vessel shapes were almost unrepresented but there were numerous pieces dating from Early Chou (9th century B.C.) to Han (206 B.C. to A.D. 220), many of types which are now almost never seen on the market.

The human figure, seldom represented in early Chinese art, appeared on a pair of lynch pins (£4,400), from the axle-caps of an early Chou chariot, each cast with a small naked figure crouching over an animal head, recalling the subject of the Shang vessel from the Sumitomo Collection which shows a human figure in the clutches of a monster. Another figure formed the knop of a square, roof-shaped cover (£4,000), perhaps originally belonging to a large 9th century *fang lei*. Also of great rarity was a kneeling bronze man (£11,000) from Than Hoa, a Han colonial site now in North Vietnam, excavated by Olav Janse in the 1930s. Unlike a thinly cast ring-shaped hanging lamp (£2,200) with a similar rich green and blue patina, which had been obtained from Janse's excavations by M. David-Weill, the figure was not documented.

The Warring States period was well represented by a lock (£6,200), the exact use of which remains mysterious, cast in intricate detail with dragons, and by a beaker (£7,500) of elegant, tall, slightly tapered shape, richly inlaid in silver with stylised birds. The collection also included a good group of bronze mirrors which show the development of late Chou and early Han decorative motifs, thus providing a useful reference for other objects; also a group of Shang and Chou bronze weapons. The mirrors each made between £40 and £1,400, and the weapons were in a similar price range.

An engraved silver cup repoussé with petal-shaped panels.
T'ang Dynasty. Height 2⅛ in., width 2¾ in.
London £14,000 ($23,000). 29.II.72.

From the D. David-Weill collection

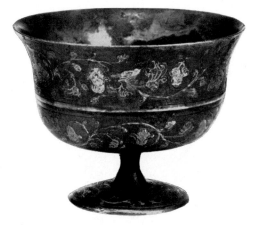

A silver stemcup, engraved with continuous stylised lotus meanders and small songbirds.
T'ang Dynasty. 3⅛ in.
London £5,000 ($12,500). 29.II.72.

Among the Han pieces was a large naturalistic gilt bronze bear (£15,000) and a set of gilt mask handles and studs from a coffin (£2,400). Of slightly earlier date was an elaborate and unusually large turquoise-inlaid belthook (£6,800) cast as a bird entwined with dragons, showing strong affinities with the Ordos art of the Steppes.

The sale also included a series of archaic jades, covering the same period as the bronzes. The finest of the early pieces was a Shang plaque carved on each side with a monster mask (£5,500) whilst a ritual blade (£3,200) of remarkably large size (19$\frac{1}{2}$ in. by 11$\frac{1}{4}$ in.) demonstrated the great skill of the early jade carver in the precision with which the bevelled edges were finished. Among the late Chou jades, the dragon pendants made up to £650 and a small belthook £750.

At the end of the sale were two pieces of T'ang silver, the first a 12 inch dish on three feet, of the same shape as many of the lead-glazed pottery dishes, engraved with fabulous animals and vine scrolls. This was bought by the Cleveland Museum of Art for £40,000. T'ang silver pieces of this size almost never appear and only one other rather smaller dish has apparently been sold at auction, in 1949 for £610, from the Homberg Collection. The second piece was a small cup (£14,000) repoussé with petals and engraved with birds and flowers, its very fine quality typical of the best T'ang metalwork.

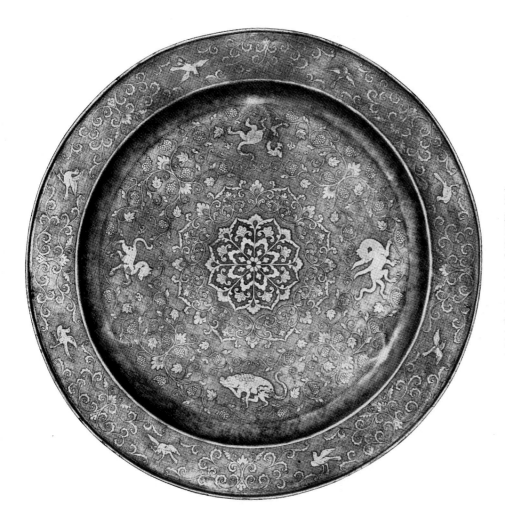

A silver dish engraved with four fabulous animals, all gilt, separated by scrolling branches of grapevine issuing from palmettes. T'ang Dynasty. 12 in. London £40,000 ($100,000). 29.ii.72.

From the D. David-Weill Collection
Now in the Cleveland Museum of Art.

A silver-inlaid bronze beaker, the bronze ground with a malachite green and azurite encrustation. 4th–3rd century B.C. Height 5⅞ in., mouth diameter 2⅞ in. London £7,500 ($18,750). 29.II.72. From the D. David-Weill Collection.

A turquoise inlaid belthook in the form of a stylised bird with outspread wings, entwined with two dragons. 3rd–2nd century B.C. Length 7 in., width 5⅞ in. London £6,800 ($17,000). 29.II.72. From the D. David-Weill Collection.

A *t'ao t'ieh* mask in thin
bronze sheet, with hooked
jaws and curled horns.
Early Chou Dynasty.
Height 10½ in., width
12½ in.
London £9,500 ($23,750).
29.II.72.

Left:
One of a pair of linchpins supporting a kneeling human figure grasping the ears of an animal head. Early Chou Dynasty. Length 5 in. £4,400 ($11,000).

Right:
An An-yang bone carving, one end with two confronted dragons on a ground of *lei wên*, the reverse with an elaborate dragon motif. Shang Dynasty. 8¾ in. £1,500 ($3,750).

Below:
A jade *t'ao t'ieh* plaque, each side incised with a mask with fangs and hooked horns. Shang Dynasty. Height 3¾ in., width 3½ in. £5,500 ($13,750).

Above:
A bronze lock cast in relief with masks and four dragons at the corners.
4th century B.C. Lock: height 2⅜ in., width 3¼ in.; with two pins: length 5½ in. £6,200 ($15,500).

Left:
A bronze kneeling figure, the right hand supporting a pole with a dragon coiled round it.
From Than Hoa, North Annam. Han Dynasty. Overall height 10 in. £11,000 ($27,500).

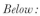

The objects illustrated on this page belonged to the D. David-Weill Collection, dispersed for a total of £247,127 ($617,817) in London on 29th February 1972.

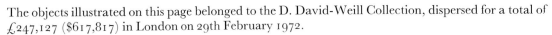

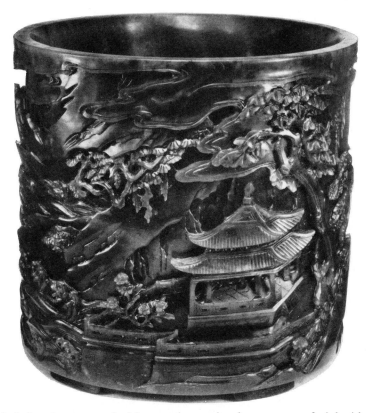

A spinach-green jade brushpot carved with a continuous landscape scene of a lakeside pavilion set amid trees.
Dated 1795 A.D. Ch'ien Lung. Height 6 in., diameter $6\frac{3}{4}$ in.
London £7,800 ($19,500). 14.III.72.
From the collection of D.A.H. Wilkie Cooper, Esq.

A jade figure of a recumbent pony with head turned backwards, the pale mottled stone of greenish tint.
Width $9\frac{1}{4}$ in., height $5\frac{1}{4}$ in.
London £7,200 ($18,000). 14.III.72.

A bronze two-handled bowl set on plinth (*kuei*), the interior with a four-character inscription apparently reading: 'A *kuei* made for travelling.'
Early Chou Dynasty. Height 8½ in.
New York $33,000 (£13,200). 5.v.72.

From the collection of the Cranbrook Academy of Art, Bloomfield Hills, Michigan.

A bronze ritual wine jar (*tsun*) with encrusted malachite green and lapis blue patina.
Shang Dynasty. Height 13¾ in.
New York $37,500 (£15,000). 5.v.72.

From the collection of the Cranbrook Academy of Art, Bloomfield Hills, Michigan.

An archaic bronze cauldron (*ling*), the body inlaid with a frieze of *k'uei* dragons on a ground of *lei wên* above cicadas. Shang Dynasty. Height 9 in., width 7 in. London £16,000 ($40,000). 14.III.72.

An archaic bronze wine vessel (*chüeh*), the pale grey-green patina with patches of reddish encrustation, decorated with *t'ao t'ieh* masks. Shang Dynasty. Height 8⅛ in. London £3,800 ($9,500). 14.III.72.

An archaic bronze cauldron (*ting*), the bowl with three *t'ao t'ieh* masks in relief. Shang Dynasty. Height 9¼ in., width 7⅞ in. London £16,000 ($40,000). 14.III.72.

The objects illustrated on this page were part of the collection of Mrs Enid Lodge and the late F. Brodie Lodge, Esq.

This vase is a composite piece and it seems unlikely that the upper and lower sections were originally joined base to base, as the motifs of the lower section are inverted. Each of the sections is in two pieces of 'L' shape and it is possible that the vase has been assembled from two identical objects, each decorated with lions on one side and fruit and strapwork on the reverse. Their purpose however, remains uncertain. The strong Buddhist associations of the pairs of lions and of the lotus do however suggest their use in a Buddhist temple.

Above: A gilt-bronze stele depicting the Bodhisattva Avalokitesvara, the reverse of the mandorla (illustrated) with the conversation of the Buddha Sakyamuni and Prabhutaratna.
Northern Wei Dynasty. 9¼ in.
London £5,000 ($12,500). 16.XI.71.

Left: A gilt-bronze figure of Kuan Yin.
Dated 650 A.D. 11¼ in.
London £7,000 ($17,500). 14.III.72.
From the collection of Mrs Enid Lodge and the late F. Brodie Lodge, Esq.

Right: A gilt-bronze vase. Late Six Dynasties or T'ang Dynasty. Height 8½ in., width 5 in.
London £5,500 ($13,750). 16.XI.71.

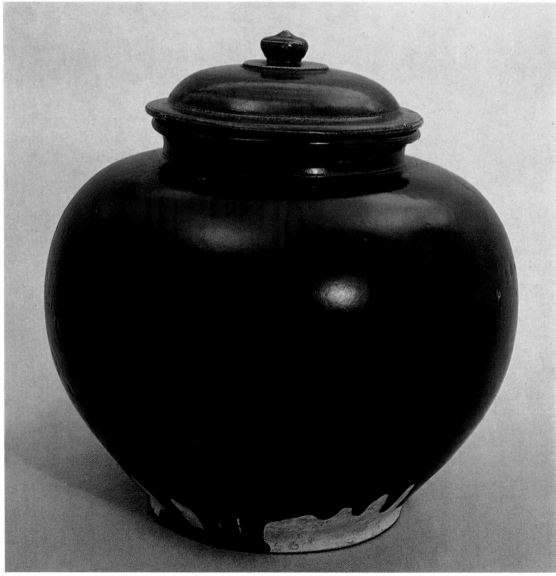

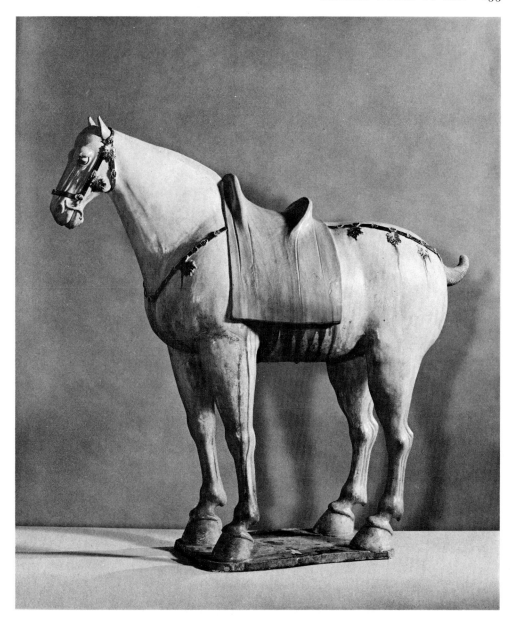

A glazed pottery figure of a horse in straw yellow with nasturtium-brown saddle-cloth.
T'ang Dynasty. Height 33¾ in.
New York $42,500 (£17,000). 1.VI.72
From the collection of the Pasadena Art Museum.

Opposite page:
Above: A fifteenth-century blue and white jar painted with winged dragons with fish
tails (*fei yü*).
Six-character mark of Ch'êng Hua within a double circle and of the period. Height
3⅜ in., width 4¾ in.
London £11,000 ($27,500). 23.V.72.

Below: A blue-glazed jar and domed cover with a very dark cobalt glaze.
T'ang Dynasty. Height 9 in., width 8½ in.
London £7,500 ($18,750). 23.V.72.
From the collection of Sam Browne, Esq.

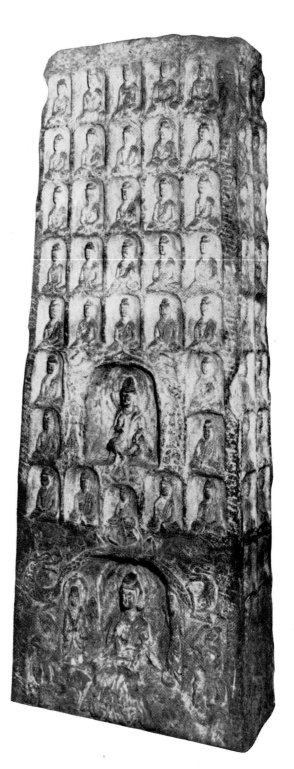

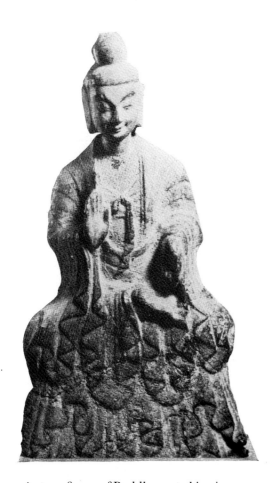

A stone figure of Buddha seated in *virasana*.
Wei Dynasty. Height 17½ in.
New York $17,000 (£6,800). 5.v.72.

From the collection of the Cranbrook
Academy of Art.

A carved sandstone Buddhist stele carved
on front and back with a seated Buddha
flanked by attendants and with the
Hundred Buddhas. Dated 461.
Northern Wei Dynasty. Height 77 in.
New York $140,000 (£56,000).

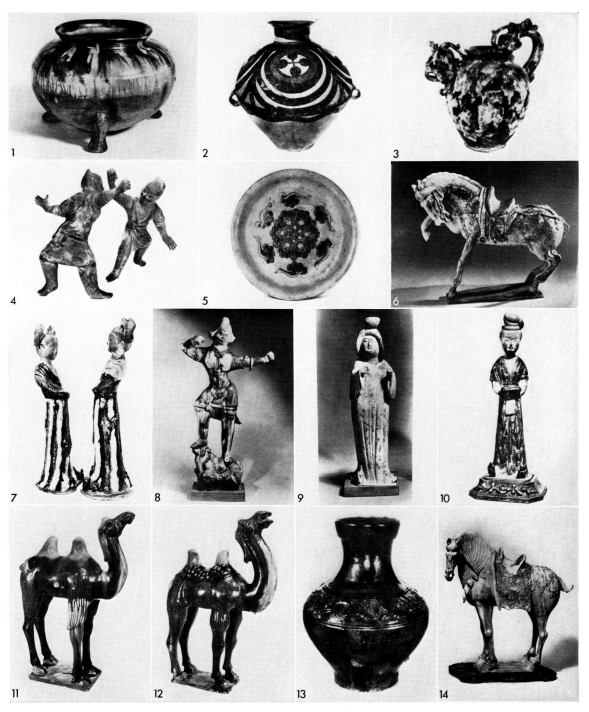

1. Splash-glazed pottery tripod bowl. T'ang Dynasty. Diameter 9 in. $4,700 (£1,880). 22.X.71. 2. Neolithic mortuary urn. Ma Chang Age. 12¾ in. £1,900 ($4,750). 23.V.72. 3. Phosphatic-splashed ewer. T'ang Dynasty. 11 in. £3,000 ($7,500). 14.XII.72. 4. Pair of unglazed wrestlers. T'ang Dynasty. 15½ in. £2,200 ($5,500). 16.XI.72. 5. Tripod offering dish. T'ang Dynasty. 7 in. £7,800 ($19,500). 14.III.72. 6. Polychrome pottery horse. T'ang Dynasty. Height 15½ in. $17,500 (£7,000). 5.V.72. 7. Pair of glazed figures of ladies. T'ang Dynasty. 13½ and 14 in. £9,250 ($23,125). 16.XI.71. 8. Splash-glazed pottery *lokapala*. T'ang Dynasty. 31 in. $4,750 (£1,900). 1.VI.72. 9. Pottery figure of a lady. Early T'ang Dynasty. 18¼ in. $3,250 (1,300). 1.VI.72. 10. Splash-glazed figure of a lady. T'ang Dynasty. 15¼ in. $9,000 (£3,600). 22.X.71. 11. Glazed pottery Bactrian camel. T'ang Dynasty. Height 20¼ in., length 16 in. £7,000 ($17,500). 14.XII.71. 12. Chestnut-glazed Bactrian camel. T'ang Dynasty. 22 in. £4,100 ($10,250). 23.V.72. 13. Green-glazed jar. Han Dynasty. 12½ in. £2,400 ($6,000). 14.XII.71. 14. Splash-glazed pottery horse. T'ang Dynasty. 22¼ in. $26,000 (£10,400). 22.X.71.

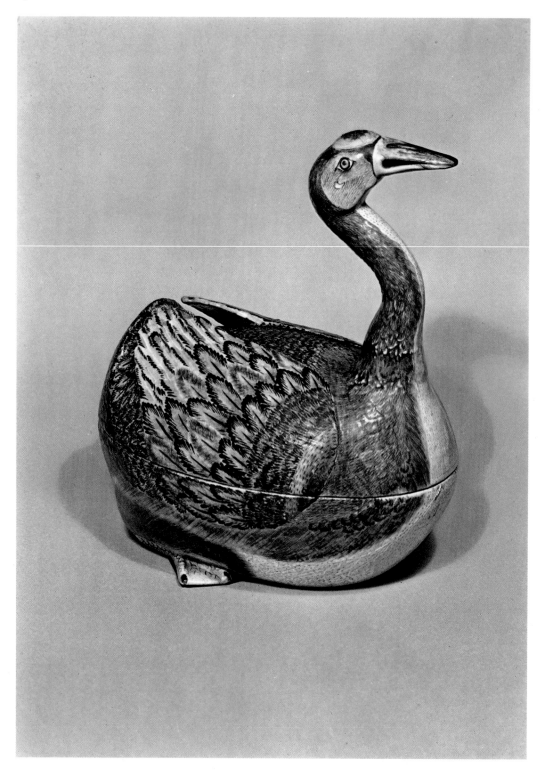

A Chinese export goose tureen.
Circa 1750–70. Length 14 in.
New York $20,000 (£8,000). 7.VI.72.

From the collection of Mrs Edward F. Hutton.

A large Chinese export dish showing the *Surrender of Burgoyne*, 19th century. Length 18 in.
New York $4,000 (£1,600). 20.v.72.

A Chinese export punch bowl, decorated in colours with the Ship Latham three times repeated,
inscribed respectively *Ship Latham bound to Bombay & China, Ship Latham at Whampoe*, and *Ship Latham
towards Old England* (illustrated), and with dolphins in the sea, the interior enamelled in European style
with Neptune and Amphitrite in a chariot drawn by sea horses, and other marine motifs. *Circa* 1765.
Diameter 15¼ in.
New York $9,250 (£3,700). 7.vi.72.

Two East Indiamen named *Latham* are recorded, one of 716 tons built in 1769, and another of 499 tons,
trading between 1764–1770. The shell and scroll border pattern of the bowl however, points to a date
of manufacture not later than 1750.

From the collection of Mrs Edward F. Hutton.

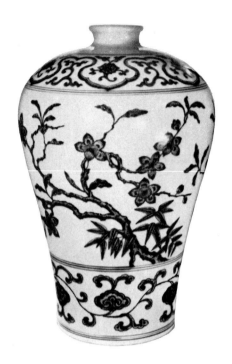

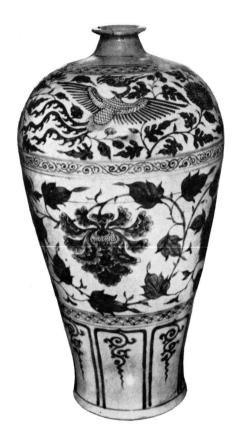

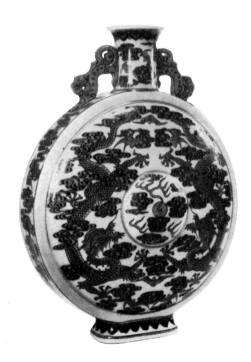

Above left: A blue and white *mei p'ing* painted in deep underglaze blue. 14th century. 17½ in.
London £11,000 ($27,500). 14.III.72.
From the collection of N. M. L. Watson, Esq.

Above right: An eighteenth-century blue and white *mei p'ing* painted with blossoming prunus branches and bamboo sprigs, the underglaze blue with stippling in imitation of the early 15th-century original.
Yung Chêng. 14 in.
London £3,200 ($8,000). 16.XI.71.
From the collection of J. W. Horwood, Esq.

Left: A moon flask decorated in puce enamel and underglaze blue with the *wu fu* and two dragons.
Seal mark and period of Ch'ien Lung. 9¾ in.
London £2,600 ($6,500). 14.III.72.
From the collection of Sam Browne, Esq.

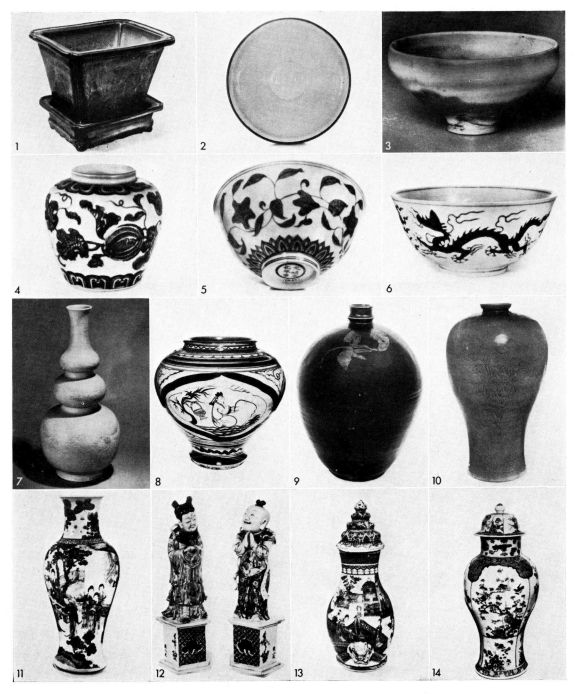

1. Chün yao jardinière and stand. Sung Dynasty. Height 6¾ in. $24,000 (£9,600). 5.v.72.
2. Ting-yao bowl. Sung Dynasty. 9⅛ in. £9,500 ($23,750). 14.XII.71. **3.** Chün yao bowl. Sung Dynasty. Diam. 3½ in. $13,000 (£5,200). 5.v.72.
4. Early 15th C. Ming jar. 4⅛ in. £7,000 ($17,500). 14.III.72. **5.** Blue and white palace bowl. Six-character mark and period of Ch'êng Hua. 6⅛ in. £18,000 ($45,000). 14.III.72. **6.** Ming green dragon bowl. Six-character mark and period of Hung Chih. 7 in. £5,000 ($12,500). 29.II.72.
7. Imperial yellow triple-gourd vase. Late Ming or K'ang Hsi. Height 19½ in. $9,500 (£3,800). 1.VI.72. **8.** Tz'u chou wine jar. Yüan Dynasty.

12½ in. £1,600 ($4,000). 16.XI.72. **9.** Tz'u chou black-glazed bottle. Sung Dynasty. 13¾ in. £2,200 ($5,500). 14.XII.71. **10.** Korean celadon mei p'ing. Koryu Dynasty. 12¾ in. £1,600 ($4,000). 14.XII.71. **11.** *Famille-verte* Kuan Yin vase. K'ang Hsi. 18¼ in. £2,100 ($5,250). 9.v.72.
12. Pair of biscuit figures of Lung-nü and Shan ts'ai. K'ang Hsi. 17½ and 18 in. £3,800 ($9,500). 9.v.72. **13.** *Famille-verte* wall cistern and cover. K'ang Hsi. 21¾ in. £2,600 ($6,500). 9.v.72. **14.** One of pair of *famille-verte* baluster jars and covers. K'ang Hsi. 19½ in. £2,000 ($5,000). 15.II.72.

Japanese Works of Art

This season brought a number of interesting Japanese works of art to the saleroom. As in the past, prints, netsuke, inro, and other lacquer wares have been very successful. Outstanding this year was the rise in demand for porcelain and for swords and their mounts.

Among the most important objects was a set of inro depicting the twelve signs of the Japanese zodiac in metal and lacquer. These were the work of two late 19th century artists Koma Kwansai and Masaharu.

The swords included several well mounted *aikuchi* and *tanto* (daggers) and a number of mounted and unmounted blades. Interest in these is growing in Japan and many of the more important blades have been bought by dealers from Tokyo and Kobe.

Porcelain wares of the 17th and 18th century are also very popular in Japan and several high prices have been recorded. The Ko-Kutani dishes illustrated below were perhaps the most exciting wares to appear on the market for some time. These large saucer dishes, made during the third quarter of the 17th century, are of a type well known in Japan but rarely seen in the West. Interest in these two pieces was keen and they obtained good prices, one being bought by a London dealer and the other returning to Japan.

A *Ko-Kutani* dish, decorated with *kiku* blooms and foliage. *Fuku* mark on base. 17th century. Width 39·2 cm., height 8·2 cm., width of base 17·3 cm.
London £3,600 ($9,000). 10.v.72

A *Ko-Kutani* dish decorated with the gnarled trunk of a pine tree. *Fuku* mark in green and black on base. 17th century. Width 36·1 cm., depth 6·1 cm., width of base 15·4 cm.
London £4,000 ($10,000). 10.v.72.

A pair of late 17th century polychrome Arita hawks on Régence ormolu mounts. The enamelling, brown, *rouge-de-fer*, aubergine, black, green and gilt, was typical of the Arita potters, whose ware was imported into Europe in great quantities by the Dutch East India Company. The rockwork ormolu mounts were probably added in France, *circa* 1720.
Height 14½ and 14⅞ in. New York $40,000 (£16,000). 6.iv.72.

From the collection of the late Reba Rubin, New York.

A *Kakiemon* dish decorated with a tiger
and bamboo and a peony plant behind
a banded hedge.
Late 17th–early 18th century. 25·2 cm.
London £1,700 ($4,250). 10.v.72.

A blue and white Arita marriage dish, the
well decorated with two coats of arms
linked by tasselled cords.
Late 17th century. 38·7 cm.
London £600 ($1,500). 26.i.72.

A *Kakiemon* jar and cover
decorated with butterflies
amid peonies and *kiku* in a
garden.
Second half of 17th
century. 26·4 cm.
London £1,400 ($3,500).
10.v.72.

Below:
One of a pair of *Nabeshima*
dishes with hydrangea
design and Buddhist
symbols on the reverse.
Mid-18th century. 15·1 cm
London £820 ($2,050).
20.x.71.

1. Ivory *netsuke* of a grazing horse. Early 18th C. £460 ($1,150). 1.iii.72. **2.** Early *netsuke* of an *oni*. Early 18th C. £560 ($1,400). 14.vi.72. **3.** Figure of a shaggy dog by Masanao of Kyoto. Signed. £1,100 ($2,750). 1.iii.72. **4.** *Netsuke* of Tobosaku. 18th C. £850 ($2,125). 1.iii.72. **5, 6, and 7.** Koma Kwansai II and Masaharu: three items from set of twelve *inro* depicting the signs of the Japanese Zodiac. The Tiger, the Cock and the Horse, each signed *Kwansai saku* for the lacquer work and *Masaharu* with *kakihan* for the metalwork; with coral *ojime* and ivory *netsuke*. The set £14,000 ($35,000). 14.vi.72. **8.** Single-case *inro* by Shibata Zeshin. Signed in scratched characters. £2,600 ($6,500). 1.iii.72. **9.** *Tonkotsu* by Shibata Zeshin with *manju* and *ojime*. Signed. $2,400 (£960). 6.iv.72. **10.** Four-case *inro* by Shirayama Shosai, with coral *ojime* and wood *netsuke*. *Inro* and *netsuke* each signed. £1,500 ($3,750). 14.vi.72. **11.** Metal-sheath three-case silver *inro*, with gold *ojime* and ivory *manju*. *Inro* signed *Okawa Motoshige* and *Koizumi Tomoyuki* both with *kakihan*; *ojime* signed *Shinsan*(?). £4,800 ($12,000). 1.iii.72. **12.** Four-case *inro* by Kwanshosai Toyo and Ichimuken Nanka, with *tsuishu ojime* and ivory *manju*. *Inro* signed *Toyo* with *kakihan*; *manju* signed *Nanka saku*. £1,100 ($2,750). 14.vi.72.

A box and cover decorated with a bridge and
a temple amid pine-clad hills, and an inlaid
silver moon, the interior in rich *nashiji*.
25·7 cm. by 20·5 cm. by 10·8 cm.
London £1,000 ($2,500). 14.VI.72.

Left:
A *kashibako*, cover and tray
of *mokko* form.
19th century. 12·1 cm. by
10·4 cm. by 5·4 cm.
London £760 ($1,900).
26.I.72.

From the collection of
Mrs. D. A. Stevens.

Right:
Moyegi-Odoshi-o-Yoroi,
comprising an *Akoda-nari*
16-plate *sujibachi* with gilt
Fukurin and *Igaki*, *Ko-manju*
Shikoro, *Kurigata-dai* in
shakudo and gilt copper with
Kuwagata mounted on the
peak.
London £3,200 ($8,000).
5.VII.72.

From the collection of
the late Paul Alther.

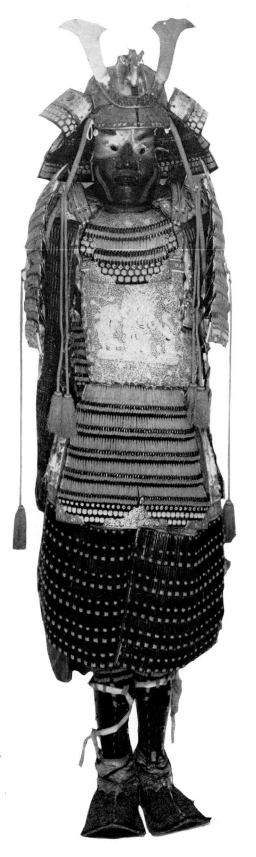

Left: An early *Higo-Owari Tsuba.* 16th century. 8·6 cm. New York $550 (£220). 2.XII.71.
Centre: A *Tsuba* decorated with a spider and flower, the reverse with two *chidori* flying over silver waves.
Signed for the spider *Masayoshi sei,* for the flower, *Joyu* with *kakihan* and for the *chidori* and waves
Inagawa Masataka saku. London £400 ($1,000). 5.VII.72.
Right: A *Shibuichi Tsuba* decorated in *takabori* with the figure of *Shoriken.* Signed *Mitsuyoshi, circa* 1860. 8·5 cm.
London £520 ($1,300). 5.VII.72.

A *Tanto,* the blade of straight *hira-tsukuri* form, the scabbard of *roiro,* inlaid with a band of silver,
the Habaki gold in the form of Fuji, the remaining mounts in silver. The blade signed *Horikawa
Kunihiro,* the mounts signed *Ishiguro Masayoshi* on the *kozuka* and *fuchi.* The blade's length 22·8 cm.
London £1,000 ($2,500). 5.VII.72. From the collection of the late Randal Hibbert.

A *Tanto,* the blade of *hira-tsukuri* form, the scabbard lacquer with swirling clouds, the other mounts
silver chased in the form of clouds and inlaid with gold, copper, *shibuichi* and *shakudo.*
The blade signed *Soshu ju Masatsugu;* the *kozuka* and *fuchi* signed *Hagiya Katsuhei* with *kakihan.*
The blade's length 30·1 cm. London £1,300 ($3,250). 5.VII.72.

A *wakizashi,* the blade of *koshi-zori, unokubi-tsukuri* form, the wood scabbard engraved with flowers
and foliage, applied with a long-armed monkey in *shibuichi,* the *hamidashi tsuba* being *shakudo.*
The blade's length 34·1 cm.
London £1,500 ($3,750). 5.VII.72. From the collection of the late Randal Hibbert.

A *wakizashi,* the blade of *koshi-zori shinogi-tsukuri* form, the scabbard of *yasurime nashiji* lacquer, the
other mounts of *shibuichi.* The blade signed *Awataguchi Ikkanshi Tadatsuna cho do saku,* dated *Hoei* 7;
the mounts each signed *Kakinuma Toshiharu* with *kakihan.* The blade's length 47·4 cm.
London £2,800 ($7,000). 5.VII.72. From the collection of the late Randal Hibbert.

Left:
A kakemono by Katsushika
Hokusai.
Signed Toyo Gakyojin
Hokusai ga with red seal
Hokusai. Circa 1805. 38¼ in.
by 12 in.
New York $3,400 (£1,360).
2.XII.71.
From the collection of the
late Albert E. Gallatin.

Right:
TOYOKUNI I
Print of a young woman
coming from her bath.
Mark of the publisher
Senichi; seal of the
Rouault Collection.
London £1,600 ($4,000).
28.VI.72.

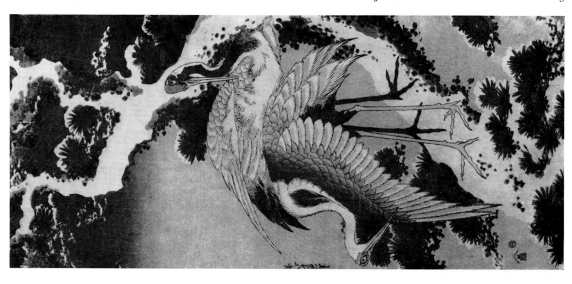

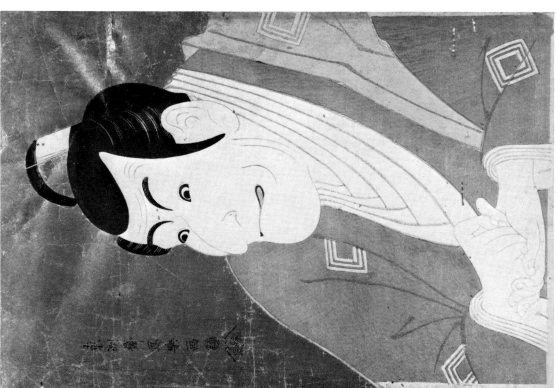

Left:
TOSHUSAI SHARAKU
Oban: Ichikawa Ebizu IV
(Danjuro V) in the role of
Takemura Sadanoshin in
the play *Koinyobo Somewake
Tazuna,* performed in 1794.
Signed *Toshinsai Sharaku ga;*
Kiwame censor's seal; mark
of publisher Tsuta-ya.
15⅛ in. by 10 in.
London £4,600 ($11,500).
28.VI.72.

Right:
HOKUSAI
Kakemono-e: two cranes on a
snow-laden pine.
Signed *Zen Hokusai I-itsu
hitsu.*
London £780 ($1,950).
24.XI.71.

The Cranbrook ivory diptych

BY JOSEPH J. KUNTZ

Innumerable ivory plaques were carved in France in the 14th century but few are comparable in quality to the Cranbrook diptych. The figures are carved in high relief and treated with a boldness more usually found in life-size sculptures; the features are carefully denoted and the drapery is highly-finished. These elements of the carving are intensified by the beautiful, soft glistening whiteness of the ivory itself.

Each of the two leaves is divided into three horizontal registers, containing six scenes illustrating events from the New Testament, mainly relating to the Passion. The panels proceed chronologically from the lower left register to the upper right in the usual way and present the Annunciation and Nativity, divided by a column; the Adoration of the Magi; the Betrayal in the Garden of Gethsemane and Death of Judas; the Crucifixion and Resurrection; distinguished only by the difference in scale of the figures; the Ascension and the Pentecost. Each panel is surmounted by five crocketed trefoil arches.

It is interesting to compare this diptych with others of similar dimensions, one of which is in the British Museum and another published by Raymond Koechlin in 1924. The diptychs are extremely close in composition and style and are part of a closely affiliated group with scenes from the Passion, undoubtedly products of one of the major Parisian workshops in the middle of the 14th century. Each register contains virtually the same composition yet, here and there, one notes a figure in a different pose, and in several instances an additional figure. There are also differences in costume and architectural or decorative elements. On the whole, however, the Cranbrook work must be judged among the finest of the group.

The diptych remains in extraordinarily good condition, the only damage to the carving being the loss of the end of the crop held in the groom's hand in the Magi register. The left-hand leaf has had two sections along the inner edge reset to hold the original silver hinges; the silver closures are also original. Extensive traces of green pigment are to be found, as well as faint traces of blue and red. The ivory came to America and Cranbrook Academy directly from Jacques Seligman & Co. in Paris, its provenance before then remaining unknown. The diptych, which fetched $61,000 (£24,400), broke previous records for a pre-19th century European ivory sold in America.

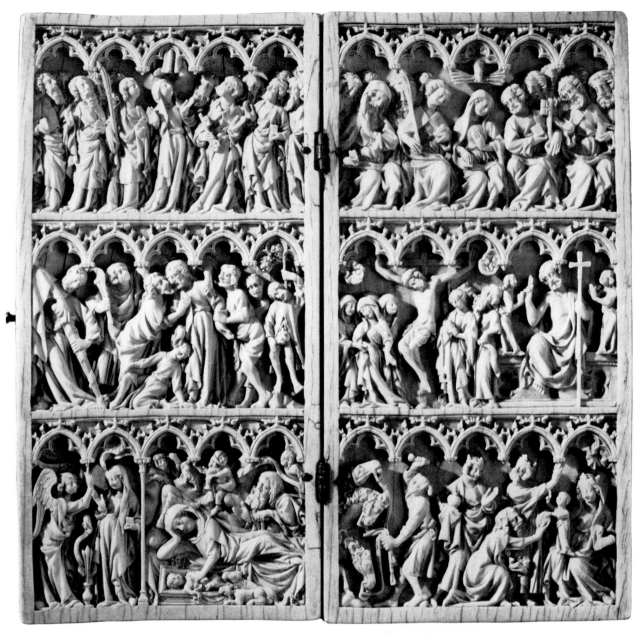

A French ivory diptych. Third quarter of the 14th century. 8¼ in. by 8⅜ in.
New York $61,000 (£24,400). 25.III.72.

From the collection of the Cranbrook Academy of Art.

Medieval, Renaissance and later Works of Art

Although medieval works of art are becoming increasingly hard to find, several fine pieces made high prices this season. In addition to the important religious gothic ivory in New York, illustrated and discussed on pages 270–71, a 14th century gothic ivory casket carved all over with profane subjects brought £3,600. These scenes of courtly love are typical of the French gothic art and especially the mirror cases and caskets of the Paris workshops, with such subjects as the romantic Meeting, the Declaration and the Crowning with Flowers. Slightly later but of especially English interest in the gothic section was the fine Nottingham alabaster (£2,500). This was unusually attractive on account of the preservation of the daisy-dotted decoration on the grass which was derived from contemporary manuscripts.

Metalwork featured prominently in the sales this season and of other early pieces a 13th century water vessel or aquamanile in the form of a roaring lion, brought £1,850 and an interesting Dinanderie ewer, with a lid in the form of a human face, made a particularly high price, £4,000. The name Dinanderie is derived from the fact that the ingredients of the particular copper alloy, zinc, calamine and a plastic clay were available chiefly on the banks of the Meuse at Dinant where a tremendous production of secular and religious metalwork was in progress from medieval times until the sacking of the town by the Duke of Burgundy in 1466. This ewer was probably exported to England in the 15th century and it is interesting to note that large pottery jugs also with human faces were produced by English potters at this time.

In the same sale in New York as the ivory diptych, a fine 16th century Nuremberg gilt and etched steel casket with an intricate locking mechanism brought $10,250 and in London a very fine German early 17th century votive crown of silver gilt by Stephan Hoetzer of Munich and applied all over with jewels in the form of flowers and foliage made £3,600. The magnificence of this piece suggests that it may have been a votive offering of the Bavarian court and it seems fitting that it was purchased by the Residenz Museum of Munich and therefore returns to its former home.

Continuing in the field of metalwork, good bronzes have been few and far between but the most interesting was the somewhat macabre German figure of Death in the form of a decomposing man being eaten by worms (£2,350), the subject of which is more common in wood than bronze. Venetian bronze andiron figures were cast in large quantities and the models of the various artists are often interchangeable but one of the finest figures of the Jupiter by Alessandro Vittoria came up in July (£2,300) while a Campagna Venus made £1,850 in the same sale. A rare pair of groups of Venus and Cupid, one of them, signed by Giovanni Francesco Susini, a 1639 dated model of one of which is in the Louvre, brought $6,000 in New York. The interest in the 19th century animalier bronzes continues to increase and an exceptionally fine collection of Barye groups was sold in New York, one proud Turkish stallion, once a horse racing trophy, alone bringing $8,000.

In sculpture, some fine Flemish oak groups of the late gothic period have held the limelight. A fine pair of Lower Rhenish 16th century groups of kings on horseback from a nativity scene were sold at Stobo Castle in Scotland; the journey North did not deter the bidders (£3,800), and a small Malines group of the Virgin and Child with the characteristic broad faces and sweet expressions was sold in London for £2,000.

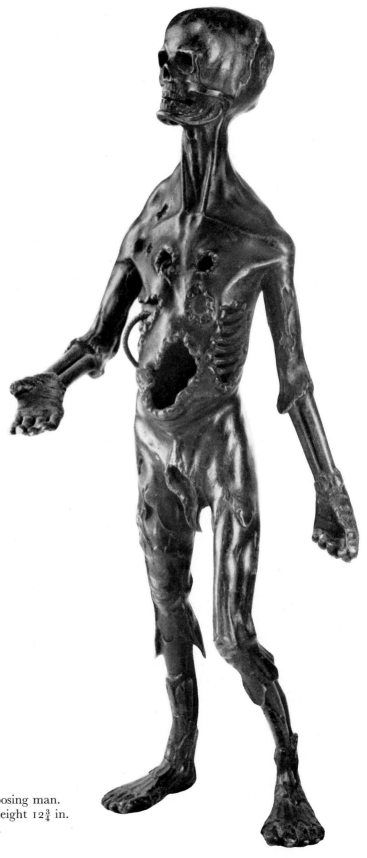

German bronze figure of a decomposing man.
Late 16th or early 17th century. Height 12¾ in.
London £2,350 ($5,875). 16.XII.71.

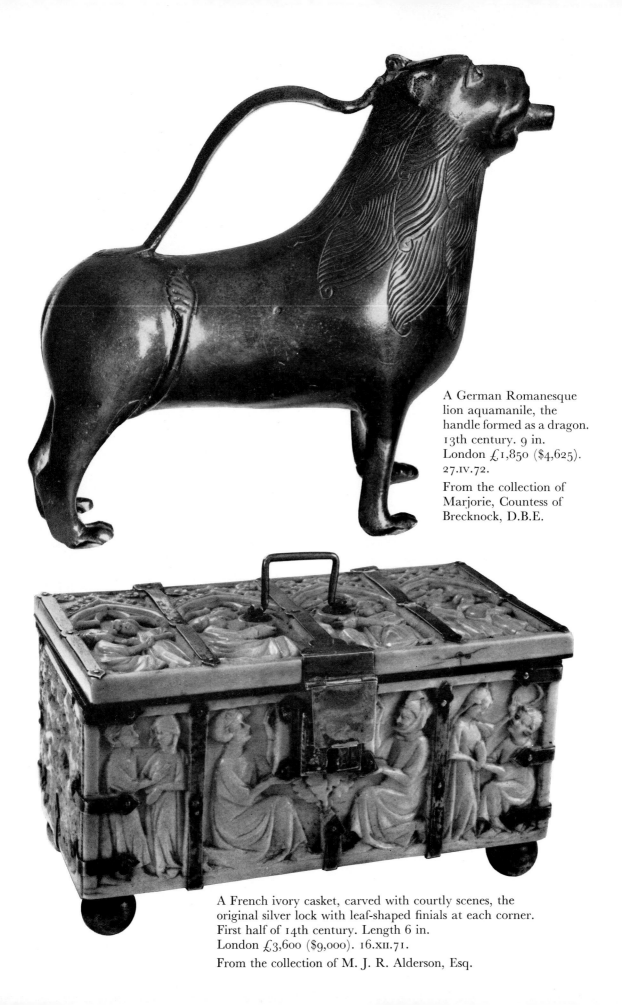

A German Romanesque
lion aquamanile, the
handle formed as a dragon.
13th century. 9 in.
London £1,850 ($4,625).
27.IV.72.

From the collection of
Marjorie, Countess of
Brecknock, D.B.E.

A French ivory casket, carved with courtly scenes, the
original silver lock with leaf-shaped finials at each corner.
First half of 14th century. Length 6 in.
London £3,600 ($9,000). 16.XII.71.

From the collection of M. J. R. Alderson, Esq.

Right:
A Dinanderie latten covered ewer, the
cover cast with a grotesque human mask
and surmounted by a lion sejant.
Late 14th century. Height 18 in.
London £4,000 ($10,000). 14.VII.72.

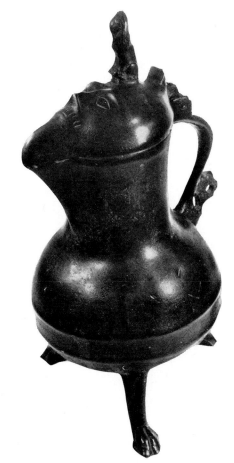

Below:
Parcel-gilt and etched steel casket.
Nuremberg, mid-16th century.
12¼ in. by 20 in. by 12 in.
New York $10,250 (£4,100). 25.III.72.

From the collection of the Cranbrook
Academy of Art.

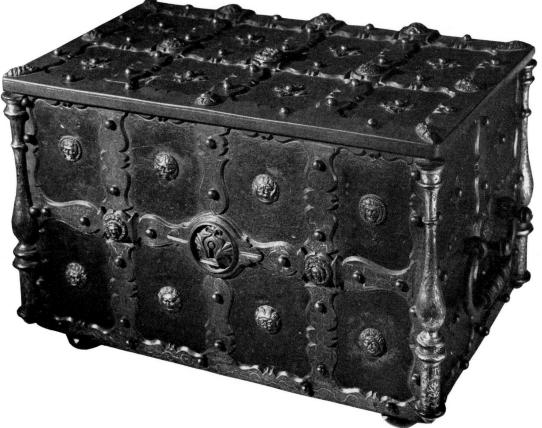

Left:
A Nottingham alabaster relief of the
Resurrection. *Circa* 1460.
16½ in. by 10¼ in.
London £2,500 ($6,250). 27.IV.72.

Below:
A pair of alabaster reliefs of angels, with
traces of gilt.
Northern France, 1475–1500.
Height 11 in.
New York $10,500 (£4,200). 25.III.72.

From the collection of the Cranbrook
Academy of Art.

Right:
A Malines carved walnut polychrome
figure of the Virgin with Child,
supported on a contemporary carved and
giltwood Gothic bracket.
Early 16th century. Height 16 in.
London £2,000 ($5,000). 14.VII.72.

A South German ivory cylinder from a
tankard, in the manner of Jordaens.
Mid-17th century. Diameter 5¼ in.
London £2,600 ($6,500). 27.IV.72.

From the collection of the late
S. R. Christie-Miller, Esq.

A German votive crown of silver-gilt, set with twenty jewels and forty-two flowerheads, all enamelled gold, by Stephan Hoetzer of Munich (1622–50).
Height 11½ in.; maximum diameter 9 in.
London £3,600 ($9,000). 16.XII.71.

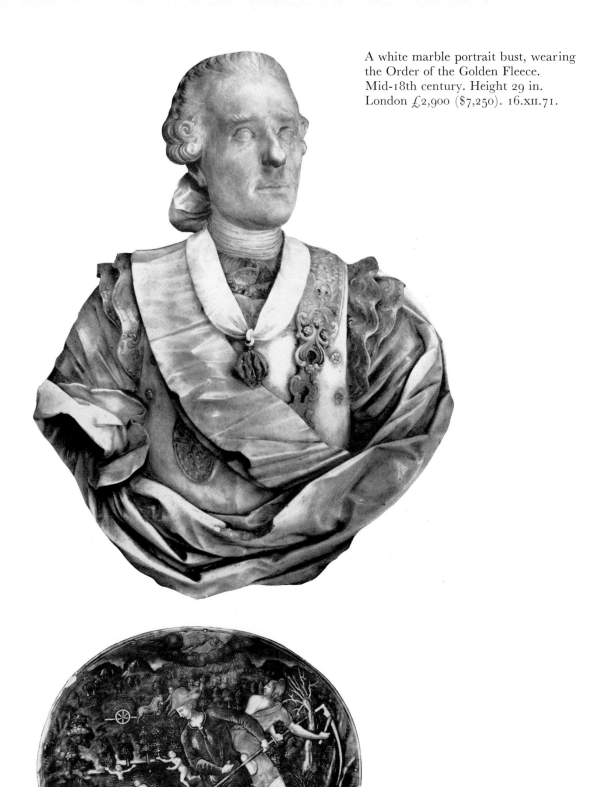

A white marble portrait bust, wearing
the Order of the Golden Fleece.
Mid-18th century. Height 29 in.
London £2,900 ($7,250). 16.XII.71.

A Mannerist Limoges painted
enamel plaque from a series
of the months. *Circa* 1580. 8¼ in.
London £980 ($2,450). 27.IV.72.

1. German bronze crucifix figure, Westphalia, *circa* 1200. 8¼ in. £480 ($1,200).16.XII.71. **2.** French ivory leaf from diptych of the Crucifixion, 14th C. 3 in. £500 ($1,250). 27.IV.72. **3.** South German turned ivory cup. First half of 17th C. 8½ in. £340 ($850). 27.IV.72. **4.** Bronze nest of weights by Paulus Ritter, stamped with initials. Nuremberg, stamped 1752. Height 8 in. £720 ($1,800). 27.IV.72. **5.** Renaissance enamelled gold pendant jewel. Late 16th C., 2½ in. £980 ($2,450). 16.XII.71. **6 and 7.** Pair of Flemish terracotta *putti*. Signed with monogram *I.V.L.*, dated 1710. Height 13 in. £470 ($1,175). 16.XII.71.

8. Italian enamelled gold hat badge converted into a pendant. 1550–75. 1¾ in. £800 ($2,000). 16.XII.71. **9.** Venetian bronze figure of Jupiter by Alessandro Vittoria. Late 16th C. 14 in. London £2,300 ($5,750). 14.VII.72. **10.** One of pair of bronze winged lions. Flemish, mid-17th C. Height 25 in. £600 ($1,500). 16.XII.71. **11.** Venetian bronze figure of Venus, in the manner of Girolamo Campagna, late 16th C. 15 in. £1,850 ($4,625). 14.VII.72. **12.** Italian bronze figure of the Farnese Hercules, after the antique, late 17th C. Height 22 in. £800 ($2,000). 16.XII.71.

1. *Gaston de Foix on horseback* by Barye. Signed. 1839–40. 13¼ in. by 11⅝ in. $4,000 (£1,600). 3.XII.71. **2.** *Turkish horse* by Barye. Signed. 1830–40. 11⅝ in. by 11⅝ in. $8,000 (£3,200). 3.XII.71. **3.** Partly gilt bronze equestrian group of scout and buffalo by Isadore-Jules Bonheur. Signed. Length 24 in. $2,300 (£920). 14.VI.72. **4.** Three from set of four carved wood figures of the Early Fathers, attributed to Christian Jorhan the Elder of Landshut. 1750–75. Height 11–12 in. £800 ($2,000). 16.XII.71. **5.** Mughal hardstone cup. *Circa* 1607-8. £2,300 ($5,750). 16.XII.71. **6.** Carved marble oval relief of the Last Supper. German, *circa* 1600. Height 13½ in. by 24½ in. £700 ($1,750). 16.XII.71. **7.** Ivory relief of the Adoration of the Shepherds, in the manner of

Dominikus Stainhardt. Late 17th C. Height 5 in.; width 4 in. £600 ($1,500). 27.IV.72. **8.** Terracotta group of the Adoration of the Shepherds. Neapolitan, second half of 18th C. 14½ in. by 15 in. £450 ($1,125). 27.IV.72. **9.** Italian terracotta relief of the Deposition, in the manner of Massimiliano Soldani. Late 17th C. 22½ in. by 14 in. £1,350 ($3,375). 27.IV.72. **10.** Terracotta group by Bartolomeo Pinelli. Signed, dated 1828. Width 18 in. £700 ($1,750). 16.XII.71. **11.** Wax picture of Turkish scene by Samuel Percy. Signed, dated 1789(?). 25 in. by 21 in. £500 ($1,250). 16.XII.71. **12.** One of pair of bronze groups with Venus, after Giovanni Francesco Susini. 17th C. Height 22 in. $6,000 (£2,400). 3.XI.71.

A Pietra Dura Panel

BY DIANA KEITH NEAL

The technique of *pietra dura* is the cutting of thin *laminae* of semi-precious hardstone such as lapis lazuli, onyx, jasper, sardonyx, chalcedony agate and rock crystal, into appropriate shapes and affixing them to panels to make up intricate designs, views or *trompe l'oeil* representations. The origins of *pietra dura* are found in classical antiquity; subsequently the tradition was handed down through the mosaics of Byzantium to 16th century Italy where the Medici family established an *Opificio* (workshop) *delle Pietre Dure* in Florence in 1580. The combination of the use of semi-precious stones and the large number of skilled artists required in its execution meant that *pietra dura* was a costly process. As an art form it was equally fit to adorn the Schatzkammer of a 16th century emperor or to be a sumptuous gift for presentation at the Mannerist courts. The most impressive example of its use is in the decoration of the vast family tomb of the Medicis, which was begun in 1597 but not completed for nearly 200 years.

Mainly staffed by Milanese or Milanese-trained craftsmen, centres of hardstone cutting were established not only in Florence but also in Vienna and Prague. Amongst the various uses to which the technique was applied was the production of table tops, pictures, altar panels and, less successfully, small sculptures.

Despite its precious associations, *pietra dura* was at the mercy of the course of fashion. In 1644, when John Evelyn visited the Capella dei Principi in the Uffizi (the Medici tomb) he commented that it was 'the third heaven if any be on Earth'. However, the poet, Walter Savage Landor, having visited the same chapel, wrote in 1851 that it was "the product of Chinese industry and Turkish taste" while the *Opificio delle Pietre Dure* was 'a mere school for fashioning piebald minerological specimens into a greater or lesser resemblance of fruit, flowers and landscapes'. The latter would certainly have been true by the 19th century as the factory had fallen on hard times and had been forced to commercialise its production.

It is rare for a panel of the 16th century to come on the market and the eye is immediately struck by the rich colours and the subtle blending of different hardstones, used to create the Bohemian landscape it is thought to represent. It shows a river cutting through mountains covered with coniferous trees and castellated towns in the background. A shepherd is seen walking with his dog and a fisherman casting his net from a boat. The distinctly Northern feeling about the scene justifies the attribution to Giovanni Castrucci, a Florentine artist who is known to have worked for Emperor Rudolf II at his Prague court. A very similar panel, set into a table top, is in the Pitti Palace, Florence (see Rossi, *La Pittura di Pietra*, Florence 1967, fig. 39) and Castrucci could have made the present panel either while he was at the *Opificio* or after his arrival in Prague.

A pietra dura panel attributed to Giovanni Castrucci, late 16th century, 25 in. by 27 in. London £4,000 ($10,000). 27.IV.72.

Arms and Armour

Neither fashion nor stock market fluctuation has affected the uninterrupted rise of prices in this field since the end of World War II. The outstanding sale of the 1971–72 season was the first part of the collection formed by the late William Goodwin Renwick of Arizona. Consisting of only 38 lots, this record-breaking sale obtained £217,410 ($543,525). A pair of early 18th century flintlock breech-loading pistols by Michele Lorenzoni brought £60,000 ($150,000); an English snaphaunce gun from the Cabinet d'Armes of Louis XIII made £21,500 ($53,750). Both these figures far exceed any previous price paid for a pair of pistols or a single gun.

The disappearance of fine swords and armour from the market combined with the

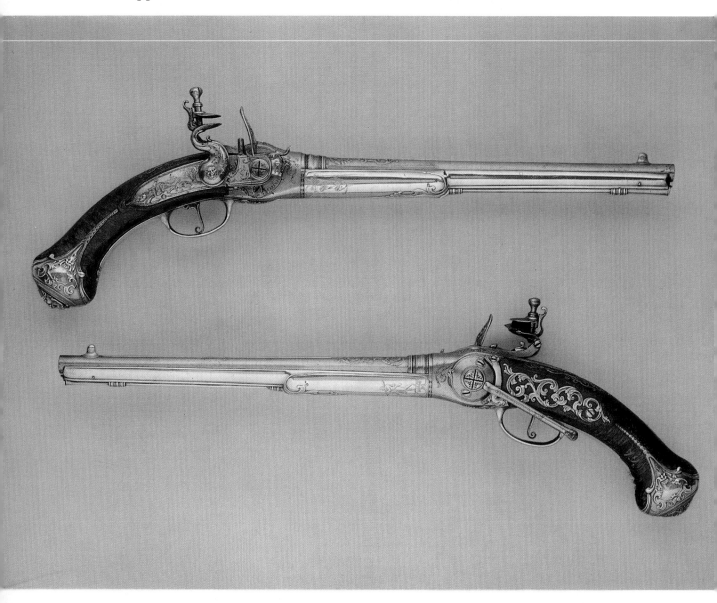

A pair of flintlock breech-loading repeating pistols by Michele Lorenzoni, gunmaker to the Grand Dukes of Tuscany, with engraved silver mounts and rootwood stocks.
Early 18th century. 20 in. long.
London £60,000 ($150,000). 17.VII.72.

From the collection of the late William Goodwin Renwick, this pair of pistols formerly came from the Imperial Russian Collection at the Hermitage.

enthusiasm of gun collectors explain why firearms now tend to attract greater attention. If, however, an early piece of armour, such as the Milanese sallet probably made in the Missaglia workshop, is offered for sale, it commands a very high price (£12,500; $31,250). It is also interesting to note the rise in price of fine English fire-arms, this is probably due to the formation of one or two specialised collections. For instance a pair of late 17th century English pistols (see pages 288–289) brought £15,500 ($38,750), while a pair of late 18th century double-barrelled pistols by Twigg made £5,200 ($12,700). The contemporary fashion for 19th century artefacts was reflected in the lively interest created by fine cased sets of pistols of this date, particularly those of international exhibition quality.

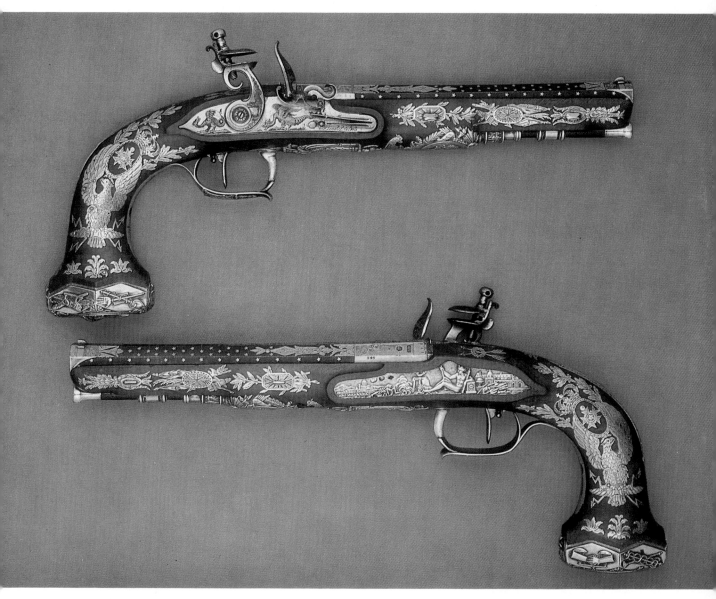

A pair of presentation pistols by Nicholas Noel Boutet, the butts inlaid with the Insignia of the Grand Cross of the Légion d'Honneur. *Circa* 1810. 14½ in.
London £19,000 ($47,500). 17.VII.72.

From the collection of the late William Goodwin Renwick, these pistols are said to have belonged to Napoleon and been captured on his retreat from Moscow. They then passed into the Imperial Russian Collection, formerly in the Palace of Tsarskoe Selo, St. Petersburg.

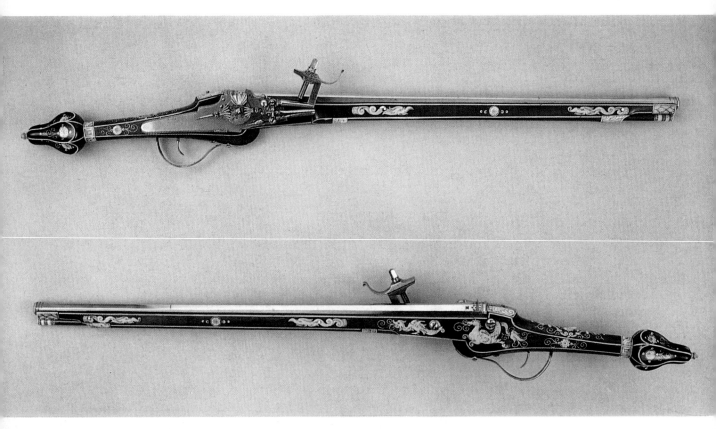

A pair of wheel-lock rifled holster pistols by Hans Stockmann, the 23¾-inch octagonal
barrels struck at the breech with the initials *HS*, the stocks inlaid in stag horn with seahorses, dragons
and birds' heads, *circa* 1610, 34¼ in.
London £12,500 ($31,250). 22.III.72.

From the collection of Mr Sam Bloomfield.
Formerly from the Richard P. Mellon collection.
This is one of the finest pair of Saxon wheel-lock pistols sold since the war.

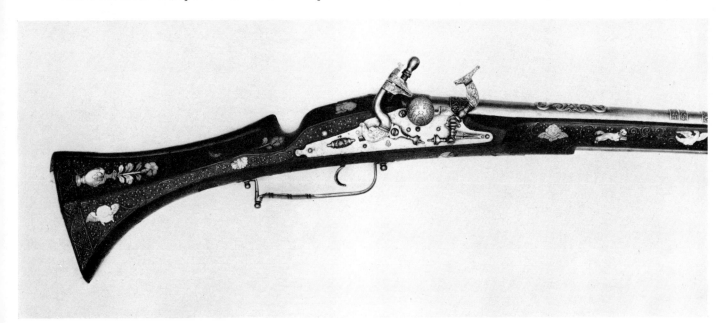

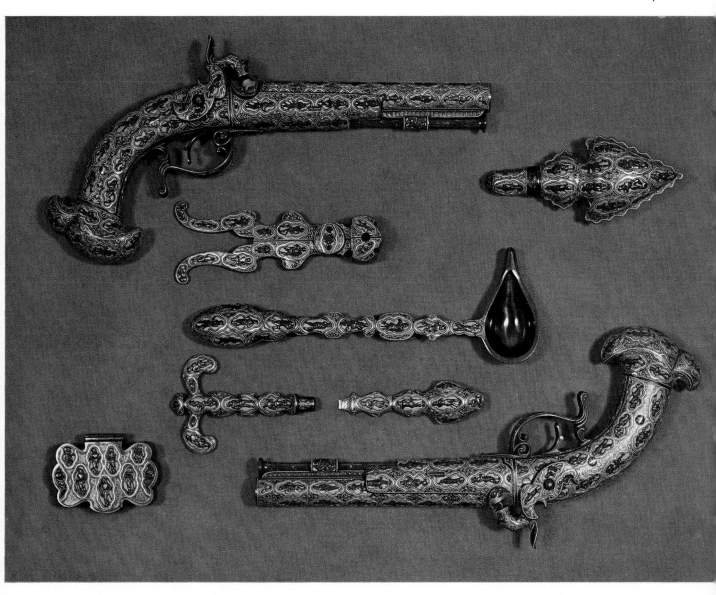

A pair of Spanish percussion cap exhibition pistols, probably by Eusebio Zuloaga, complete
with companion powder flask, bullet mould, screwdriver, nipple key, ladle and cartouche shaped box,
all decorated *en suite* with chiselled figures in 16th-century costume bearing various edged weapons
and with silver borders and gold floral inlaid decoration. Mid-19th century. Pistols 14 in. long.
London £4,000 ($10,000). 13.XII.71.

Eusebio Zuloaga, after working under Le Page in Paris and at the State Arms Factory at St Etienne,
set up a factory for luxury arms in Eibar where he developed the revived Renaissance style shown by
these pistols.

Opposite page, below:
An English snaphaunce gun, number 130 from the Cabinet d'Armes of Louis XIII, with maker's
mark H.B. and dated 1622. Length 50 in.
London £21,500 ($53,750). 17.VII.72.

From the collection of the late William Goodwin Renwick.

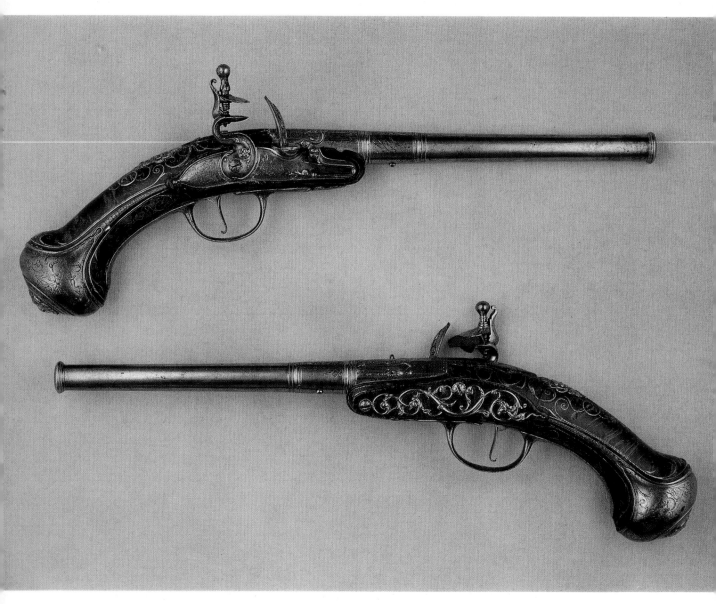

A pair of flintlock turn-off pistols by Andrew Dolep, with chiselled steel locks, rootwood stocks inlaid with scrolling silver wire, the escutcheons chiselled and gilt with the arms of the Grand Duke of Tuscany, the pommels terminating in a lion mask and engraved with mounted warriors. *Circa* 1680–85. Length 16 in.

London £15,500 ($38,750). 15.v.72.

From the collection of The Cranbrook Academy of Arts, Bloomfield Hills, Michigan, U.S.A.

The Dolep Pistols

On 15th May 1972 Sotheby's offered for sale one of the finest and most historic pairs of English pistols of the late 17th century seen in recent years. They were made by a Dutch immigrant gunmaker, Andrew Dolep, who was first recorded as working in London in 1681.

His first attempt to obtain admittance as a Master Gunmaker to the London Gunmakers' Company was rejected but eventually, through the patronage of the Earl of Dartmouth, Master General of the Ordnance, he was admitted in 1686. His works are represented in Windsor Castle, in the Dresden Armoury of the former Kings of Poland and Electors of Saxony and elsewhere. In 1709 he was employed to appraise the firearms of Prince George of Denmark, consort of Queen Anne, after his death the previous year. The gun in the Windsor Armoury by Dolep presumably formed part of Prince George's collection. This pair of pistols is believed to have been a gift from an English king, either Charles II or William III, to the Grand Duke Cosimo III of Tuscany.

The Dolep pistols were sent for sale by the Cranbrook Academy of Arts, Michigan, U.S.A., and they were of particular interest to Mr John Hayward, an associate director at Sotheby's, who had made a study of the works of this gunmaker. In 1948 he was invited to go to Turin and report on the collection of arms and armour in the Royal Palace which had, after the end of the monarchy in Italy, become state property. Among the pieces he identified was an unusual flintlock fowling piece by Andrew Dolep. The gun bears, inlaid on each side of the butt, the monogram *F.M.* surmounted by the crown of the Grand Dukes of Tuscany, probably for Ferdinando de' Medici, eldest son of Grand Duke Cosimo III. Some years later Mr Hayward was in Naples to re-organise and catalogue the arms and armour collection of the former Bourbon Kings of the Two Sicilies. There he discovered a pair of pocket pistols of superb quality, also signed by Dolep and bearing the Medici arms. Subsequently, a small combination tool for firearms with the same signature and coat of arms was presented to the Royal Armouries in the Tower of London.

The obvious conclusion was that these arms must have formed part of a set which had been commissioned either by Charles II or William III for presentation to Cosimo III. Alternatively the latter, who visited England in 1669, having been acquainted with Dolep's craftsmanship, may have ordered these in subsequent years.

In his book *The Art of the Gunmaker* vol.II, published in 1963, Mr. Hayward commented 'The set was probably completed with a pair of holster pistols as well, which may yet be discovered in some public or private collection'. Ten years later the magnificent pair of holster pistols, well worthy of being a royal gift or a grand-ducal commission, was brought to Sotheby's.

An officer's bell top shako, of 1829–43
pattern of the Royal Artillery.
London £300 ($750). 21.II.72.

From the collection of the late W. J. Dear.

An officer's shapska of the 17th Lancers of
1828 pattern, the inside with a label with
George IV cypher signed *Cater Hatter and
Cap Maker to the King, the Dukes of York,
Clarence, Cumberland, Cambridge and
Prince Coburg, 60 Pall Mall, circa* 1829.
London £560 ($1,400). 15.XI.71.

From the collection of the late W. J. Dear.

A Milanese sallet, from the Missaglia
workshop, the back of the bowl struck
with three marks, apparently the crowned
M. of the Missaglia workshop, and the
AM in monogram, surmounted by a
device, of Antonio Missaglia, mid-15th
century.
London £12,500 ($31,250). 15.V.72.

From the collection of The Cranbrook
Academy of Arts, Bloomfield Hills,
Michigan, U.S.A.

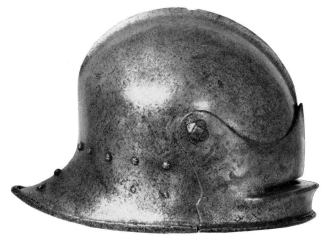

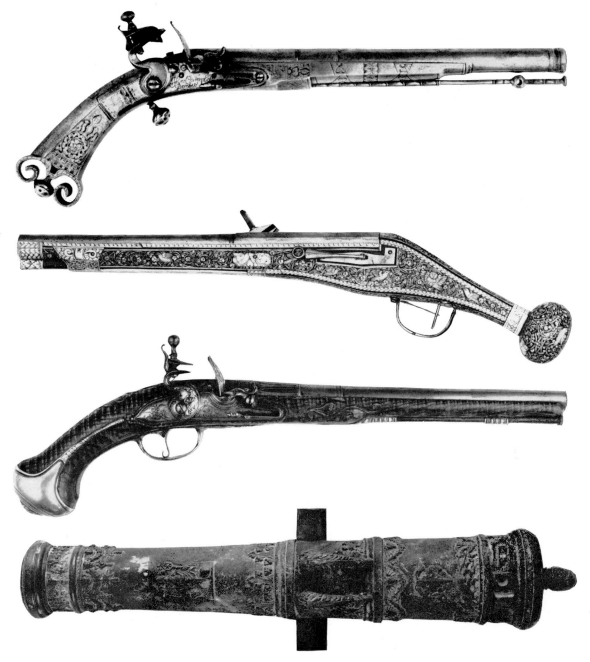

One of a pair of Scottish all steel flintlock belt pistols, signed *John Campbell Doune*, early 18th century, 16 in.
London £2,200 ($5,500). 15.v.72.

A large Saxon wheel-lock pistol, dated 1579, the stock profusely inlaid with staghorn. 24½ in.
London £3,400 ($8,500). 13.XII.71.

One of a pair of English silver mounted flintlock holster pistols, signed *I. Cosens*, *circa* 1670. 18¾ in.
London £4,000 ($10,000). 15.v.72.

A Renaissance bronze cannon, attributed to Hans Christoph Löffler of Innsbruck, the muzzle cast with a plaque of Fortuna after the engraving of the subject by Hans Sebald Beham of Nuremberg, 3rd quarter of the 16th century, 21⅝ in.
London £950 ($2,375). 15.v.72

Portrait Miniatures and Silhouettes

There has been a marked increase in the prices of miniatures this year, especially for the major artists of the eighteenth century. John Smart, one of the leading artists of this period, has broken his previous record of £2,300 when on the 5th June, Sotheby's sale of Fine Portrait Miniatures brought a new record price with a miniature of an unknown lady in Indian costume, which sold for £2,800. Other high prices in the same sale were £2,400 for a lady reputed to be the Countess of Effingham by Smart; Mrs Louisa Dent and her daughter Charlotte Maria Dent by George Engleheart £720; a self-portrait of the artist James Scouler £880. The portrait of a gentleman, by Thomas Flatman, £2,300; Mary Princess of Orange by John Hoskins, £3,000. The sale realised a total of £65,187.

Interest in the silhouette market has continued and on the 31st January a silhouette of a lady by the very rare artist, Lea of Portsmouth, fetched a record price of £380. Other high prices included £250 for a pair of silhouettes by John Miers.

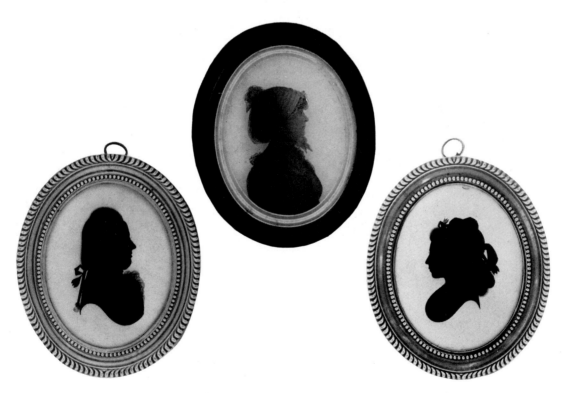

Left and right: A pair of silhouettes of a gentleman and a lady by John Miers, oval 3½ in. London £250 ($625). 31.i.72.

Centre: A silhouette of a lady by Lea of Portsmouth, signed, painted on convex glass with plaster backing, oval 4 in. London £380 ($950). 31.i.72.

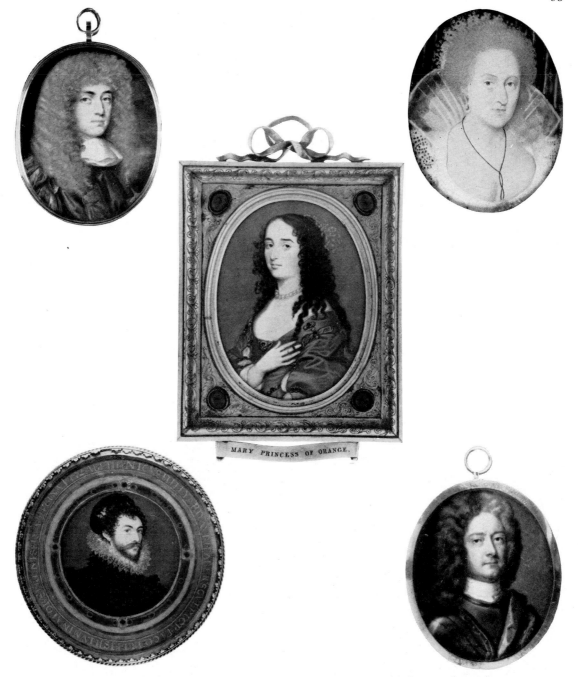

MARY PRINCESS OF ORANGE.

Above: A miniature of a gentleman by
Thomas Flatman, signed, oval 2¾ in.
London £2,300 ($5,750). 28.II.72.
From the collection of Mrs K. Kay.

Below: A portrait of the artist Nicholas
Hilliard, probably 18th century, circular
2¾ in
London £1,650 ($4,125). 18.X.71.

Above: A miniature of Queen Anne of
Denmark, by Isaac Oliver, signed, oval 2¼ in.
London £950 ($2,375). 18.X.71.

Below: A miniature of Thomas, Earl of
Pembroke, by Christian Frederick Zincke,
signed, oval 2¼ in.
London £620 ($1,550). 5.VI.72

Centre: A miniature of Mary, Princess of
Orange, by John Hoskins, signed, oval 3¼ in.
London £3,000 ($7,500). 5.VI.72.

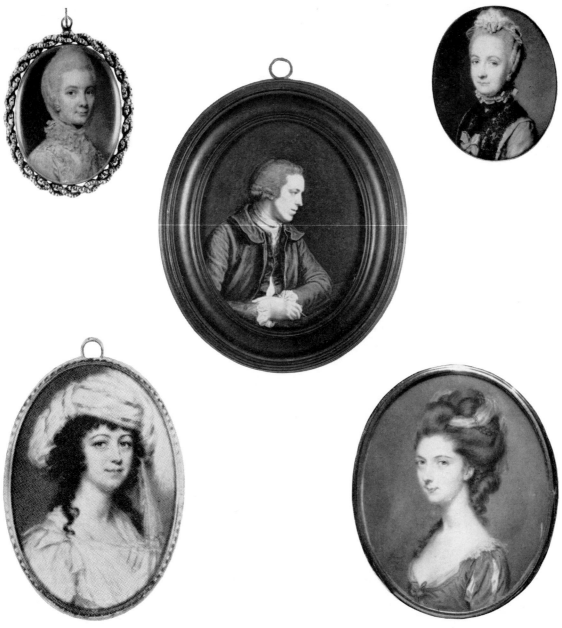

Above: A miniature of a lady called the Countess of Effingham, by John Smart, signed and dated 1770, mounted in a diamond bordered frame, oval 1½ in. London £2,400 ($6,000). 5.VI.72.

Below: A miniature of a lady by John Smart, signed and dated 1788 *I*, oval 2⅜ in. London £2,700 ($6,750). 5.VI.72.
From the collection of the late J. B. Milne.

Centre: A self-portrait of James Scouler, oval 4½ in. London £880 ($2,200). 5.VI.72.
From the collection of Miss Irene Howe.

Above: A miniature of Mrs Samuel Fludyer, *née* Caroline Brudenell, by John Smart, signed and dated 1760, oval 1⅝ in. London £2,250 ($5,625). 5.VI.72.

This superb miniature was painted by Smart when he was 17 years old and is among his earliest known works.

Below: Detail of a miniature of Mrs Robinson, by John Smart, signed and dated 1780, oval 2½ in., set in a tortoiseshell box. New York, $2,800 (£1,120). 16.XII.71.

The box contains the following note: 'Mrs Robinson-Perdita. Painted by order of the Prince of Wales and presented to Mrs Robinson. Afterwards in the possession of Sir Richard Wallace, and then in the collection of Lady Sackville.'

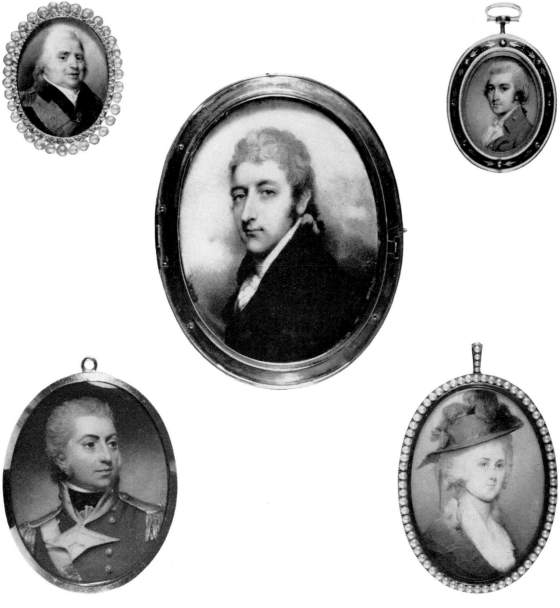

Above: A miniature of Louis XVIII by Jean Baptiste Isabey, signed, oval $1\frac{1}{2}$ in., pearl frame.
London £600 ($1,500). 28.II.72.

Below: An enamel miniature of an officer, by Henry Bone, signed, oval $2\frac{7}{8}$ in.
London £600 ($1,500) 28.II.72.

Centre: A miniature of Henry Bone by Andrew Plimer, oval $2\frac{3}{4}$ in.
London £380 ($950). 5.VI.72.

From the collection of Mr Hales-Tooke. Andrew's brother, Nathaniel, was assistant to Bone when the two brothers first came to London, while Andrew was employed as a servant to Richard Cosway in order to learn his methods as a miniature painter.

Above: A miniature of a gentleman by George Engleheart, mounted in a blue and white enamel and gold frame with diamonds, oval $1\frac{5}{8}$ in.
London £510 ($1,275). 28.II.72.

Below: A miniature of a lady by Jeremiah Meyer, in a split-pearl bordered frame, oval $3\frac{1}{4}$ in.
London £500 ($1,250). 28.II.72.

Jewellery

For the last two or three years, we have emphasised in these pages the rising market in coloured stones, and this season the prices paid for superb rubies, emeralds and sapphires were further evidence of this trend. The two magnificent sales in Zurich, which between them realised SF19,257,190 (£1,971,407; $4,928,519) contained some incomparable examples, greatest of which was an emerald and diamond necklace, which realised SF4,300,000 (£436,550; $1,091,370), one of the two highest prices ever paid at auction for jewellery.

This magnificent piece contained emeralds which are thought to have once been in the possession of Tsar Alexander II of Russia; the centre pear-shaped stone weighed 75·63 carats, and eight more emeralds weighed a total of 83·68 carats. In the same sale in November, a sapphire and diamond clip, the centre stone, of splendid colour, weighing 66·03 carats, fetched SF680,000 (£69,035; $172,589); the following May, a sautoir in rubies and diamonds by Cartier of London fetched SF670,000 (£67,000; $167,500). In New York in November, an emerald and diamond ring, the emerald weighing 34·40 carats, fetched $135,000 (£54,000).

All these prices, it should be stressed, are remarkably high, even for jewels of such great quality. The prices for fine diamonds have remained more stable, possibly because the flow to the market is so steady and carefully regulated. In contrast, the areas which have traditionally produced the finest rubies and sapphires, Burma and Kashmir, now yield only a very small number of top quality stones, and at present all the indications are that outstanding examples such as those offered this season, will become increasingly rare.

The finest emeralds now being mined in Columbia are of a completely different "material" to the so-called "Old Indian" stones, some outstanding examples of which were contained in the great necklace mentioned above. Although each type has its admirers, the "Indian" stones, whilst perhaps having more richness and depth of colour, sometimes lack the purity found in recently mined stones.

There is still a rising demand for the more unusual categories of stones, as demonstrated by the price of $19,000 (£7,600) paid for a cat's eye and diamond ring in New York. In London, there is an ever-increasing interest in 19th century jewellery, although very fine examples are naturally expensive, it is still possible to purchase a good representative piece for a reasonable sum, for instance the Victorian open quatrefoil diamond brooch sold in October for £650 ($1,625).

A sapphire and diamond manchette bracelet pierced in an architectural design.
London £33,000 ($82,500). 23.III.72.

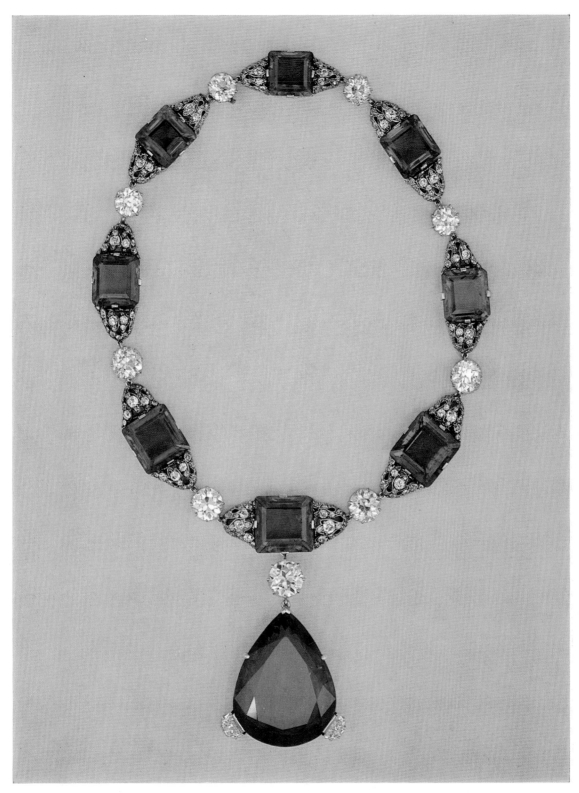

A necklace in emeralds and diamonds, most of the emeralds said to have belonged to a necklace originally in the possession of Tsar Alexander II of Russia. Pendant emerald 75·63 carats. Zurich SF4,300,000 (£436,550; $1,091,370). 24.XI.71.

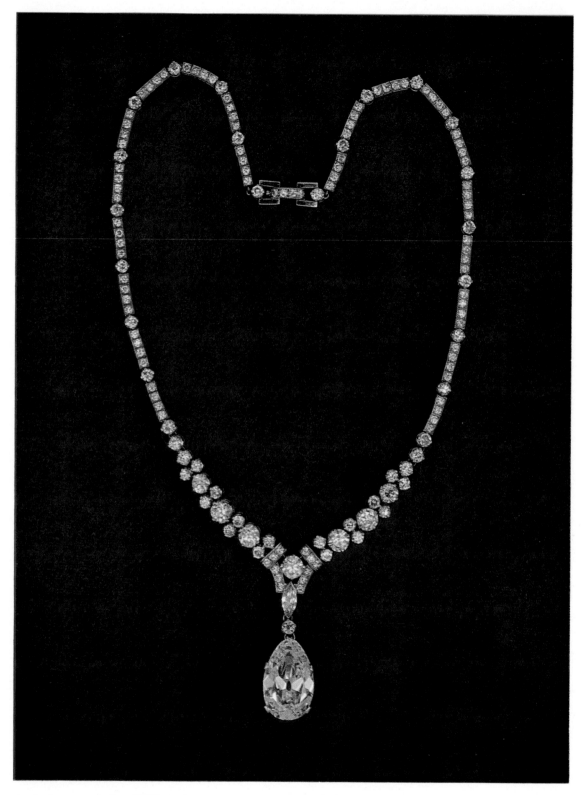

A platinum and diamond necklace, with a pear-shaped stone weighing 18·55 carats.
Zurich SF440,000 (£44,670; $111,675). 24.XI.71.

Below right: A clip in platinum, sapphires and diamonds in the form of a two-flower spray. Zurich SF58,000 (£5,888; $14,720). 24.XI.71.

Above right: A pair of earclips in platinum, sapphires and diamonds by Van Cleef & Arpels. Zurich SF145,000 (£14,720; $36,802). 24.XI.71.

Left: A sapphire and diamond two-stone dress ring by Cartier. Zurich SF40,000 (£4,060; $10,152). 24.XI.71.

Centre: A sapphire and diamond clip, the sapphire 66·03 carats mounted as the centre of a stylised diamond bow. Zurich SF680,000 (£69,035; $172,589). 24.XI.71.

A necklace in emeralds and diamonds, the emerald 12·62 carats. Zurich SF480,000 (£48,730; $121,827). 24.XI.71.
A pair of earclips in platinum, emeralds and diamonds, the two emeralds 16·20 carats. Zurich SF185,000 (£18,781; $46,955). 24.XI.71.

Above left: An emerald of oblong shape mounted as a single stone ring, by Cartier. 8·18 carats.
Zurich SF210,000 (£21,320; $53,300). 24.XI.71.
Centre: A bracelet in emeralds and diamonds, the seven emeralds weighing 42·19 carats.
Zurich SF1,050,000 (£106,600; $266,500). 24.XI.71.
Below right: An oblong emerald mounted in gold and platinum as a ring. 21·08 carats.
Zurich SF340,000 (£34,518; $86,295). 24.XI.71.

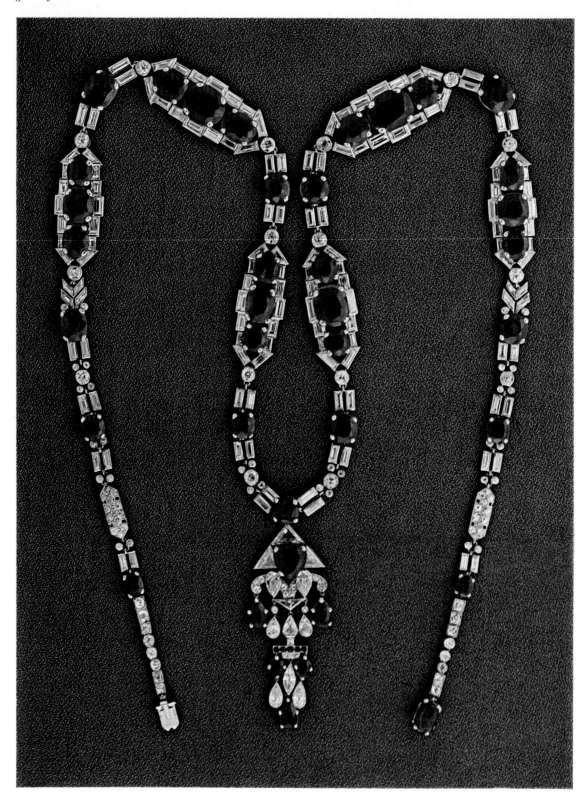

A sautoir in rubies and diamonds by Cartier, London. Zurich SF670,000 (£67,000; $174,025).
4.v.72.

A pair of early 19th-century diamond pendent earrings in the form of a pavé-set festoon.
London £4,200 ($10,500). 18.v.72. From the collection of Sir Montague Cholmeley.
A Victorian emerald and diamond brooch/pendant. London £4,600 ($11,040). 7.x.71.
From the collection of Mrs G. M. Campbell.
An emerald and diamond pendant brooch. New York $41,000 (£16,400). 17.XI.71.
A Victorian diamond stomacher brooch. London £2,500 ($6,250). 20.VII.72.
From the collection of the Rt Hon. R. W. F. A. Baron Gerard.
A Victorian diamond brooch of open quatrefoil design. London £650 ($1,625). 28.x.71.

A necklace in rubies, diamonds and platinum which divides to form other ornaments en suite.
Zurich SF580,000 (£58,885;$147,208). 24.XI.71.
A pair of ruby, diamond and platinum earclips.
Zurich SF110,000 (£11,167;$27,918). 24.XI.71.
A bracelet in rubies, diamonds and platinum, the six rubies weighing 25·35 carats.
Zurich SF210,000 (£21,320; $53,300). 24.XI.71.

1. A diamond ring with platinum mount. 16 carats. $80,000 (£32,000). 17.XI.71. **2.** A diamond pendant necklace, 30·95 carats. $190,000 (£76,000). 17.XI.71. **3.** A diamond ring with platinum mount, cut from the Jonker Diamond. 11·43 carats. $75,000 (£30,000). 9.XII.71. **4.** A diamond ring with platinum mount, 17 carats. $120,000 (£48,000). 26.IV.72. **5.** A diamond ring with a central emerald-cut diamond weighing approx. 13·25 carats. $52,000 (£20,800). 13.I.72. **6.** A diamond ring by Tiffany and Co. 13 carats. $89,000 (£35,600). 17.V.72 **7.** A 23·75-carat emerald and diamond ring by Van Cleef & Arpels. $80,000 (£32,000). 13.I.72. **8.** A cat's-eye (37·50 carats) and diamond ring. $19,000 (£7,600). 8.VI.72. **9.** A sapphire (34·60 carats) and diamond ring. $27,000 (£10,800). 17.XI.71. **10.** A sapphire (30·60 carats), emerald and diamond ring. $40,000 (£16,000). 17.V.72. **11.** An emerald (34·40 carats) and diamond ring by Winston. $135,000 (£54,000). 17.XI.71. **12.** An emerald (22 carats) and diamond ring. $55,000 (£22,000). 26.IV.72.

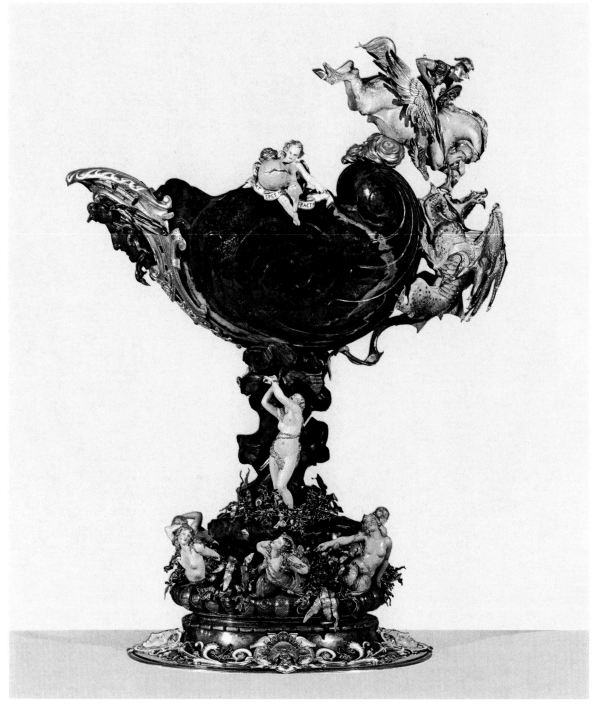

The Hope Vase.
A standing cup in jasper, gold and enamel by Jean Valentin Morel, Paris, 1855, in the form of a
nautilus shell. Height 26 in.
New York $20,500 (£8,200). 6.x.71.

Objects of Vertu

BY IAN VENTURE

Objects of vertu is a term used to describe a wide range of precious objects produced during the 18th and 19th centuries. The reason that this expression often mystifies the collector as well as the layman is probably that the word 'vertu' has altered its meaning somewhat in the last century. In the late 17th century a 'man of vertu' was a gentleman having a special interest in the fine arts and sciences, or a connoisseur who carried out such pursuits as a dilettante. It was not until the middle of the 18th century that small boxes and costly bijouterie were termed *objets de vertu* or *objets de vitrine* because of their size and beauty; they fall into a number of divisions: for example, snuff boxes, chatelaines, patch boxes, boxes for rouge and *étuis-à-cire*. By 1830 the objects produced throughout Europe took on a much heavier appearance so as not to be out of keeping with the more severe styles of dress of the day, which demanded larger and more flamboyant articles, such as jewelled desk ornaments and objects in varying techniques and styles, the most popular being made during the pre-Raphaelite revival, when these objects became imitative of the Renaissance period.

Towards the end of the 19th century, Peter Carl Fabergé the Russian goldsmith, whose family were descended from the Huguenots and had settled in Russia about 1845, produced many excellent works in an attempt to bring back the fashion and interest in small objects of vertu which had not been made since the end of the previous century.

Among the more interesting items sold this season was a very fine hardstone, gold and enamel standing cup, by Jean Valentin Morel, Paris 1855, called 'The Hope Vase'. The carved jasper bowl is mounted with an enamel figure of Perseus seated on the back of Pegasus and attacking a winged dragon, the pointed lip is applied with a chased head of Medusa surrounded by a gold and enamel foliate cartouche, and the stem has a figure of Andromeda shown chained to the rocks whilst the reverse shows Melusines among seaweed. Jean Valentin Morel (1794–1860) was a pupil of Vachette, the famous 18th century French gold box maker. A fine box by Adrien Maximilien Vachette, circa 1790–1800, set with panels of malachite within gold cagework mounts, was sold this season and realised £2,900. Another attractive object recently sold was a Louis XV gold and mother-of-pearl aide-mémoire, the covers and spine set with panels of mother of pearl applied with a gold cagework chased with putti among scrollwork; this object was sold for £1,700. An interesting agate bonbonnière made in Germany in the 18th century and carved in the form of a mouse fetched £1,600. Among the more recent items sold was a pair of 19th century Viennese silver and enamel urns decorated with classical inspired figures within elaborate foliate surrounds, which fetched £2,200, as well as a Viennese lapis lazuli and enamel Roc, a mythical bird with two dragon-like heads surmounted with a coronet, this realising £1,600.

1. Louis XV snuff box, Paris, 1757. $3\frac{1}{4}$ in. £1,400 ($3,500). 20.XII.71. **2.** Louis XV gold and enamel snuff box, Paris, 1774. $3\frac{1}{4}$ in. £1,500 ($3,750). 5.VI.72. **3.** Louis XV gold snuff box. Paris, 1743. 3 in. £1,700 ($4,250). 20.XII.71. **4.** Swiss gold and enamel watch and musical box, *circa* 1800. 3 in. £2,000 ($5,000). 20.XII.71. **5.** Louis XV gold and enamel snuff box, Paris, 1767. $2\frac{1}{2}$ in. £1,000 ($2,500). 5.VI.72. **6.** Swiss gold and enamel snuff box, early 19th C. $3\frac{1}{2}$ in. £880 ($2,200). 5.VI.72. **7.** Royal presentation gold snuff box set with miniature of Queen Victoria, *circa* 1840. $4\frac{1}{4}$ in. long. $5,000 (£2,000). 9.v.72.

8. George III gold and enamel snuff box, London, 1816. Maker's initials H.C. $3\frac{1}{4}$ in. £720 ($1,800). 5.VI.72. **9.** German hardstone bonbonnière, 18th century. $2\frac{1}{2}$ in. £1,600 ($4,000). 1.V.72. **10.** Gold and hardstone snuff box by Adrien Maximilien Vachette. Signed. Paris, *circa* 1800. $3\frac{1}{2}$ in. £2,900 ($7,250). 5.VI.72. **11.** Louis XV gold and mother of pearl aide-mémoire. Mid-18th century. $3\frac{1}{2}$ in. £1,700 ($4,250). 20.XII.71. **12.** Louis XVI two-colour gold snuff box, Paris, 1775. Maker Jean Baptiste Martine. $3\frac{1}{8}$ in. £750 ($1,875). 5.VI.72.

1. Art Deco gold and enamel minaudière by Van Cleef and Arpels. $3\frac{3}{4}$ in. £520 ($1,300). 20.XII.72. **2.** Silver-gilt, jade and coral boudoir clock. $3\frac{1}{2}$ in. $3,600 (£1,440). 29.IV.72. **3.** French lapis lazuli cigarette case. $3\frac{1}{2}$ in. long. $2,200 (£880). 29.IV.72. **4.** Gold, jade, lapis lazuli and enamel cigarette box by Cartier. $7\frac{3}{4}$ in. long $6,000 (£2,400). 29.IV.72. **5.** Gold-mounted hardstone photograph frame. 16 in. high. $7,750 (£3,100). 29.IV.72. **6.** Gold two-compartment cigarette box set with jade, by Cartier. $4,300 (£1,720). 29.IV.72. **7.** French Art Deco agate casket

mounted in gold, enamel and jewels, by Cartier. $8\frac{1}{2}$ in. $1,400 (£560). 16.XII.71. **8.** Cut-glass boudoir clock mounted in gold and enamel, by Cartier. $4\frac{1}{4}$ in. high. $1,100 (£440). 16.XII.71. **9.** Gold, hardstone and mother of pearl cigarette box by Cartier. $6\frac{1}{2}$ in. $10,000 (£4,000). 29.IV.72. **10.** Gold cigarette box set with sapphires and diamonds by Cartier. $7\frac{1}{4}$ in. $1,600 (£640). 16.XII.71. **11.** Gold and nephrite hand mirror by Cartier. 10 in. long. $1,300 (£520). 29.IV.72. **12.** Gold-mounted agate casket, by Cartier. $7\frac{3}{4}$ in. $10,000 (£4,000). 29.IV.72.

Left:
An Augsburg gold enamel and rock-crystal standing cup and cover.
Signed *J. J. Priester Pin. circa* 1700. Height 5⅜ in.
New York $3,000 (£1,200). 6.x.71.

Centre:
Viennese silver enamel and lapis lazuli two-headed Roc.
19th century. Height 26½ in.
New York $4,000 (£1,600). 6.x.71.

Right:
One of a pair of Viennese enamel urns decorated with allegorical scenes.
19th century. Height 18¼ in.
London £2,200 ($5,500). 5.VI.72.

Two Bilston enamel plaques.
Above: The Fortune Teller 7¾ in. £1,100 ($2,750).
Below: Watteau's *La Leçon d'Amour.* 7¾ in. £1,350 ($3,375).

From the collection of Miss E. Powell, sold at Sotheby's on 17th July, 1972.

Russian Works of Art

BY VICTOR PROVATOROFF

The ever-growing popularity of the icon is due to three factors: first its late recognition as an important work of art, second the need in this modern world for peaceful enjoyment and lastly the still relatively low prices. Whereas, only a few years ago, the bulk of the potential buyers at a public auction of icons consisted of dealers, the private buyer is now more prominent.

Many more icons were sold during the past season than in any of the previous years, both at Sotheby's in London and Parke-Bernet in New York. On the whole, prices were higher but there were icons offered in a very wide price range, from a few pounds to several thousands.

Of particular interest were a pair of small Stroganov school icons of the late 16th century (opposite page), perhaps the finest of their kind to come on the market. The colouring, the miniature-like precision of the painting were remarkable. The double-sided processional icon of *The Mother of God of the Sign* with *The Fiery Ascension of the Prophet Elijah* on the reverse (illustrated below), was impressive for its monumental dignity and laconic conception. It belonged to the 15th century Novgorod school. At Parke-Bernet highly decorative icons with elaborate rizas embellished with cloisonné enamels continued to have a strong following. The one of *The Vernicle* with a beautiful riza by Ovchinnikov (page 315) deserves attention. Of the earlier ones, that of *The Intercession of Pokrov* is a good example of the 16th century Novgorod-Pskov school (page 315).

Russian silver and, especially, Russian enamels more than continue to hold their appeal.

STROGANOV SCHOOL

Two icons, probably of a series of twelve, that were part of the Ryabushinsky Collection; believed to be the work of Ivan Sobol, a pupil of the Stroganov painter Prokopy Chirin. Late 16th century. $8\frac{3}{4}$ in. by $6\frac{3}{4}$ in.

Left: The Dormition of the Virgin. £3,000 ($7,500). *Right: The Descent into Hell.* £2,900 ($7,250).

From the collection of Ambassador Michele Lanza, sold at Sotheby's on 14th December 71.

Opposite page:

NOVGOROD SCHOOL

A double-sided processional icon painted with the Mother of God the Sign, the Virgin half-length, with Christ Emmanuel in the circular mandorla on her breast.

15th century. $22\frac{1}{2}$ in. by 20 in. (with handle $33\frac{1}{2}$ in.).

London £3,200 ($8,000). 14.XII.71. From the collection of His Excellency Ambassador Michele Lanza.

An icon of the Intercession of the Virgin, from the Novgorod-Pskov area.
Early 16th century. 29¼ in. by 21½ in.
New York $6,500 (£2,600). 1.XII.71.

An icon of the Vernicle,
covered in a gilded-silver
and enamel riza by Pavel
Ovtchinnikov, Moscow 1889.
16 in. by 13¼ in.
New York $7,300 (£2,920).
I.XII.71.

A Greek triptych of
Italo-Cretan origin.
16th century. 10 in. by 16 in.
London £560 ($1,400).
8.XI.71.

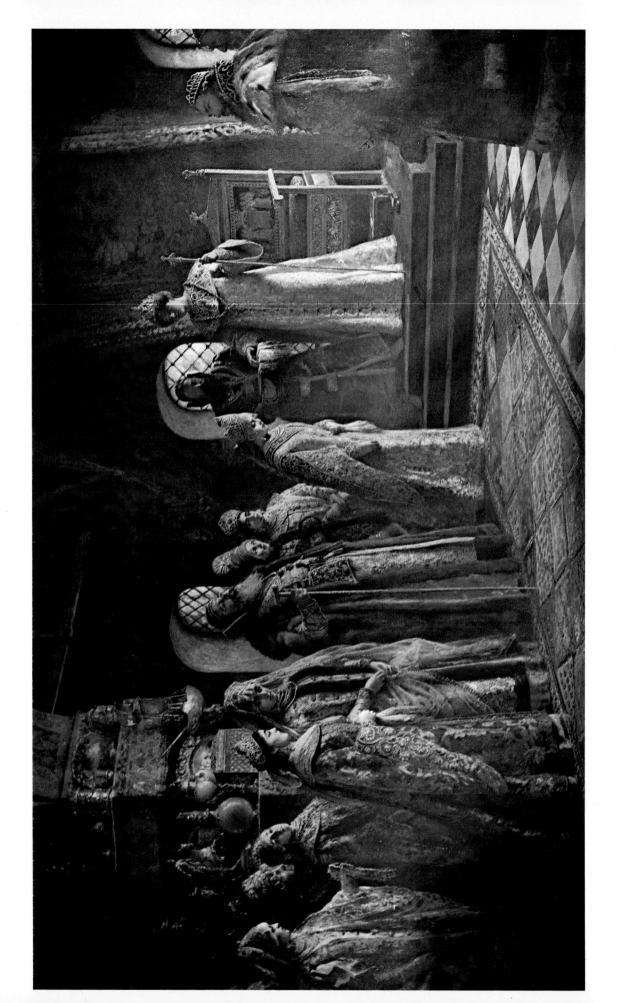

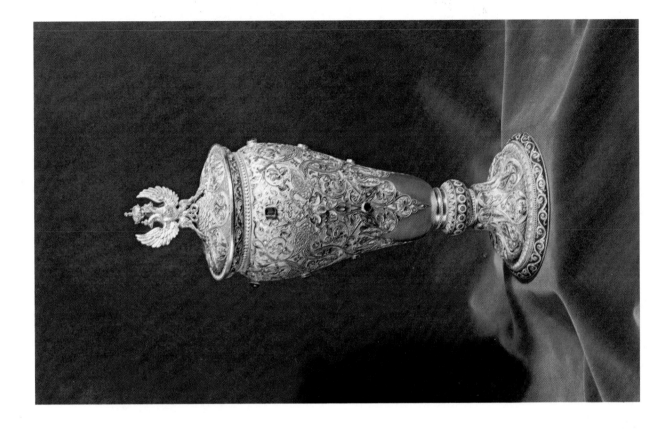

Opposite page :
CONSTANTIN MAKOVSKY
The choosing of the Bride.
Signed. 120 in. by 180 in.
New York $19,000 (£7,600). 1.XII.71.
This painting depicts the Tsar Alexei Michaelovitch receiving a group of young girls accompanied by the Boyar Boris Ivanovitch Morozov.

Right :
A Russian jewelled, gilded-silver and shaded enamel presentation covered goblet by Vasilii Agafonov.
Height 16 in.
New York $11,000 (£4,400). 27.IV.72.
This goblet was presented by the Dowager Empress Maria Feodorovna to Sir Edward Henry, K.C.V.O., C.S.C., as a souvenir of her visit to England.

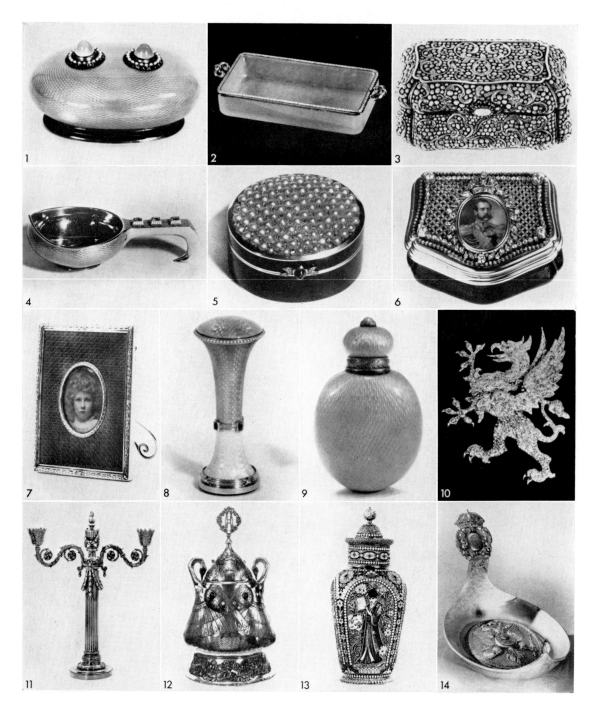

1. Fabergé silver and enamel bell push. Workmaster Henrik Wigström. $2\frac{1}{2}$ in. £500 ($1,250). 26.VI.72. **2.** Fabergé jewelled, bowenite miniature tray. Workmaster Henrik Wigström. 1 in. by $5\frac{1}{8}$ in. $7,500 (£3,000). 27.IV.72. **3.** Russian jewelled snuff box. $3\frac{1}{4}$ in. £1,350 ($3,375). 8.XI.71. **4.** Fabergé jewelled kovsh. Workmaster Michael Perchin. $1\frac{1}{8}$ in. by 4 in. $5,500 (£2,200). 30.XI.71. **5.** Fabergé gold and enamel snuff box. 1 in. by $1\frac{7}{8}$ in. $4,800 (£1,920). 30.XI.71. **6.** Russian gold and enamel snuff box. Mid-19th C. 3 in. £1,000 ($2,500). 8.XI.71. **7.** Fabergé photograph frame. Workmaster Michael Perchin. $3\frac{1}{8}$ in. £920 ($2,300). 8.V.72. **8.** Fabergé seal with monogram of Grand Duchess Tatiana Nicholaievna.

Workmaster Anders Nevalainen. $2\frac{1}{2}$ in. $3,100 (£1,240). 27.IV.72. **9.** Fabergé gold-mounted enamel scent bottle. Workmaster Michael Perchin. 2 in. £500 ($1,250). 8.V.72. **10.** Silver, gold and rose diamond griffin brooch. St. Petersburg, late 19th C. 3 in. high. $3,600 (£1,440). 30.XI.71. **11.** One of pair of Fabergé silver-gilt candelabra. $15\frac{3}{4}$ in. £1,900 ($4,750). 26.VI.72. **12.** Fabergé silver urn and cover. Height 22 in. £1,850 ($4,625). 8.V.72. **13.** Shaded enamel tea caddy by Orest Kurliukov. $8\frac{1}{2}$ in. by $3\frac{1}{2}$ in. $9,000 (£3,600). 30.XI.71. **14.** Silver presentation kovsh. Period of Peter the Great. $7\frac{1}{4}$ in. high by $12\frac{1}{2}$ in. long. $4,800 (£1,920). 30.XI.71.

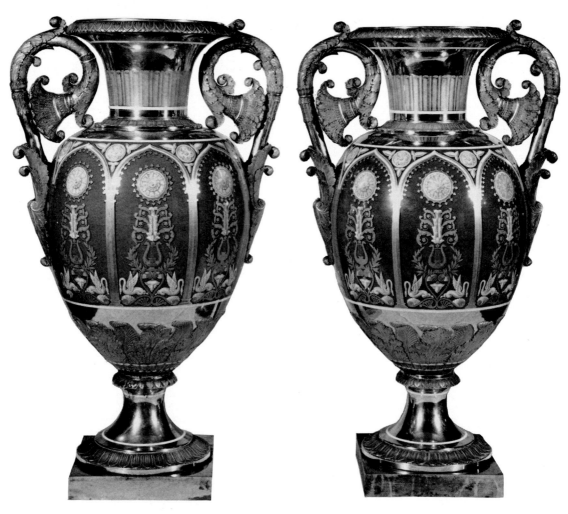

A pair of Russian Imperial porcelain palace vases in Neo-Egyptian taste, 1825–55.
Height 28½ in.; width 17 in.
New York $5,750 (£2,300). 30.XI.71.

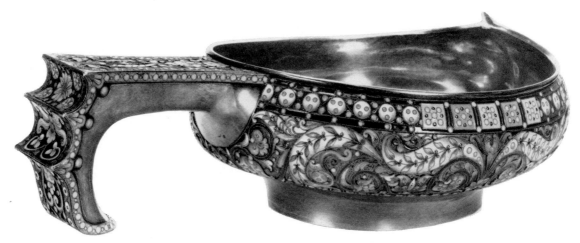

A silver-gilt and cloisonné enamel kovsh by Ovtchinnikov. 14¾ in.
London £3,000 ($7,500). 8.XI.71.
From the collection of Mrs. S. Kent.

Glass and Paperweights

There continues to be a scarcity of good English and Continental glass on the market, so that it is not easy to pin-point a definite trend. But the exception to this is perhaps the crizzled and footless decanter jug from the glass house of George Ravenscroft (fig. 1, opposite page), which was sold from the collection of Mrs Traudi Plesch in December 1971, so making its fourth appearance in these salerooms since the second World War. In December, 1947 it was found in a collection in North Wales, and in the enthusiasm of early post war collectors it fetched the then extravagant sum of £180. When it next appeared 13 years later in the collection of Sir Hugh Dawson in October 1960, its value had fallen to £160, mainly because a cache of Ravenscroft glass, some pieces marked with his device of a raven's head seal, had come to light in a minor London auction. In 1964 in the Donald Beves collection the price was the same. But in December 1971, it was sold for £570. Other high prices in the same sale were for two pieces from the Horridge collection dispersed in a country sale in 1959. One of these, here illustrated in colour, is a goblet enamelled by William Beilby of Newcastle with the arms of Couper impaling Gray. The 1959 price was £1,120 and the December 1971 price £3,100. The second piece was an Anglo-Netherlandish flute which rose from £560 in 1959 to £2,300 in 1971.

As for paperweights, the season has seen a steady rise in values from the low point of late 1969, as is shown by the colour plate.

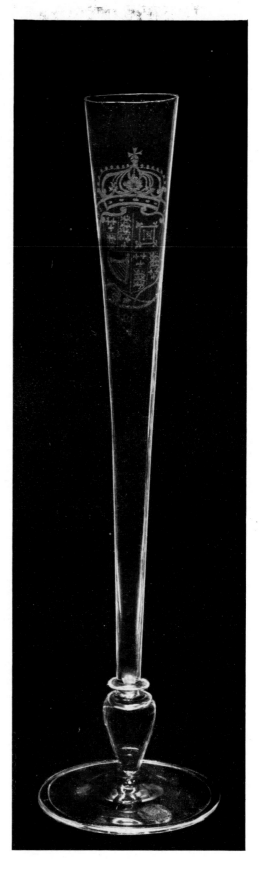

An armorial flute of soda glass, the bowl engraved with the arms of Charles II and James II, Dutch or English, *circa* 1660. Height 15½ in.
London £2,300 ($5,750). 6.XII.71.
From the collection of Mrs Traudi Plesch.

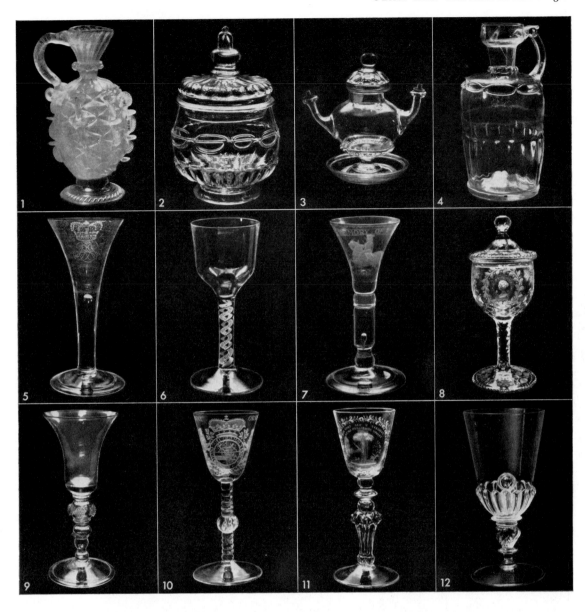

1. A Ravenscroft 'crissled' decanter jug, *circa* 1674, later gilt-metal foot and hinged lid, 8 in. £570 ($1,425). 6.XII.71. 2. A late 17th C. covered bowl, 6⅛in. £420 ($1,050). 6.XII.71. 3. A covered chamber lamp, 6in. £310 ($775). 19.VI.72. 4. A Ravenscroft decanter jug, *circa* 1685, 8½in. £900 ($2,250).6.XII. 71. 5. An 'Amen' glass dated March 6th, 1725, inscribed *To His Royal Highness*/PRINCE HENRY/*Duke of Albany & York*, commemorating the birth of Prince Henry. 7½in. £1,950 ($4,875) 19.VI.72. 6. A colour-twist goblet, 7¾in. £1,000 ($2,500). 10.IV.72. 7. A Williamite wine glass, inscribed

THE GLORIOUS MEMORY OF KING WILLIAM III, under his equestrian portrait, 5 15/16 in. £500 ($1,250). 24.I.72. 8. A parade goblet and cover, inscribed O FAIR BRITANNIA HAIL, 14in. £360 ($900). 10.IV.72. 9. A coin goblet containing a silver twelfth of an ecu of Louis XIV dated 1704, 9⅝in. £410 ($1,025). 6.XII.71. 10. An armorial wine glass of Newcastle type, inscribed VIVAT ORANIE above the arms of William IV of Orange, 7⅜in. £280 ($700). 1.XI.71. 11. A composite-stem wine glass, 7in. £220 ($550). 1.XI.71. 12. A large sealed goblet, glass of lead, 8⅜in. £1,250 ($3,125). 6.XII.71.

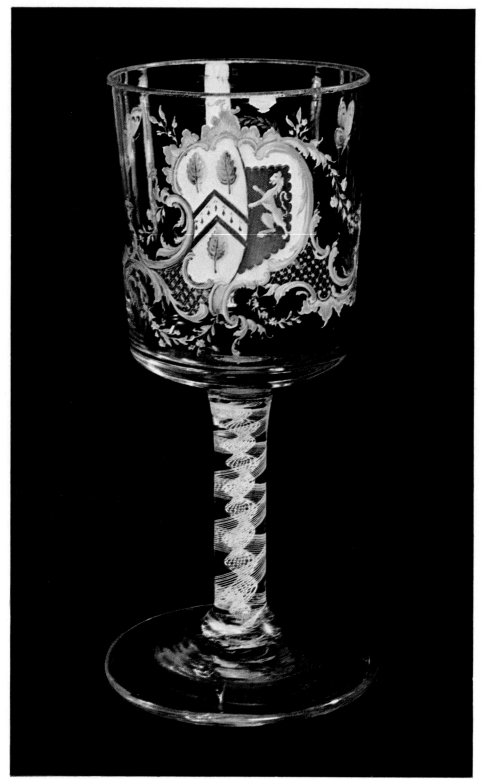

THE COUPER GOBLET

An enamelled armorial goblet by Beilby of Newcastle, bearing the arms of
Couper impaling Gray within a rococo cartouche. Height 8½ in.
London £3,100 ($7,750). 6.XII.71.
From the collection of Mrs Traudi Plesch.

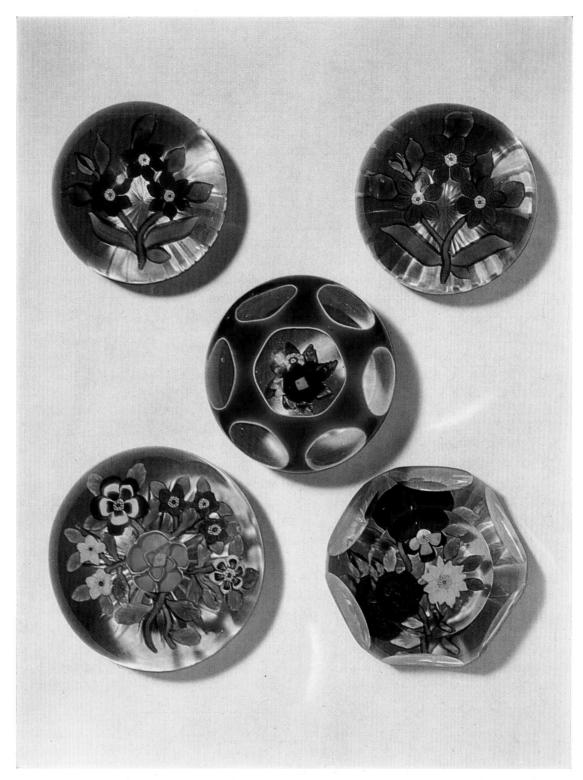

Above left: A Baccarat triple clematis weight. $2\frac{7}{8}$ in.
£1,100 ($2,750).
Above right: A Baccarat triple clematis weight. 3 in.
£1,450 ($3,625).
Centre: A St. Louis encased dark blue overlay weight. $3\frac{1}{8}$ in.
£2,600 ($6,500).
Below left: A Baccarat flat bouquet weight. $3\frac{5}{8}$ in.
£1,100 ($2,750).
Below right: A Baccarat flat bouquet weight. $3\frac{3}{8}$ in.
£1,450 ($3,625).
The paperweights illustrated on this page were sold in London on 10th July, 1972.

Silver

Fine pieces of 16th and 17th century silver reach the salerooms all too rarely these days. The result is that the demand for early silver is much greater than in the pre-1940 period when there were a greater number of important works of art on the open market which had not already passed into museum collections. This competition has been adequately illustrated twice this season by comparative prices.

On June 8th one of the finest and most widely represented collections of English silver to be sold recently was auctioned in 95 lots for £246,581. The most important lot deservedly fetched the highest price, £36,000. This was the Sutton cup, a magnificent Elizabeth I cup and cover of silver-gilt and rock crystal attributed to the maker Isaac Sutton, London 1573. It was previously sold at Sotheby's only 15 years ago for a mere £2,500. The second item which also showed an increase was the Cunliffe Cup, a James I steeple cup and cover, maker's mark T.C. 1616–17 which was sold in 1946 for £950 and realised £10,000 in June.

Also included in the sale was a superb silver-gilt twelve sided porringer, 1661, with maker's mark I.N. a bird below which fetched £26,000. Such simplicity and yet fine quality in a piece of silver made just after the Restoration is rare. Other lots of interest were two that once belonged to the famous George Booth, 2nd Earl of Warrington. A pair of silver-gilt chargers by David Willaume, 1742, fetched £7,200 whilst a shaped circular salver of simple form but weighing 42 oz. 4 dwt. and measuring only $10\frac{3}{4}$ in. in diameter fetched a staggering £3,800.

Earlier in the season a sale on April 20th included silver from various owners. A rare set of six James II single-light wall sconces, 1687, from the collection of the late William, Lord Hylton was sold for £26,000. A fine silver-gilt cup and cover with salver on foot *en suite*, engraved with the arms of the South Sea Company and made in 1715, at a time when the company was still on the crest of the wave and presumably well able to afford fine board room plate, fetched £7,800. The continuing demand for outstanding pieces of Irish silver was again shown by the last lot in the sale which made £7,000; this consisted of an extremely rare pair of small cups of tumbler type by Robert Goble of Cork *circa* 1680. They came from the collection of Mrs E. L. Sarsfield who is a descendant of Patrick Sarsfield, the celebrated General of James II, the cups were thought to have belonged to his sister's father-in-law because of the engraved armorials.

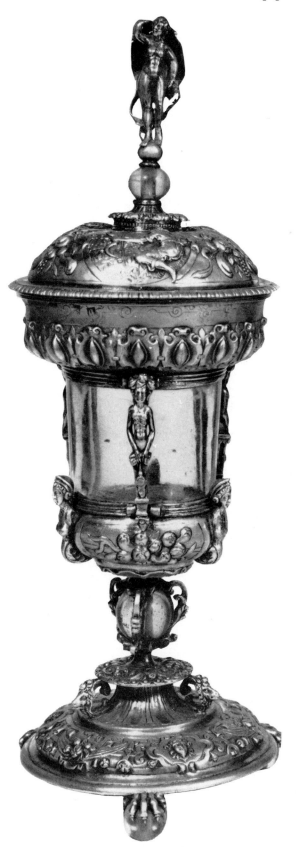

The Sutton Cup, of silver-gilt and rock-crystal, the bowl enclosed by three caryatid figures. Fully marked on lip, foot and cover. Maker's mark *S* on a cross, probably for Isaac Sutton. London, 1573. Height 10½ in.
London £36,000 ($90,000). 8.vi.72.
Previously sold at Sotheby's 27th June 1957 for £2,500 ($7,000).
This cup, though smaller and later in date, can be compared with the Bowes Cup of 1554, which is in the collection of the Goldsmiths' Company.

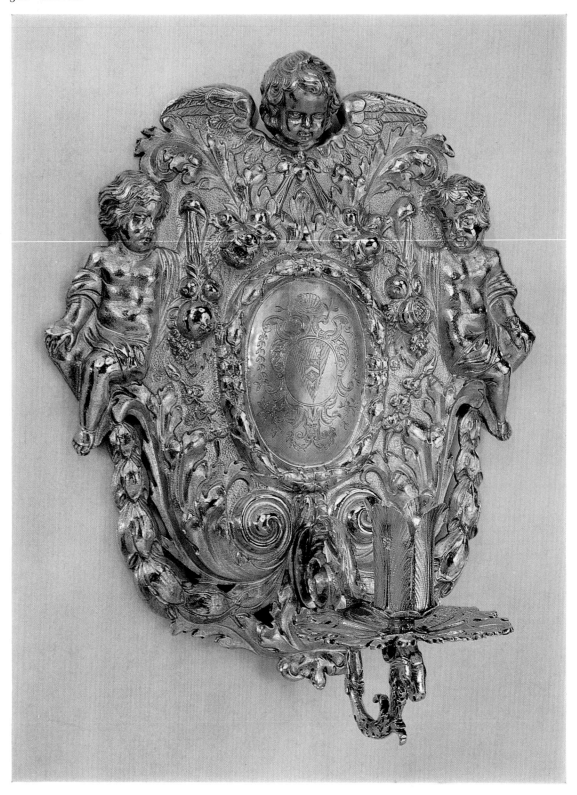

One of a set of six James II single-light wall sconces, engraved with armorials and other motifs and flanked by a pair of seated cherubs.
Maker's mark *T.I.*, London 1687. Height 12½ in.
London £26,000 ($65,000). 20.IV.72.
From the collection of the late William, Lord Hylton.

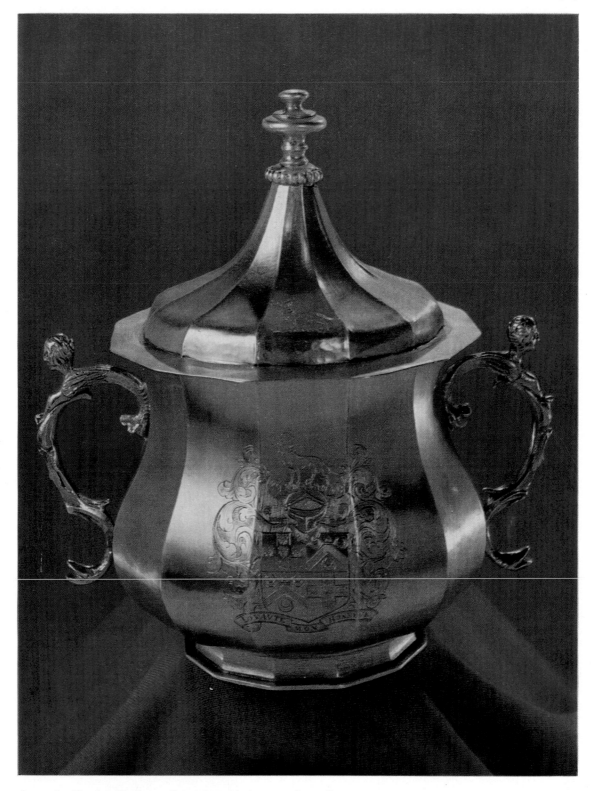

An early Charles II silver-gilt twelve-sided covered porringer.
Maker's mark *I.N.* with a bird below in a heart-shaped shield. London 1661.
Height 9 in., diameter of bowl 5 in.
London £26,000 ($65,000). 8.vi.72.
The arms engraved on the porringer are those of Sir Edward Walker, Kt., Garter King of Arms, who died in 1676.

A pair of late 17th-century Irish provincial cups of tumbler type, engraved with contemporary armorials, by Robert Goble. Cork. *Circa* 1680. Diameter 4¼ in., height 2¾ in. London £7,000 ($17,500). 20.IV.72. From the collection of Mrs E. L. Sarsfield. The arms are those of Sarsfield, impaling another, probably Fitzgerald.

A Charles II silver tankard, the barrel engraved with a contemporary crest. Maker's mark *T.I.* London, 1671. Height 7¼ in. New York $6,000 (£2,400). 28.IV.72. From the collection of Jessie Woolworth Donahue.

A pair of Charles II silver-gilt ginger jars and covers, of baluster form derived from oriental ceramic vases. Maker's mark *I.B.* crescent below. London, 1675. Height 8¾ in. New York $14,000 (£5,600). 26.X.71.

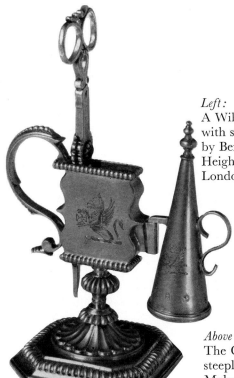

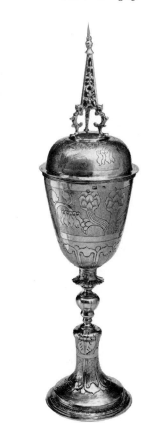

Left:
A William III snuffers stand, complete
with snuffers and extinguisher
by Benjamin Bradford. London 1698.
Height 5¼ in.
London £7,800 ($19,500). 8.vi.72.

Above right:
The Cunliffe Cup, a James I silver-gilt
steeple cup and cover.
Maker's mark *T.C.* London 1616/17.
Overall height 15¼ in.
London £10,000 ($25,000). 8.vi.72.
Previously sold at Sotheby's, 12th
November, 1946 for £950 ($3,829).

Below left:
An Elizabeth I parcel-gilt tankard, the
thumbpiece formed as a crowned lion's
mask flanked by animal supporters.
Maker's mark *G.A.* pellets above and
below in a shaped shield. London 1581
Height 7 in.
London £5,200 ($13,000). 20.iv.72.
Sold in London on the instructions of
the Vicar and Churchwardens of St
James the Great, Longdon, Staffordshire.

Right:
A Queen Anne Irish wine jug engraved
with the contemporary arms and
supporters of Queen Anne.
By Thomas Bolton. Dublin, 1702.
Height 12½ in.
London £7,000 ($17,500). 8.vi.72.
Previously sold at Sotheby's on 1st
February 1951 for £550 ($1,540).

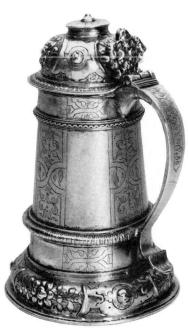

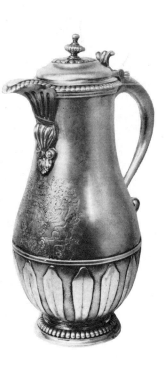

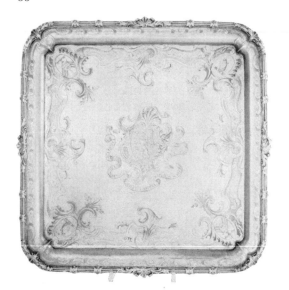

A George II square salver engraved
with a contemporary coat of arms and a
Latin inscription, by Paul de Lamerie,
London, 1735. 15 in. square.
London £6,800 ($17,000). 8.vi.72.

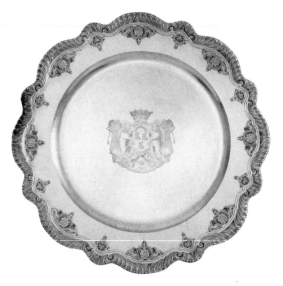

One of a pair of George II silver-gilt chargers
engraved with the coat of arms, supporters
and motto of Booth, Earl of Warrington,
by David Willaume Jr., London, 1742.
Diameter 24 in.
London £7,200 ($18,000). 8.vi.72.

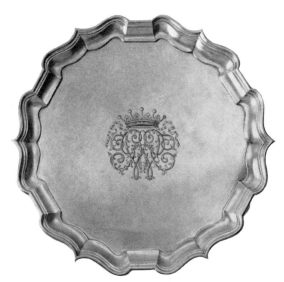

A George II salver engraved with the
foliate monogram G.W., George Booth,
2nd Earl of Warrington, by Peter
Archambo, London. 1732.
Diameter 10¾ in.
London £3,800 ($9,500). 8.vi.72.

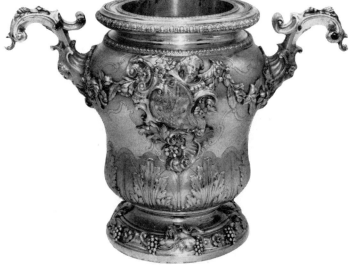

One of a pair of George III wine
coolers in Louis XV style by Paul Storr.
London, 1813.
Fully marked. Height 10 in.
London £5,800 ($14,500). 22.vi.72.
From the collection of Admiral Sir F.
Dalrymple-Hamilton, K.C.B., D.L.

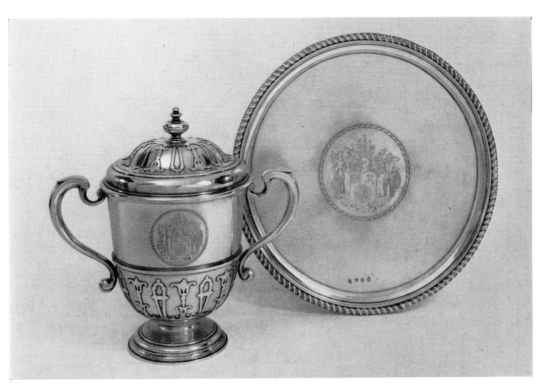

A George I silver-gilt two-handled cup and cover with salver on foot *en suite*, engraved with the arms of the South Sea Company, by Thomas Farren, London, 1715.
The cup: height 11 in.; the salver: diameter 14¼ in.
London £7,800 ($19,500). 20.IV.72. From the collection of Major F. M. H. Leyland.

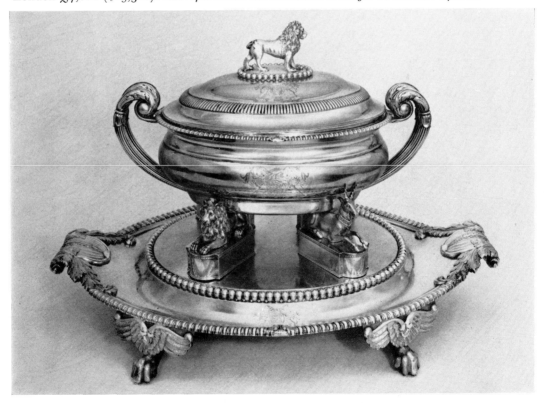

One of a pair of George III soup tureens, covers and stands, by Digby Scott and Benjamin Smith, London, 1806. Width 23½ in.
London £6,800 ($17,000). 22.VI.72.
From the collection of Admiral Sir F. Dalrymple-Hamilton, K.C.B., D.L.

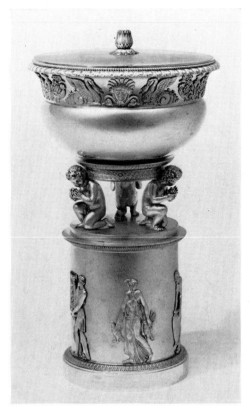

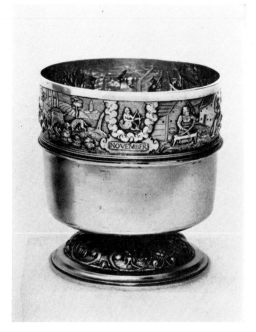

One of a pair of late 16th century German silver-gilt Monatsbecher engraved with scenes depicting agricultural activities. Maker's mark *G.P.*, Augsburg, *circa* 1580. Height 3¼ in.
London £4,200 ($10,500). 20.IV.72.

A French Empire silver-gilt sugar-bowl, cover and stand, the bowl supported on three kneeling *putti*, by Jean-Baptiste-Claude Odiot.
Paris. 1809–19. Height 11 in.
New York $5,750 (£2,300). 26.X.71.
From the collection of Mr and Mrs Donald W. Clarke.

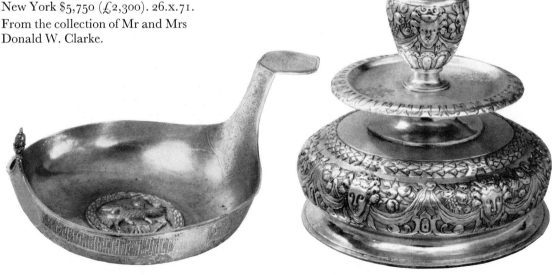

A 17th-century Russian parcel-gilt *kovsh* of boat shape.
Contemporary inscription dated 1683.
Width 14¼ in. (over handle).
London £2,600 ($6,500). 20.IV.72.

One of two matching South German candlesticks engraved with contemporary armorials. Probably Augsburg, *circa* 1590–1601. Height 7¼ in.
London £3,000 ($7,500). 20.IV.72.

A pair of George III sugar tongs from the family
of George Washington, by Robert Cox. London,
circa 1755. Length 4½ in.
New York $3,750 (£1,500). 28.1.72.

An American silver flat-top tankard by
Thauvet Besley, engraved with the
initials I.H.I.
New York, *circa* 1730. Height 7 in.
New York $7,500 (£3,000). 28.1.72.

An American silver porringer with the
contemporary monogram J.M.D., by
Paul Revere.
Boston, *circa* 1790. Diameter 5½ in.
New York $11,000 (£4,400). 28.1.72.
From the collection of F. David Mathias,
Montreal.

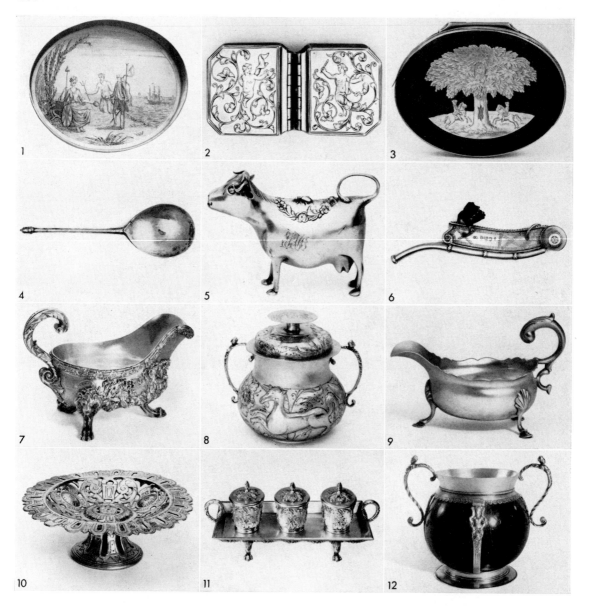

1. George III gold Newcastle freedom box, by Langlands and Robertson. *Circa* 1780. Width 4 in. £3,600 ($9,000). 20.IV.72. **2.** Late 17th-century two-division spice box. Marked *F.S.* crown above, small *s* below. *Circa* 1690. Width 2½ in. £440 ($1,100). 11.XI.71. **3.** A "Boscabel Oak" snuff box. *Circa* 1700. Width 3¼ in. £480 ($1,200). 3.II.72. **4.** Acorn knop spoon. Probably early 15th century. £440 ($1,100). 2.XII.71. **5.** Early George III cow cream jug, by John Schuppe. 1768. Width 5¾ in. £900 ($2,250). 2.XII.71. **6.** George III boatswain's whistle by Hester Bateman, 1784. Length 5½ in. £560 ($1,400). 2.XII.71. **7.** One of a pair of George III sauce boats, by Paul Storr.

1818. 8¾ in. £3,600 ($9,000). 22.VI.72. **8.** A Charles II porringer, maker's mark I.H. probably Salisbury area. *Circa* 1665. Height 6¼ in. £2,100 ($5,250). 21.X.71. **9.** One of a pair of American silver sauce boats by Thomas Shields, Philadelphia. *Circa* 1770. Length 7 in. $5,250 (£2,100). 19.V.72. **10.** James I sweetmeat dish in Portuguese style. Maker's mark *C.B.* in monogram, 1619. Diam: 6½ in. £1,550 ($3,875). 20.IV.72. **11.** Royal christening present of George III, a silver-gilt inkstand, by Digby Scott and Benjamin Smith. 1803. Overall width 14 in. £6,500 ($16,250). 8.VI.72. **12.** Coconut cup with Commonwealth York silver mounts, by John Plummer, 1653. 5¾ in. £3,600 ($9,000). 22.VI.72.

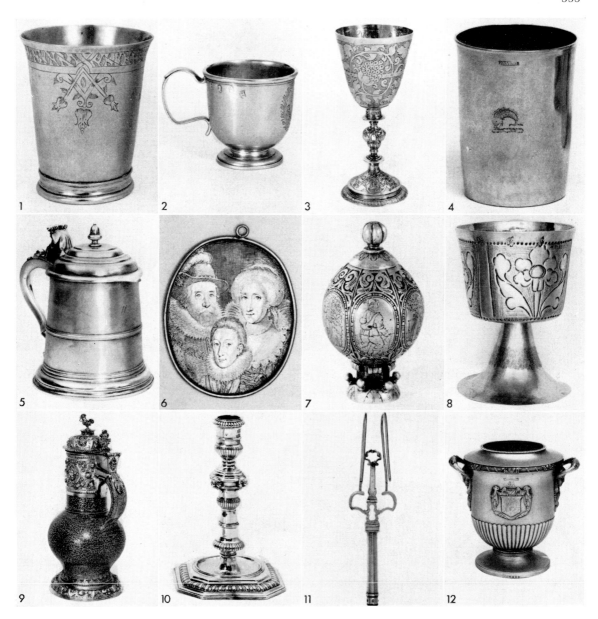

1. Commonwealth provincial beaker, by Thomas Waite. York, 1655. Height 3½ in. £1,200 ($3,000). 3.11.72. **2.** George I stirrup cup, by John Chartier. 1714. Height 2¼ in. £700 ($1,750). 8.VI.72. **3.** James I silver-gilt wine cup. Maker's mark *A.B.* conjoined. 1606. Height 8 in. £4,200 ($10,500). 8.VI.72. **4.** One of three American silver beakers, by Paul Revere, Jr. Boston *circa* 1790. One unmarked. Height 3¼ in. $12,000 (£4,800). 13.XI.71. **5.** George I silver tankard by William Ged. Edinburgh, 1715. Height 8 in. £1,550 ($3,875). 3.11.72. **6.** Silver-gilt medallion by Simon de Passe, engraved with royal portrait busts. Signed *S.P.* 1615–22. Height 2½ in. £680 ($1,700). 21.X.71. **7.** German

spherical pomander. *Circa* 1670. Height 2 in. £450 ($1,125). 21.X.71. **8.** Charles II provincial wine cup by Thomas Dare, Taunton, *circa* 1675. Height 3½ in. £2,000 ($5,000). 2.XII.71. **9.** Tigerware jug with silver-gilt mounts. Makers mark a millrind. 1580. Height 10 in. £1,450 ($3,620). 20.IV.72. **10.** One of four William III Irish candlesticks, by Anthony Stanley. Dublin, 1696–9. Height 8½ in. £6,200 ($15,500). 22.VI.72. **11.** George II Irish toasting fork. Dublin, *circa* 1730. Length 43¼ in. £1,100 ($2,750). 22.VI.72. **12.** One of a pair of George III silver wine coolers, by Digby Scott and Benjamin Smith. London, 1804. Height 10 in. $4,700 (£1,880). 2.VI.72.

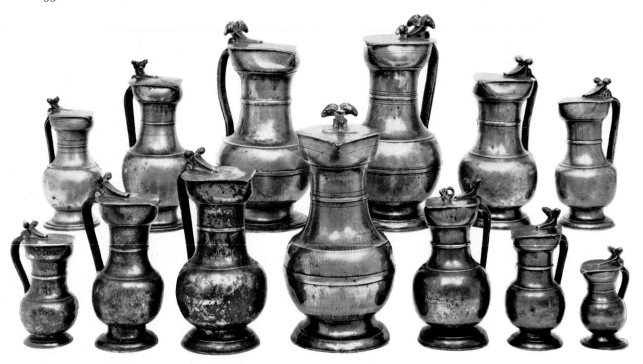

A collection of thirteen pewter measures, some by the 19th century maker Paolo Giuseppe Maciago, the 18th century makers Pierre Roze, Jean Antoine Charton of Geneva, Nicolas Paul of Geneva, and I. Alvazzi.

Sold at Sotheby's for a total of £2,657 ($6,642) on 25th October 1971.

From the collection of Mrs. C. E. Burgess.

A double-handled pewter loving cup, maker's mark *IL* struck three times, *circa* 1700.
Height 5¾ in., diameter 6½ in.
London £670 ($1,675). 25.x.71.

A pair of American pewter chalices by Peter Young, Albany, New York, *circa* 1784, engraved
RBDC – Boght – 1784. Height 8¼ in.
New York $5,250 (£2,100). 13.XI.71.

Furniture

On October 23rd, Parke-Bernet sold some magnificent French furniture and works of art from the estate of the late Martha Baird Rockefeller. This included two master-pieces, the Louis XV marquetry table presumed to have belonged to Madame de Pompadour, signed by Jean-François Oeben and his brother-in-law Roger Vander-creuse called Lacroix, and a similar table signed by Oeben alone; these fetched $410,000 (£164,000) and $270,000 (£108,000) respectively. Both had been included in the great Elmer Gary sale held in April, 1928, in New York at the American Art Association which was to become Parke-Bernet, when they were bought by Lord Duveen for $71,000 (£14,200), then an American auction record price for French furniture, and $28,000 (£5,600).

Although these were the most remarkable lots, the Rockefeller sale contained other fine pieces; a large and sumptuous Louis XV *bureau plât* fetched $37,500 (£15,000), a rare Louis XV black lacquer *bureau plât* by Jacques Dubois realised $16,000 (£6,400), while a Louis XV *secrétaire cabinet* and matching *secrétaire à abattant* were sold for $30,000 (£12,000) each.

In London the following month, a very beautiful ormolu-mounted Louis XVI black lacquer *secrétaire à abattant* by J. H. Riesener fetched £72,000 ($180,000). Like the two major Rockefeller pieces, this too had an auction history. Together with the famous matching *secrétaire* and *commode* now in the Metropolitan Museum, this piece was purchased by Cornelius Vanderbilt for £5,460 ($28,300) after the great Hamilton Palace sale of 1882. The mounts of this piece are particularly impressive, with a large central bas-relief ormolu medallion sculpted by Clodion; the remainder of the ormolu is attributed to Pierre Gouthière.

The finest piece of American furniture to appear in the saleroom this season was the Chippendale carved mahogany five-leg gaming table which fetched $25,000 (£10,000) in the American Heritage sale in November. The apron and cabriole legs showed the detailed carving so typical of New York cabinetmakers. The same sale contained a rare Queen Anne walnut highboy from Salem, Massachusetts, one of the finest of only twelve known examples of Salem highboys, which fetched $18,000 (£7,200).

In the field of English furniture where, as in French, prices continued to rise, a pair of George II giltwood tables attributed to Thomas Johnson, fetched £9,500 ($23,750) in London in December. Johnson flourished around the middle of the 18th century and is renowned for the exuberance of his carving – he was a specialist carver rather than a cabinetmaker. His best known work is the set of designs for *Twelve Gerandoles*, first published in 1755, and considered amongst the finest achievements of the English rococo.

In the last sale of the season at Sotheby's a very rare George I red-japanned bureau-cabinet, decorated with scenes in Chinese and Japanese taste, fetched the remarkably high price of £12,000 ($30,000).

Opposite page:
JEAN-FRANÇOIS OEBEN
A Louis XV kingwood and mahogany marquetry writing table. The shaped sliding top decorated with a panel of superb floral marquetry in various natural and stained woods, on a mahogany ground within a cross-banded kingwood border with an ormolu rim. Height 2 ft. 4 in.; width 2 ft. 7¼ in.
New York $270,000 (£108,000). 23.x.71.
From the collection of the late Martha Baird Rockefeller.

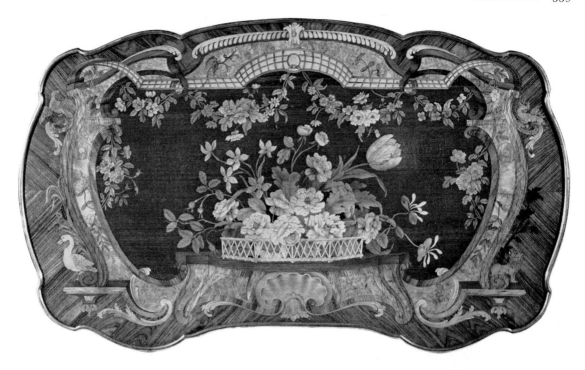

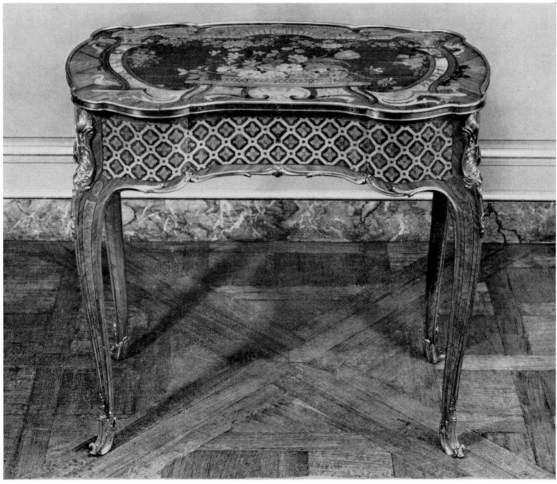

Right:
A George III satinwood and harewood demi-lune commode, probably Irish.
Height 2 ft. 10 in.; width 3 ft. 10 in.
New York $8,250 (£3,100). 29.IV.72.
From the collection of the late Jessie Woolworth Donahue.

Below:
An early 19th century painted Italian cistern, in painted metal and gilded wood.
Height 5 ft. 5½ in.; width 6 ft. 7 in.
London £1,150 ($2,875). 3.III.72.
From the collection of Miss Lavender Trevor.

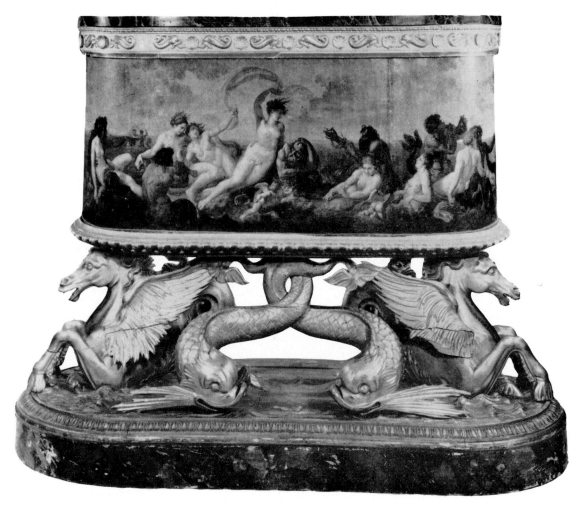

A Louis XV style *bureau à cylindre*, in the manner of J. H. Riesener.
Height 5 ft. 1 in.; length 5 ft. 11 in.
Los Angeles $12,000 (£4,800). 14.IV.72.
The original Louis XV *Bureau du Roi* by Jean Henri Riesener, which is now in the Musée du Louvre in Paris, was completed in 1769. Emperor Napoleon III gave permission for the bureau to be copied; however, the *Garde Meuble* stipulated that each model must vary from the original in noticeable detail and size, and that no bronze mount actually could be cast from the original. It is recorded that F. Linke completed one version of the bureau for the Paris Exhibition of 1878.
Of the five known copies, the last to appear on the market, was sold in London in July 1937, the property of Grand Duke Paul of Russia. An almost identical version of this piece is illustrated in the Catalogue of the Wallace Collection, London, plate 71, f. 460.

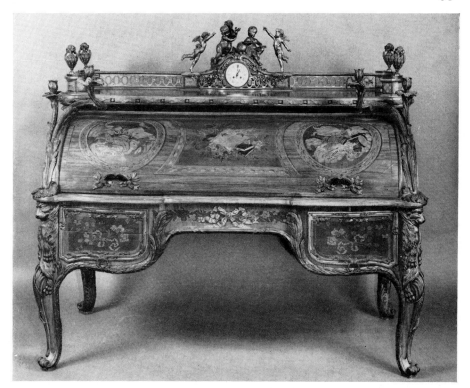

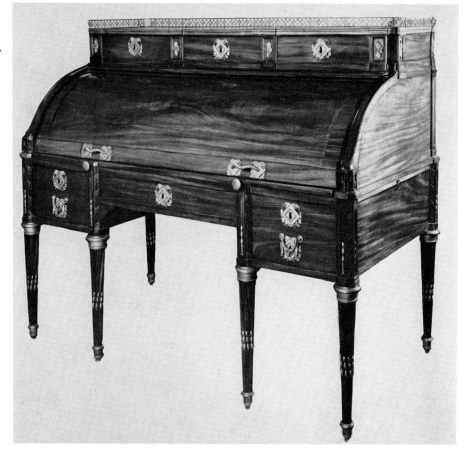

A late Louis XVI *bureau à cylindre*, the superstructure with a trellised gallery with three drawers, the frieze with three drawers on spirally fluted legs and ormolu mounts.
Height 4 ft. 6 in.; width 5 ft. 2 in.; depth 2 ft. 10 in.
London £7,000 ($17,500). 19.V.72.

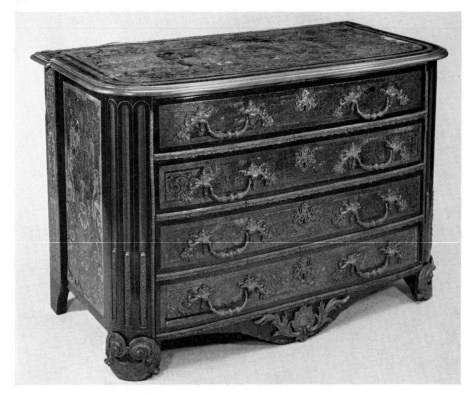

A late Louis XIV *boulle* commode with slightly bowed front, shaped apron, and fluted corners continuing to shaped feet faced with massive scroll mounts.
Width 4 ft. 2 in.
London £3,600 ($9,000).
19.V.72.

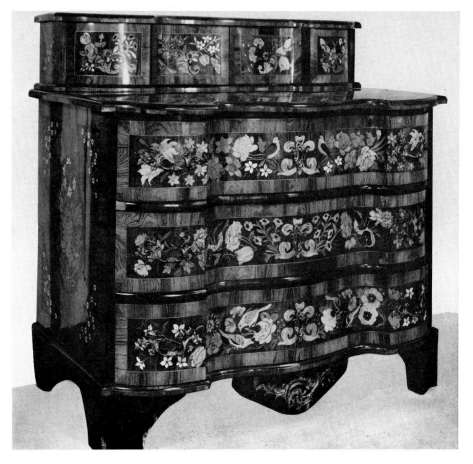

One of a pair of early 18th-century German or Dutch marquetry commodes inlaid with various woods and ivory, on a kingwood ground, with pewter stringing.
Height 3 ft. 5½ in.; width 3 ft. 7 in.
London £3,000 ($7,500).
22.V.72.
From the collection of the late Sir Humphrey de Trafford, Bart.

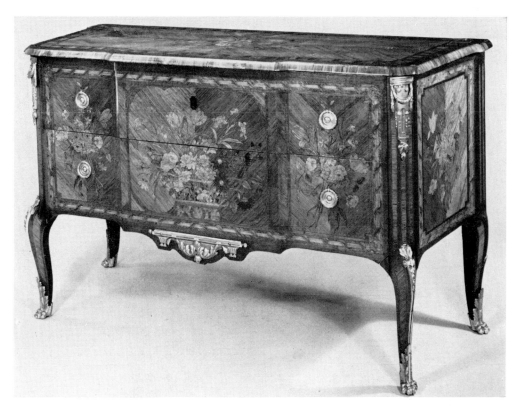

A late Louis XV/XVI transitional parquetry commode attributed to J. F. Oeben, with an inlaid top and cabriole legs, the whole mounted in ormolu. Height 2 ft. 11 in.; width 4 ft 10 in. London £3,400 ($8,500). 19.v.72. From the collection of the late Lord Marks.

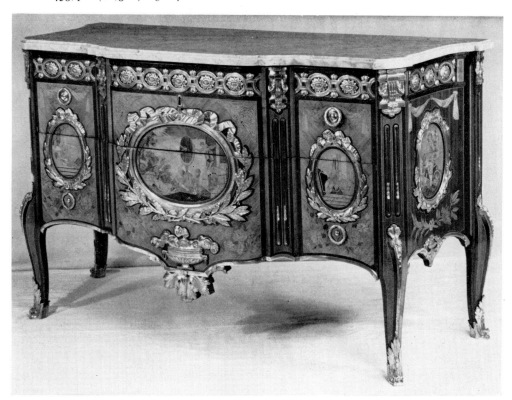

A Louis XVI ormolu-mounted marquetry breakfront commode with a white marble top, inlaid with three oval marquetry allegorical panels on the front and similar panels on the sides. Signed *P. A. Foullet*, *JME*. Height 2 ft. 10½ in.; width 4 ft. 9½ in.
Pierre Antoine Foullet was received Master in 1765.
London £6,800 ($17,000). 22.v.72. From the collection of the late Sir Humphrey de Trafford, Bart.

A George I carved and giltwood console table in the manner of William Kent, with a red and green veined marble top.
Height 3 ft. 1 in.; width 5 ft. 8 in.
London £5,300 ($13,250). 5.XI.71.
From the collection of the late Viscount Chandos, K.G., D.S.O., M.C.

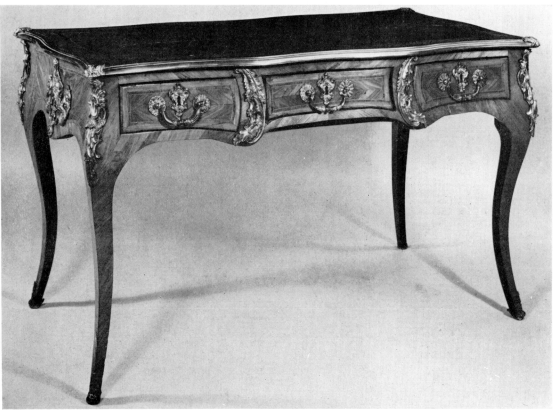

An ormolu-mounted Louis XV serpentine *bureau plât* stamped *J. C. Ellaume JME.*
Height 2 ft. 6 in.; width 4 ft. 3 in. London £3,000 ($7,500). 19.V.72.
Jean-Charles Ellaume or Allaume, was received Master in 1754.

One of a pair of Louis XVI carved and painted oak consoles, with *breccia* marble tops.
Height 2 ft. 11¼ in.; width 5 ft. 2½ in.
New York $6,900 (£2,760). 5.11.72.
From the collection of the late Marion T. Allen.

A George III satinwood side table, the D-shaped top with a metal rim.
Height 3 ft. 3 in.; width 5 ft. 2 in.
New York $4,750 (£1,900). 16.x.71.
From the collection of the late Martha Baird Rockefeller.

One of a pair of George II giltwood console tables, with *brèche violette* marble tops. Attributed to Thomas Johnson.
Height 2 ft. 10 in.; width 3 ft. 3 in.
London £9,500 ($23,750). 10.XII.71.

From the collection of the Most Hon. The Marquess of Waterford.

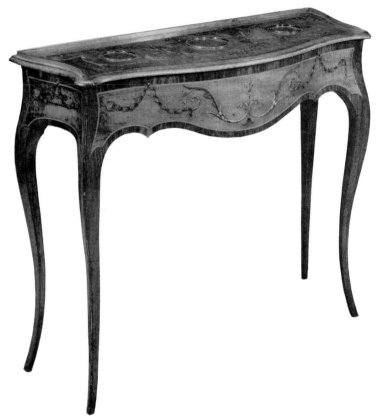

One of a pair of small George III serpentine marquetry side tables in sycamore banded in tulipwood.
Height 2 ft. 7 in.; width 2 ft. 11½ in.; depth 1 ft. 1 in.
London £5,000 ($12,500). 17.III.72.

From the Judith E. Wilson Fund Collection, Cambridge University.

A Chippendale carved mahogany five-leg gaming table. New York. *Circa* 1760–85.
Height 2 ft. 2½ in.; width 2 ft. 10 in.
New York $25,000 (£10,000). 13.XI.71.

Left:
A George III satinwood and sabicu secretaire cabinet.
Height 8 ft.; width 3 ft. 3 in.
New York $6,000 (£2,400).
16.x.71.

From the collection of the late Martha Baird Rockefeller.

Right:
A small George III satinwood secretaire bookcase.
Height 6 ft. 1 in.; width 25 in.
New York $6,750 (£2,700).
16.x.71.

From the collection of the late Martha Baird Rockefeller.

Left:
A George I walnut bureau bookcase with arched and moulded pediment.
Height 7 ft. 4 in.; width 3 ft. 1 in.
London £3,000 ($7,500).
5.xi.71.

From the collection of Maxwell Joseph, Esq.

Right:
A small Louis XVI ormolu-mounted mahogany *secrétaire à abattant.* Stamped:
J. H. Riesener.
Height 4 ft. 8 in.; width 2 ft. 6 in.
London £6,000 ($15,000).
19.v.72.

From the collection of the Baroness von Wrangell. Formerly in the collection of George Blumenthal.

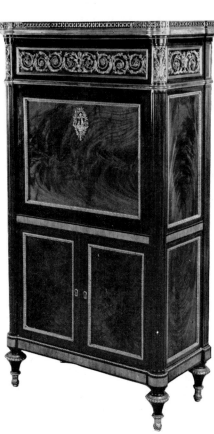

Left:
One of pair of George III
sycamore secretaire
cabinets.
Height 6 ft. 11 in.; Width
3 ft. 8 in.
London £5,800 ($14,500).
5.XI.71.

From the collection of
A. F. C. Forrester, Esq.

Right:
A mid-18th century Dutch
marquetry cabinet bureau.
Height 8 ft.; width 4 ft. 3 in.
London £1,800 ($4,500).
19.XI.71.

From the collection of
Brigadier G. F. Gough.

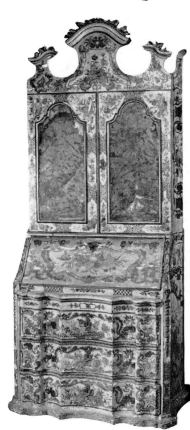

Left:
A William and Mary
bureau cabinet in figured
walnut.
Height 6 ft. 11 in.; width
3 ft. 4 in.
New York $9,500 (£3,800).
29.IV.72.

From the collection of
Jessie Woolworth Donahue.

Right:
A mid-18th century
Sicilian painted bureau
cabinet.
Height 8 ft. 1 in.; Width
3 ft. 6½ in.
New York $3,100 (£1,240).
20.XI.71.

From the collection of the
late Reba H. Rubin.

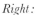

1. One of four German mid-18th century walnut and parcel-gilt side chairs. £2,160 ($5.400). 6.v.72. **2.** George III parcel-gilt mahogany armchair in manner of Giles Grendey. £1,800 ($4,500). 10.xII.71. **3.** Chippendale carved mahogany side chair. Philadelphia, 1760–80. $7,800 (£3,120). 23.vi.72. **4.** George II mahogany armchair. $4,000 (£1,600). 16.x.71. **5.** One of pair of Louis XV fauteuils. Signed: *N. Heurtant*. $5,500 (£2,200). 16.xII.71. **6.** One of set of four early 18th century Dutch marquetry chairs. $3,750 (£1,500). 19.iv.72. **7.** One of set of four mid-18th century Venetian painted and gilt-wood side chairs. $1,500 (£600). 20.xi.71. **8.** Late 18th century painted Italian armchair. £500 ($1,250). 19.xi.71. **9.** One of pair of George II carved mahogany library armchairs, upholstered in needlework. $4,500 (£1,800). 16.x.71. **10.** One of set of five Queen Anne oak side chairs. $2,400 (£960). 15.i.72. **11.** One armchair part of a set of two armchairs and eight side chairs, George III, mahogany. $6,000 (£2,400). 6.xi.71. **12.** Late George II mahogany armchair in the manner of Thomas Chippendale. $5,000 (£2,000). 10.vi.72.

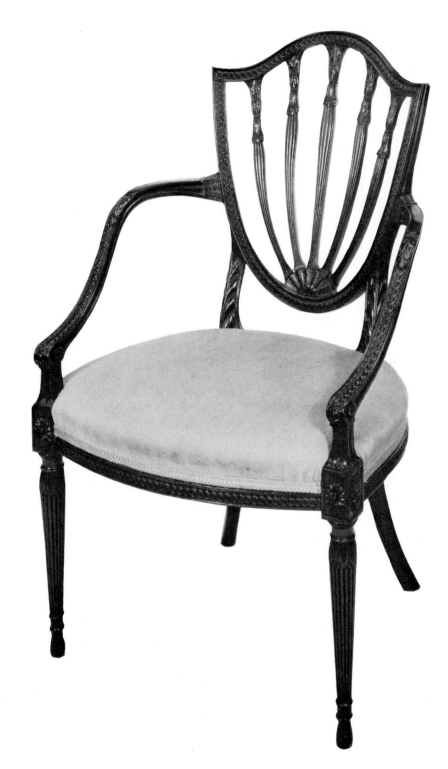

A George II mahogany armchair with a shield-shaped back.
London £1,500 ($3,750). 17.III.72.

A French writing table

BY THIERRY MILLERAND

Multipurpose pieces of furniture fitted with elaborate mechanisms became widely popular in France during the second half of the eighteenth century, as a result of the increasing sense of comfort. Writing tables with sliding tops incorporating reading stands, secret drawers and compartments were not infrequently made by Jean-François Oeben, *ébeniste du Roi* in 1754, one of the most renowned cabinet-makers of his time. One can be seen in the Residenzmuseum, Munich; others are in the Rijksmuseum and the Victoria and Albert Museum; further examples are in private collections. But probably none of them can rival the one sold at Sotheby-Parke-Bernet, New-York, for $410,000 (£164,000) on 23rd October from the collection of Martha Baird Rockefeller, which particularly well exemplifies Oeben's skill as an *ébeniste* and a *mecanicien*. Because he enjoyed royal protection he was able to carry on both activities which guild regulations precluded a *maître* from practising at the same time.

Although this table is very similar in design to the other known examples, the outstanding quality of the particularly rich floral marquetry, the ingenious mechanical fitment and the highly unusual pierced legs all contribute to the exceptional interest of this piece. Moreover, its original ownership can be attributed to Madame de Pompadour. The main charge of her coat of arms, i.e. a tower, is incorporated at the top of each ormolu corner-mount; a *veilleuse* by Tilliard, the frame of which is carved with the same motif, in the Victoria and Albert Museum, is said to have belonged to her. This is corroborated by the fact that Louis XV's favourite is known to have patronized Oeben at an early date; his name repeatedly appears in conjunction with hers in Lazare Duvaux's Journal.

A further interesting particular of this table is the presence on it of the stamps of two different *ébenistes*, that of R.V.L.C. (Roger Vandercruse dit Lacroix) occurring with that of Oeben. This is by no means unusual on eighteenth-century French furniture, since an *ébeniste* was compelled to stamp each piece which he was called upon to repair. In spite of the fact that Oeben was married to Lacroix's sister and although some of their works bear certain similarities (e.g. a combined toilet and writing table attributed to Oeben, No. F 110 in the Wallace Collection, and another one stamped by Lacroix sold at Sotheby's on 28th June 1963 from the Rene Fribourg collection, lot 223, repr. cat.), there is no evidence that they ever worked in collaboration. It is still more improbable that both of them would have stamped the same piece subsequent to its completion. Therefore, it seems reasonable to assume that Lacroix repaired it at a later date. What Lazare Duvaux calls *raccommodage* was a quite common practice at a time when signs of age certainly did not appeal to collectors as they do today.

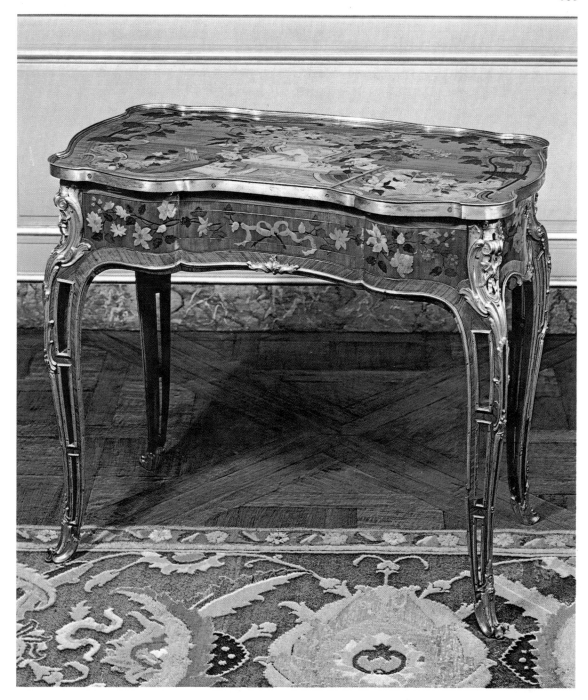

A Louis XV mahogany and kingwood marquetry table. Signed: *J. F. Oeben and R.V.L. (C.) JME*. Height 2 ft. 3½ in.; width 2 ft. 8¼ in. New York $410,000 (£164,000). 23.x.71.

From the collection of the late Martha Baird Rockefeller.

One of a pair of late Louis XV
mahogany *rafraichissoirs*.
Signed: *Canabas*.
Width 1 ft. 11 in.
London £4,600 ($11,500).
19.v.72.

Canabas was the pseudonym o
Joseph Gegenbach, who was
received Master in 1766.

Below:
A K'ang H'si twelve-fold
coromandel screen with
polychrome decoration.
Each panel: height 9 ft. 5 in.;
width 1 ft. 6½ in.
London £3,400 ($8,500).
19.XI.71.

From the collection of Commander
Sir Michael and Lady Faith
Culme-Seymour. Formerly in the
collection of the Earls of Sandwich
at Hinchingbrooke.

1. Early 19th century German letter box. 36 in. by 20 in. $225 (£90). 27.XI.71. **2.** Steiner bisque *bébé*. Impressed: *Bté SGDG, Paris, Fi.re A15.* 2 ft. 2 in. £150 ($375). 10.III.72. **3.** Cigar Store Indian. Total height 6 ft. 9 in. $3,700 (£1,480). 12.XI.71. **4.** One of pair of late George III library globes. Height 45 in; diameter 26 in. $9,750 (£3,900). 10.VI.72. **5.** One of a pair of George I walnut footstools. Width 23 in. $6,000 (£2,400). 10.VI.72. **6.** Inlaid mahogany shelf clock by Simon Willard. Roxbury, Mass. *Circa* 1800. Height 35½ in. $3,250 (£1,300). 13.XI.71. **7.** George I walnut clock-case barometer. Signed: *Jno. Hallifax, (Barnsley), Invt & fecit.* Height 4 ft.

£1,900 ($4,750). 10.IV.72. **8.** Mid-18th century Norwegian sledge. 6 ft. 7 in. by 6 ft. 4 in. £500 ($1,250). 4.II.72. **9.** George III gilt-metal hall lantern. 37½ in. by 21 in. $9,000 (£3,600). 6.XI.71. **10.** Late Louis XIV ormolu-mounted pedestal clock by Pierre Gaudron. Signed: *Gaudron à Paris.* Height 2 ft. 3 in. £1,700 ($4,250). 26.XI.71. **11.** One of pair of Louis XV ormolu-mounted Ch'ien Lung *famille-rose* pot-pourri vases and covers. 10½ in. by 8½ in. £3,400 ($8,500). 26.XI.71. **12.** One of pair of Chinese cloisonné enamelled cranes. Ch'ien Lung. Height 16 in. $5,250 (£2,100). 23.X.71.

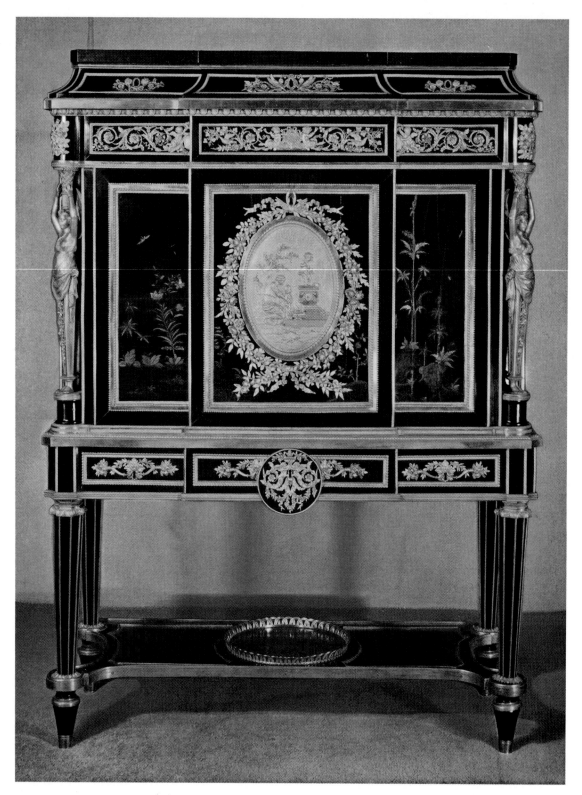

An ormolu-mounted Louis XVI black lacquer *secrétaire à abattant* by J. H. Riesener. The fall front with two black lacquer panels of flowers and grasses divided by a central lacquer panel forming a slight breakfront and centred by a very fine ormolu medallion in *bas relief* attributed to Clodion. The front falling to reveal a removable nest of nine drawers and pigeon-holes within a mahogany frame concealing secret compartments below. The base with three drawers centred by a projecting circular panel and raised on four fluted tapering octagonal legs joined by a shaped rectangular stretcher centred by a circular ormolu basket, on *toupie* feet and the mouldings throughout chiselled with petals and delicate ribbing. Height 5 ft. 1½ in.; width 3 ft. 9 in. London £72,000 ($180,000). 26.XI.71.

From the collection of the late Countess Laszlo Széchényi, *née* Gladys Vanderbilt.

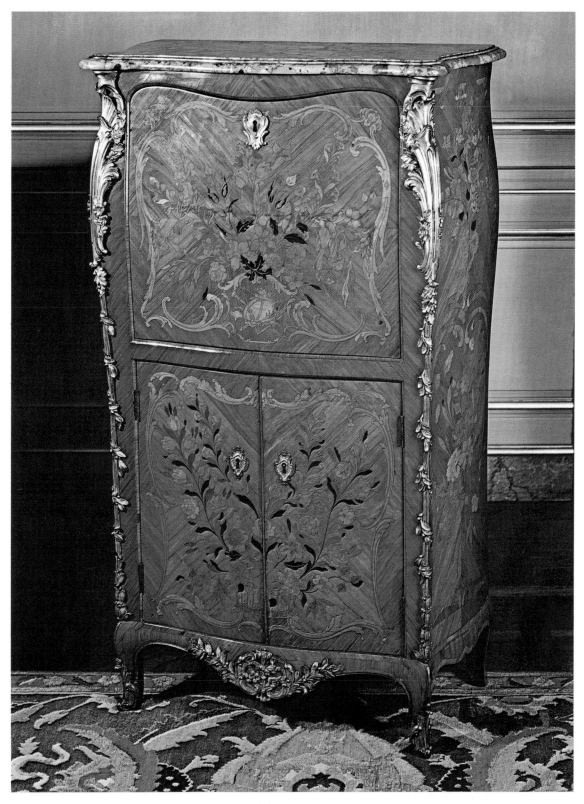

A Louis XV kingwood marquetry *secrétaire à abattant*, the shaped fall front opening to reveal an antique red velvet writing surface, shaped shelves and veneered drawers with ormolu pulls; the lower part with a pair of doors enclosing three drawers, *sans traverse*, the interior of the doors and the drawers veneered. The corners with ormolu mounts, raised on cabriole legs joined by shaped aprons. With a *breccia* marble top. Height 3 ft. 8½ in.; width 2 ft. 3 in. New York $30,000 (£12,000). 23.X.71.

From the collection of the late Martha Baird Rockefeller.

Carpets and Tapestries

Late Gothic tapestries of great importance rarely appear on the market today; there have been only about six in the salerooms in the last fifteen years. This season, however, Parke-Bernet have sold, among others, an early 16th century Brussels tapestry of a couple playing draughts on a millefiori ground, replete with figures, birds and flowers symbolic of various aspects of courtly love. It belonged to the collection of the Cranbrook Academy of Art, and fetched $85,000 (£34,000).

Early oriental carpets in good condition are not frequently offered; dispersals to compare with that of the Kevorkian Foundation at Sotheby's three years ago are now rare occurrences. Perhaps the finest example to appear on the market this season was the 17th century Isphahan Palace carpet, over twenty six feet in length, which was sold for $20,000 (£8,000) in New York on October 23rd; this was included in the Martha Baird Rockefeller sale, and had once been in the collection of Judge Elbert H. Gary. Later in the season, a superb Kazac rug, dating from the late 18th–early 19th century, realised $6,000 (£2,400), a high price for this type of rug.

In London, some outstanding 17th century English stumpwork boxes have been sold, including a Charles I example, illustrating *The Story of Isaac*, at £700 ($1,750). A box dating from the reign of Charles II, decorated with Algerian eye stitch needlework and silkwork and depicting Biblical scenes and *The Four Seasons*, fetched £880 ($2,200). Also of the period of Charles II, an interesting needlework mirror in its original oak case and in excellent condition, was sold for £4,000 ($10,000).

A late 18th – early 19th century Kazak rug.
7 ft. 10 in. by 4 ft. 10 in.
New York $6,000 (£2,400). 4.III.72.

A 17th century Isfahan palace carpet.
26 ft. 8 in. by 11 ft. 9 in.
New York $20,000 (£8,000). 23.x.71.
From the collection of the late Martha Baird Rockefeller.

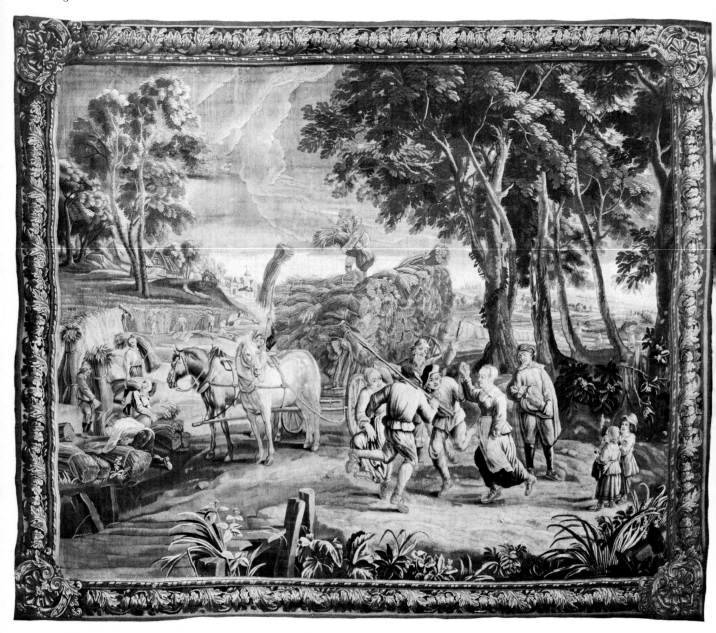

A mid-18th century Brussels Teniers tapestry of *The Return from the Harvest*.
Height 9 ft. 5 in.; width 11 ft. 1 in.
New York $13,000 (£5,200). 25.III.72.

A Brussels tapestry of a couple playing draughts, on a *mille-fleurs* ground, *1500–1530*
Height 10 ft. 1 in.; width 9 ft. 7 in.
New York $85,000 (£34,000). 25.III.72.

From the collection of the Cranbrook Academy of Art, Bloomfield Hills, Michigan.

An early 18th century Beauvais tapestry of *The Disarming of Cupid*.
Height 8 ft.; width 13 ft.
New York $5,750 (£2,300). 9.x.71.

From the inventory of the Hartman Galleries.

A mon seul Désir, a Gobelins replica of *The Lady and the Unicorn* Cluny tapestry, inscribed *Haute Lisse Munier des Gobelins texit* 1897. Height 13 ft. 2 in.; width 14 ft. 9 in. London £1,300 ($3,250). 19.v.72.

From the collection of Mrs Denis Dobbs.

A mid-18th century Brussels mythological tapestry ascribed to Judocus de Vos and probably from *The Story of Pastor Fido*. Height 11 ft. 5 in.; width 16 ft. 4 in.
London £2,700 ($6,750). 26.XI.71.

An early 16th century Tournai Gothic narrative tapestry from *The History of Susanna*.
Height 10 ft.; width 13 ft.
London £4,700 ($11,750). 19.XI.71.

A Charles II needlework easel toilet mirror in a contemporary japanned oak case.
Height 2 ft. 10 in.; width 2 ft. 7 in.
London £4,000 ($10,000). 30.VI.72.

From the collection of B. Seward, Esq.

Loaned to the *Decorative Art Needlework* 1873 exhibition at the Victoria and Albert Museum, then the South Kensington Museum, by Mr Charles Seward.

A Charles I stumpwork toilet box worked with scenes from the story of Isaac. Height 12 in.; width 9 in.
London £700 ($1,750). 10.XII.71.

From the collection of Mrs H. S. Irwine.

A Charles II Algerian eye stitch needlework and silkwork box worked with panels representing the four seasons and scenes from the Bible. Height 10½ in.; width 12½ in.
London £880 ($2,200). 17.III.72.

Chippendale Drawings

BY DEREK SHRUB

Perhaps it is trite to say that drawings are like handwriting – not that one doesn't know some pretty individual forms of typing! – but even so, the simile is obvious when the rare opportunity of handling designs by the almost legendary Chippendale arises. Perhaps with amazement we discover that he, like Uccello, grappled with perspective and sometimes lost and yet always creates a pleasurable design.

Chippendale typifies the pre-Adam 18th century in England: the robust yet decorative age that produced such characters as the rather haughty lady of title who objected strongly to the creation of so many new peers and claimed she now hesitated to spit from her window for fear of hitting one. The same sturdiness can be discerned in many of Chippendale's designs, as for instance in the chairs illustrated below.

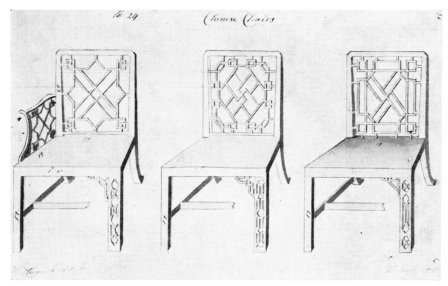

Designs for Chinese chairs.
Pen and ink and grey wash. Inscribed and numbered 24. 8 in. by 13¼ in.
London £700 ($1,750). 20.IV.72. From the collection of John L. Marks, Esq.

Here the theme is chinoiserie, and yet Chippendale produces chairs which are a nice compromise between fantasy of ornament and stability of form – a chair in which a man may sit with confidence, to quote Sir Walter Scott.

A comparison between the drawings and the resultant engravings reveals the delicacy and nervous liveliness of Chippendale's pen and wash and the ironed-out practicality of his engravers. Gone is the strange flickering light which he achieves with his somewhat arbitrary shadowing.

One of the main reasons for Chippendale's success was his ability to cater for a wide range of tastes and needs. Although this drawing for an architect's table (opposite page) was not a published design it is a prime example of the strictly functional traditions in much of English furniture.

It may seem incredible that Chippendale having designed this could also present us with the drawing for ribband back chairs. These chairs are particularly interesting

Design for an architect's table.
Pen and ink and grey wash. Inscribed with instructions and measurements.
7¼ in. by 9 in.
London £500 ($1,250). 20.IV.72. From the collection of John L. Marks, Esq.

because they were one of the few examples of the full rococo to be included in Chippendale's first *The Gentleman and Cabinet-Maker's Director* (1754).

A few years ago a letter from Chippendale dated 1759 was discovered in which he made the excuse for not attending in person to a client's order because he had

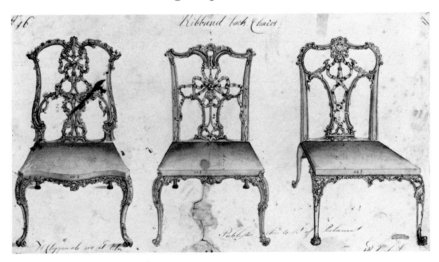

Designs for ribband back chairs.
Pen and ink and grey wash. Inscribed and numbered 16. 7½ in. by 13¼ in.
London £1,200 ($3,000). 20.IV.72. From the collection of John L. Marks, Esq.

recently been in France. This visit was said to explain the more 'French' qualities to be seen in the 1762 edition of his book, but surely this page of designs alone proves that he had little to learn in the way of rococo ornament. In any case Chippendale had premises near Slaughter's coffee house to which he must have gone and there would meet people such as Hubert Gravelot, a Parisian painter who, besides being Gainsborough's teacher, designed decorative work for publishers.

It is, perhaps, particularly apt to cite Gravelot as a possible inspiration to Chippendale because Charles Ricketts has described Gravelot as combining 'something of the France of Watteau and the England of Hogarth'. Anything more descriptive of Chippendale I cannot imagine.

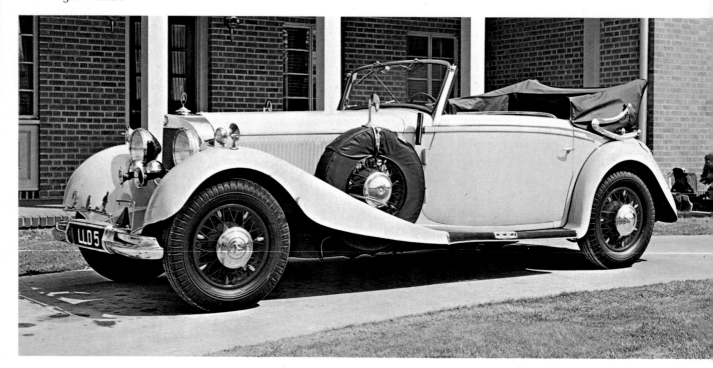

A 1933 Mercedes-Benz 380K convertible sedan, Daimler-Benz, A. G., Stuttgart, Unterturkheim, Germany, 1926 to present.
Los Angeles $16,000 (£6,400). 4.vi.72.
From the collection of James C. Leake's Horseless Carriage Museum, Muskogee, Oklahoma.

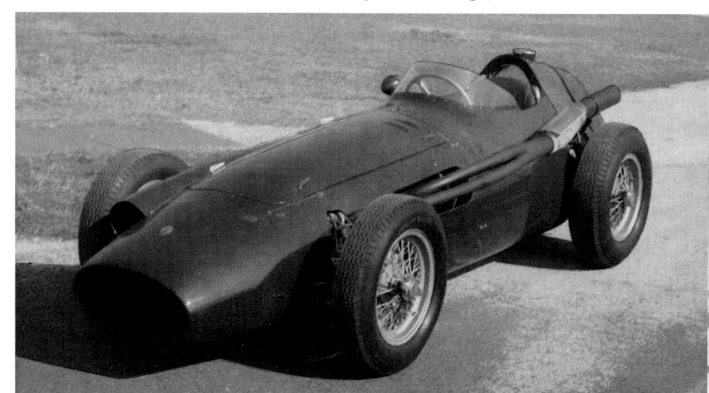

A 1957 Maserati 250 F single-seater Grand Prix racing car.
Monza Lire 16,500,000 (£11,055; $27,637). 17.vi.72.

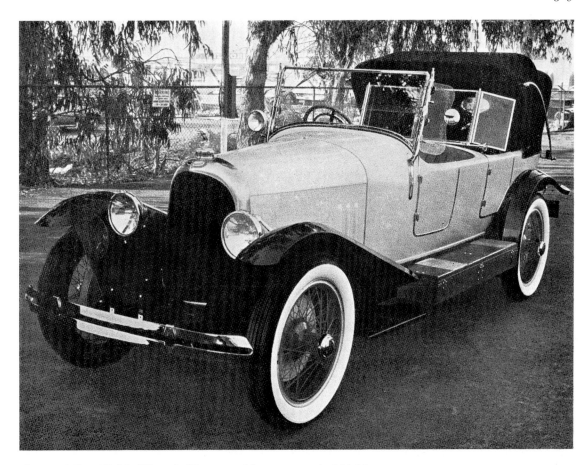

A 1923 Avions Voisin Victoria Phaeton with tonneau windshield.
Formerly the property of Rudolph Valentino.
Los Angeles $22,000 (£8,800). 6.III.72.

The Bridgewater House Collection of Coins

BY M. R. NAXTON

Single pistoles £9,500 ($23,740). Double pistoles £13,500 ($33,750).

It is only rarely that the numismatist has the opportunity of examining coins as fine as those contained in the collection originally formed at Bridgewater House and this collection was certainly the most important cabinet of British coins to be sold at auction since that formed by the late R. C. Lockett was dispersed between the years 1955 and 1961. The Bridgewater House Collection was seen by only a few privileged scholars and although it was placed in the British Museum for safe-keeping by the first Earl of Ellesmere (1800–57) while his house was being rebuilt, and remained there until about 1900, the cabinet was never exhibited and was never available for public examination since its inception. A precise date for the formation of the collection cannot positively be ascertained for while it is known that Scrope, fourth Earl of Bridgewater, continued adding to a collection left to him by his father, John, third Earl (1646–1701), it appears that the family interest in numismatics began even earlier with John, second Earl (1622–86). Thus, although the collection could not be credited to any single member of the Bridgewater family, it was certainly of the 18th century, a fact borne out by there being only five coins dated after 1740. Similarly, the very full series of milled coins, in both gold and silver, covering the years immediately prior to 1740 suggested that the collectors had completed their task by the middle of that century and later additions were purely coincidental.

The collection contained a wide range of pieces from Stephen to George II but it was in the coinages of the Tudor and Stuart monarchs that it was particularly full and any examples from this period in choice condition are seldom offered for sale. The coins of Scotland and Ireland were also strongly represented and the most outstanding rarities were the Irish "pistole" pieces of 1646. The importance of the two "double" and "single" pistoles cannot be overestimated as they represent the only gold coins ever struck for Ireland and, of the few issued, these double pistoles are the only two surviving specimens. Similarly, of the 10 known examples of the single pistoles, the two from the Bridgewater House Cabinet were the only two that will ever be available for sale – the others being divided between the Dublin and American Numismatic Society Collections. The first of the double pistoles realised £13,500 and was bought on behalf of the National Museum of Ireland, the second reached £13,000 and was acquired for the British Museum and these two prices created new auction records for a British coin (the previous highest price being £10,500), whilst the single pistoles brought £9,000 and £9,500 respectively.

The final total of £221,510 was remarkable in itself but it is only when considering that 32 coins each realised over £1,000 that the significance of the whole collection to the numismatic world is fully appreciated. It will undoubtedly be many years before another cabinet of this quality is sold by auction, if indeed any that are comparable still remain untouched by the scrutiny of the 20th century.

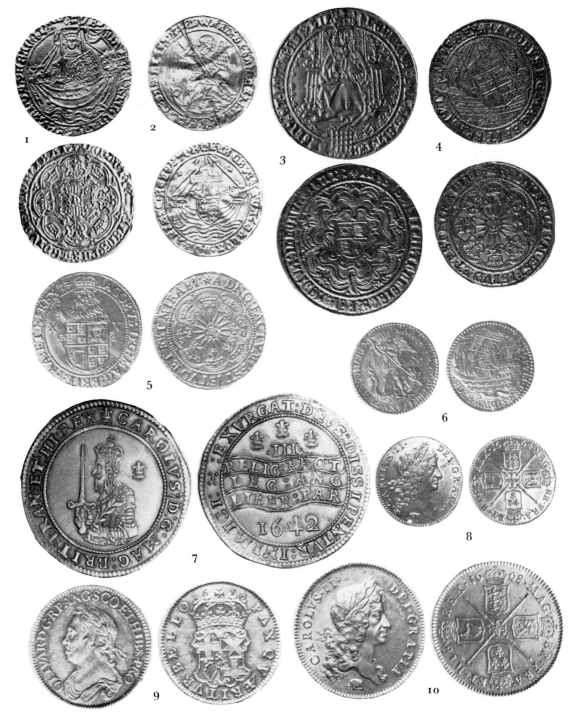

1. Henry VI, London noble, Leaf-trefoil issue 1435–38. £2,400 ($6,000).
2. Edward IV, London angel. £2,800 ($7,000).
3. Mary, sovereign of 30 shillings, 1553. £900 ($2,250).
4. James I, Spur Ryal, Second coinage. £3,800 ($9,500).
5. James I, Spur Ryal, Third coinage. £3,500 ($8,750).
6. Charles I, Pattern angel, by Nicholas Briot. £9,000 ($22,500).
7. Charles I, triple unite, 1642, Civil War issue. £2,800 ($7,000).
8. Charles II, guinea, 1664, Elephant below the bust. £1,400 ($3,500).
9. Oliver Cromwell, Pattern half-crown in gold, 1658. £3,000 ($7,000).
10. Charles II, five guineas, 1668, Elephant below the bust. £1,100 ($2,750).

The Bridgewater House Collection was sold at Sotheby's on 15th June 1972.

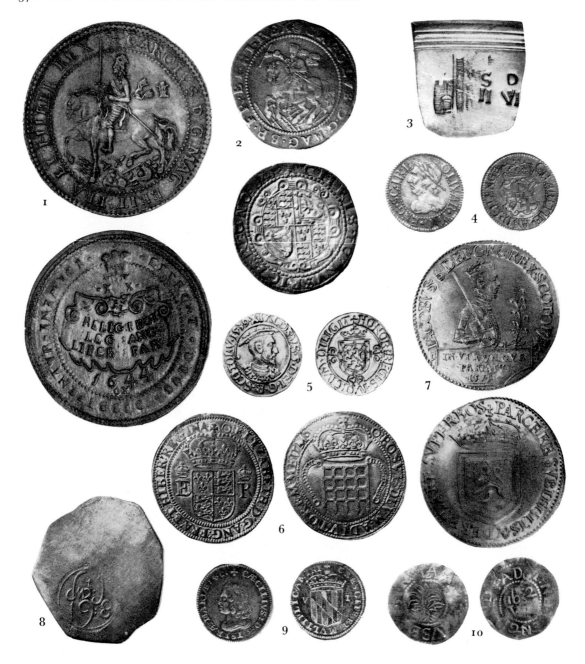

1. Charles I, Oxford mint, pound, 1644.
£1,900 ($4,750).
2. Charles I, Exeter mint, half-crown, 1645.
£1,900 ($4,750).
3. Civil War. Siege piece of Scarborough, 1644–45.
£2,200 ($5,500).
4. Oliver Cromwell, Pattern farthing. £420
($1,050).
5. SCOTLAND. James I, ducat, 1539.
£1,400 ($3,500).

6. ANGLO-INDIAN COINAGE. Portcullis half-
dollar. £270 ($675).
7. SCOTLAND. James VI, £20 piece, 1575.
£8,000 ($20,000).
8. IRELAND. Charles I, Inchiquin crown,
1642–46. £500 ($1,250).
9. ANGLO-AMERICAN. Baltimore sixpence, 1658.
£800 ($2,000).
10. ANGLO-AMERICAN. Willow Tree sixpence,
1652. £2,800 ($7,000).

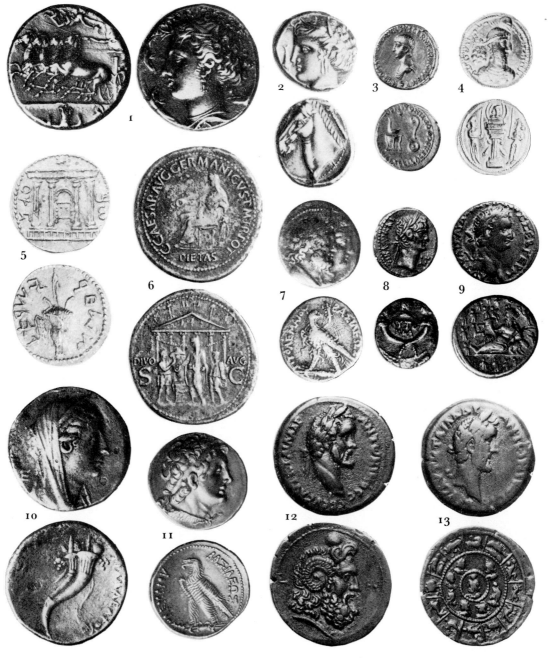

1. SYRACUSE. Decadrachm by Euainetos,
circa 412–406 BC. £1,100 ($2,750). 29.IX.71.
2. SICULO-PUNIC WAR. Tetradrachm,
circa. 350–320 BC. £200 ($500). 25.XI.71.
3. ROME. Nero, Aureus. £170 ($425). 16.II.72.
4. SASSANIAN EMPIRE. Ardeshir II, Gold stater.
£260 ($650). 29.IX.71.
5. JUDAEA. Tetradrachm of the Bar Cochba
War. £610 ($1,525). 21.X.71.
6. ROME. Caligula, Sestertius. £105 ($275). 21.X.71
7. EGYPT. Ptolemy VI and Cleopatra,
Tetradrachm. £75 ($187). 16.II.72.

8. ALEXANDRIA. Claudius, Di-drachm.
£70 ($175). 9.III.72.
9. ALEXANDRIA. Domitian, Tetradrachm.
£85 ($212). 9.III.72.
10. EGYPT. Arsinoe II, Decadrachm. £115 ($287).
16.II.72.
11. EGYPT. Ptolemy VIII, Tetradrachm.
£52 ($130). 16.II.72.
12. ALEXANDRIA. Antoninus Pius, Drachm, *rev.*
bust of Zeus Ammon. £60 ($150). 9.III.72.
13. ALEXANDRIA. Antoninus Pius, Drachm
rev. signs of the zodiac. £160 ($400). 9.III.72.

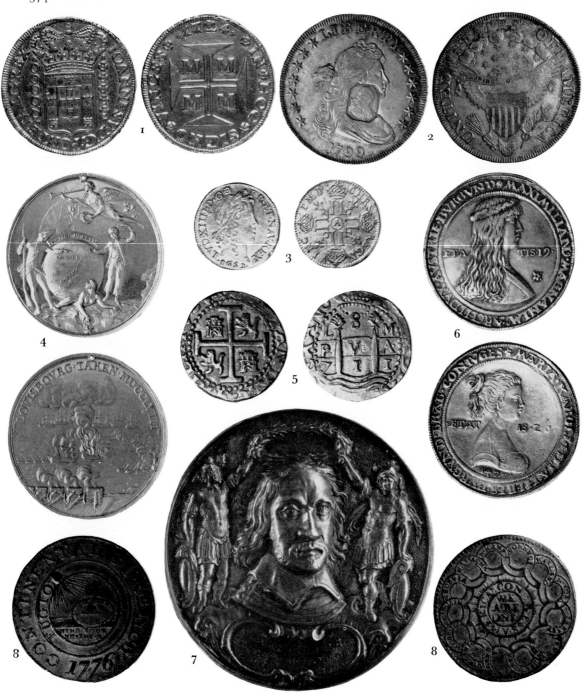

1. BRAZIL. John V, 20,000 reis, 1724,
Minas mint. £580 ($1,450). 10.V.72.
2. USA. Dollar, 1799, with octagonal countermark
of George III. £1,400 ($3,500). 29.IX.71.
3. FRANCE. Louis XIV, Louis d'or, 1652,
Paris mint. £150 ($375). 16.II.72.
4. CANADA. Louisburg medal in gold,
1758. £1,450 ($3,625). 25.XI.71.

5. PERU. Philip V, cob 8 scudos, 1711.
£220 ($550). 16.II.72.
6. HOLY ROMAN EMPIRE, Maximilian I and
Maria marriage thaler, 1479. £600 ($1,500).
16.II.72.
7. Oliver Cromwell, hollow silver medal, by
Müller, 1658. £110 ($275). 21.X.71.
8. USA. Continental pewter dollar, 1776.
£260 ($650). 29.IX.71.

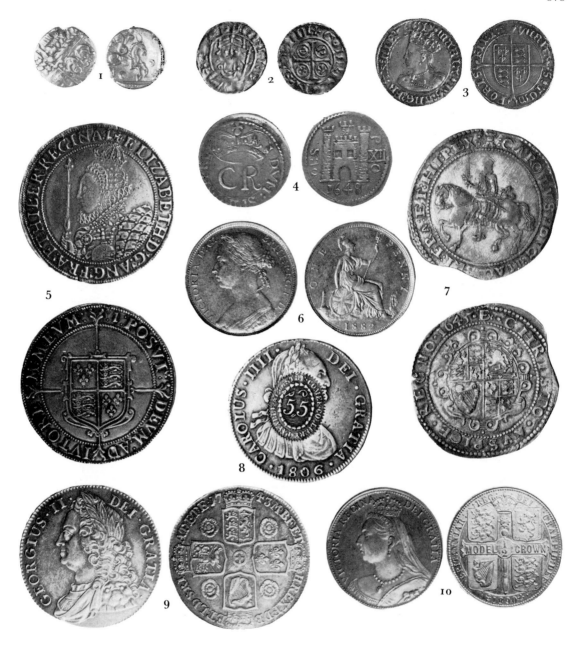

1. ANCIENT BRITISH. Catuvellauni, gold stater,
First century B.C. £180 ($450). 10.V.72.
2. William I, Paxs penny. £25 ($62). 29.IX.71.
3. Mary I, Groat, 1553–54, £115 ($287). 10.V.72.
4. Charles I, Pontefract siege shilling, 1648.
£90 ($225). 10.V.72.
5. Elizabeth I, crown, 1601–02.
£300 ($750). 29.IX.71.

6. Victoria, bronze penny, 1882, no H.
£360 ($900). 29.IX.71.
7. Charles I, Exeter mint crown, 1643–46,
£78 ($195). 16.II.72.
8. IRELAND. County Kilkenny, countermarked
Spanish dollar, 1806. £210 ($525). 16.II.72.
9. George II, Crown, 1743. £95 ($237). 25.XI.71.
10. Victoria, Pattern half-crown, 1890.
£100 ($250). 21.X.71.

The *Hollandia* Treasure Sale – Sotheby's, April 18th, 1972

The *Hollandia*, of 700 tons, was built in Amsterdam in 1742, and on her maiden voyage to Jakarta, in the early morning of July 13th, 1743, she struck the Gunner Rock in the Isles of Scilly and sank. Her commander was badly off course and, although distress signals were fired, there were no survivors as it now seems likely that the ship blew up.

The *Hollandia* was carrying over 129,000 guilders in silver specie for the Dutch East India Company and, despite the fact that the wreck has been greatly dispersed by strong tides and currents, over 14,000 silver pieces have so far been recovered in two years of diving in the area. Many of the coins are Dutch ducatoons from the various provinces of Holland but the greater proportion of them are Spanish-American Eight Reales, the famous 'Pieces of Eight' of pirate fiction. At first the metal for these coins was cast into rough 'cob' pieces, cut from bar silver and then stamped with the Arms of Spain, and it was only later that they were produced in conventional form from a number of mints all over Spanish-ruled South America.

The discovery of this great colonial wealth coincided with the expansion of trade which had in itself been the main cause of the discovery of the New World. The 'Piece of Eight' thus entered the trade of the Far East, including the area of Dutch influence, from both points of the compass, thereby creating an endless market in bullion. This impact was so great that even some of our own domestic silver coinage has been restruck from 'Pieces of Eight' in times of shortage.

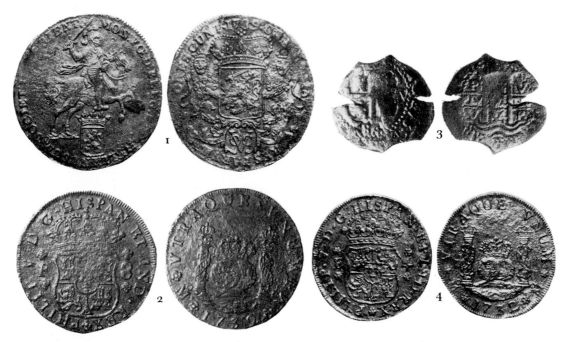

1. NETHERLANDS. United East India Company, silver ducaton, 1739. £105 ($262). 18.IV.72.
2. MEXICO. Philip V, pillar eight reales, 1732F. £650 ($1,625). 18.IV.72.

3. POTOSI. Charles II, cob four reales, 1684 PV. £120 ($300). 18.IV.72.
4. MEXICO. Philip V, pillar four reales, 1732F. £650 ($1,625). 18.IV.72.

An Unknown Seven Bar Naval General Service Medal

BY M. R. NAXTON

Although three specialised sales of war medals, orders and decorations have taken place during this season, that held on 26th January contained an item of unique interest to medal collectors all over the world – namely the Seven Bar Naval General Service Medal awarded to Gunner Thomas Haines. When this medal for service in the Napoleonic Wars was finally and rather retrospectively issued in 1848, most veterans of the great naval struggle were not only well-advanced in years but an even greater number had not survived the forty or so years since Trafalgar at all. When each man received his medal with accompanying 'bars' denoting service in particular battles or theatres of war – seven bars being the maximum number awarded to any one seaman – it became apparent that certain bars were extremely rare because of the very few surviving claimants. Similarly, Admiralty records state only two such seven bar medals were issued and this, therefore, was the background to the remarkable discovery of a third, and previously unknown, seven bar medal consigned to us for sale by the great-great-grand-daughter of the recipient himself. Although the official Medal Roll did not confirm it, extremely thorough research at the Public Records Office found the medal and all its seven bars to be proved and it can therefore be considered as one of the most important medals of the British naval series ever to appear at auction. Such a rarity aroused the greatest controversy and speculation and when finally sold realised £1,600, therefore creating a new record price for a campaign medal.

Of the many medals sold this season, this is probably the most significant but nevertheless every campaign from the earliest issued medals has been represented and the awards for bravery include four Victoria Crosses and three George Crosses, all illustrating the highest gallantry and devotion to duty. It is often said that the greatness of nations can be measured by the deeds of the individual, and such men as Thomas Haines will always live on for as long as their successors care to preserve the rewards of the past, and thus indirectly, the heritage they fought for.

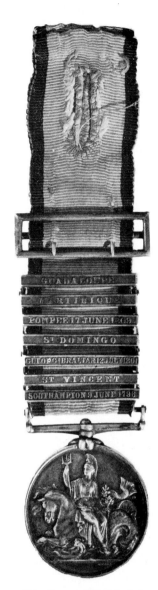

The Seven Bar Medal

Gunner Thomas Haines

Clocks, Watches and Scientific Instruments

In November, Sotheby's sold a magnificent quarter repeating cylinder watch and chatelaine of *circa* 1800 for £6,600 ($17,000). It was made by Jefferys & Jones of Cockspur Street, London, who were in partnership from 1776 to 1800; they were renowned for their richly decorated watches of which the present piece, in almost mint condition, was an outstanding example, liberally embellished with diamonds. It had originally belonged to Anne Whitaker, Lady of the Manor of Loughton, whose diamond monogram appears on the back of the watch and on the intaglio.

Also of special interest are the three modern high precision watches sold this season. A split seconds chronograph with perpetual calendar by Patek Philippe fetched £3,700 ($9,350) in Zurich on November 25th, 1971, whilst a tourbillon watch by Charles Frodsham and a minute repeating grande et petite sonnerie keyless lever perpetual calendar watch by S. Smith & Son, were sold for £4,000 ($10,000) and £3,700 ($9,250) respectively in London on March 27th.

Although a large number of high precision watches were made prior to the Second World War, hardly any are produced today by the large watch firms, due to lack of craftsmen and to prohibitive cost; such pieces were always expensive, the Patek Philippe, for instance, cost £400 ($2,000) in the 1920's, equivalent in real money terms to spending £2,000 ($5,000) today. Nevertheless, to have a hand finished high precision watch made now by one of the few craftsmen capable of making such a piece would cost between £5,000 and £10,000 ($12,500 and $25,000). It is probable that many people owning pre-war watches of this kind are not aware of their current market value.

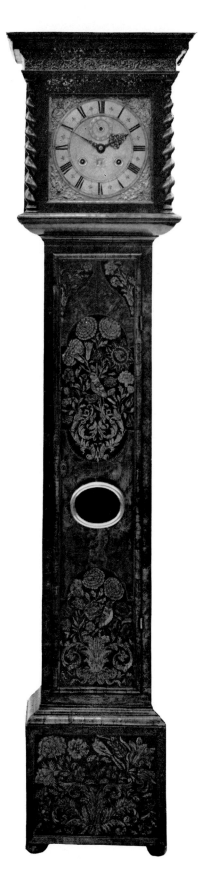

A late 17th-century walnut marquetry longcase clock by Daniel Quare. Height 6 ft. 9 in.
London £5,800 ($14,500). 27.III.72.

Daniel Quare (1649–1724), a celebrated maker, was Free of the Clockmakers' Company in 1671 and Master in 1708.

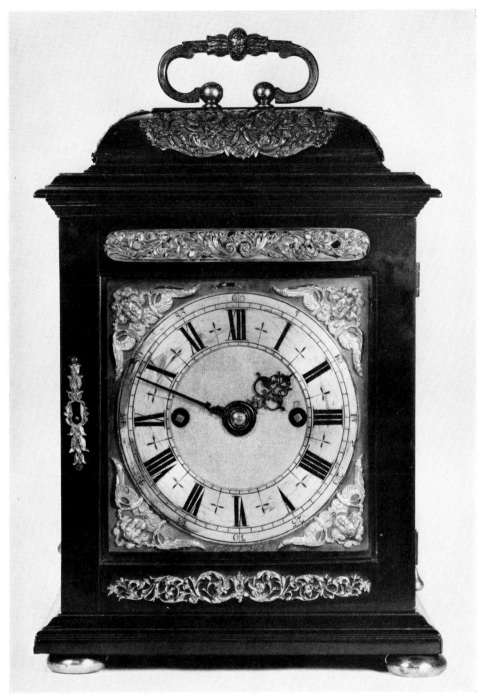

A small veneered ebony repeating bracket clock, Thomas Tompion no.99, the 6-inch dial signed *Thomas Tompion Londini fecit* below the silvered chapter ring and with strike/silent lever and cherub spandrels, the movement with latched dial and plates, verge escapement, the backplate well engraved and numbered 99. Height 12 in.
London £16,000 ($40,000). 22.v.72.

The dial signature is the smallest recorded on any Tompion clock. See *Antiquarian Horology*, volume I, number 5, December 1954, where this clock is illustrated and it is stated that it originally belonged to the son of Sir Thomas Herbert, who walked to the scaffold with King Charles I.

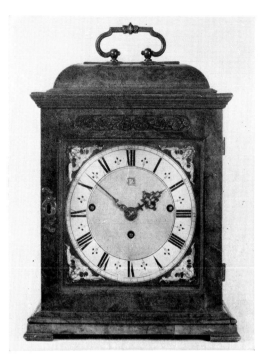

A late 17th-century burr-walnut
grande sonnerie bracket clock by
Joseph Knibb. Height 1 ft. 1½ in.
London £11,000 ($27,500). 22.v.72.

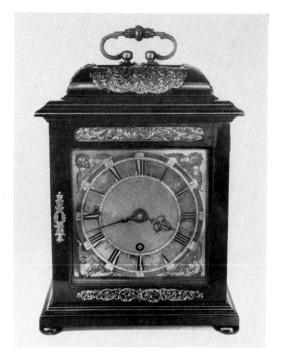

A pre-numbered veneered ebony
quarter repeating single train
bracket clock by Thomas Tompion.
Height 12½ in.
London £10,000 ($25,000) 22.v.72.

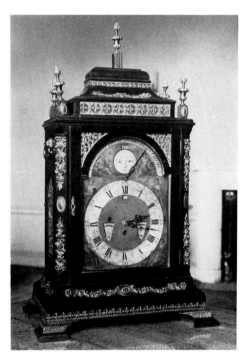

A George II chiming bracket clock by
J. M. Weygel, the spandrels painted
with the seasons and with apertures for
day-of-the-week and for months and
age-and-phase of the moon dial in the
arch and selector for eight and twelve
bells chime. Height 3 ft.
London £800 ($2,000). 10.iv.72.

From the collection of the Rt Hon. the
Countess of Dysart.

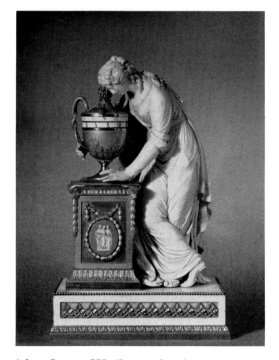

A late George III gilt-metal and
porcelain mantel clock by Vulliamy,
signed at the base *Vulliamy, London,
N.228*. Height 18 in.
New York $2,900 (£1,160). 6.xi.71.

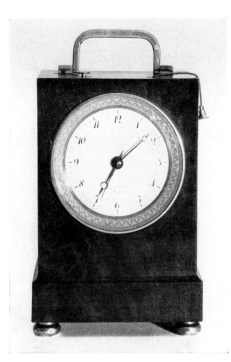

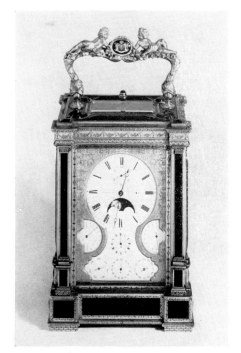

A pendule de quatre parties by
Breguet no.2020, the movement with
grande et petite sonnerie and alarum,
Breguet's échappement naturel, in
mahogany case with gilt bezel. Height 7½ in.
London £2,900 ($7,250). 19.VI.72.

A gilt metal and bloodstone grande
sonnerie carriage clock with alarum,
by Bourdin of Paris. Mid-19th
century. Height 9½ in.
London £5,000 ($12,500). 19.VI.72.
From the collection of Le Vicomte de
Noailles.

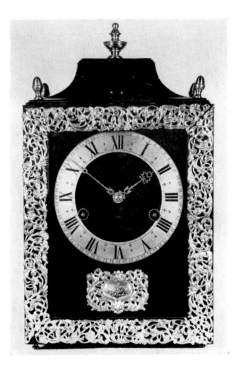

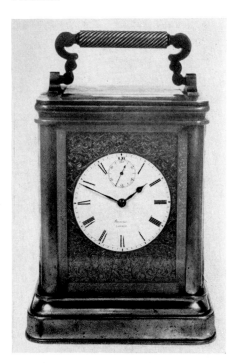

A Dutch ebonized table clock by
Claude Pascal, mounted in gilt metal,
the 6¼ in. dial covered in purple
velvet, signed *C. Pascal Hagae Hollandiae*
on a heart-shaped cartouche. The
movement with verge escapement
and a very rare form of grande
sonnerie striking. Height 14 in.
London £3,400 ($8,500). 27.III.72.

A brass carriage clock by Barwise, the
white enamel dial signed *Barwise,*
London, and with seconds dial at
twelve o'clock, the two train
movement with chain fusées and
striking the quarters on two gongs and
with strike/silent. Height 8½ in.
London £1,600 ($4,000). 27.III.72.

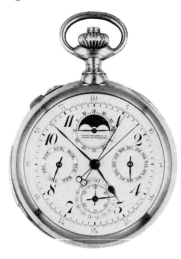

A gold cased minute
repeating split seconds
chronograph with perpetual
calendar, by Patek Philippe,
no.174496, 54 mm.
Zurich £3,700 ($9,350).
25.XI.71.

From the collection of Mr
Sam Bloomfield.

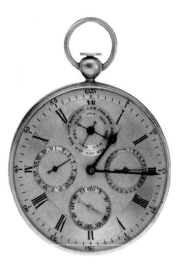

A gold minute repeating
pump wind free-sprung
chronometer by Viner of
London, no.4896,
hallmarked 1850, 64 mm.
Zurich £2,300 ($5,750).
25.XI.71.

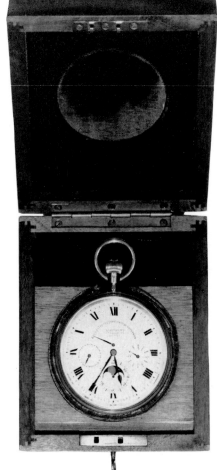

A minute repeating grande
et petite sonnerie keyless
lever perpetual calendar
watch by S. Smith & Son,
no.304–2, 78 mm.
London £3,700 ($9,250).
27.III.72.

From the collection of Mr
Sam Bloomfield.

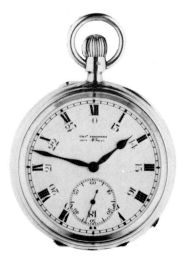

A gold open-faced keyless
lever minute repeating
clockwatch with one minute
tourbillon, no.09714 by
Charles Frodsham, 27
South Molton Street,
London, 65 mm.
London £4,000 ($10,000).
27.III.72.

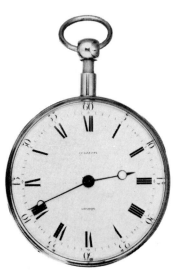

A gold half-quarter
repeating duplex clockwatch
by Vulliamy of London,
no.aor, hallmarked 1824,
74 mm.
London £1,500 ($3,750).
15.XI.71

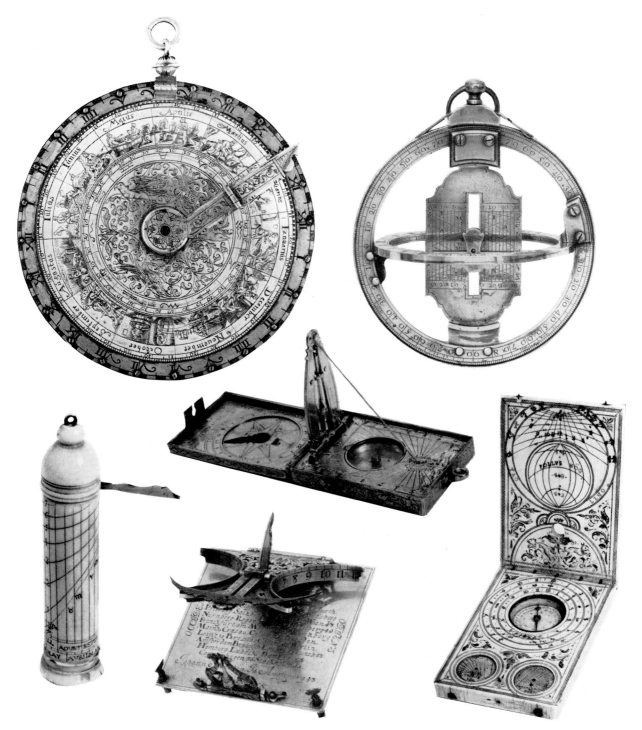

Above left: A silver and gilt metal astrological disc, engraved with signs of the zodiac and the months, the reverse with an altitude dial for the planetary hours. Diameter 127 mm. London £2,200 ($5,500). 27.III.72.

Above right: A silver universal ring dial, by Le Maire of Paris, first half of the 18th century. Diameter 104 mm. London £2,000 ($5,000). 24.VII.72.

Left: A 17th century ivory pillar dial for latitudes 10–65 degrees and spiral scales for the corresponding hours. Height 92 mm. London £820 ($2,050). 27.III.72.

Centre above: A gilt metal tablet dial by Ulrich Schniep, dated 1586. Length 60 mm. London £1,100 ($2,750). 27.III.72.

Centre below: An early 18th century gilt-metal equatorial dial by Johann Martin of Augsburg. 60 mm. square. London £2,400 ($6,000). 19.VI.72.

Right: An ivory diptych dial, with maker's mark and initials *TD* for Thomas Tucher. *Circa* 1600. Length 120 mm. London £1,900 ($4,750). 27.III.72.

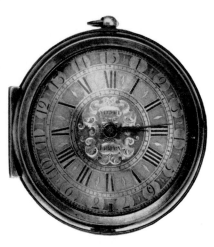

Left:
Silver pair-cased verge watch, by Richard Street, no.214, *circa* 1710, 63 mm. London £2,600 ($6,500). 15.XI.71.

From the collection of Mr Sam Bloomfield. Richard Street was a contemporary of Sir Isaac Newton and is reputed to have made instruments for him.

Right:
A silver Japanese verge clockwatch, 19th century, 80 mm.
Zurich £980 ($2,450). 25.XI.71

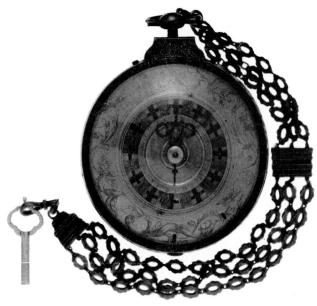

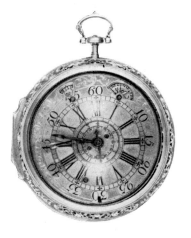

A repoussé gold pair cased alarum verge watch by D. Hubert of London. No.2029, *circa* 1720. 57 mm. London £3,900 ($9,750). 24.VII.72.

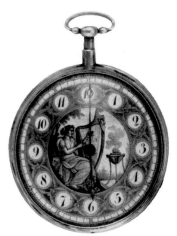

A gold quarter-repeating musical cylinder watch, by Perrin Frères, *circa* 1820, 63 mm. Zurich £800 ($2,000). 25.XI.71.

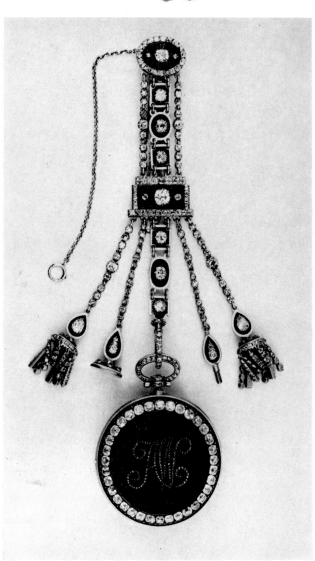

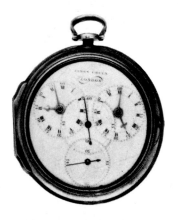

A silver pair-cased solar and siderial verge watch by James Green, no.5969, hallmarked 1776, 57 mm. London £3,600 ($9,000). 15.XI.71.

From the collection of Mr Sam Bloomfield.

A richly decorated quarter repeating cylinder watch and chatelaine by Jefferys & Jones of London, *circa* 1800, 57 mm. London £6,800 ($17,000). 15.XI.71
From the collection of Sir John Maitland, D.L.

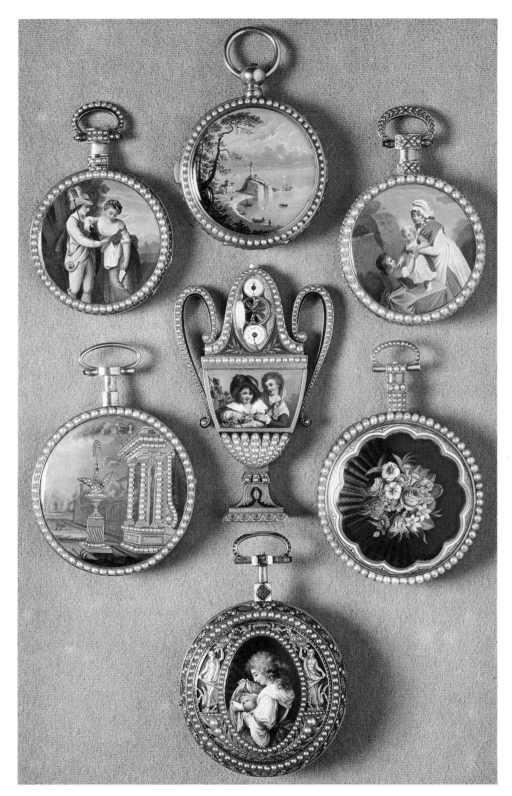

Above left: Gold and enamel quarter-repeating cylinder watch, 53 mm. £1,250 ($3,125). *Above centre:* Gold and enamel minute repeating centre seconds lever clockwatch, no. 46276, 19th century, 55 mm. £1,050 ($2,625). *Above right:* Gold and enamel quarter-repeating cylinder watch, *circa* 1830, 55 mm. £1,300 ($3,250). *Centre left:* Gold and enamel quarter repeating cylinder watch, *circa* 1820, 60 mm. £1,200 ($3,000). *Centre:* Gold and enamel musical automaton watch in the form of an urn, *circa* 1830, 91 mm long. £2,300 ($5,750). *Centre right:* Gold and enamel ruby cylinder watch, by Charman & Co., London, no. 0906, *circa* 1820, 62 mm. £800 ($2,000). *Centre below:* Gold and enamel cylinder centre seconds musical watch, by John Rich, no. 807, *circa* 1790, 62 mm. £3,200 ($8,000). The watches illustrated on this page were sold in Zurich on the 25th November 1971.

Ceramics

Perhaps the most important Continental porcelain offered this season was part of the Prince de Rohan service from the Jesse Woolworth Donahue collection sold in New York. This service, delivered from the Sèvres factory on 7 September 1772, is considered one of their masterpieces. Originally of 368 pieces, it was commissioned by Louis-René-Edouard, Prince, later Cardinal Prince de Rohan (1734–1803), probably at the time he was appointed by Louis XV *Ambassadeur Extraordinaire* to the Court of Vienna. The service is now dispersed among the major Museums and collections of the world; after the Second World War, about half of it went to the United States.

In London, the most important piece was the Wedgwood copy number 22 of the Barberini or Portland vase, which was sold from the Oster collection of Wedgwood pottery on November 30. The original glass vase is of Graeco-Roman origin, and is thought to have been found in a marble sarcophagus under the Monte del Grano on the outskirts of Rome in 1582. It occupied a place of honour in the library of the Barberini Palace, was later acquired by Sir William Hamilton who sold it in 1785 to the Duchess of Portland. It was smashed by a madman in 1845, while on loan, and was bought by the British Museum in 1945. Wedgwood was deeply influenced by the design of this vase, as were the great neoclassicists, including John Stuart Flaxman who was employed by the factory as a designer. The 'First Fifty' copies were offered on subscription for 50 guineas, although not more than half that number were actually produced. This particular example, which fetched £20,000 ($50,000), the auction record for English ceramics, was originally bought by the Dowager Duchess of Beaufort. Three other copies from the 'First Fifty' have been sold at auction in the past sixteen years, in 1956 for £480 ($1,344), in 1963 for £1,357 ($3,780) and in 1964 for £3,045 ($8,946).

Very high prices have been paid for good examples from minor European factories. In New York on April 4, a Vezzi Venice teapot with floral decoration of circa 1720–27, realised $5,000 (£2,000), whilst a figure of a parrot from the Höchst factory fetched $19,000 (£7,600) in the Donahue sale in April; it is interesting to note that at Sotheby's in 1965, a pair of ormolu-mounted parrots of equal quality to the present single, unmounted piece fetched £8,500 ($23,800). Some unusually fine du Paquier porcelain has also been sold, including a figure of Columbine, *circa* 1730, which fetched $12,500 (£5,000) and a Holy Water stoup of *circa* 1725–35, which realised $10,000 (£4,000); both these pieces had been sold at Sotheby's in the famous Blohm sale of 1960 for £1,400 ($3,920) and £860 ($2,408) respectively.

English 18th century porcelain was also well represented, and prices were significantly high. The Ronald Hughes collection sold in February contained some magnificent pieces including a vary rare pair of Worcester figures of a gardener and his companion at £5,000 ($12,500) and a first period yellow ground teapoy and cover at £3,000 ($7,500).

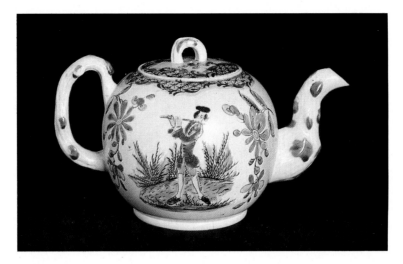

A saltglaze teapot and cover with crabstock handle and spout, enamelled in brilliant colours with a flute-player on one side and a court scene on the other. 4½ in.
London £400 ($1,000). 2.v.72.

Formerly in the Dr Day Collection.

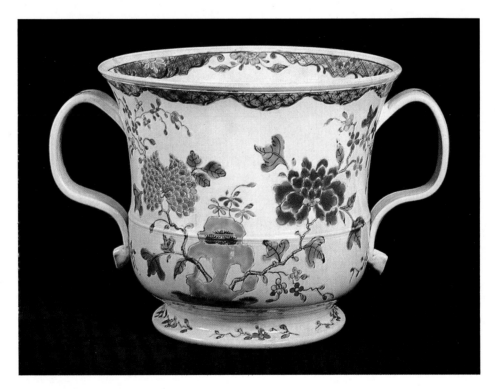

A saltglaze loving cup of campana shape.
Overall diameter 10 in.
London £1,900 ($4,750). 2.v.72. From the collection of Mr & Mrs J. E. Lowy.

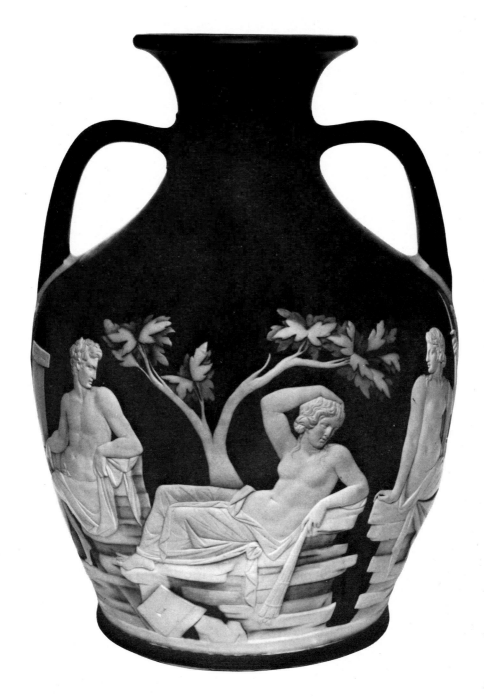

THE BARBERINI OR PORTLAND VASE

Wedgwood's copy number twenty-two of the Graeco-Roman original, the sides adorned with a frieze depicting Peleus and Thetis in white relief, washed in places with grey body colour, and a Wedgwood oval medallion with a trial piece of foliage from the Portland Vase design.
The vase 10 in., the medallion $3\frac{3}{8}$ in., impressed *3*.
London £20,000 ($50,000). 30.XI.72.

From the collection of Catherine G. Oster and the late Samuel B. Oster. Wedgwood received the vase on 10th June 1786 and took orders for the 'First Fifty' at fifty guineas each; this copy, one of about twenty-five actually produced, was subscribed for by the Dowager Duchess of Beaufort, but she did not receive it until some time between 1799 and her death in 1831.

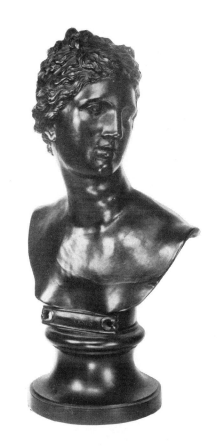

Left:
A Wedgwood and Bentley black basaltes bust of Venus. Impressed: *WEDGWOOD & BENTLEY*. 18½ in. London £1,800 ($4,500). 16.v.72.

From the collection of Catherine G. Oster and the late Samuel B. Oster.

Right:
A Wedgwood and Bentley urn and cover, the body covered with a bluish-green glaze, the centre with a relief medallion depicting the Three Graces. Impressed: *WEDGWOOD & BENTLEY: ETRURIA.* 17 in. London £1,900 ($4,750). 16.v.72.

From the collection of Catherine G. Oster and the late Samuel B. Oster.

Below left:
A Wedgwood and Bentley bust of Francis Bacon, from a plaster cast by Hoskins and Grant, perfected by Keeling. Bust and socle impressed: *Wedgwood & Bentley*, the bust impressed: *BACON.* Height 18 in. New York $3,250 (£1,300). 26.ii.72.

Below right:
A Wedgwood black basaltes bust of Dr Fothergill, modelled by J. Flaxman. Reverse impressed *Dr: Fothergill* and *Wedgwood*, socle impressed *WEDGWOOD* and *Z*. Height 17¼ in. New York $2,600 (£1,040). 26.ii.72.

These two busts were part of the Bernheim Collection.

1. Wrotham globular tyg. Signed *IE Wrotham 1707.* 4⅝ in. £1,250 ($3,125). 18.i.72.
2. Bristol delft Farrier's punch bowl, inscribed *Thomas Nowell*, 1742. 12 in. £950 ($2,375). 18.iv.72. **3.** English delft charger. 10½ in. £1,750 ($4,375) 18.iv.72. **4.** Saltglaze monogrammed plate. 9 in. £950 ($2,375). 2.v.72. **5.** Saltglaze. polychrome punch pot and cover, the cover repaired. 7 in. £1,400 ($3,500). 2.v.72.
6. Transfer-printed saltglaze plate. 8½ in. £250 ($625). 2.v.72. **7.** Saltglaze figure of a woman, 5 in. £1,000 ($2,500). 18.iv.72. **8.** Lambeth wet drug jar, inscribed: *DE: QUI: RADIO* 1666. 7 in. £700 ($1,750). 18.i.72. **9.** Delft polychrome pill slab with the arms of Charles II, initialled *NB*, 1664. 9½ in. £2,800 ($7,000). 18.i.72. **10.** Dublin delft plate, inscribed *IEC*, 1748, Crisp's factory. 8⅞ in. £430 ($1,075). 8.ii.72. **11.** Prattware figure of a lion. 6½ in. £320 ($800). 18.i.72. **12.** Liverpool delft dish. 13¼ in. £360 ($900). 8.ii.72.

1. One of pair of Chelsea 'hob-in-the-well' plates, painted in kakiemon enamels. One with red anchor mark. Diameter 9½ in. $700 (£280). 29.x.71. 2. One of pair of Chelsea silver-shaped plates, raised red anchor period, with triple spur marks. Diameter 8¾ in. $975 (£390). 29.x.72. 3. Chelsea fable-decorated dish painted by J. H. O'Neale, red anchor period. 8 in. £1,200 ($3,000). 22.ii.72. 4. Chelsea dish of silver form, red anchor period. 9 in. £900 ($2,250). 21.xii.71. 5. One of pair of Chelsea bough pots, red anchor period. 6 in. £1,000 ($2,500). 5.x.71. 6. One of pair of Chelsea covered melon tureens, red anchor period. Length 6½ in. $4,000 (£1,600). 7.vi.72. 7. One of pair of Chelsea covered melon tureens, red anchor period. Length 3½ in. $4,250 (£1,700). 7.vi.72. 8. Chelsea acanthus leaf cream jug, triangle period. 4¼ in. £750 ($1,875). 22.ii.72. 9. One of a pair of Chelsea groups of the seasons, gold anchor mark. 13¼ in. £1,550 ($3,720). 5.x.71. 10. Chelsea Italian figure of Isabella. Red anchor period. 6½ in. £3,200 ($7,680). 5.x.71. 11. Chelsea Italian comedy figure of Pantaloon. Red anchor period. 5¾ in. £1,550 ($3,875). 22.ii.72. 12. Chelsea group of the Virgin and Child by Joseph Willems. Red anchor mark. 8¼ in. £750 ($1,875). 22.ii.72.

A pair of Worcester figures of a gardener and companion, each standing on a mound base applied with brightly coloured florettes.
$6\frac{1}{2}$ in. and $6\frac{3}{4}$ in.
London £5,000 ($12,500). 22.II.72.

From the collection of the late Ronald Hughes, Esq.

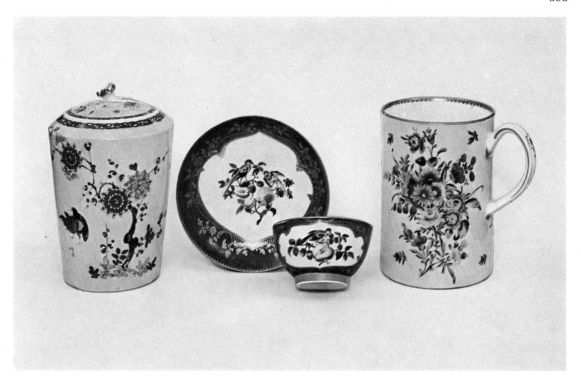

Left: A Worcester yellow-ground teapoy and cover. Height 5¾ in. £3,000 ($7,500).
Centre: A claret-ground teabowl and saucer. £1,550 ($3,875).
Right: A yellow-ground cylindrical mug. Height 4¾ in. £3,000 ($7,500), all first period.

From the collection of the late Ronald Hughes, Esq., sold at Sotheby's on 22nd February 1972.

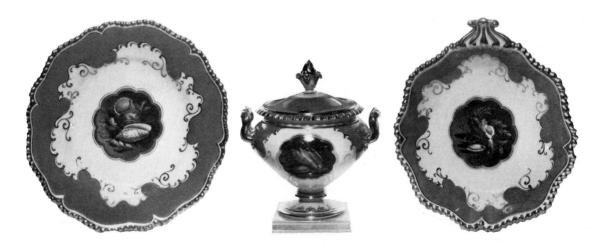

An apple-green Flight Barr and Barr conchological dessert service,
marks printed in sepia and impressed.
London £2,300 ($5,750). 20.VI.72.

A Castel Durante armorial saucer dish, painted with the Judgement of Paris after Raphael. School of Pellipario, *circa* 1530. 10 in. London £720 ($1,800). 7.XII.71.

An Urbino *tondino* painted with a classical scene. Inscribed *Limme et Fonte*, Fontana workshop, *circa* 1540. 7¾ in. London £1,450 ($3,625). 7.XII.71.

A Faenza *tondino* painted by the 'Green Man' or 'Master of the Bergantino Bowl'. Mark *F* within a circle. *Circa* 1525. 9½ in. London £2,300 ($5,750). 7.XII.71.

A Deruta portrait *tondino* painted with a profile of a boy. Painted mark *AA* and an asterisk. *Circa* 1500. 9¼ in. London £1,000 ($2,500). 24.IV.72.

A Castelli 'Gobbi' plaque by Francesco Saverio Grue. 8⅞ in. by 12⅞ in. London £1,000 ($2,500). 10.VII.72.

A Montelupo dish decorated with a soldier on horseback. 17th century . 12¾ in. London £460 ($1,150). 24.IV.72.

Left:
The Confession of Augsburg: a
Nuremberg faience
documentary tankard
commemorating the 200th
Jubilee of the Augsburg
Confession, painted by
G. F. Grebner, with cover in
parcel-gilt silver.
Signed *G.F.G.*, dated 1730
d. 23 Juny. The cover
with maker's mark,
Nuremberg, *circa* 1735. 10 in.
London £4,200 ($10,500).
7.XII.71.

From the collection of
C. H. Fairman, Esq.
An interesting point to note
is that the date of the
signature on the base
antedates the actual jubilee
by two days.

Right:
One of a pair of Dutch 18th
century delft blue and white
tulip vases, supported on
three recumbent lions.
AP3 monogram in blue.
Height 18 in.
New York $4,600 (£1,840).
19.I.72.

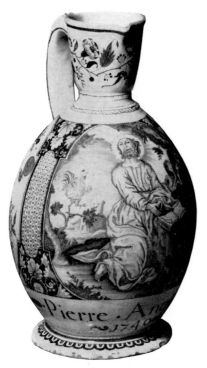

A Rouen ewer painted with a saint within
a shaped panel, the reverse with two
kakiemon panels of flowering prunus.
Inscribed *Pierre Anquetil*, dated 1740.
Height 12¼ in.
New York $1,700 (£680). 19.I.72.

From the collection of Mrs Lillian Jost.

A Sceaux faience covered lettuce tureen.
Fleur-de-lis mark in brown. *Circa* 1760.
Length 11½ in.
New York $6,000 (£2,400). 7.VI.72.

From the collection of Mrs Edward F.
Hutton.

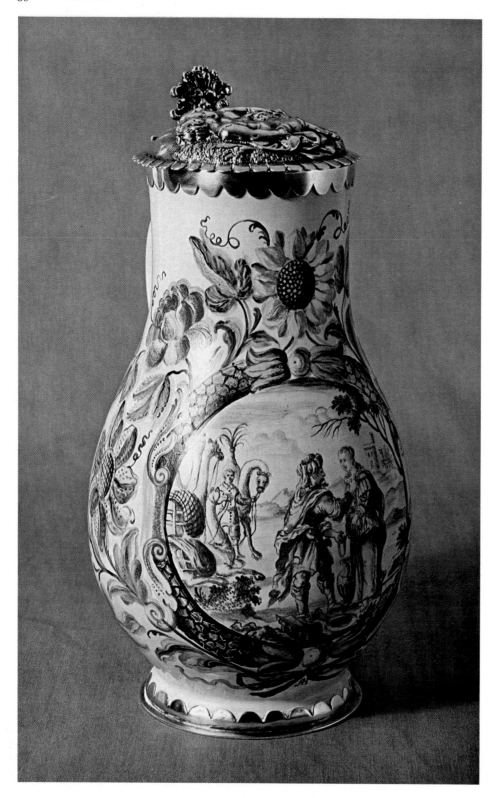

A Nuremberg Hausmaler faience *Birnkrug* painted by Abraham Helmhack.
Signed *AH* in monogram, Hanau or Frankfurt, *circa* 1690. 10¼ in.
London £5,000 ($12,500). 7.XII.71.

From the collection of Mr and Mrs James.

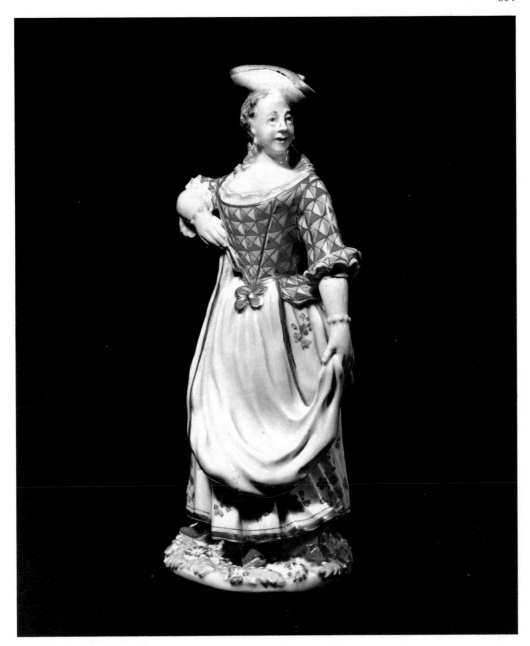

A Vienna du Paquier figure of Columbine, the mound base encrusted with flowers.
Circa 1730–40. $7\frac{1}{4}$ in.
New York $12,500 (£5,000). 6.vi.72.
From the collection of Mr Leo Stoll.

A Meissen yellow-ground Augustus Rex vase of trumpet shape, probably by J. G. Höroldt.

Large *AR* monogram in underglaze-blue, a cross-incised. 9¼ in.

London £3,700 ($9,250). 4.VIII.72

One of a pair of Meissen orange tubs painted with an Imari pattern of sprays of *indianische Blumen* and insects.

Crossed swords marks in underglaze-blue, one with a letter K. 15½ in.

London £2,500 ($6,250). 4.VII.71.

A Meissen Augustus Rex vase of trumpet shape.

Large *AR* monogram in underglaze-blue, a cross incised. 9½ in.

London £4,800 ($12,000). 4.VII.72.

From the collection of the Rt Hon. the Viscount Chaplin.

A Meissen tankard with contemporary silver-gilt mount and cover, probably the work of J. G. Höroldt.
Open crossed swords mark in blue on an unglazed base. 6¼ in.
London £4,000 ($10,000) · 7.XII.71.
From the collection of the late Michael Moseley, Esq.

A Meissen tankard painted with a chinoiserie scene of a riverboat party by Johann Gregorious Höroldt, after Petrus Schenk. 5¾ in.
London £7,500 ($18,750) · 4.VII.72.

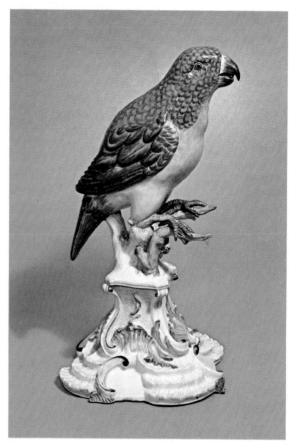

A Höchst figure of a parrot perched on a gnarled tree
stump. *Circa* 1755–60. Height 14 in.
New York $19,000 (£7,600). 28.IV.72.

Opposite page, below:

Left:
A Vienna du Paquier holy-water stoup
modelled as St Veronica.
Circa 1725–35. Height 10¼ in.
New York $10,000 (£4,000). 6.VI.72.

From the Fritz Katz collection.
Formerly in the Blohm collection.

Right:
A Meissen figure of the court jester
Schindler by J. J. Kaendler.
Crossed swords marks in underglaze-blue. 7 in.
London £3,600 ($9,000). 4.VII.72.

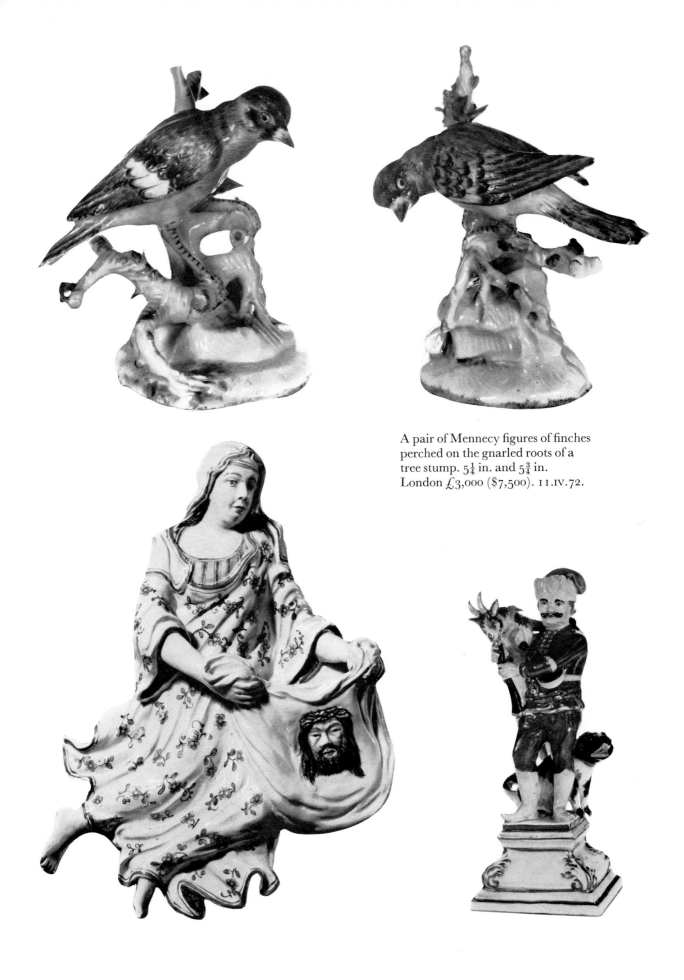

A pair of Mennecy figures of finches
perched on the gnarled roots of a
tree stump. $5\frac{1}{4}$ in. and $5\frac{3}{4}$ in.
London £3,000 ($7,500). 11.IV.72.

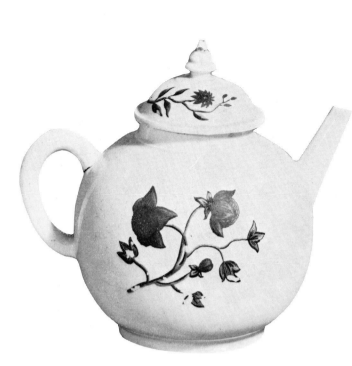

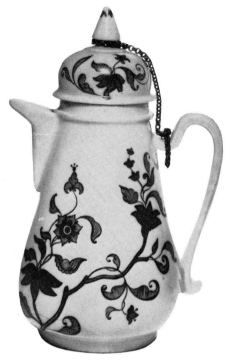

A Vezzi Venice teapot and cover with
floral decoration.
Marked *Ven:ᵃ* in iron-red and incised *A*.
Circa 1720. 5¼ in.
New York $5,000 (£2,000). 4.IV.72.

From the collection of the Dr William P.
Harbeson Trust.

A Vezzi Venice milk jug and cover
painted in iron-red and gilding.
Marked *Vena:* in iron-red and incised *A*.
6¾ in.
London £1,400 ($3,500) 7.XII.71.

From the collection of D. H. King, Esq.

A Doccia covered ecuelle, with twig
fruiting vine handles.
Incised *V* mark.
Circa 1755. Width 7¼ in.
New York $7,750 (£3,100). 4.IV.72.

From the collection of the Dr William P.
Harbeson Trust.

A Vienna du Paquier double-handled
sauceboat with *famille verte* decoration.
Circa 1725. Length 9½ in.
New York $4,200 (£1,680). 10.XII.71.

From the collection of the Dr William P.
Harbeson Trust.

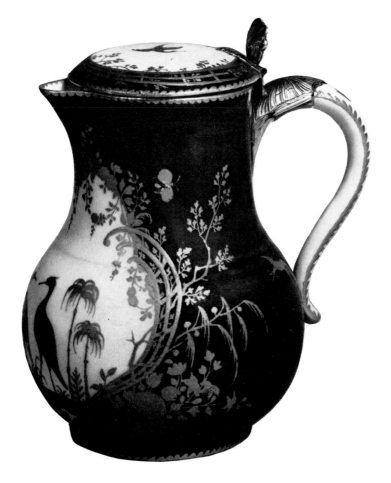

Above:
A shell-shaped dish and a *seau à bouteilles* from the 35-piece Sèvres porcelain Prince de Rohan service, with reserved panels of birds on a *bleu céleste* ground. *Circa* 1771, the dish: length 8½ in.; the *seau*: height 6½ in.
The set was sold in New York on 28 April 1972 for a total of $69,150 (£27,660).

From the collection of Jessie Woolworth Donahue.

Left:
A Vincennes covered ewer decorated with a panel of exotic birds on *gros bleu* ground. Interlaced *L* marks in underglaze-blue, the mounts with Paris Hallmarks of 1752 and discharge mark for 1750-6. Height 4⅞ in.
New York $2,500 (£1000). 4.IV.72.

From the collection of the Dr William P. Harbeson Trust.

Musical Instruments

BY GRAHAM WELLS

This season has been notable for the number of violins by Stradivari that have come up for sale. Five in all, they were: the Ludwig of *circa* 1730, the Red Diamond of 1732, the Dickson-Poynder of 1703, the Lord Amherst of Hackney of 1734 and an unnamed Stradivari of 1729. Of these the highest price was fetched in the May sale by the Lord Amherst, a violin that formerly belonged to Fritz Kreisler, which brought £32,000. This would have been a saleroom record for a violin but for the £84,000 paid for the Lady Blunt last season.

As always, 17th and 18th century Italian violins commanded the highest prices. A handsome Venetian violin by Montagnana, the 'Hubay', brought £11,000 in December. However a clear record for a French maker was established by a fine violin by J. B. Vuillaume, the 19th century Paris maker, which brought £3,800 in May.

More players are now seeking authentic instruments for performances of early music. This would explain the high prices paid for two viols in the March sale, the bass viola da gamba by Richard Meares of London bringing £2,200. There was also strong competition for woodwind instruments of the 18th century and earlier. In the June sale, £3,600 was given for an oboe by Stanesby, Senior and £1,200 for a flute by his son.

Among keyboard instruments sold during the season, have been three harpsichords and a square piano by the Kirckman family. In the March sale a fine two manual harpsichord by the hitherto unrecorded English maker, Thomas Blasser, brought £3,000. Finally a bureau organ by Henry Holland, of more domestic proportions than most chamber organs, brought £1,900 in the June sale.

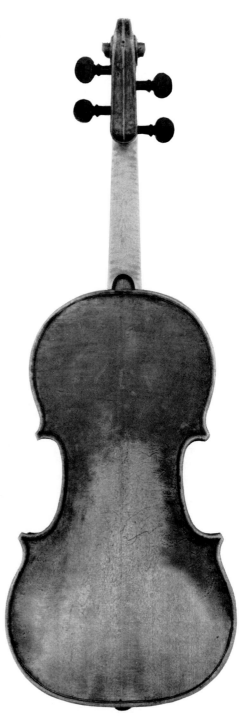

The Red Diamond
A violin by Antonio Stradivari, Cremona 1732, the original label inscribed *Antonius Stradivarius Cremonenfis faciebat Anno 1732*. Length of back 14 in.
London £26,000 ($65,000). 16.XII.71.

From the collection of the Evergreen House Foundation.

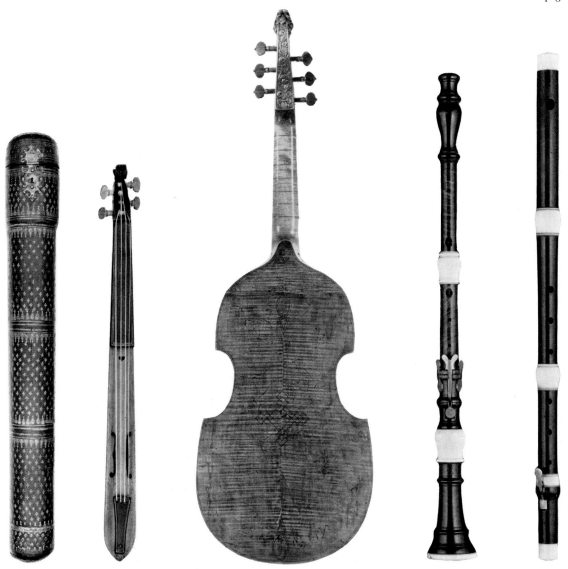

Left:

A French pochette by Mauceau Mathreu, Paris, labelled *Mauceau Mathreu au fut Core rue St. Honoré*, with case. Mid-17th century. Length 17 in.

London £850 ($2,125). 16.XII.71.

Centre:

A bass viola da gamba by Richard Meares, London.

Unlabelled. Second half of 17th century. Length of back 17⅝ in.

London £2,200 ($5,500). 13.III.72.

Right:

A three-keyed Baroque oboe by Thomas Stanesby, Senior, London. Stamped *T. Stanesby* above a star. Late 17th–early 18th century. Length 23 3/16 in.

London £3,600 ($9,000). 29.VI.72.

From the collection of Eric Halfpenny, Esq., F.S.A.

Extreme right:

A one-keyed flute by Thomas Stanesby, Junior, London 1738. Stamped *Stanesby Junior* in three places. Length 24¼ in.

London £1,200 ($3,000). 29.VI.72.

From the collection of Eric Halfpenny, Esq., F.S.A.

The head-cap bears a silver plaque engraved *The Gift of His Royal Highness Frederick, Prince of Wales, to T. Wackett, 1738.*

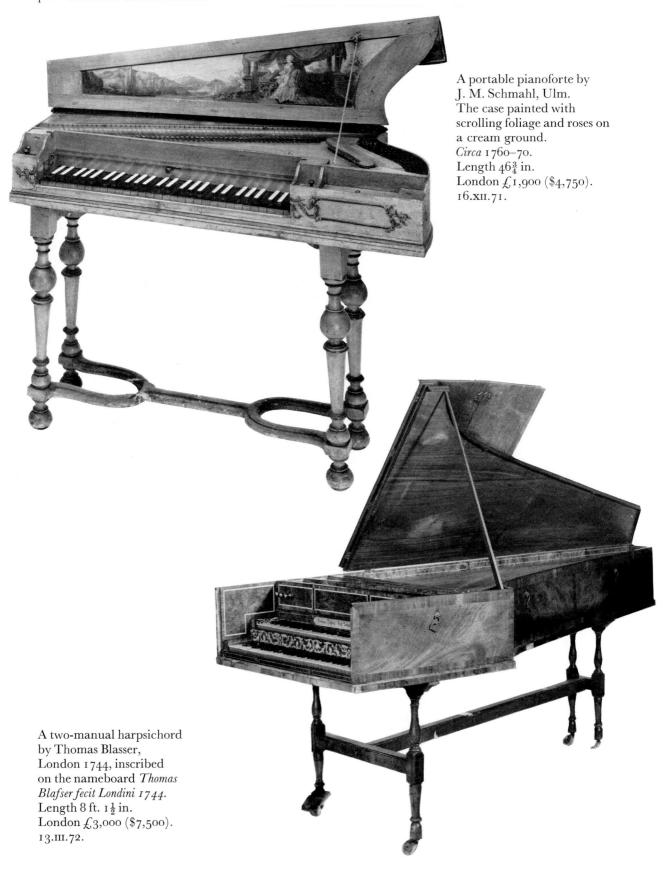

A portable pianoforte by
J. M. Schmahl, Ulm.
The case painted with
scrolling foliage and roses on
a cream ground.
Circa 1760–70.
Length 46¾ in.
London £1,900 ($4,750).
16.XII.71.

A two-manual harpsichord
by Thomas Blasser,
London 1744, inscribed
on the nameboard *Thomas
Blafser fecit Londini 1744.*
Length 8 ft. 1½ in.
London £3,000 ($7,500).
13.III.72.

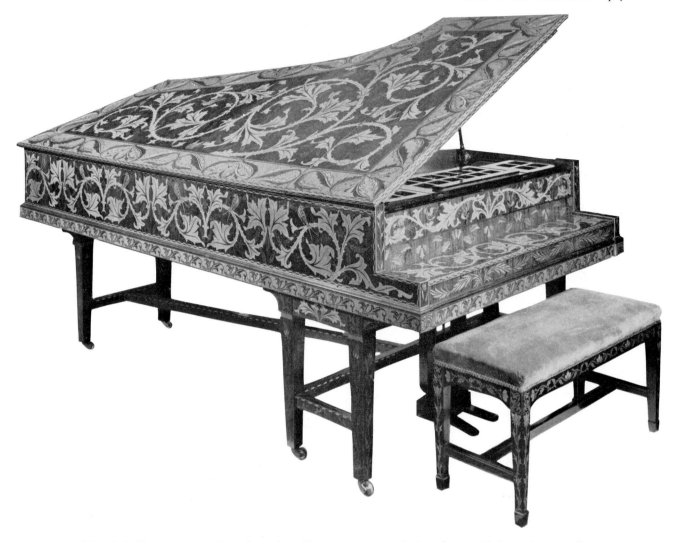

A Morris & Co. marquetry Broadwood medium concert grand pianoforte, with long piano stool en suite.
Labelled *J. Angold 42935* and stamped *T. Hinton. Circa* 1890. Length 7 ft. 6 in.
London £2,300 ($5,750). 27.XI.71.

From the collection of I. M. Ballantyne, Esq.
This piano was made to rest on the large Hammersmith carpet designed by William Morris in the 1880's for Bullers Wood, the home of J. Sanderson.

The Kirckman Family of Harpsichord Makers

BY GRAHAM WELLS

English harpsichord making in the 18th century was dominated by two men, Jacob Kirckman and Burkat Shudi. Both were formerly apprenticed to Hermann Tabel, who came from Flanders and had studied in the tradition of the renowned Ruckers family of makers.

When Tabel died in 1738, Kirckman took the sensible step of marrying his widow, thus acquiring his master's stock of seasoned wood and other desirable assets. However, as his elderly wife died a year or so later, there were no children to help him or carry on the business. In 1772 he took into partnership his nephew Abraham, whose son Joseph also joined the firm shortly before Kirckman's death in 1792. Under Joseph' management the firm made its last harpsichord and entered the 19th century as manufacturers of the pianoforte.

Jacob Kirckman confined his production almost entirely to double and single manual harpsichords. However, three spinets are recorded, and a claviorgan, a combined harpsichord-organ, which was made in conjunction with the famous organ-builder John Snetzler. The firm also made a number of square pianos, of which one of the earliest, dated 1775, was sold in June this year.

The Kirckman and the Shudi harpsichords were very similar in design. In the later years of the 18th century, both had to contend with the growing popularity of the pianoforte with its more flexible and dynamic possibilities. In 1769 Shudi patented the Venetian swell mechanism, a system of shutters placed over the soundboard and controlled by a foot pedal. Kirckman soon incorporated this into some of his own instruments but it was not very successful as, when closed for a 'piano' passage, the tone was muffled. The last recorded Kirckman harpsichord was made by Joseph in 1809.

Jacob Kirckman's business acumen cannot be doubted. He was so successful that, according to Charles Burnley, he indulged in money-lending. Burnley also tells us that, during the third quarter of the 18th century, there was a craze for the cittern or English guitar and the harpsichord went out of fashion. Kirckman bought up a number of these instruments and gave them to shop girls and others, thus causing the wealthier classes to return rapidly to their harpsichords.

In direct contrast to the heavily ornate continental instruments of the 18th century, English harpsichords often had simple walnut cases with shaped brass hinges extending over the lid. Of the 100 or so surviving Kirckman instruments, three or four have extremely handsome cases with beautifully figured panels of veneer outside and marquetry interiors. These show a marked German influence and must have been executed by workmen brought over from the Kirckman's native country.

Tonally Kirckman's instruments are still among the best and his design is used as a basis by many of the revived school of harpsichord makers.

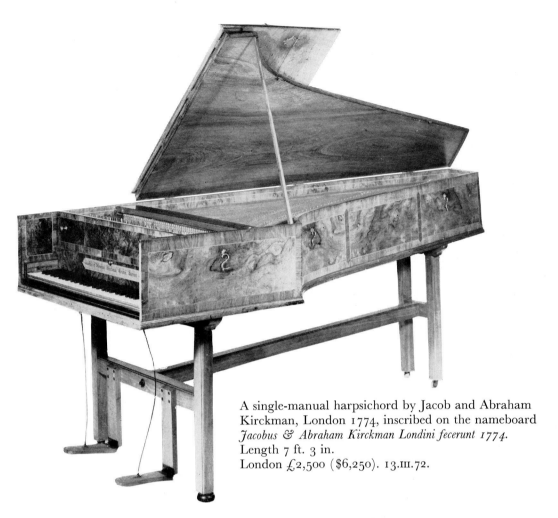

A single-manual harpsichord by Jacob and Abraham
Kirckman, London 1774, inscribed on the nameboard
Jacobus & Abraham Kirckman Londini fecerunt 1774.
Length 7 ft. 3 in.
London £2,500 ($6,250). 13.III.72.

A square piano by Jacob and Abraham Kirckman,
London, 1775, inscribed on a satinwood plaque on the
nameboard *Jacobus et Abraham Kirckman, Londini
fecerunt 1775.* Length 4 ft. 8¾ in.
London £460 ($1,150). 29.VI.72.

From the collection of A. C. Hilton, Esq.

19th and 20th Century Decorative Arts

The first season at Sotheby's Belgravia has been an unqualified success. The wealth and scope of 19th century fine and applied art, the multifarious activities of its many designers and painters have perhaps for the first time been placed in their proper perspective. The emphasis has been, and will continue to be, upon pieces of high quality and no-one, after following the season at Belgravia, could seriously question the fact that the Victorians were not only as inventive but also as skilful as the craftsmen of any previous age.

An interesting aspect of this new saleroom is the broad spectrum of buyers from many countries. As an experiment in the coming season, to help any prospective buyers who are unable to view the sales themselves, the Belgravia catalogues will provide estimates of expected prices, and indication of condition of all lots, and the catalogues will be even more extensively illustrated.

Victorian paintings, after years of neglect, appear once more to be attracting the attention of serious collectors. Hicks' famous *The General Post Office* (*1 minute to 6*), depicting with spirited realism the scene so vividly described by Dickens, fetched £7,200 ($18,000) at the beginning of the season, a very high price which boded well for the future. Indeed, some four months later, another version of the same subject, but much smaller, almost equalled the previous price at £7,000 ($17,500). The most important painting appeared in the sale of 19th century pictures held at Sotheby's Los Angeles in November. Alma-Tadema's justly famous *Spring* was bought by the Paul Getty Museum for an auction record $55,000 (£22,000). The peak of Alma-Tadema's fame was the period between 1895 and 1905, when prices between £4,000 and £6,000 ($20,000 and $30,000) were commonplace for his work, prices equivalent in modern terms to between £40,000 and £60,000 ($100,000 and $150,000). By 1909, however, prices had already fallen drastically and *Spring* realised only £945 ($4,725) when sold by the New York collector James A. Garland at Christie's.

The number of important things was so great as to defy proper analysis here. Certain pieces, Burne-Jones' magnificent tapestry of *The Pilgrim in the Garden*, designed for the Merton Abbey looms, the powerful black marble *Sitting Condor*, executed in 1929 by Edouard Marcel Sandoz, one of the masterpieces of Art Deco sculpture sold by the Cranbrook Academy in New York, the sumptuous marquetry grand piano by Morris and Co. sold in London, or the superb cameo glass plaque by George Woodall, a *tour de force* of its kind, stand out in the mind and serve to emphasise the richness of 19th and 20th century applied art.

There were also some remarkable pieces of silver, none more so than the seven-piece tea-set by the Italian Antonio Cortelazzo which is discussed in detail on page 422, and the rare teapot by Christopher Dresser, one of a very small number of silver pieces signed by one of the most original Victorian designers.

The Pilgrim in the Garden, one of the Merton Abbey tapestries, designed by Sir Edward Burne-Jones and
woven in 1901 by Taylor, Martin and Ellis, for Morris and Company.
5 ft. 1 in. high by 6 ft. 7 in. wide.
London £7,400 ($18,500). 7.VI.72.
From the collection of J. M. D. Fleming, Esq.
William Morris moved his craft works from Queen's Square to Merton Abbey in 1881, setting up a
special tapestry works with huge 'highwarp' hand looms. After his death in 1896 the craft revival
continued at the works in the same tradition.

GEORGE ELGAR HICKS
Billingsgate.
Panel. Signed and dated 1861. 10 in. by 17 in.
London £3,400 ($8,500). 22.II.72. From the collection of Miss E. Cochran.

GEORGE ELGAR HICKS
The General Post Office (1 minute to 6).
Signed and dated 1860. 35 in. by 53 in.
London £7,200 ($18,000). 19.X.71. A smaller version of this painting was
 sold on 22 February 1972 for £7,000.

FREDERICK WILLIAM WATTS
A View of Sonning-on-Thames.
12¾ in. by 19½ in.
London £4,700 ($11,750). 20.VI.72. From the collection of Colonel M. G. Bull.

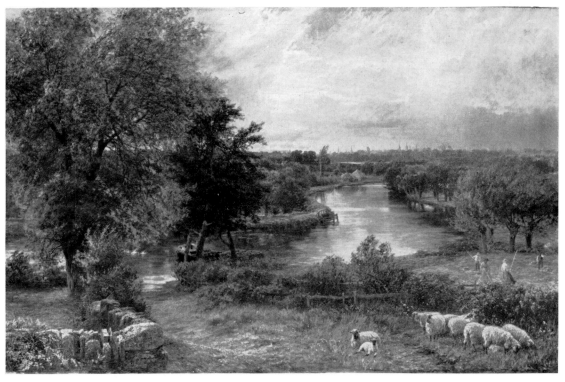

GEORGE VICAT COLE, R.A.
Oxford from Iffley.
Signed with monogram and dated 1884. 50 in. by 83 in.
London £5,200 ($13,000). 14.XII.71. From the collection of the Atsoparthis family.

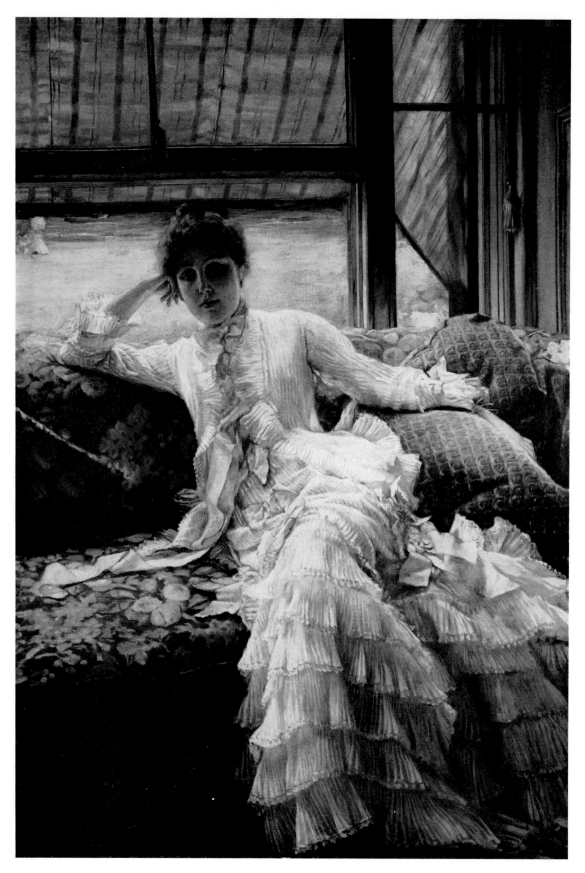

JAMES JACQUES JOSEPH TISSOT
Jeune femme assise.
Executed *circa* 1878–82. 34 in. by 23½ in.
Los Angeles $19,000 (£7,600). 23.v.72. From the collection of Dr Herbert T. Schwarz, Montreal.

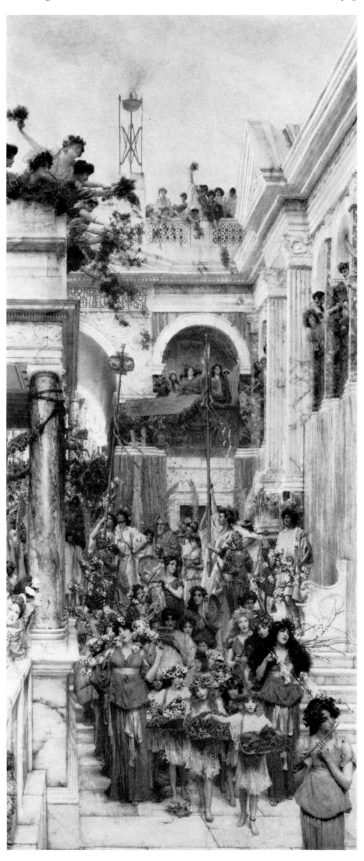

SIR LAWRENCE
ALMA-TADEMA, R.A.
Spring.
Signed and inscribed 'op
CCCXXVI'. Painted 1894.
70¼ in. by 31½ in.
Los Angeles $55,000
(£22,000). 28.11.72.

From the collection of the
late Victor Emmanuel
Wenzel von Metternich.

1. *The Sick Doll* by William Powell Frith. Signed, dated 1885. 28 in. by 36 in. £1,400 ($3,500). 20.VI.72. **2.** *Hamlet and Ophelia* by William Quiller Orchardson. Signed with initials, dated 1865. 38 in. by 56½ in. £850 ($2,125). 19.X.71. **3.** *The Opinion of the Press* by Thomas E. Roberts. 24¾ in. by 29¾ in. £900 ($2,250). 20.VI.72. **4.** *A View on the Grand Canal, Venice* by Edward Pritchett. Signed. 28 in. by 41½ in. £3,000 ($7,500). 22.II.72. **5.** *A View of San Giorgio Maggiore* by Edward William Cooke. Signed, dated 1846, on panel. 9¾ in. by 21 in. £1,400 ($3,500). 22.II.72. **6.** *The Imperial Palace of God* by George Elliot. Pen, brown ink, grey wash. Signed, inscribed, dated 1856. 25½ in. by 38¼ in.

£160 ($400). 1.II.72. **7.** *Philae from Biggeh* by Andrew MacCallum. Signed, dated 1871. 36 in. by 52 in. £1,350 ($3,375). 11.IV.72. **8.** *Sailing Barges by a Windmill on the Broads, Evening* by Henry Bright. 23 in. by 42 in. £2,400 ($6,000). 20.VI.72. **9.** *An Extensive Landscape* by Sydney Richard Williams Percy. Signed, dated 1861. 24 in. by 38 in. £2,200 ($5,500). 22.II.72. **10.** *A View of Grasmere* by Alfred Vickers Sr. Signed and dated 1844. 8 in. by 15 in. £800 ($2,000). 14.XII.71. **11.** *Farmyard companions* by Edgar Hunt. Signed, dated 1920. 21½ in. by 29½ in. £1,400 ($3,500). 23.XI.71. **12.** *Cornish Breakers off Newquay, Cornwall* by David James. Signed, dated '98, inscribed on reverse. 24¼ in. by 49½ in. £800 ($2,000). 22.II.72.

1. *The Rose Garden* by Sir Edward Burne-Jones. Signed, dated 1862. 28 in. by 21 in. £1,400 ($3,500). 20.VI.72. **2.** *Opie, when a Boy, reproved by his Mother* by John Absolon. Signed and dated '62. 22¼ in by 18½ in. £280 ($700). 14.XII.71.
3. *Eastward Ho! August 1857* by Henry Nelson O'Neil. Signed, dated 1858. 35½ in. by 27½ in. £2,600 ($6,500). 22.II.72. **4.** *Cinderella* by Sir John Everett Millais. Signed with monogram, dated 1881. 50 in by 35 in. £5,500 ($13,750). 20.VI.72. **5.** *The Carter's Return* by John Atkinson Grimshaw. Signed, dated 1875, on panel. 21½ in. by 17 in. £1,300 ($3,250). 20.VI.72. **6.** *Doves and Apple Blossom* by Edwin Alexander. Signed, dated '97, on canvas. 16 in. by 12¾ in. £400 ($1,000). 22.II.72. **7.** *The King of the Jungle* by William Huggins of Liverpool. Signed, dated 1867, on panel. 10 in. by 18 in. £1,900 ($4,750) 22.II.72.
8. *'Dust Crowns All'* (*Links to the Vanished Past*) by E. G. Handel Lucas. Signed, dated 1886–7, on panel. 13½ by 11½ in. £2,000 ($5,000). 22.II.72.
9. *Portrait of Mrs Anna Maria Hall* by Daniel Maclise. Pencil and watercolour. Signed with initials, dated 1833. 9 in. by 6½ in. £480 ($1,200). 20.VI.72. **10.** *The Lady of Shalott* by William Holman Hunt. Pen and sepia ink. 4½ in. by 3 in. £360 ($900). 20.VI.72. **11.** *Portrait of J. M. W. Turner, R.A., 1851* by Sir John Everett Millais. Pen and sepia ink. 9 in. by 7 in. £300 ($750). 20.VI.72. **12.** *The Altar of Hymen* by Sir Edward Burne-Jones. Watercolour heightened with body-colour and metallic paint, on vellum. Signed with initials. 14½ in. by 10¼ in. £2,700 ($6,750). 20.VI.72.

JULIA MARGARET CAMERON
Head and shoulders portrait of J. F. W. Herschel.
Inscribed 'From life Taken at his own residence
Collingwood April 1867 not enlarged'.
Signed by Cameron and Herschel.
357 mm by 270 mm.
London £260 ($650). 21.XII.71.

WILLIAM HENRY FOX TALBOT
The Chess Players.
Talbotype. Dated '*c.* 1839'. 248 mm by
193 mm., including margins.
London £410 ($1,025). 21.XII.72.

GARDNER, ALEXANDER *et al.*
The Lincoln Conspiracy.
Album of 38 mounted
photographs, with ink
captions. Bound in leather.
This album is part of the
collection of Arnold A.
Rand, a Union colonel in
the Civil War, who was,
with Gen. Albert Ordway,
the earliest collector of the
war photographs of Brady
and Gardner. The entire
collection was offered for
sale to Congress in 1884 and
refused, rediscovered in the
early part of this century
and used as the basis of the
10 volumes *Photographic
History of the Civil War*
(1911). The negatives
disappeared sometime
after the publication. (See
Taft, pp. 487–8).
New York $2,500 (£1,000).
22.II.72.

Right:
An eggshell lacquer vase by Jean Dunand,
circa 1929. Signed. Height 8½ in.
New York $2,100 (£840). 2.v.72.

From the collection of the Cranbrook
Academy of Art.

Below:
Sitting Condor by Edouard Marcel Sandoz.
Belgian black marble. *Circa* 1929. Signed.
Height 17½ in., length 24 in.
New York $7,750 (£3,100). 2.v.72.

From the collection of the Cranbrook
Academy of Art.

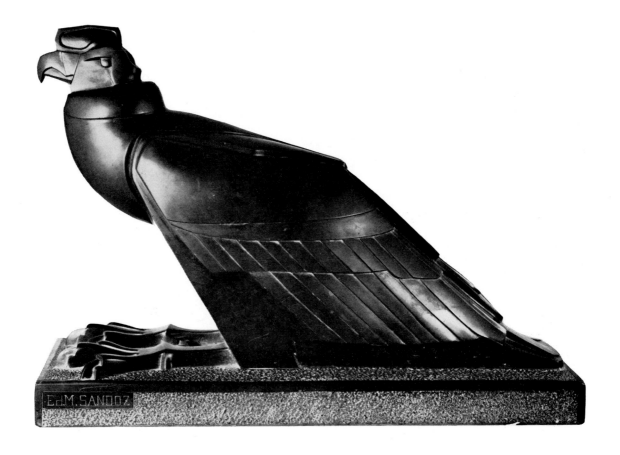

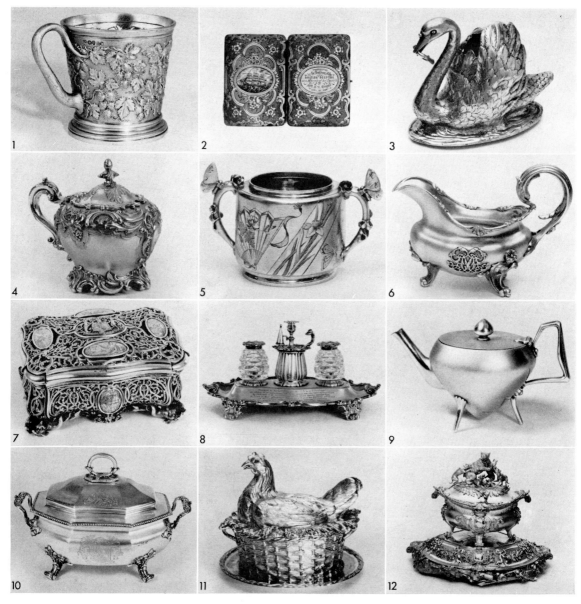

1. William IV silver-gilt mug by Paul Storr, London, 1834. Height 3¼ in. £210 ($525). 26.x.71. **2.** Victorian memorandum case, maker's mark R. T., Birmingham, 1868. Height 4 in. £48 ($120). 24.ii.72. **3.** Early Victorian silver-gilt table snuff box in the form of a swan, by J. Charles Edington, London, 1850. Height 2¾ in. £300 ($750). 24.ii.72. **4.** One of a pair of Victorian mustard pots by Robert Garrard, London, 1854, with spoons by G. W. Adams, London 1852–8. £200 ($500). 18.xi.71.
5. One of a Victorian parcel-gilt three-piece teaset in Japanese style by Elkington and Co., Birmingham 1875–77. £400 ($1,000). 24.ii.72.
6. One of a pair of early Victorian sauceboats with monogram initial A. T. by William K. Reid,

London, 1843. 8¼ in. £385 ($962.50). 6.iv.72. **7.** Victorian freedom box of City of Bristol, by John Brogden, London, 1851. Width 6¾ in. £720 ($1,800). 26.x.71. **8.** Victorian two-bottle inkstand by E. and J. Barnard, London, 1852. Width 15¼ in. £200 ($500). 26.x.71. **9.** Silver teapot designed by Christopher Dresser, made by James Dixon and Son, London, 1880. 4⅛ in. £750 ($1,875). 8.iii.72. **10.** William IV soup tureen and cover by Paul Storr, London, 1835. Width 14½ in. £1,700 ($4,250). 25.v.72. **11.** An electro-plated pie dish, cover and stand stamped 'G. R. Collis & Co., 130, Regent St. London'. Circa 1875. Width 9½ in. £175 ($437.50). 24.ii.72. **12.** Danish soup tureen, cover and stand by Anton Michelsen, Copenhagen. 1866. Width 23 in., height 17 in. £2,200 ($5,500). 24.ii.72.

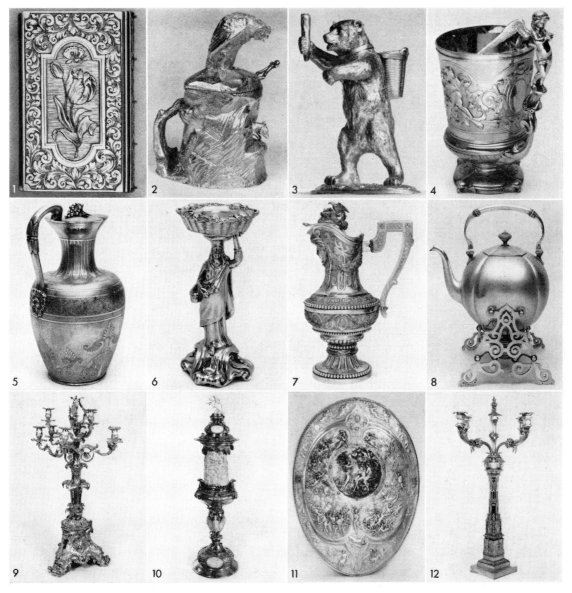

1. Early Victorian silver-gilt vinaigrette, 17th-century Dutch manner of Jacob van Huysum, by Rawlings and Summers, London, 1846. Width $1\frac{1}{2}$ in. £190 ($475). 29.VI.72. **2.** Victorian mustard pot in the form of a mossy rock with mouse by L. Dee, London 1882. Height $4\frac{1}{2}$ in. £155 ($387.50). 9.XII.71. **3.** Victorian table lighter in the form of a grizzly bear by J. B. Hennell, London, 1876. Height $6\frac{1}{4}$ in. £200 ($500). 25.V.72. **4.** Victorian silver-gilt christening mug by Francis Higgins, London, 1865. $4\frac{1}{2}$ in. £130 ($325). 24.II.72. **5.** Victorian wine ewer by George Fox, London 1867. Height $9\frac{1}{4}$ in. £240 ($600). 24.II.72. **6.** One of a pair of Victorian silver-gilt pedestal salt-cellars in the form of a figure of Abundance by Charles T. and George Fox, London, 1858. Height 8 in. £380 ($950). 18.XI.71. **7.** Belgian vase-shaped wine ewer by Jean Dufour et Frères, Brussels. *Circa* 1868. Height $10\frac{1}{4}$ in. £230 ($575). 24.II.72. **8.** Russian tea kettle on lampstand by Valentine Igatievitij Sasikov, St Petersburg, 1865. Overall height 15 in. £520 ($1,300). 24.II.72. **9.** Nine-light centrepiece by Paul Storr, London, 1830. Height 37 in. £2,600 ($6,500). 18.XI.71. **10.** German cup and cover of silver and ivory. Mid-19th C. Height $41\frac{3}{4}$ in. £2,600 ($6,500). 25.V.72. **11.** Oval plaque, L. Morel Ladeuil's *The Milton Shield*, electrotype by Elkington & Co., *circa* 1866. Height 34 in. £165 ($412). 29.VI.72. **12.** George IV four-light candelabrum by Emes and Barnard, London, 1828. Height $30\frac{1}{4}$ in. £460. ($1,150). 26.X.71.

Antonio Cortelazzo and the Narishkine Tea Service

BY JOHN CULME

The Narishkine tea service arrived at Sotheby's Belgravia in the autumn of 1971. Even a superficial examination revealed that the maker, Antonio Cortelazzo, was a very talented and imaginative artist. His profound knowledge of techniques of earlier centuries gave him the ability to create highly individualistic pieces.

Born in Vicenza in 1819, Cortelazzo spent much of his early career, under pressure from dealers, simulating Renaissance works of art for gullible connoisseurs. This dishonourable, though remunerative occupation, an indictment more of the patronage system than of Cortelazzo, was cut short when Sir Austen H. Layard suggested an alternative. Layard's sphere of friends was large, including influential politicians and business men of the day, some of whom wished to extend their private interests into Art. In addition to a number of continental collectors, these patrons included Layard's brother-in-law, Ivor Guest, later 1st Baron Wimborne[1] (1835–1914), Sir William Richard Drake[2] (1817–90), who had at one time ordered work from Burne-Jones, and the mathematician and physicist, William Spottiswoode[3] (1825–83).

Cortelazzo, in his new role as the respectable artist, is first mentioned in connection with a magnificent sword he had made for King Victor Emmanuel II. It was shown at the Florence Exhibition of 1861, and again in London during the following year.

Five years later at the Paris Exhibition of 1867, and at a time of his greatest renown, Cortelazzo exhibited a considerable number of his finest pieces. The Narishkine tea service, named from the coat-of-arms it bears, was probably a central feature of this display. A spiteful contemporary British report on the Italian metalwork section mentions a tea service "of large dimensions . . . both in size and in style, only fit for Gog and Magog."

Despite their sheer size, and an exuberance of design verging on the absurd, Cortelazzo shows in these pieces a complete mastery of his art. The silver bodies are chased or applied with figures, monsters and panels of grotesques, and inset details of damascened steel are finely worked with "The Triumph of Galatea" and other mythological scenes. Above all it is evident that Cortelazzo had a great sense of fun.

His admirers, including the energetic Sir Henry Cole, were sometimes over extravagant in their claims. He was hailed as a "Benvenuto Cellini" rediscovered, and his productions were "verily gems", or works worthy of "the best of the *cinque-cento* masters". Nevertheless, in a letter which Sir William Richard Drake wrote to Layard in 1869 about the French-made mounts on a recently re-set agate cup, he unwittingly levelled the balance for us by his comment: "It is *elegant* & *pretty* & such a work as might be looked for . . . but it lacks altogether that peculiar artistic *go* which gives the charm to Cortelazzo's works."

[1] Any works by Cortelazzo from Lord Wimborne's collection are presumed lost, probably in the fire which destroyed most of Canford Manor about ninety years ago.

[2] A ewer and dish of steel and silver inlay from Drake's collection, exhibited at South Kensington in 1871, is now in Italy.

[3] Mr Spottiswoode's famous clock, executed by Cortelazzo in silver, steel and lapis lazuli and shown at the same exhibition, is now in the Western Park Museum, Sheffield.

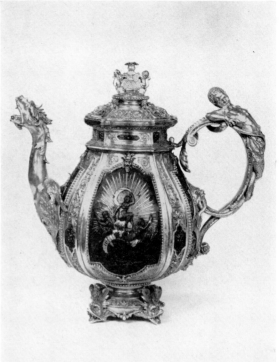

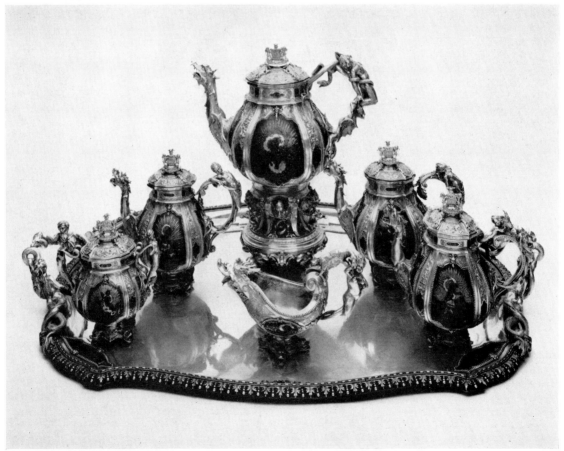

An important Italian seven-piece teaset of massive proportions, comprising three teapots, a covered sugar vase, a milk boat, a tea kettle on lampstand, and a two-handled tea tray. Bearing the arms of Narishkine. Signed 'A. Cortelazzo. Di Vicenza Fece'. *Circa* 1865.
Teapots 9¾ in. high; sugar vase 7¾ in.; kettle on stand 15¾ in.; milk boat 10¼ in. wide; tea tray 29 in.
London £3,500 ($8,750). 24.11.72.

1. Bronze African elephant after Barye. Signed. Stamped F. Barbedienne. Height 10 in. £230 ($575). 10.XI.71. **2.** Bronze group of horse and jockey by I. Bonheur. Signed. Height 1 ft. 8 in. £750 ($1,875). 10.XI.71. **3.** Bronze labrador after E. Delabrierre. Signed. *Circa* 1880. Height 8 in. £275 ($687.50). 1.III.72. **4.** Ormolu ewers French 1825–50. Height 23 in. £600 ($1,500). 1.III.72. **5.** Ebony and ivory cabinet by Gatti of Rome, with portrait medallions of Leonardo da Vinci and Petrus Vennucci, 1870–80. 32 in. by 29 in. £820 ($2,050). 1.III.72. **6.** Sculptural bronze mantel clock by J. Martinot. Signed. *Circa* 1840–60. Height 24½ in. £250 ($625). 15.XII.71. **7.** Bronze figure of a Norseman after J. H. Foley, cast by J. A. Hatfield, 1876. Height 2 ft. 7 in. £110 ($275). 17.V.72. **8.** One of a pair of busts of Turkish warrior maidens by A. Gaudez. Signed *Circa* 1880. Height 2 ft. 6 in. The pair £920 ($2,300). 7.VI.72. **9.** Bronze figure of Queen Victoria, after HRH Princess Louise. *Circa* 1880. Height 24 in. £60 ($150). 15.XII.71. **10.** Bronze figure of the tired driver by C. S. Jagger. Signed. *Circa* 1920. Height 2 ft. 10 in. £750 ($1,875). 7.VI.72. **11.** French gilt-metal and champlevé enamel mantel clock. *Circa* 1850. Height 18 in. £410 ($1,025). 24.XI.71. **12.** French porcelain-mounted ormolu mantel clock by Japy Frères. *Circa* 1860. 1 ft. 9 in. high. £270 ($675). 10.XI.71. **13.** Ormulu-mounted porcelain clock garniture. Stamped *C. & S. Circa* 1870. Height 18 in. £460 ($1,150). 17.V.72. **14.** French ormolu and porcelain garniture de cheminée. Mid-19th C. Height of clock 23 in. £400 ($1,000). 19.IV.72.

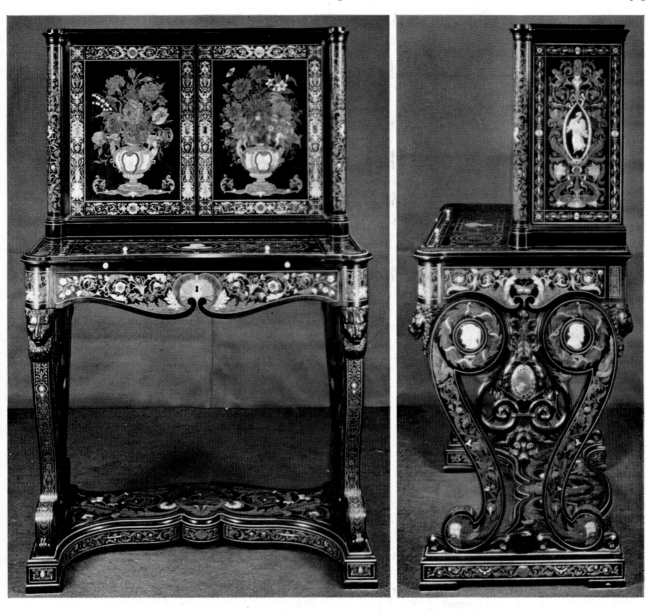

A documented ebony marquetry writing cabinet by G. B. Gatti.
Signed *Gatti F. Fec. Roma 1855*, with ivory portrait medallion signed *Pernie Graf*.
Width 2 ft. 10 in., height 4 ft. 4 in.
London £2,200 ($5,500). 7.VI.72.

A letter in Gatti's hand entitled *Work executed by me, Gio Batt. Gatti, for the Great exhibition in Paris 1855 upon commission from Mr. Wright Post*, which describes the cabinet in great detail and sets out minutely the specifications of the inlays, was sold with the cabinet.

1. Pilkington's Royal Lancastrian vase painted by R. Joyce. Marked with monogram, 1909. 10 in. £220 ($550). 20.1.72. **2.** One of a pair of Belleek centre-pieces based on a shell. With Co. Fermanagh marks and printed John Mortlock retailer's mark. 13 in. £1,900 ($4,750). 20.IV.72. **3.** George Owen Royal Worcester vase and cover. Marked and coded for 1890. 7 in. £360 ($900). 20.1.72. **4.** Triple bird group modelled by Robert Wallace Martin. Signed and dated 1911. 7½ in. £480 ($1,200). 1.VI.72. **5.** Porcelain plaque painted with the Rape of the Daughters of Leukippos, after Rubens. Marked KPM. 22½ in. by 18 in. £1,450 ($3,625). 3.II.72. **6.** Sèvres *pâte-sur-pâte* plaque painted by Marc Louis Solon.

Signed 'Miles' and dated 69. 11¾ in. £210 ($525). 17.II.72. **7.** One of a pair of Berlin porcelain plaques of Antigone and Psyche. Marked KPM. *Circa* 1840. 12¾ in. by 6¼ in. £920 ($2,300). 3.II.72. **8.** Crosse & Blackwell advertising plaque 13 in. by 9¾ in. £350 ($875). 16.XII.71. **9.** Canton *famille-rose* vase. Mid-19th C. 31½ in. £350 ($875). 15.VI.72. **10.** One of a pair of Doulton vases by George Tinworth. Marked with artist's monogram, dated 1888. 25 in. £250 ($625). 20.1.72. **11.** Enamelled Kinkozan hexagonal vase. Marked. Second half of 19th C. 16 in. £140 ($350). 23.III.72. **12.** One of a pair of *famille-rose* vases. Mid-19th C. 37 in. £830 ($2,075). 3.II.72.

1. Wall plaque painted in silver lustre by Richard Joyce after design by Walter Crane. Marked and dated 1907. 19¼ in. £340 ($850). 20.I.72. 2. A pot lid showing a bear in a ravine. £390 ($975). 16.XII.71. 3. De Morgan dish painted by Charles Passenger. Painter's initials, late Fulham period, 1898–1907. 14½ in. £330 ($825). 20.I.72. 4. Deck faience wall plate by Schaeppi. Signed. Circa 1890. 13 in. £120 ($300). 2.XII.71. 5. *Pâte-sur-pâte* circular plaque painted by W. Willis. Signed. Possibly Minton, probably 1896. 10⅛ in. £205 ($512.50). 17.II.72. 6. One of a pair of Vienna porcelain wall dishes painted with portraits of English actresses by Wagner, after Joshua Reynolds. Signed 14 in. £310 ($775). 3.II.72. 7. Continental porcelain plaque with Venus rising from the sea. Incised 'C'. Mid-19 C. 12¾ in. £320 ($800). 20.IV.72. 8. *Famille-rose* porcelain plaque or table top. *Circa* 1880. 20¼ in. £100 ($250). 15.VI.72. 9. Paris porcelain plateau with a central painting of the Three Graces after Angelica Kauffman. 1825–50. 17¾ in. £300 ($750). 3.II.72.

A very rare cameo-glass plaque of circular concave form by Geo. Woodall, the deep ruby glass carved with a figure of Syrenea in transparent billowing drapery.
Signed. *Circa* 1885. 10¾ in.
London £6,500 ($16,250). 23.III.72.

From the collection of Mrs R. E. Edward.

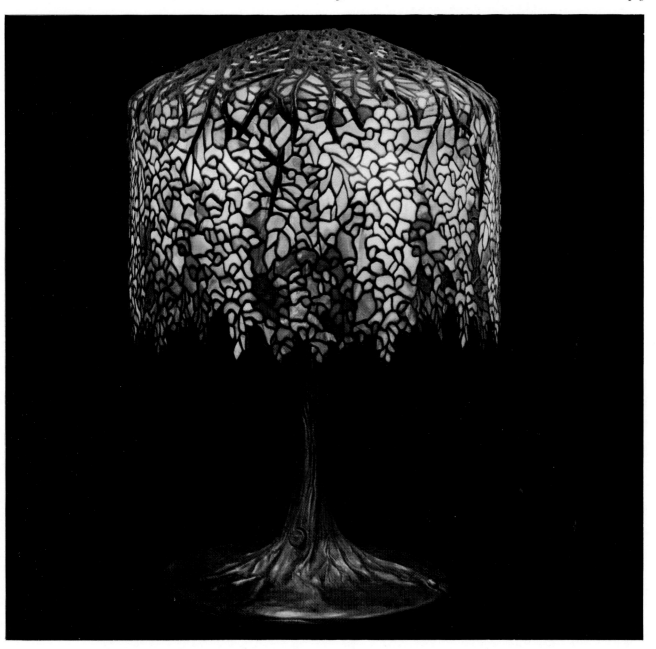

A Tiffany Studios wisteria lamp, the blue, green and purple shade concealing four light fittings and supported on a slender cylindrical stem modelled in verdigris bronze as a tree trunk.
Signed *Tiffany Studios New York 26854*, marked *Tiffany Glass and Decorating Company*.
Overall height 27 in.
London £6,500 ($16,250). 3.XI.71.

1. Art Deco glass vase by Antoine Daum. Signed. Height 10 inches. $750 (£300). 2.v.72. **2.** Tiffany paperweight vase. Base engraved *8520 N L. C. Tiffany Inc. Favrile.* 6 in. £1,800 ($4,500). 3.xi.71. **3.** Silver-mounted carved cameo and marqueterie vase by Emile Gallé. The mount by Cardeilhac. 9¼ in. £850 ($2,125). 8.iii.72. **4.** Tiffany Studios poppy lamp. Signed. 16¾ in. £2,300 ($5,750). 22.vi.72. **5.** A mahogany writing desk by Louis Majorelle. Height 43¼ in., width 37 in. £310 ($775). **6.** An enamel vase signed *C. Fauré Limoges.* £210 ($525). 22.vi.72. **7.** An Art Deco enamelled silver sugar bowl by Laparra, France, *circa* 1930.

Height 4½ in. $350 (£140). 2.v.72. **8.** An Art Deco gold-mounted dark green jade, lapis lazuli and agate minute repeating boudoir clock by Cartier. Height 4¾ in. $13,500 (£5,400). **9.** Art Deco dancing girl with the stamp of Leverrier, Paris. Signed 'Fayral'. 16½ in. £130 ($325). 8.iii.72. **10.** *Dancing*, silver panel by George Frampton. Signed and dated 1894. 33¼ in. by 15¼ in. £400 ($1,000). 8.iii.72. **11.** Charcoal study for *The Moon* by Alphonse Mucha, for 1897 series of four stars. Signed. 42½ in. by 20 in. £1,100 ($2,750). 3.xi.71. **12.** *Tango*, bronze group by G. Eberlein. Signed. 21½ in. £620 ($1,550). 22.vi.72.

Art Deco Bacchus and Ariadne vase designed by
Lotte Fink of Vienna and executed by Lobmeyer.
Dated 1925. Height 7 in.
New York $2,900 (£1,160). 2.v.72.
From the collection of the Cranbrook Academy of Art.

A marqueterie de verre vase by Emile
Gallé, in shades of toffee and aubergine,
impressed with blue and brown glass.
Engraved 'Gallé 1900'. 13½ in.
London £2,300 ($5,750). 3.XI.71.

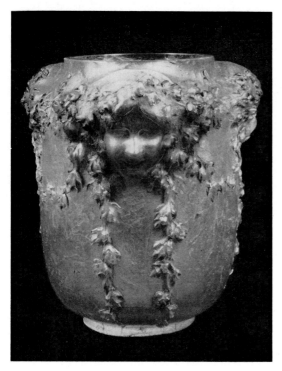

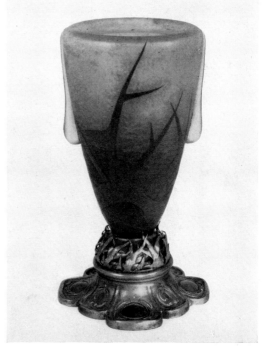

An early *cire perdue* vase by René Lalique in
grey glass with three laughing female heads
modelled in full relief. Engraved *Lalique*. 9 in.
London £1,600 ($4,000). 22.VI.72

A gilt-bronze mounted wheel-worked Daum
vase in milky-blue glass overlaid with blue-grey
glass. Engraved *Daum Nancy*. Height 11 in.
London £580 ($1,450). 3.XI.71.

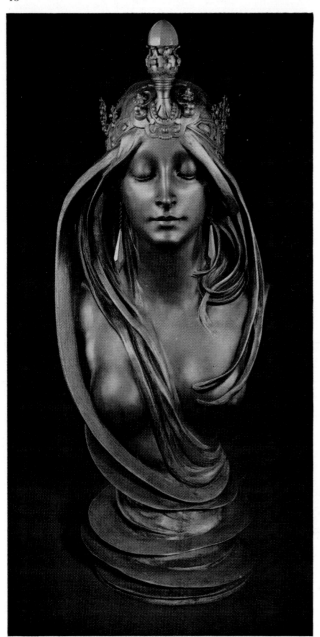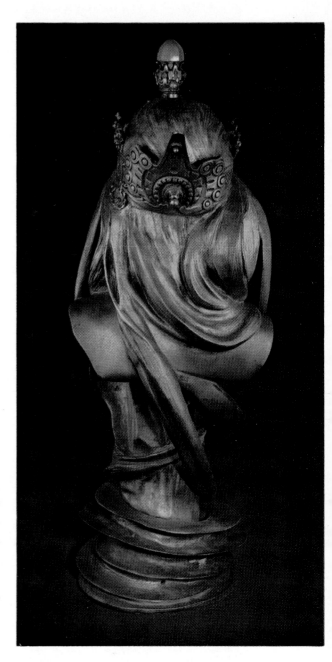

Fig. 1. An important gilt-bronze bust by Alphonse Mucha. Signed and bearing the founder's mark, Pinedo, Paris. Height 27½ in.
London £11,000 ($27,500) 3.XI.71.

The Bronzes of Alphonse Mucha

BY PHILIPPE GARNER

Alphonse Mucha was an artist of considerable imagination, which is surely apparent when one compares the bronze figure and the artist's photograph of the model posing (figs. 2 and 3).

The volume and range of Mucha's work is prodigious, for this designer, who epitomises the French 'hothouse' style of Art Nouveau, produced jewels, furniture, shop interiors, exhibition pavilions, murals, a variety of metalwork, costume and theatre designs, bronze busts and figures, in addition to the vast range of posters and decorative panels for which he is best known. It was through the medium of the poster that his work first became popular. The incident that started his success, and his relationship with Sarah Bernhardt, is recorded in his diary.

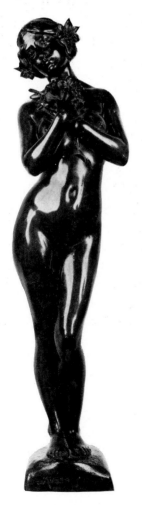

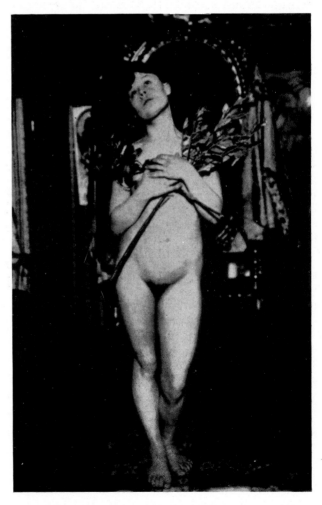

Fig. 2. Bronze full figure of a nude by Alphonse Mucha. Height 79 cm. Galerie du Luxembourg, Paris

Fig. 3. Photograph of a model in Mucha's studio, 6 rue du Val de Grâce, Paris, *circa* 1900. (Courtesy of Academy Publications).

'At two o'clock (it was St Stephen's day and Mucha was in a hurry to finish a job at the lithographers) . . . de Brunoff came to see me . . . "Mucha," he said, "I am in trouble. Sarah Bernhardt has just phoned. She needs a poster for her new play and she wants it up on the hoardings by New Year's Day . . . Have you ever done anything like that before?" "Well no," I replied, "but I could try." "There's no time for trying . . . we'd have to get down to it straight away".'

Mucha was rushed off to the Théâtre de la Renaissance where he found Sarah 'sublime' in the role of Gismonda. The artist sketched out a design which was hurriedly approved. He worked fast, obliged by the urgency of the job to draw directly on the lithographic stone. When the posters had been delivered, a telephone call summoned the nervous artist to the presence of 'La Divine Sarah' for the first time. She was thrilled by his interpretation of her and, as a result, between the years 1895 and 1901 she commissioned many more posters and other printed ephemera from Mucha, who also designed exquisite jewels for her, which were executed in collaboration with Georges Fouquet.

Mucha was launched by this relationship with Bernhardt, which provided him with as much inspiration as it did fame, and explains why many have been tempted to see the bronze bust sold at Sotheby's Belgravia on 3 November 1971 as a portrait of Sarah Bernhardt (fig. 1). In fact it bears little resemblance to her though it exudes the same charisma. The sale of this bust for £11,000, a record for any item of Art Nouveau, caused considerable excitement.

This was in part due to the result of an earlier Sotheby sale in March 1970, when another bust by Mucha had reached £7,500, a record at that time, after very heated competition between rival Paris bidders. Many commentators considered this price out of proportion and felt sure that the sale of the second bust in 1971 would prove this. The stage was therefore set to test the strength of the Art Nouveau market and it was interesting that the 1970 price was not only equalled but comfortably exceeded after competition among a healthy number of bidders, in spite of the fact that, while the first bust was thought to be unique at the time of the sale, it was known that a cast of the second one was in the Robert Walker Collection, Paris, and rumour had it that yet another cast existed in Italy. (It is now known that the first bronze was recast commercially by the German founders Gladenbeck & Sohn between 1900 and 1906.) Mucha undoubtedly ranks amongst the most important artists of the Art Nouveau world. Both record prices, however, are partly due to the extreme rarity of his three-dimensional work. Research inspired by the sale on 3 November, brought to light the existence of only five works sculpted by him.

Mucha was specially interested in sculpture between 1899 and 1903 and, apparently, all his work in this particular field was made in collaboration with Auguste Seysses, a mediocre sculptor who occupied the ground floor of Mucha's studio. At least two bronzes were cast for the Paris Exhibition of 1900. In his record of his hurried preparations, Mucha recalls 'Besides, I was busy modelling the statue of Bosnia and Herzegovina which I started at Seysses's studio, and I had another statue to make for the Houbigant exposition. The perfumer was a good friend of mine and I promised it to him, unawares that I would be so hard pressed for time. It was a bust of a woman, gilded and crowned with a diadem . . .' It is generally agreed that the

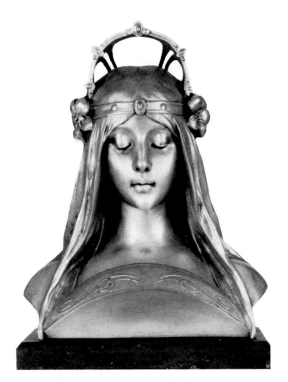

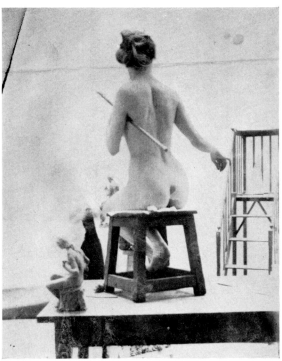

Fig. 4. Bronze bust by Alphonse Mucha, silvered and parcel-gilt made for the Houbigant stand at the Paris 1900 Exhibition.
London £7,500 ($18,000). 9.III.70.

Fig. 5. Photograph of a model posing beside the maquette of Alphonse Mucha's *Bosnia and Herzegovina, circa* 1900. (Courtesy of Academy Publications).

first bust sold at Sotheby's was the piece commissioned by Houbigant. It won for Mucha a bronze medal, as did the statue of Bosnia and Herzegovina which he mentions above. Of this latter all that survives is a photograph (fig. 5) showing the model posing beside the maquette. The catalogues of the Austrian section of the 1900 Exhibition list another bronze entitled 'La Nature' (expo. no. 153), though it is uncertain to which bronze this refers.

The bust sold this season appeared from an unknown source. The Robert Walker Collection cast, which was discovered in the early sixties, had inspired a certain amount of speculation as to its history. A different finish distinguishes the two busts: fully silvered and gilded in the case of the Walker bronze; gilded but with a soft, matt finish for the Sotheby's Belgravia bronze, together with slight differences in the form of the crestpiece. In neither case is the decoration inserted in the crestpiece original, nor do the earrings correspond to those shown in contemporary photographs (fig. 6). Only the Sotheby's Belgravia bronze bore the Paris foundry mark of Pinedo. Some said, and still say, that this bust was designed for the shop of the jeweller Georges Fouquet in the Rue Royale, Paris, which was created by Mucha. This is certainly not the case, as the bust was started during 1899 and is illustrated in the Czech journal *Zlata Praha* dated 1900, thus antedating Mucha's design for Fouquet's shop which, according to Jiri Mucha, his father undertook after 1900. The confusion probably arises from the sketches made by Mucha for the shop interior, in which he suggests a similar bust with the same stylized, swirling hair and a diadem (fig. 7). The embodi-

Fig. 6. A contemporary photograph of the bust (Fig. 1) by Alphonse Mucha sold at Sotheby's. (Courtesy of the Grosvenor Gallery).

Fig. 7. Sketch for the fireplace of Georges Fouquet's shop in Paris, *circa* 1901, by Alphonse Mucha in the Musée Carnavalet, Paris (photo Giraudon).

ment of these sketches exists, however, to dispel any doubts. It is the bust now in the Musée des Arts Décoratifs, Paris, which indeed uses a similar, though more naturalistic swirling hair motif as the base. This bronze (fig. 8), cast in 1901 and signed by Mucha and Seysses was removed from Fouquet's shop when the interior was dismantled in 1920 and acquired by the Museum in 1958. It is the only known cast.

Thus the question remains unanswered of who commissioned the record-breaking bronze. The evidence is unfortunately of a very negative nature. It is interesting to note that the idea of the heavy, studded headdress with its prominent crestpiece and decoration of cult symbols was conceived as early as 1896, for an almost identical piece is used in a lithographic poster of that date for the contemporary magazine *La Plume* (fig. 9).

There remains one bronze which must be mentioned, this is the most recent discovery and it is a full length study of a naked young woman holding flowers (fig. 2). This piece is signed only by Seysses, though it varies considerably from his personal style and the photograph discovered by Jiri Mucha of the model posing for this work

Fig. 8. Bronze bust by Alphonse Mucha (signed Seysses & Mucha), from Georges Fouquet's shop, now in the Musée des Arts Decoratifs, Paris.

Fig. 9. Lithographic design by Alphonse Mucha for *La Plume*, 1896.

in his father's studio serves to corroborate the attribution to Mucha already advanced by several specialists.

It is ironic that Mucha should have become famous for work, such as these sculptures, which is essentially decorative, and that he should be the most expensive artist to have appeared on the Art Nouveau market, for he was never aligned by any doctrine to the Art Nouveau movement although his work epitomises certain aspects of the style. He was, at heart, a passionate Slav whose ambition was to paint a series of giant canvases depicting the history of the Slav people. These he completed towards the end of his life when the fashion for Art Nouveau had passed and fewer demands were made upon him. The canvases are now sadly forgotten in Prague.

Mucha worked endlessly on the theme of innocently sensual young women with languorous eyes, in flowing patterns of delicate stylised flowers and arabesques. It was his sincerity as an artist and the intensity of his personal vision that raised him above the level of a mere decorator and gave these young women their ethereal, enigmatic appeal.

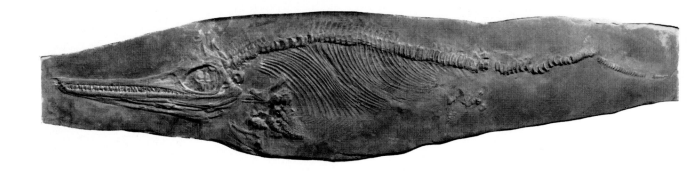

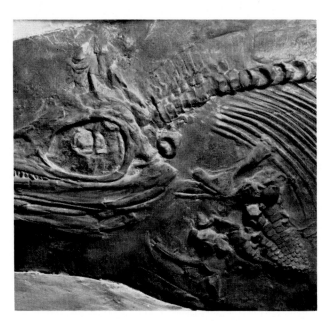

Above and left:
A specimen of the Ichthyosaur *Ichthyosaurus communis*,
on Lower Lias matrix, of Jurassic age (approximately 150
million years old), Lyme Regis, Dorset. Length 46½ in.
London £700 ($1,750). 17.III.72.

From the collection of the Abingdon Museum.

Below:
Two specimens of the fossil fish *Dapedium sp.*, from the
Lower Lias, of Jurassic age (approximately 150 million
years old), Lyme Regis, Dorset. Lengths 9 and 11 in.
London £160 ($400). 17.III.72.

From the collection of the Abingdon Museum.

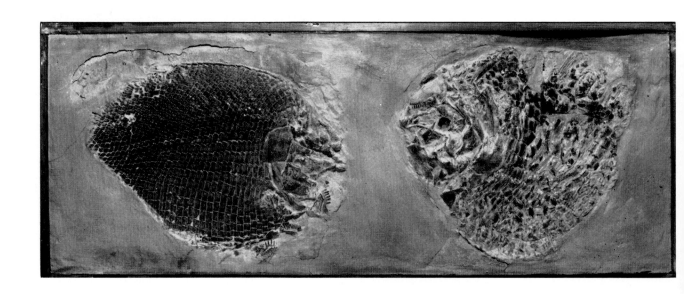

Natural History

The collecting and the study of natural history specimens has long been a pastime for enquiring minds. The fashion for the acquisition of fragments, specimens and remnants of our natural surroundings reached its height during the Victorian Age. Salerooms such as Stevens Auction Rooms in Covent Garden and Tennants, mineralogists to Her Majesty the Queen, catered for a new breed of men imbued with a deep scientific curiosity. Many were also concerned with aesthetics and 'taste', perhaps the most influential amongst them was John Ruskin. A collection of minerals catalogued by him was sold at Sotheby's in March 1971.

When Sotheby's new salerooms specialising in art of the Victorian Period opened in the autumn of 1971, it was decided that natural history sales would be held there. The opening sale for this speciality took place at Sotheby's Belgravia on 17th March.

A consistently high level of prices was obtained for fossils, many of which are now at least as expensive as minerals. There are hardly any dealers in this field and the market is almost completely supported by private collectors and museums, many of whom are concerned with the decorative appeal of a fossil as much as with its scientific aspect. Prices for rare birds were also consistent as demonstrated by a pair of extinct passenger pigeons which fetched £380 ($950). A single male specimen was sold by Sotheby's in December 1969 for £180 ($432).

A pair, male and female, of the extinct passenger pigeon *Ectopistes migratorius*, from North America, in glazed case, 30 by 14 in.
London £380 ($950). 17.III.72.

From the collection of the Bankfield Museum, Halifax, Yorkshire. The last wild specimen was taken at Babcock, Wisconsin, September 1899. The last living specimen died in Cincinnati Zoo in 1914. It was formerly abundant in large numbers from the Great Plains on the west of America extending eastward to the Atlantic coast.
Cf. J. C. Greenway, *Extinct and Vanishing Birds of the World*, p. 304.

1. Fossil fish *Dapedium pholidotum* in matrix from the Lower Lias, Jurassic age, Holzmaden, Württemberg, Germany, 11½ in by 8 in. £110 ($275). 2. Skull of the oreodon *Merycoidodon sp.*, from the Brule formation, Oligocene age, Sioux County, Nebraska, U.S.A., 7 in. by 4 in. £70 ($175). 3. Fossil fish *Diplomystus sp.*, on matrix from the Green River formation, Eocene age, Wyoming, U.S.A., 10 in. by 8 in. £42 ($105). 4. Ammonite *Asteroceras obtusum* on matrix from the Lower Lias, Jurassic age, Lyme Regis, Dorset, 18 in. by 15 in. £150 ($375). 5. Fossil turtle, from the Brule formation, Oligocene age, Sioux County, Nebraska, U.S.A., 8 in. £70 ($175). 6. Ammonite *Primarietites reynesi*, from the Lower Lias, Jurassic age, Keynsham, Somerset, 14 in. diam. £34 ($85). 7. Petrified wood, two quarter sections from Utah, U.S.A., 12 in. by 8½ in. £65 ($162). 8. Head of ichthyosaur *Ichthyosaurus platyodon* from the Lower Lias, Jurassic age, Lyme Regis, Dorset, 34½ in. by 17 in. £55 ($137). 9. Nodules split open to show both sides of fish from the Lower Cretaceous period, Santana formation, Serra do Araripe, Ceara, Brazil: top left, *Vinctifer comptoni*, 14 in. £24 ($60), below left, *Anaedopogon tenuideus*, 15 in. £32 ($80), top right, *Calamopleurus brama* 12½ in. £28 ($70), below right, *Vinctifer comptoni* 13 in. and 7½ in. £24 ($60). 10. A matrix covered with trilobites, from the Cambrian period, House Mountains, Utah, U.S.A., 9½ in. by 7 in. £35 ($87). 11. Footprints of a prehistoric reptile, probably *Apatichnus sp.*, on matrix from the Upper Portland series, Newark formation, Triassic age, Holyoke, Massachusetts, U.S.A., 21 in. by 12 in. £42 ($105). 12. Twelve specimens of the fossil fish *Lycoptera sp.* on matrix from the Lower Cretaceous/Upper Jurassic periods, Port Arthur, Manchuria, China, 13 in. by 7½ in. £60 ($150).

1. Botryoidal haematite (kidney ore) from Cumberland, 9 in by 11 in. by 7 in. £78 ($195).
2. Crystal of beryl *var.* morganite, from Galilea, Minas Gerais, Brazil, 12 in. by 4 in. by 7 in. £360 ($900). **3.** Azurite from the Tsumeb Mines, South West Africa, 4 in. by 3 in. by 2 in. £95 ($237).
4. Group of milky quartz crystals from Ouray, Colorado, U.S.A., 17 in. by 9 in. by 11 in. £170 ($425). **5.** Milky quarts crystals from Ouray, Colorado, U.S.A., 4 in. by 8 in. by 6 in. £20 ($50).
6. Dolomite from Eugui, Navarra, Spain, 7 in. by 6½ in. by 4 in. £60 ($150). **7.** Stibnite crystals from Iyo Province, Island of Shikoku, Japan, 7½ in. by 4½ in. by 3 in. £100 ($250). **8.** Calcite crystals from Egremont, Cumberland, 11 in. by 7½ in. by 7 in. £140 ($350). **9.** Crystal of gypsum *var.* selenite

from South Wash, Wayne County, Utah, U.S.A., 13 in. by 10 in. by 6 in. £32 ($80). **10.** Stibnite crystals from Baja Sprie, Roumania, 5 in. by 3 in. by 2 in. £50 ($125). **11.** Scalenohedral intergrowth of yellow calcite from Joplin, Missouri, U.S.A., 18 in. by 14 in. £32 ($80). **12.** Green tourmalin crystals from Cruzeiro, Minas Gerais, Brazil, 7⁴⁄₅ in. £100 ($250) and 6½ in. £160 ($400).
13. Brown alabandite from Broken Hill, New South Wales, Australia, 14 in. by 5 in. £60 ($150).
14. Single quartz crystal from Hot Springs, Arkansas, U.S.A., 18 in. by 7 in. by 6 in. £125 ($312).

The objects illustrated on this and the opposite page were sold at Sotheby's Belgravia on the 17th March 1972.

Wine

The Wine Department ended its second season with over two-and-a-half times as large a turnover as in its first year, a 160 per cent increase: £148,288 in 1970–71 compared with £386,822 in 1971–72. The auction room has become increasingly wanted for wine, with its rapidly changing values in new market conditions. Proof that the department's establishment has been timely is to be seen in the many buyers and sellers – both old and new friends of Sotheby's who began attending the sales so quickly.

Publicity naturally centred upon the exceptional prices obtained for rare bottles. On 5th October 1971 a Jeroboam of Château Mouton Rothschild 1929 was sold for £2,850. A new level of prices has also been witnessed in less rare wines, of vintages as recent as 1962, 1964 and 1966. After a lot of wine had been consumed by Christmas 1971, and the quantity of the 1971 vintage was seen to be below average, buyers competed at our sale on 9th February 1972 to push prices about 20 per cent higher than before. For the 1966 vintage (which is a favourite for quality, as well as for long-keeping) prices rose still more at the end of the season.

Prices have indeed outpaced inflation, for world demand for fine wine has increased and is increasing, while its supply (from vineyards discovered to be the finest over centuries) cannot significantly alter.

The investor is being attracted to the wine commodity market, which is to be encouraged so long as he does not lose sight of the ultimate drinker. It is in the eventual interests of buyer and seller that prices should remain realistic. For this reason Sotheby's now print estimates in each catalogue for every wine, as well as giving as much detailed information as possible about the condition of the stock.

The introduction of V.A.T. in Britain on 1st April 1973 should not cause more than a temporary realignment of prices. A few wines may come down in price, while others will go up. However, drinkers should find new wines to satisfy their needs at old price levels.

A Jeroboam of Château Mouton Rothschild 1929. London £2,850 ($7,125). 5.x.71.

Left:
Grande Champagne des Héritiers 1848 Cognac,
bottled in 1950 by Berry Bros. & Rudd. £26 ($65).
Below left:
Du Tierçon, Venerable, Grande Champagne
Cognac 1918. £18 ($45).
Below right:
Kirsch, age unknown. £6 ($14.50).

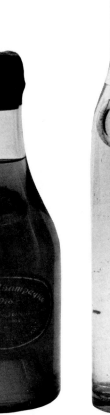

Above, extreme right:
A Methuselah of Taylor 1924, bottled 1926. Wax seal
embossed 'Thos Peatling & Sons, Kings Lynn, 1924'.
London £220 ($550). 5.x.71.

Above left:
A Rehoboam of Romanée Conti 1953, bottle No. 664.
Imported by J. L. P. Lebègue Bichot et Cie.
London £300 ($750). 8.iii.72.

Acknowledgements

Messrs Sotheby & Co. and Parke-Bernet Inc. are indebted to the following who have allowed their names to be published as the purchasers of the works of art illustrated on the preceding pages.

Alvin Abrahams, New York, 61 below; Acoris Fine Art, Surrealist Centre, London, 174(8); Adlam Burnett (Historic Keyboard Instruments), Goudhurst, 406 below; Thos. Agnew & Sons Ltd., London, 86 below, 87 above, 88 above, 95 above, 100 above, 110, 169, 417(9, 11); A. F. Allbrook, London, 390(2); S. S. Amar, Turin, 195 below right; Albert Amor Ltd., London, 393 above centre; Angel & Kaye, London, 421(3); The Antique Porcelain Co., of London & New York, 4, 125, 238, 239, 257 (11, 13), 261 (8), 263, 339, 357, 391 (3, 6, 7), 392, 393 above left and right, 396, 399 right, 400, 401 above and below right, 403 above; Antiques Corner Ltd., London, 308(8); Mr and Mrs George J. Arden, New York, 115 above; Asprey & Co. Ltd., London, 293 below right; A.A. Atkinson, Wolverhampton, 420 (4, 6), 421 (4);

Herman Baer, London, 276 above, 277 below, 280(1), 281(6), 313, 383 above left, 394 below left, 395 above left, 417(8); Douglas Barrett, London, 226(12); Barry's Art Gallery, Surfers Paradise, Queensland, Australia, 96 above, 97 above; J. N. Bartfield Books Inc., New York, 116 below, 215 left and right; Baskett & Day, London, 19, 57, 60 above centre, 63 above; G. H. Bell, Winchester, 380 above left; Bentley & Co., London, 309(1); 318(9); Farley L. Berman, Anniston, Alabama, 424(7); Herbert N. Bier, London, 131, 219, 295 above left; Ernest Bieri, Zurich, 380 above right; Ben Birillo, New York, 233(7); L. G. Blair, Toledo, Ohio, 281(11); N. Bloom & Son Ltd., London, 326, 420(8); Bluett & Sons Ltd., London, 252 centre, 257 (12), 261 (6, 10, 11), 264 above left; Mrs M. Bodmer, Zurich, 355(2); Yayoi Boeki Co. Ltd., Tokyo, 394 above left; Miss Norah Breen, Dublin, 390(10), 426(2); Martin Breslauer, London, 197, 209, 308(11); Brod Gallery, London, 54 above right, 55(1); The Roy Butler Militaria and Arms Museum, Lewes, 290 above left;

Mr and Mrs Henry B. Caldwell, Allentown, Penna, 318(8); Museum of Art, Carnegie Institute, Pittsburgh, Penna, Egyptian Art Fund, 228(8); Cartier Inc., New York, 309 (2, 3, 12); Lumley Cazalet Ltd., London, 62 above; The Masters, Fellows and Scholars of Christ's College, Cambridge, 421(9); J. C. Ciancimino Ltd., London, 226(1); Cinzano Collection, Wraxall, Bristol, 321(5, 10), 322; William Clayton Ltd., London, 249 below; Levi Cohen, London, 394 below right; Coins & Antiquities Ltd., London, 228(5); P. & D. Colnaghi & Co. Ltd., London, 46, 54 below right, 58, 75, 89 above; Sandro Comolli, Milan, 394 centre left; Giuseppe Costantini, Rome, 402 below left; Craven Antiques, London, 249 above; John Crichton, London, 264 below right; Cummer Gallery of Art, Jacksonville, Florida, 276 below;

Peter Dale Ltd., London, 286 above; Dalva Brothers Inc., New York, 350(8); Delomosne & Son Ltd., London, 365 below; Paul Delplace, Brussels, 308(10); Richard Dennis, London, 321(9), 426(1, 4, 10), 431 below right; Michael Denton Antiques, London, 295 below left; Devenish & Company Inc., New York, 348 above left, 349 below left; Anthony D'Offay, London, 105 below; Joseph Dollinger, M.D., New York, 383 centre left and right; Luiz de Mello do Rogo, Lisbon, 261(13); Mr and Mrs Samuel Dorsky, New York, 257(6); D. Drager, London, 318(3); David Drey Ltd., London, 407; Henry C. Dryon, Ohain, Belgium, 382 below right; Mr and Mrs P. J. Duff, Pontypool, 424(10);

E. Edwards, Beauchamp Galleries, London, 393 below; Francis Edwards Ltd., London, 200 right, 213 above; Dr W. Eisenbeiss, St. Gallen, Switzerland, 2, 132, 138,

226(9); Eskenazi Ltd., London, 6 above left, 243 below 253 left, 254 below, 255, 257 (2, 5, 10), 261 (2, 3), 265 (3, 4, 5, 6, 7, 8, 11); R. Esmerian Inc. New York, 309 (4, 5, 6, 11);

Faerber & Maison Ltd., London, 55(8), 133; Max Falk, New York, 279 below; Farhadi & Anavian Co., New York, 317, 318(13); Jocelyn Feilding, London, 417(2); R. L. Felix, Allestree, Derby, 290 above right; The Fine Art Society Ltd., London, 95 below, 367 above, 416(2), 417(6); John Fleming, New York, 201 left; Mrs Judith Fogler, London, 409 below; Dr Roland W. Force, Bernice P. Bishop Museum, Honolulu, 233(12); Lawrence Ford, New York, 306, 310 centre; Colin Franklin, Culham, Oxford, 204 left; Franses of Piccadilly, London, 362 below; I. Freeman & Son Inc., of London and New York, 328 above right; Miss H. Fritz, London, 49 below;

Galerie Aenne Abels (Dr Rainer Horstman), Cologne, 152, 174(9); Galerie Beyeler, Basle, 153, 168; Galerie Cailleux, Paris, 50, 52 below; Galerie du Lac (Peter Zervudachi), Vevey, Switzerland, 330 above left and right, below right, 331 below, 334(7), 335(3); Galerie Ostler, Munich, 361; Galleria Internazionale, Milan, 149, 175(5), 182; T. Galli, New Jersey, 228(7); B. Garber, Montreal, 175(13); Gay Antiques, London, 424(11); The J. Paul Getty Museum, Malibu, California, 30, 415; Gimpel Fils, London, 158; Ginsburg & Levy Inc., New York, 391(1); Helen Glatz, London 261(12); Mrs John B. Gooch, New Orleans, Louisiana, 333 below right; A. & F. Gordon, London, 349 above right; F. Gorevic & Son Inc., New York, 424(2); Graham Gallery, New York, 116 above, 333 below left; Graus Antiques, London, 381 above right; Richard Green Gallery, London, 23 below, 84 below, 85 above, 89 below, 94 below, 412 above and below, 413 below, 416 (4, 9), 417(7); Grosvenor Gallery, London, 174(13); Grover Antiques, Cleveland, Ohio, 430(2); A. V. Gumuchian, New York, 358;

Otto Haas, London, 199 below, 265(2); Stephen Hahn Gallery, New York, 151, 175(2, 6), 177 left; M. W. Hall, Abinger, Surrey, 294 above and below left; The Hallsborough Gallery, London, 27, 29; Gordon F. Hampton, San Marino, Calif., 171 above; J. Harounoff, London, 310 right; Roland Hartman Inc., New York, 308(7), 309(8); Hartnoll & Eyre, London, 416(1), 417(4, 12); Haslam & Whiteway Ltd., London, 421(11); Mrs Daniel Neal Heller, Miami Beach, Florida, 140; Frank R. Heller, Sari Heller Gallery Ltd., Beverly Hills, Calif., 146; K. John Hewett, London, 226 (7, 8) 232 left; G. Heywood Hill Ltd., London, 214 right; W. E. Hill & Sons, London, 404; Hirschler, London, 420(7); Hoffmann & Freeman Ltd., Shoreham, Kent, 198 above; Mr and Mrs Raymond J. Horowitz, New York, 120; House of Books, New York, 203 right; House of El Dieff Inc., New York, 216 right; How of Edinburgh, London, 282–283, 325, 327, 329 above right, 334(8, 12), 335(5, 8), 364; John Howell Books, San Francisco, Calif. 217 left; Cyril Humphris, London, 279 above, 335(6);

International Museum of Photography, George Eastman House, Rochester, New York, 418 below; Andrew Ivanyi Gallery Pty., Ltd., South Yarra, Australia, 97 below;

Jellinek & Sampson, London, 390(3); John H. Jenkins, Austin, Texas, 208–209; Geoffrey P. Jenkinson, Columbus, Ohio, 290 below; Sir Harry Jephcott Bt., London, 390(8); C. F. Jerdein, London, 174(11); Jeremy Ltd., London, 346, 348 above right; Oscar & Peter Johnson Ltd., London, 416(8);

Beldon Katleman, Los Angeles, 350(5); Daniel Katz, Brighton, 424(1); Arthur Kauffmann, London, 32, 166, 167, 411; Simon Kaye Ltd., London, 420(3); Paul Kewan, Wentworth, 139 above; Walter Klinkhoff Gallery Inc., Montreal, 108 below, 109 below; Martin Koblitz, London, 318(7); David M. Koetser Gallery, Zurich, 17, 25; Leonard Koetser Gallery, London, 20, 26 left, 28; E. & C. T. Koopman & Son Ltd., London and Manchester, 308 (5, 12); Gerald Kornblau Gallery, New York, 355(3); H. P. Kraus Inc., New York, 195 above left and right;

Ladysmith House, Sidmouth, 308(6); Mr and Mrs Paul H. Lauer, Ridgefield, Conn. 388; Ronald A. Lee, London, 355(7), 381 below right; The Leger Galleries Ltd., London, 82, 84 above; Leggatt Brothers, London, 78, 83, 85 below; Armin Lemp, Zurich, 269 right; Alain Lesieutre Collection, Paris, 431 above right; Levinson's Inc., Chicago, Ill., 305 (1, 11); Frances and Sydney Lewis, Richmond, Va., 126, 317, 318(12), 429, 430(3); R. E. Lewis Inc., Nicasio, Calif. 269 left; Limner Antiques, London, 295 centre; Jack Linsky, New York, 5, 353; Miranda & Sasha Linell, London, 441, (9 above left); Eris Lister, Portal Gallery, London, 416(6); Littlecote Antiques, Hungerford, 387 below, 390 (4, 5, 6); Lloyds, London, 321(6); London Gallery, Tokyo, 262 left, 266 above left, 266 right, 267 4th scabbard; Meredith Long & Co., Houston, Texas, 114 above;

J. S. Maas & Co., London, 417(10); R. Alistair Macalpine, London, 216 below; McCrory Corporation, New York, 162 right and left; Dr and Mrs. John J. McDonough, Youngstown, Ohio, 118; Brian McRoberts, Armagh, 441 (10, 11); Maggs Bros. Ltd., London, 105 above, 106 below, 107 below, 194, 202 left, 205 left, 207 right, 220; Manning Gallery, London, 86 above; Mansour Gallery, London, 226(6); Paul Martini, New York, 350(9); Gilbert May, Granville, Mass., 233(4); Roy Miles Fine Paintings, London, 76 above, 79; Minerals Engineering, Geneva, 440(13); C. C. Minns, Hove, Sussex, 321(8); Modarco S. A. Collection, London, 148, 175(3), 177 right, 179; D. C. Monk & Sons, London, 426(9); Moore Interior Design Inc., New York, 77 above; A. Moretti, Florence, 424(13); Earl Morse, New York, 257(9), 261(7); Hugh H. Moss, London, 230 right, 243 above, 254 above, 260 above right and below left, 262 right, 336; Mount Vernon Ladies Association, Virginia, 333 above; Richard Mundey, London, 336 below; Winifred A. Myers (Autographs) Ltd., London 216 left;

National Museum of Ireland, Dublin, 321(7); National Portrait Gallery, London, 14; W. Keith Neal, Warminster, 286 below, 288–289; Christopher D. Neame, Faversham, 440(4, 8); Meyrick Neilson of Tetbury Ltd., Tetbury, 379, 381 below left; J. B. Nethercutt, Los Angeles, 341 above, 369; David Newman, London, 264 above right;

O'Hana Gallery, London, 147; Libreria Leo S. Olschki, Florence, 196; Michel Dumez-Onof, London, 281(10), 441 (6, 7); Martin Orskey Ltd., London, 212 below; James St. L. O'Toole, New York, 349 below right; S. Ovsievsky, London, 332 above and below right, 337 above right and below right, 355(8);

Frank Partridge, London, 15, 18, 76 below, 77 below, 331 above (with S. J. Phillips Ltd.), 340 above, 341 below, 342 above, 355(10), 391(12); W. H. Patterson, London, 16, 90 above and below. 91 below; The Pedal Collection, Amersham, 380 below left; Howard Phillips, London, 320, 321(12); S. J. Phillips Ltd., London, 174(3), 280(8), 308(1, 3, 4, 9), 331 above (with Frank Partridge), 334 (1, with D. S. Lavender), 384 centre; The Piccadilly Gallery, London, 174(5), 176 right, 427(1); Mrs Corina Pierides, Nicosia, Cyprus, 363 above; Ponce Art Museum (The Luis A. Ferré Foundation), Puerto Rico, 316; Stanley J. Pratt, London, 350(2);

Bernard Quaritch Ltd., London, 199 above, 200 left, 202 right; Quinneys of Chester, Chester, 348 below left;

W. Christie Rae, Lavenham, Suffolk, 321(11); Rare Art Inc., New York, 257 (8), 309 (10), 318(5), 335(4), 427(8); Dr Ewald Rathke, Frankfurt-am-Main, 175(12); Residenzmuseum, Munich, 278; Michael Rice, London, 228(2); Howard Ricketts, London, 291 bottom of page; Mr and

Mrs Riklis, New York, 175(9); James Robinson Inc., New York, 420(12); Rogers & Fielder, Richmond, Surrey 426(3); E. Rokhsar, American Foreign Trade Development Co., New York, 362 above; Dr R. Rosenbaum, Scarsdale, New York, 405, 406 above; Rosenberg & Stiebel, New York, 12; Rosicrucian Egyptian Museum, San Jose, Calif. 226(5);

Frank T. Sabin Ltd., London, 106 above; Samuel Sachs II, Minneapolis, 441(1); St. Ouen Antiques (London) Ltd., London, 342 below; Santa Barbara Museum of Art, Calif., 229 above left; J. M. E. Santo Silva, Lisbon, 329 below left, 334(10), 335 (2, 7, 11), 420(10); Mrs D. A. Sardanis, Zambia, 440 (3, 12); Robert G. Sawers, London, 268 left and right; Hans Ulrich, Graf Schaffgotsch, Frankfurt-am-Main, 424 (3, 14); Hubert F. Schippers, Joboken, Belgium, 267 above right; Armin W. Schwaninger, Basle, 226(4); Schweitzer Gallery, New York, 100 below; L. S. Scott, London, 273; Seven Gables Bookshop Inc., New York, 204 right; S. J. Shrubsole Ltd., London & New York, 328 below, 332 above left, 334 (4, 5, 6), 420(11), 421 (1, 5, 6); Silverpost Private Collection, 334(3); John Simmons Collection, London, 440(10); The Norton Simon Foundation, Los Angeles, 128, 154, 226(10); Dr Paul Singer, 248 centre; John F. Smith, New York, 345 above; J. Bourdon Smith, London, 420(1), 421(2); A. R. Duncan Smith, London, 427(7); John Sparks Ltd., London, 6 above right, 237, 261(5); Edward Speelman Ltd., London, 22 above, 24 left, 26 right, 48 above and below; Spink & Son Ltd., London, 228(11), 245, 261(4), 281(5), 323 above and below right, 416(5); Garrick C. Stephenson, New York, 430(7); The Vigo Sternberg Galleries, London, 363 below; N. St. John Stevas, M.P., London, 424(9); The Suaréz Fine Art Co., London, 281(4), 335(9); R. J. Symes, London, 228(12);

The Tate Gallery, London, 160; The Temple Gallery, London, 314; Thayer Galleries Ltd., London, 426(12); Mrs Maureen Thompson, London, 321(4); B. & T. Thorn & Son, Budleigh Salterton, 391(10); Dr G. C. Thornley, Burgess Hill, Sussex, 378; Tilley & Co. (Antiques) Ltd., London, 390(7, 9); Alan Tillman (Antiques) Ltd., London, 321 (1, 3), 323 above and below left, 427 (4, 6, 9), 428, 429; The Time Museum, Rockford, Ill., 383 centre below, 384 above left and below right, 397, 398 left, 401 below left, 402 above left; Charles W. Traylen, Guildford, 188, 195 below left, 206 left; Barbara Troy & James Busby, Laguna Beach, Calif., 368 above; M. Turpin, London, 347 above;

Andrew R. Ullmann Ltd., London, 318(6); Manuel Ulloa, New York, 233(14);

Malcolm Vallance, New York, 350(6); Joseph and Earle D. Vandekar, London, 261(14), 355(11), 395 below left; Robert Vater, Frankfurt-am-Main, 398 centre; Eric Vaule, Bridgewater, Conn., 287; Ulrich von Külmer, Friedberg, 315 below;

The Waddington Galleries, London, 99, 101 above, 171 below, 184; Jack J. Walker, London, 417(3); Bob Ward, Indian trader, Sante Fé, New Mexico, 233(9); Dennis F. Ward, Lewes, 441(2, 8); Mr and Mrs F. A. Wartnaby, Beaconsfield, 294 above right; B. Weinreb Architectural Books, London, 367 below; Herner Wengraf Ltd., London, 87 below; T. M. Whiteway, London, 420(5); N. A. Whittley, 291 the two top; Williams & Son, London, 44; B. Williams, Borrowash, Derby, 427(2); Barry M. Williams, Brenchley, Kent, 426(8); Thomas D. Williams, Litchfield, Conn., 337; Winifred Williams of London and Eastbourne, 391(4, 9), 398 right, 399 left; Walter H. Willson Ltd., London, 328 above right, 334(2); Ian Woodner, New York, 53; Charles Woollett & Son, London, 293 above right, 391(8); Douglas J. K. Wright Ltd., London, 265(10), 267 second and bottom scabbards; Mr and Mrs Martin Wright, New York, 233(5), 345 below;

Susumu Yamamoto, Tokyo, 143; Dr Norman Young, New York and Palm Coast, Florida, 192; David E. Zeitlin, Merion, Penna, 389 below right; Zietz Alte Kunst Antiquitäten Hanover, 394 above right and centre right; Donald Zinman, Boston, Mass., 334(9).

Index

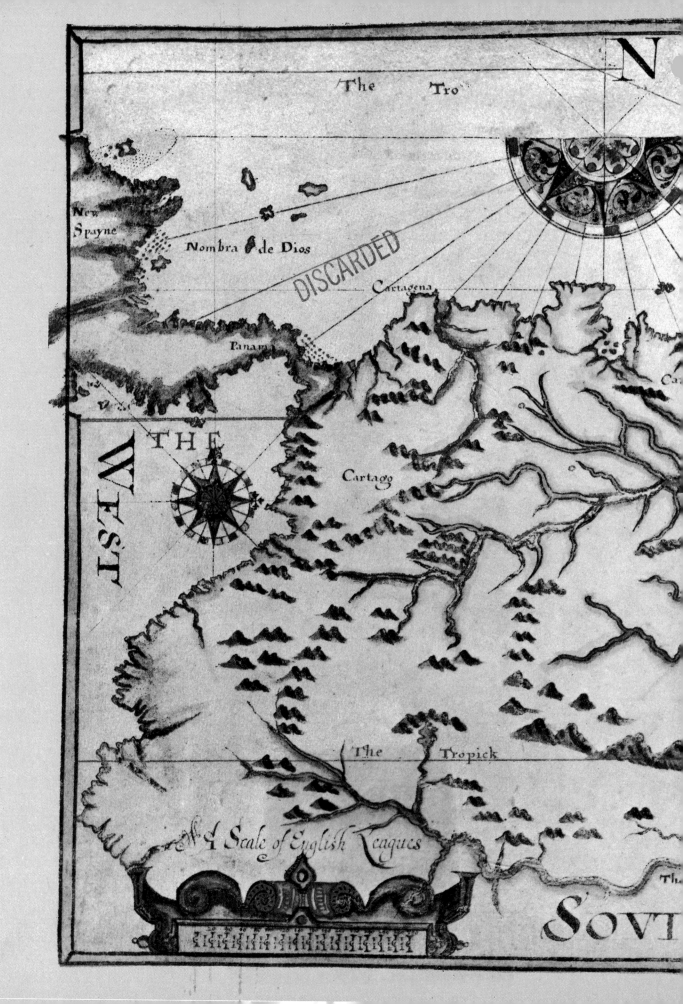